The Photographer's Guide to
POSING

Techniques to Flatter Everyone

Lindsay Adler

rockynook

The Photographer's Guide to Posing
Techniques to Flatter Everyone

Lindsay Adler
info@lindsayadlerphotography.com

Project editor: Maggie Yates
Project manager: Lisa Brazieal
Marketing manager: Mercedes Murray
Copyeditor: Patricia Pane
Interior design and layout: Kim Scott, Bumpy Design
Cover design: Aren Straiger
Indexer: Maggie Yates

ISBN: 978-1-681981-94-9
1st Edition (5th printing, July 2020)
© 2017 Lindsay Adler
All images © Lindsay Adler unless otherwise noted

Rocky Nook Inc.
1010 B Street, Suite 350
San Rafael, CA 94901
USA

www.rockynook.com

Distributed in the UK and Europe by Publishers Group UK

Distributed in the U.S. and all other territories by Ingram Publisher Services

Library of Congress Control Number: 2016944449

Printed in China

*This book is dedicated to photographers who
want to do more than just take pictures.*

*It is dedicated to those of you who want to help your subjects
look their best, feel their best, and know their own worth.*

Photography is powerful, and you aim to empower others.

CONTENTS

**Introduction:
Posing with Confidence** **1**

Your Posing Guide .. 4
 Is Pose a Four-Letter Word? 6
 Your Goals ... 7
 ❌ and ✅, Bad and Good 7
 Rules Are Meant to Be Broken 8
 "Train Your Eye" .. 9
 Other Ways to Learn 11

1 Posing and How Your Camera Sees **13**

Posing, Lens Choice, Perspective, and How Your Camera Sees 14
 The Rule of Perspective That Changes Everything 14
 Lens Choice and Focal Length 15
 Perspective and Pose: Body Placement 18
 Perspective and Camera Angle 22
 Lens Choice to Exaggerate Camera Angle 24
 Camera Angle and Subject Height 26
Why It All Matters .. 29

2 Posing and Directing the Face **35**

Directing ... 36
 Mirroring .. 36
 Gesture .. 37
 Verbal Direction ... 39
 Your Subject's "Better Side" 39
 Head Position ... 43
Elements to Consider in a Headshot 46
 Chin and Jawline ... 46
 Eyes ... 48

Shoulders and Neck .50

Nose .54

Relaxing the Features .58

Putting It Together .58

3 Posing Pitfalls

61

Poor Posture .62

The Problem: Neck .62

The Problem: Midsection .63

The Problem: Reduced Height64

The Solution: Improve Posture64

Foreshortening .66

The Problem: Arm Pointing at Camera66

The Solution: Adjust the Arm66

The Problem: Body Facing Camera68

The Solution: Adjust the Camera68

The Problem: Subject Facing Camera70

The Solution: Rotate the Subject70

Mergers .72

The Problem: Arms to the Sides Create Mergers72

The Solution: Create Negative Space72

The Solution: In-Body Posing75

The Solution: Using Arms to Contour77

The Problem: Baggy Clothing Creates Mergers78

The Solution: Adjust the Clothing78

The Solution: Adjust Hands .79

Poorly Posed Hands .80

The Problem: Distracting Hands; Palm or
 Back of Hand Toward Camera80

The Solution: Place Pinky Toward Camera80

The Problem: Tension .82

The Solution: Relax the Hands . 82

The Problem: Covering the Jaw . 83

The Solution: Adjust Hand Placement . 83

The Problem: Hands Pressed Against Face/Body 84

The Solution: Gently Place Hands . 84

Bad Expression . 84

The Problem: Tense Serious Face . 85

The Solution: Relax Head and Lips . 85

The Problem: Deer-in-Headlights Look . 86

The Solution: Draw Out Emotion or Expression with Eyes 86

Expression Tips and Tricks . 87

Train Your Eye . 90

4 10 Steps to Posing Success and Posing Variations

99

10 Steps to Posing Success . 100

Step 1: Select a Base Pose . 100

Step 2: Adjust the Pose or Change Angles to
Draw Attention To or Away From Body Parts 100

Step 3: Check for Foreshortening and Mergers 102

Step 4: Ensure Good Hand Position and Posture 103

Step 5: Engage the Subject to Get a Good Expression 104

Step 6: Shoot! . 104

Step 7: Vary Your Subject's Hands, Expression,
and Shoulder Placement to Create New Poses 104

Step 8: Try Different Camera Angles, Camera Positions,
Crops, Depths of Field, and Lens Choices for Variety 105

Step 9: Repeat! . 110

Step 10: Analyze Your Images and Learn from
Your Successes and Mistakes! . 110

5 Posing Women 115

Guidelines for Posing Women . 116
 Emphasize Assets, Reduce Weaknesses 116
 Bend and Curve! . 124
 Create Interest with Asymmetry and Levels 134
 Pose Your Subject to Create Mood and Drama 138
 Use Narrowing Points to Create Curves and an
 Hourglass Shape . 147
 A Go-To Pose . 151

Movement . 152
 Bounce Step . 152
 Falling Through the Step . 152
 The Windup . 153
 The Fan . 154

Train Your Eye . 156

5 Go-To Poses for Women . 165

6 Posing Men 167

Guidelines for Posing Men . 168
 Structured, Stable Poses . 168
 Using an Anchor or Prop . 175
 Shoulders Define Broadness . 181
 Hands and Feet: Direct Them! 185
 Direct and Tweak . 190

Train Your Eye . 195

5 Go-To Poses for Men . 203

7 Posing Couples 205

Guidelines for Posing Couples . 206
 For Romance: Create Multiple Points of Interaction 206
 Go Asymmetrical—Avoid Mirrored Poses 216

"Making the Rounds" for New Pose Ideas 225
 The Four Bases for "Making the Rounds" 225
 Creating Variety Through Digits and Expression 226
 Changes in the Photographer's Settings 230
 Quality and Expression Over Quantity 238

Train Your Eye . 239

5 Go-To Poses for Couples . 247

8 Curves 249

Guidelines for Posing Curves . 250
 Exaggerate Pose and Perspective 250
 Choose Clothing Carefully . 255
 Define the Waist . 259
 Create Visual Balance . 263
 Cropping and Narrowing Points Are Your Best Friends 269

Train Your Eye . 273

5 Go-To Poses for Curves . 281

9 Family Portraits 283

Guidelines for Posing Families . 284
 Build with Triangles . 284
 Balanced Composition . 293
 "Together" Body Language . 296
 Expressions . 303
 Don't Forget Perspective . 303

Train Your Eye . 309

5 Go-To Poses for Family Portraits 317

10 Boudoir 319

Guidelines for Posing Boudoir 320
 Bend, Curve, Arch! . 320
 Showcase Strengths, Downplay Weaknesses 331
 Hands Caress the Body and Direct the Eye 341
 Camera Work . 342
 Steps to Boudoir Variety 344

Train Your Eye . 348

5 Go-To Poses for Boudoir . 357

11 Maternity 359

Guidelines for Maternity Portraits 360
 3/4 or Profile to Emphasize Bump 360
 Bend or Elevate the Front Leg 362
 Use Arms to Contour . 366
 All Rules of Posing and Perspective Still Apply 370
 Include the Parental Partner in Supportive, Framing Poses . . . 372

Train Your Eye . 378

5 Go-To Poses for Maternity 386

12 Bringing It All Together 389

Posing Checklist . 391

Subject #1: Slender Young Woman 392

Subject #2: Curvy Woman . 402

Subject #3: Family . 412

Subject #4: Couple . 418

Subject #5: Curvy Woman . 425

Conclusion . 433

Index 434

Acknowledgements

Words can hardly express how thankful I am for this incredible moment in my life. I am the happiest I've ever been and every single day I try to appreciate the joy that I have found (and created) with others. I am aware that happiness is not always easily attained, and I have many incredible people to thank not only for the creation of this book but for the wonderful life I've built.

First and foremost, thank you Mom and Dad. I have some of the very best parents in the world and I believe this whole-heartedly. Thank you for the unwavering support when I've taken on big projects and even bigger dreams—and now I've been able to see so many of those dreams come true. Undoubtedly you've both helped to make these happen. In particular, an extra thank you to my mother. You are one of the most dedicated and hardest working people I know, and I'm lucky that this work happens to be for me.

Next, a very special thanks goes to my brand manager, Robert Gordon. You have helped me to develop the successful brand and business I have (and love) today. More than that, you've cared for both my business and for me as a friend. I have no doubt that the future continues to hold exciting and rewarding things for both of us.

Thank you Maggie Yates for helping to bring this book to life! You were more than gracious to work with my crazy schedule and constantly evolving ideas, and I appreciate all the hard work you've put in to make this book be the success I knew it would be! Thank you to Ted Waitt for inviting me to create this book. I always have a million ideas swirling around, so I appreciate both the direction and support for the education I value so dearly.

Finally, thank you to my handsome, kind and brilliant man, Chris Knight. This book has been a *long* (too long) time in the making, and I've loved being your book buddy. Sitting side by side with you has made the process far more pleasant and you've helped keep up my momentum even when I felt deflated. You certainly are an essential element of the extreme joy I've found, and I'm honored to have you in my life.

About the Author

Fashion photographer Lindsay Adler has risen to the top of her industry as both a photographer and educator. Based in New York City, her fashion editorials have appeared in numerous fashion and photography publications, including *Marie Claire*, *InStyle*, *Noise Magazine*, *Zink Magazine*, *Elle*, *Rangefinder*, *Professional Photographer*, and dozens more. As a photographic educator, she is one of the most sought after speakers internationally, teaching on the industry's largest platforms and most prestigious events, having been named 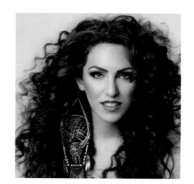 one of the top 10 best fashion photographers in the world. Lindsay has worked with some of the top brands in the photographic and related industries such as Canon, Adobe, and Microsoft.

A clean, bold, and graphic style has become the hallmark of her work, whether shooting advertising campaigns, designer look books, jewelry, hair campaigns, fashion editorials, or professional athletes. Lindsay is renowned for her creativity and collaborating with designers and stylists in order to create fresh looks.

Author of five books, she is always working on new ways to share her passions and knowledge with others. Each year she teaches to tens of thousands of photographers world-wide through prestigious platforms such as creativeLIVE, KelbyOne, and the industry's biggest conferences.

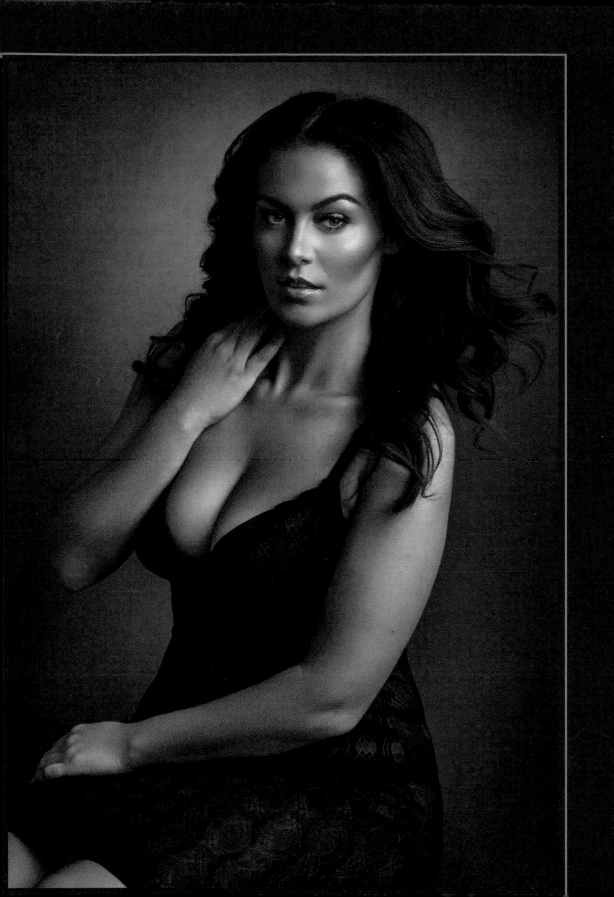

POSING *with* CONFIDENCE

Photographing people can feel intimidating, especially when you are still conquering the foundations of photography. Non-photographers don't realize just how much there is to think about! We have to worry about lighting, camera angle, exposure, focus, and all of the other technical elements before we even introduce a subject into the scene. Then, not only do we need to find a flattering pose, we must also do our best to coax great expressions from our subject, even if the person hates having their photo taken. We've got *a lot* of obstacles to overcome to get that perfect portrait, and the more you learn, the more smoothly a portrait session will go!

This may all sound overwhelming, so I am here to help you master the most essential elements of portrait photography. In this book, I'm going to simplify and share all the lessons I've learned about posing and directing a wide range of subjects in more than 15 years as a professional photographer. While today I am a fashion photographer in New York City, I began my career with a portrait studio where I learned to flatter every body type for every subject, from maternity sessions (**FIGURE I.1**) to boudoir to weddings—and more.

Mastering posing is an invaluable piece of the equation for photographing and flattering your subjects, and there really is a *lot* to learn. Does posing frighten you? Trust me, I've been where you are! For years as a portrait photographer I would stick primarily to one or two poses that would yield

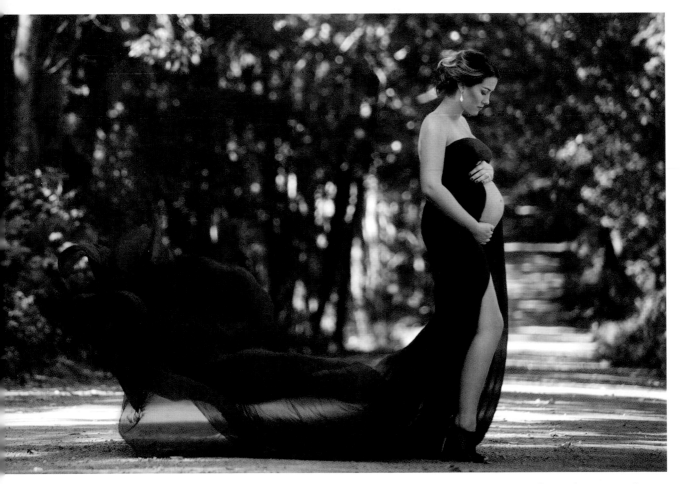

I.1 I've used the pose, hand placement, and styling to emphasize the subject's baby bump and to flatter the curves of her body. For some portrait types, like maternity, there are special considerations that will help ensure that you flatter your subject.

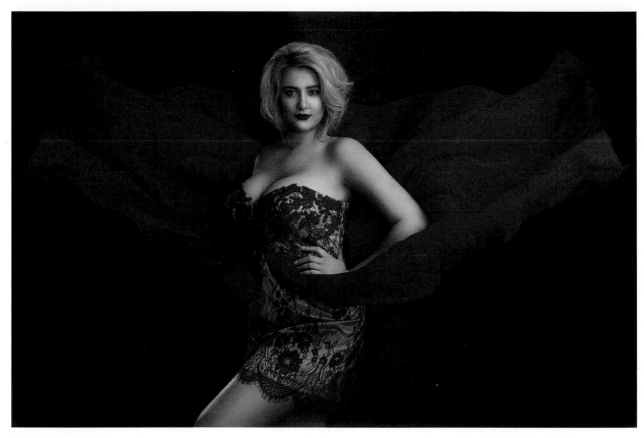

I.2 When you exude confidence, it becomes contagious. This confidence helps your subjects feel more comfortable throughout the process. Insecurity often becomes apparent in a pose or expression. Here, you can feel the subject beaming her confidence.

decent results for my subjects. I was afraid to experiment and even more afraid of photographing different body types. Through years of practice and education, posing is now as natural to me as exposure and composition. I want to share this knowledge and confidence with you using the lessons in this book.

I really must stress the importance of confidence when posing your subject (**FIGURE I.2**). When you exude confidence, your clients will trust you and feel more comfortable throughout the process. When you seem uncertain, insecure, or confused, you'll be able to see a difference in the subject's posturing. This book will help you build that essential confidence to successfully approach posing any portrait subject.

Your Posing Guide

This book is your guide to pose and flatter anyone! After studying this book and putting its lessons into practice, you'll have the confidence to bring out the best in any subject that steps in front of your lens. I crafted this project as a must-have quick-reference guide for any portrait photographer or photo enthusiast who wants to master posing.

We will begin our lessons by uncovering how your camera sees, and thus, how camera angle, lens choice, perspective, and more will affect the appearance of your subject. You may have a fantastic pose that looks awful because you've selected a less-than-ideal camera angle or lens. It is essential to understand how all of these parts work together, so we will begin there to build a strong foundation. We will cover posing fundamentals, must-know poses, specialty considerations, and training your eye to tweak a pose for more pleasing results.

We will also explore the most common posing problems and mistakes that can ruin an otherwise great pose. We will train ourselves to identify problem areas *before* we click the shutter and make subtle changes that result in drastically more successful images. Together we will explore tips for posing the body, face, and hands for successful results.

The second part of this book will dive in-depth into the essentials of flattering any subject—from men, women, and couples to full-figured subjects, families, boudoir, maternity, and more (**FIGURE I.3**). For each subject, we cover essential guidelines and tips to keep in mind so that your posing goes more smoothly. Then, for every subject we will walk through go-to poses to get you started. These poses are a starting point that will give you a quick reference when preparing for a portrait session. This book will prepare you to tweak poses and camera angles to better flatter every subject. I'll also cover how to take a few base poses and create endless variations so that all your shots don't feel the same and you can come up with new poses, even in a time crunch.

My hope is that this book will become your go-to resource for navigating the challenging world of posing and photographing a wide range of subjects, while helping you to build the foundations of posing that give you the confidence you need to create compelling portraiture.

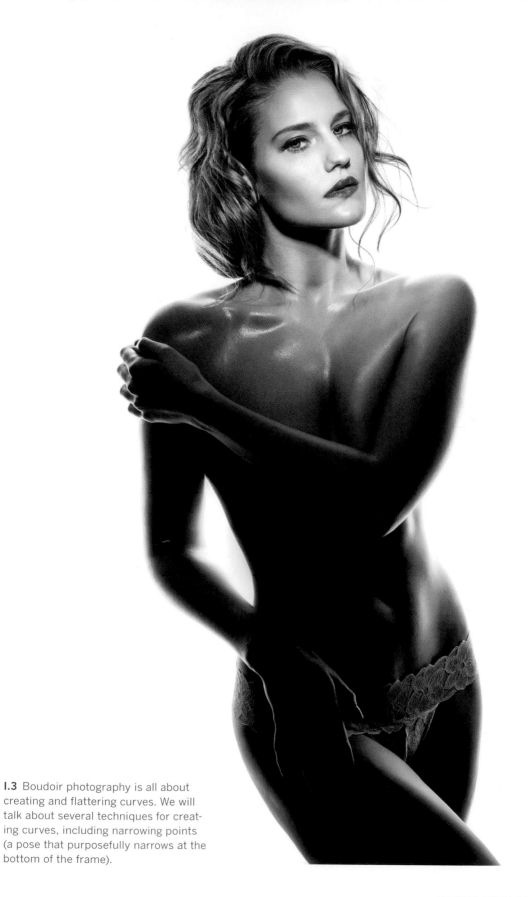

I.3 Boudoir photography is all about creating and flattering curves. We will talk about several techniques for creating curves, including narrowing points (a pose that purposefully narrows at the bottom of the frame).

Is Pose a Four-Letter Word?

I've worked with subjects who have begged not to look too posed and specifically insisted upon candids. But is this really what they mean?

For them, pose is a four-letter word. They associate posing with stiff body positions and uncomfortable expressions. Candids are informal images, typically taken without the subject knowing they are being photographed. People often associate candids with relaxed, natural expressions.

Usually, though, your subjects don't really want candids—they are trying to ask you to make them feel comfortable so the photos will show genuine expressions (**FIGURE I.4**). Even if they are uncomfortable with the word *pose*, you can still direct them into body positions and angles that will flatter them while helping achieve the expression that makes the shot really shine.

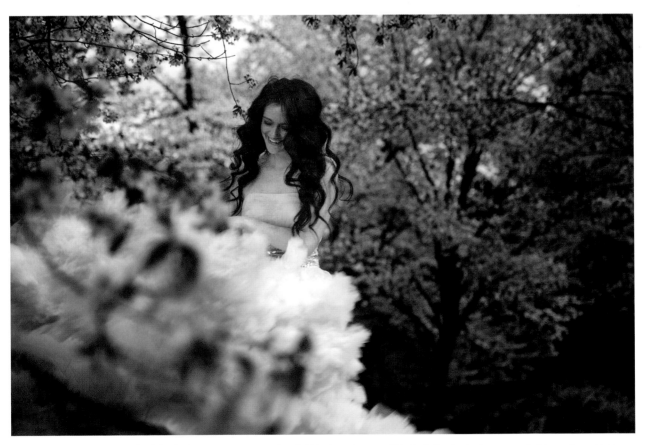

I.4 Although the subject in this shot appears very natural, this is not a candid shot. I selected a pose, light, and angle to flatter the subject and achieve this dreamy mood. Instead of creating a static and rigid body position, I directed the subject's movement and interacted with her to achieve a genuine expression.

Your Goals

Another goal for this book is to learn to enhance an individual's strengths while drawing attention away from any weaknesses. Everyone is different. No one pose works for every situation or for every individual. When you understand how your camera sees, combined with posing fundamentals, you'll be able to make adjustments to flatter every subject.

Every single subject that steps in front of your camera is beautiful. Every single one. Your job is to help the subject appreciate his or her beauty. Having a portrait taken can be a vulnerable experience that requires a great deal of trust. Your job is to see and showcase their beauty, and to use all the tools available to you as a photographer to do so.

Go-to poses and guidelines give you a great place to start, but your photographic expertise can allow you to make appropriate changes to help an individual really shine. In this book, we will cover the posing and perspective tools available for you to control exactly how your camera represents your subject (**FIGURE I.5**).

No more saying "the camera adds 10 pounds." In fact, the camera can remove 10 pounds if that's what you want it to do. Know your gear and take control.

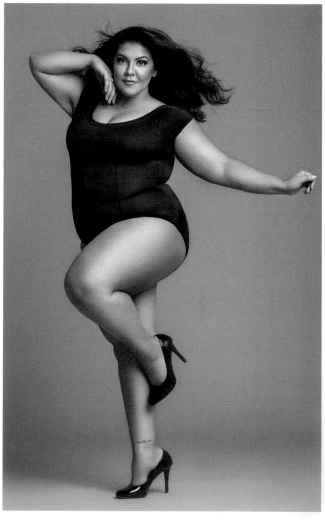

I.5 This curvy subject wanted to be bold and try a bodysuit fashion shot for her image. The light, pose, and her expression all work together to communicate her confidence and strength.

⊗ and ⊘, Bad and Good

I've designed this book for the visual learner to quickly and easily determine the differences between "good" and "bad" poses. When I first started studying posing by comparing poses side by side, I sometimes found it difficult to determine which pose was better. In this book, I've worked to

eliminate confusion by clearly marking bad poses with an X and good poses, or improvements, with a checkmark. Use these markers as a guide to educate your eye. Read the text for further explanation and to understand any nuances.

Rules Are Meant to Be Broken

As with all aspects of photography, rules are meant to be broken. I will teach you many rules of posing that will help build a better understanding of how to flatter your subjects. That being said, these guidelines are meant to be a strong foundation and not intended to constrain you (**FIGURE I.6**).

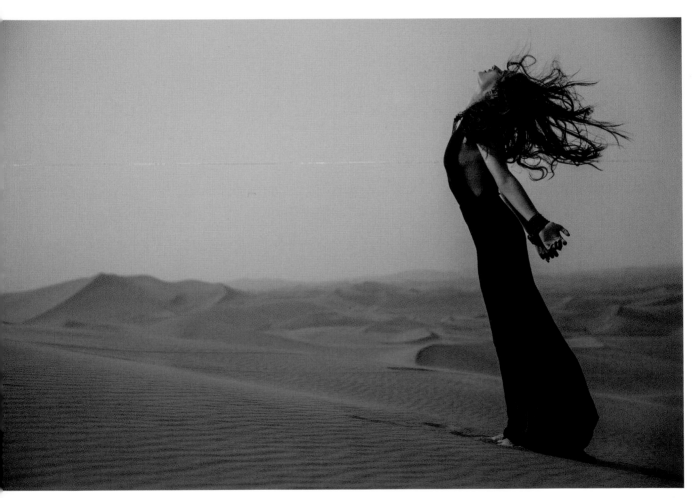

I.6 I've broken several posing rules in this image: we have not created curve, she is in complete profile, and her hands are thrown back with palms toward the camera. This shot, however, effectively creates a mood of liberation and wildness that was desired for the shoot. Sometimes breaking rules can be an effective tool for visual communication.

For example, in a fine art image of pain or suffering, you may have the subject curled up in a ball, hands tensed in an uncomfortable posture. Is this a wrong pose? Absolutely not. It is furthering the creative vision of the photographer. If that's what you are going for...do it! For the purposes of this book, though, we are focusing more on traditional portrait posing and techniques to flatter. Learn the posing rules, and then break them where appropriate.

As you learn these guidelines, don't forget the importance of facial expressions. Even the most elegant pose is nothing without an expression to suit the photograph. A client, however, may *love* an image with a terrible pose as long as their expression is glowing. Don't let the rules get in the way of your connection with your subjects, and don't feel that an overly posed image is always the way to go. Keep in mind that you can create more candid variations of many of the poses in this book. I'll teach you the base and essentials, but feel free to mix it up and add some spontaneity.

"Train Your Eye"

At the end of each subject-specific chapter, I've included an exercise to test your knowledge and train your eye. I will present you with a photograph that has posing issues. These could be general issues like posture and mergers, or issues specific to the subject matter. I invite you to examine the photograph, identify the problem areas, and try to formulate solutions to fix the problems (**FIGURE I.7**).

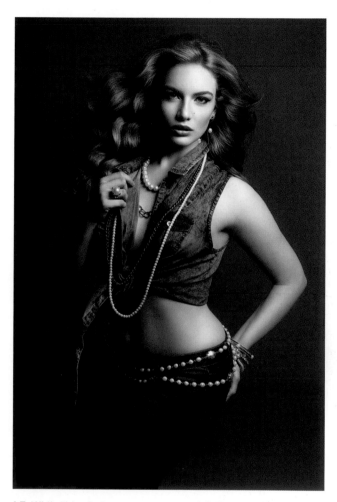

I.7 While this shot was very successful, there were other images in which the hips were misplaced, the hand awkward, or the expression ill-fitting. By training my eye, I can now catch these common mistakes while they are happening and improve them to get the results that bring out the best in my subject.

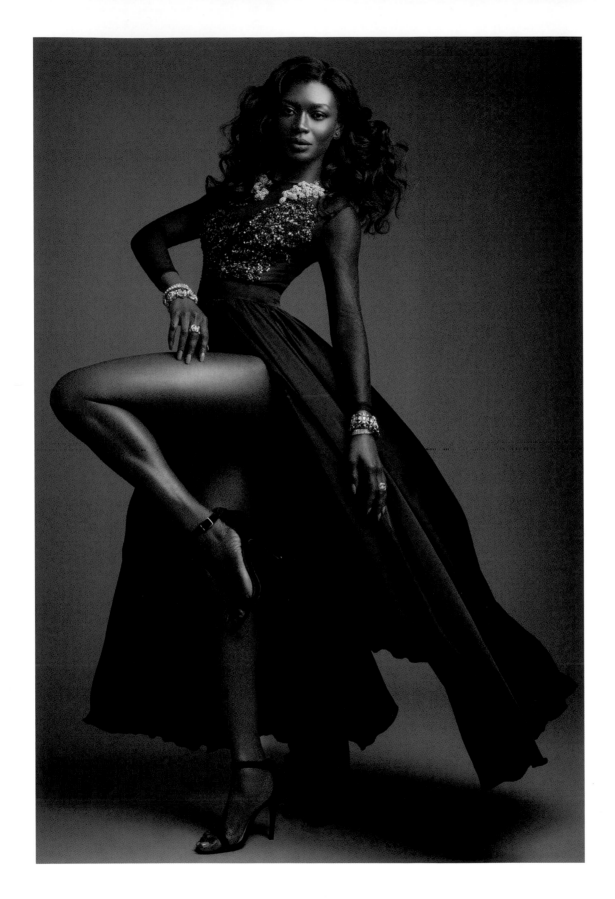

My goal is to help you start to identify issues so that you can fix them in-camera and get the shot at your session. These exercises help you build and flex your posing muscle so it will be at its strongest during a portrait session. I will provide one possible solution to improve the pose for each example, and clearly annotate the problem I identified. Of course, there are endless different solutions, but I'll share just one approach of many and a solution I would actually use during one of my own sessions.

At the end of each chapter, you'll have the opportunity to test your knowledge to catch and correct posing problems in the "Train Your Eye" sections. This will enable you to go back over your own portrait sessions and identify common issues. I don't always achieve perfect poses in my photographs, but I have the ability to catch a lot more problems in-camera instead of smacking my head and saying, "How'd I miss that?" when reviewing my shots.

The final chapter brings together everything you've learned, so you can see just how much posing knowledge you've gained.

Other Ways to Learn

While this book is a fantastic resource, you'll definitely want to visit learnwithlindsay.com/posing to see a wide range of instructional posing videos, review posing guides, take posing quizzes, and much more (**FIGURE I.8**). You haven't really learned it until you practice. Don't feel frustrated if you don't get it right away. It took me years and hundreds of sessions before I really got it down. My hope is that this book speeds up your learning process and saves you the time and mistakes of learning the hard way. Let's dive in and get started breaking apart what it takes to master posing.

I.8 Aspiring model Melody hired me to shoot a series of portfolio images to show off her beautiful physique through styling and posing. Go behind the scenes of this shoot at **learnwithlindsay.com** (opposite).

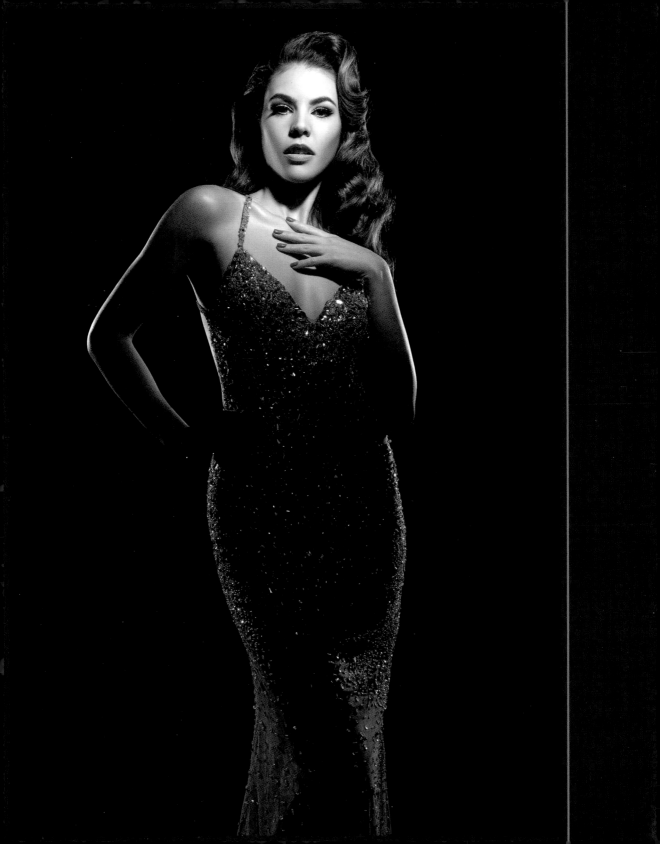

POSING *and* HOW YOUR CAMERA SEES

One of the biggest obstacles that photographers face with posing is understanding how their camera sees. You may have a beautiful pose that flatters your subject, but the lens, direction, and camera angle you have chosen may prove to be unflattering. Similarly, a pose may look somewhat unnatural to the naked eye, yet because of your camera angle and lens choice, the shot comes out stunning!

Posing is not a stand-alone aspect of photography. It works in conjunction with perspective and how your camera sees and interprets your subject. In fact, these elements are inextricable. For that reason, we need to take some time to truly understand this intertwining of tools.

Posing, Lens Choice, Perspective, and How Your Camera Sees

Learning perspective and how your camera sees will help you choose the most flattering poses for your subjects. When you really start to grasp the concepts of perspective, lens choice, and camera angle, understanding how to flatter the body becomes significantly easier. I'm going to break this down piece by piece, but know that all of the elements work together in a final pose. Let's jump in!

The Rule of Perspective That Changes Everything

Let's start by establishing the two most important things you can remember about how your camera sees when posing. Repeat these over and over again in your head.

Rule 1: Whatever is closer to the camera appears larger.

Rule 2: Whatever is farther from the camera appears smaller.

Remember these rules and never forget them. They will become your very best friend in posing as we learn to flatter our subject.

Let's take a look at this in practice. The easiest way to remember the first rule is by imagining your subject extending her hand toward the camera. Suddenly, the hand looks huge in comparison with the rest of the body. When the hand comes closer to the camera, it appears larger. In this instance, it appears even larger than her entire head due to perspective (**FIGURE 1.1**). Now, when the subject pulls her hand back to the face, it has returned to correct proportion. The farther the hand is from the camera, the smaller it will appear (**FIGURE 1.2**). Both of these images were taken at an average focal length of 50mm.

This will become an infinitely powerful concept as you seek to make certain parts of the body appear larger or more emphasized, while making other parts of the body appear smaller or with less visual emphasis.

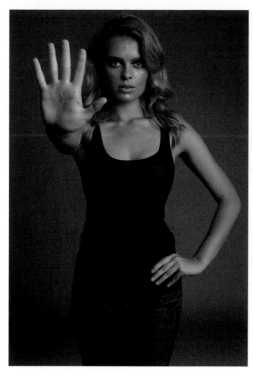
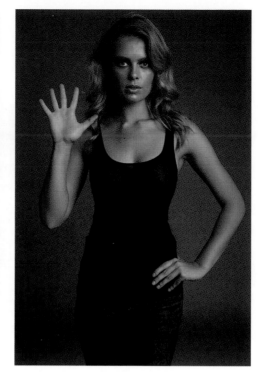

1.1 1.2

Lens Choice and Focal Length

The next piece of the equation of perspective is lens choice. Yes, whatever is closest to the camera looks larger. Yes, whatever is farther from the camera looks smaller. However, the focal length you choose will serve to make this effect either subtler or more exaggerated.

For lens choice, remember the following two core rules:

Rule 1: Wider focal lengths exaggerate distance.

Rule 2: Longer focal lengths compress distance.

Think of it like this: You are photographing a mountain with a tree in the foreground. If you use a wide-angle lens, the tree looks very far away from the mountain, but looks larger in comparison because it is closer. If you use a long lens, the tree looks much closer to that mountain, and more correctly proportioned. Focal length changes appearance of distance.

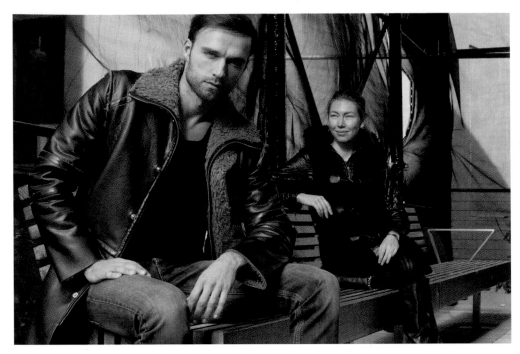

1.3 70mm

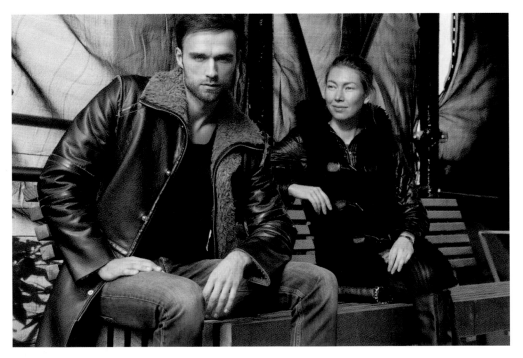

1.4 180mm

In **FIGURES 1.3** and **1.4**, the couple is sitting the same distance from each other on the bench. In Figure 1.3, I have chosen a focal length of 70mm, whereas I've chosen a 180mm focal length for Figure 1.4. Though they didn't move between shots, the longer lens used in Figure 1.4 makes the subjects look as if they are sitting right next to each other. You can see the compression of distance before your very eyes.

Let's revisit the hand example to see how this concept may affect a single person. In all three examples, the subject has her hand in the same position and at roughly the same distance from the camera. What changes? In each of these three images, I changed my focal length. **FIGURE 1.5** was shot at 50mm; **FIGURE 1.6** was shot with a wide-angle lens at 24mm; and **FIGURE 1.7** was shot with a telephoto lens at 135mm. Notice how the rules of perspective are drastically altered by focal length.

With a wide focal length (24mm), the distance between the hand and face is exaggerated. This also results in the hand looking much larger (whatever is closer to the camera appears larger). With the longer lens (135mm), distance is compressed. Even though the hand is closer to the camera, it looks virtually unchanged by perspective (it looks the same as if the hand were back by the face).

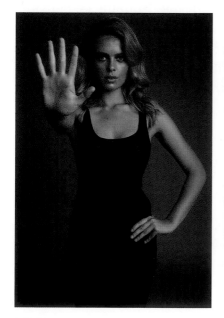 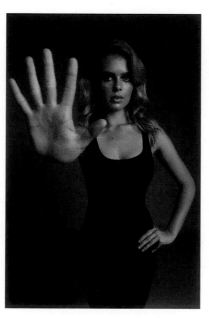 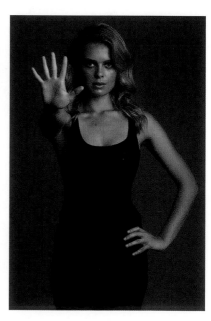

1.5 50mm **1.6** 24mm, wide-angle lens **1.7** 135mm, telephoto lens

In short, if you want to exaggerate the effects of perspective, use a wider focal length. If you want to reduce the effects of perspective (important with families and groups), then you'll want to use a longer lens.

We've established the basics of perspective and how it is established by focal length. Now, what the heck does that have to do with posing? I'm glad you asked.

Perspective and Pose: Body Placement

Let's now imagine this concept as it applies to photographing the human form. Whatever we want to appear larger or draw more attention in the frame, we bring closer to camera. If we want to exaggerate this effect, we use a slightly wider lens.

One way we can bring things closer to the camera is through our subject's pose and position. One of the most obvious examples of this concept has to do with posing a subject's hips. In the next two images, I keep my focal length constant and my camera angle at the *exact* same point; the only thing that changes is my subject shifting her weight. In **FIGURE 1.8**, she shifts her weight so that her hips are toward the camera. The hips are closest to the camera, and therefore they look *larger*. I've placed a line that points out the approximate width of her thighs in **FIGURE 1.9**.

In **FIGURE 1.10**, I've asked the subject to shift her weight back away from the camera. In doing so, her hips and her waist are farther from the camera's view and thus will appear *smaller*. By comparing these two shots side by side, you will notice an extreme difference. In fact, we've cut the size of her hips and thighs by nearly a third by pushing them away from the camera (**FIGURE 1.11**)! This demonstration illustrates the power that perspective can play in how you control the appearance of your subject's form.

As you shoot, you should always remember this essential technique that will allow you to draw attention to and away from certain areas of the body. When you want more attention on a body part or for it to appear larger, bring it closer to the camera. When you want less attention on a body part or want it to appear smaller, push it away from the camera. This is true whether the subject is sitting, standing, in shorts, wearing a dress, or is male or female. Perspective will make a huge difference.

1.8

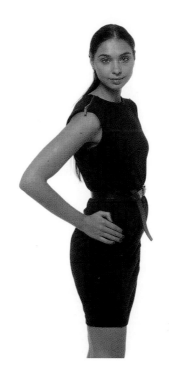

1.10

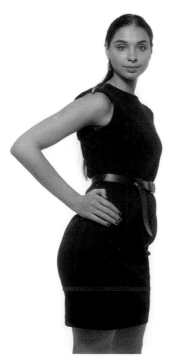

1.9

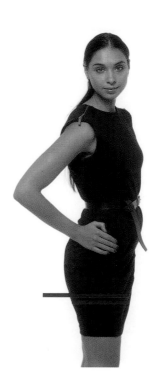

1.11

1.12

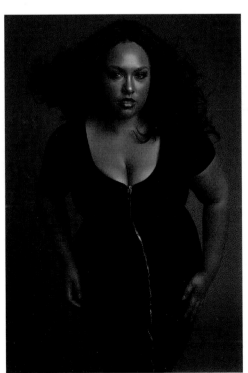

1.13

Let's take a look at another example of the same concept. In this photograph, my camera angle and lens choice are exactly the same. The only difference? In **FIGURE 1.12**, I have my subject stand upright. In **FIGURE 1.13**, I've asked her to bring her face and chest closer to the camera. As she does so, suddenly her chest looks larger and there is more attention on both her face and chest. In short, if you want the chest to look fuller or you want more attention to the face, lean the chest and face closer toward the camera.

So now that we see how perspective can work in conjunction with body position, let's add choice of focal length into the mix. Changing your focal length can enhance or reduce the effects of perspective when you adjust a subject's pose or position.

In **FIGURE 1.14**, I'm using a 70mm lens and the subject is standing straight. Then I ask her to lean her chest toward the camera. The chest does look fuller in **FIGURE 1.15**, with more attention to the face, but the difference is subtle. You can also notice a bit more definition to her waist.

Let's switch it up. In this next example, I've selected a 35mm lens. In **FIGURE 1.16**, my subject stands up straight, and everything is roughly of normal proportion. Then I ask her to lean her chest forward the same amount as in the previous example. The results? The wider focal length exaggerates distance (**FIGURE 1.17**). Her head and chest now look *much* larger.

Relative Distances

When I fill the frame with my subject at different focal lengths, the effects vary drastically. In the wider focal length shot, you can see how her proportions are exaggerated. The chest gets fuller, head bigger (almost distorted), and waist smaller. If, however, I backed up a foot or two, the effect would be a bit subtler. Relative

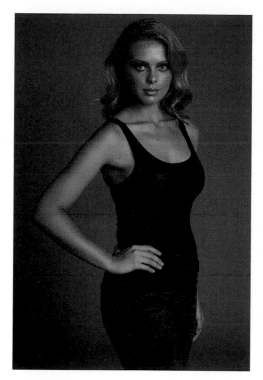

1.14 70mm

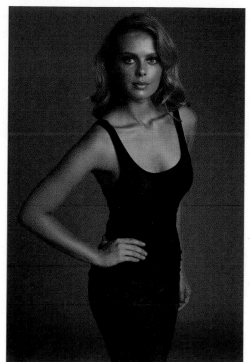

1.15 70mm

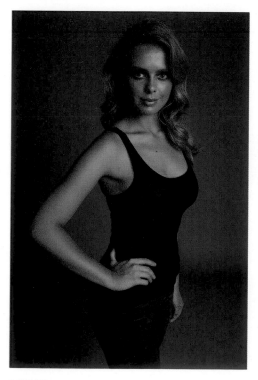

1.16 35mm

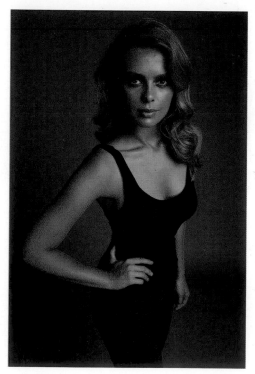

1.17 35mm

distance matters too! When you are closer to a subject with a wider lens, even a small difference in position is significant. When you are farther back, the same movement may be too subtle to recognize. This has to do with relative distance. When you are close (filling the frame) with a wider lens, not only is distance exaggerated, but even a few inches is relatively far. When I back way up, a few inches are relatively insignificant (since I am already so far away).

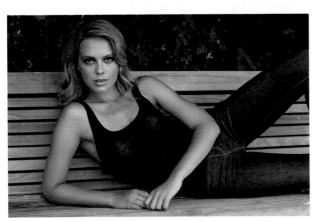

1.17

Many great portrait artists love the 35mm focal length, and they avoid distortion by not having the head/body too close to the edges of the frame and adding a little more distance between the subject and the camera. A 35mm lens may not work 18 inches away for a headshot, but it may be brilliant several feet away for a mid-length shot.

As you can see, combining perspective, pose, and focal length makes a profound difference in the appearance of your subject. I would *love* to recommend the best lens to use for a portrait, but I can honestly say there isn't one! It depends on a number of factors, and we will continue to explore these concepts further.

Perspective and Camera Angle

Another way to bring certain things closer/farther from the camera (and thus make them larger/smaller) is to change your camera angle, so let's discuss moving your camera.

In **FIGURES 1.17–1.19**, I have my subject reclining on her side on a park bench. I take three different shots of her—each at the same focal length (50mm) and approximate distance from subject to camera. The difference in each shot is my camera position.

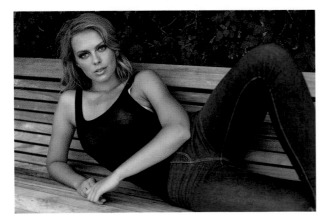

1.18

1.19

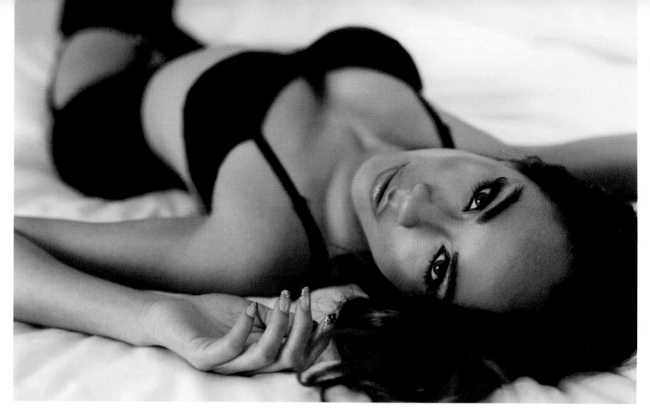

1.20 Because I selected a camera angle closer to her face and chest, they now appear larger.

In Figure 1.17, my angle is to shoot more from her head and torso. In Figure 1.18, I am even with her midsection. In Figure 1.19, I am more at an angle toward her feet. Notice how the position of my camera changes the emphasis in the image and proportions of the subject.

How does this apply to a portrait session?

For boudoir or a subject lying on their back, you may adjust your camera angle to the side closer to the face. Suddenly, the face and chest will appear larger and garner more attention in the image. This is readily apparent in **FIGURE 1.20**, where the hips and waist look small and the eyes and chest look fuller. This has been achieved by camera placement.

For a portrait of a standing subject, for example, shooting from a higher angle will make the face and chest look larger, while the hips and waist look smaller. Camera angle allows you to change perspective.

Let's take a look at a series of images in which the focal length stays the same, distance to subject stays the same, crop stays the same, and only the camera angle changes.

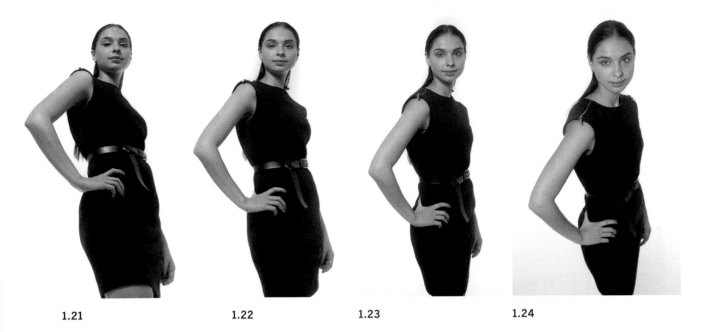

1.21 1.22 1.23 1.24

I begin by shooting at a low camera angle just below the subject's hips (**FIGURE 1.21**). Since the hips are closer to the camera, they appear much larger and the head appears smaller in comparison. In **FIGURE 1.22**, I get a little higher, just below the waist. The hips still look larger, but not as drastic as in the previous example, and the emphasis is just below the waist at her midsection. I shot **FIGURE 1.23** at chest and shoulder level. Her proportions have been improved from the previous shot, with emphasis more on the face and chest. For **FIGURE 1.24**, I stood on a ladder just above eye level. Now her hips and waist look tiny, with more emphasis on her face, chest, and shoulders.

Lens Choice to Exaggerate Camera Angle

Now that we understand how camera angle affects perspective, let's take a look at the importance of lens choice to push this concept even further. In the next example, the subject stays in the exact same position, and I fill the frame the same in both shots. In **FIGURE 1.25**, I've used a wider focal length, at 28mm, which exaggerates distance and perspective. The distance

between her face and her feet looks farther apart. Her head looks *much* bigger than her feet. In **FIGURE 1.26**, I select a longer focal length, at 70mm. Her feet and head look closer together (so her body does not look as long), and her face still looks larger but the effect is not as exaggerated.

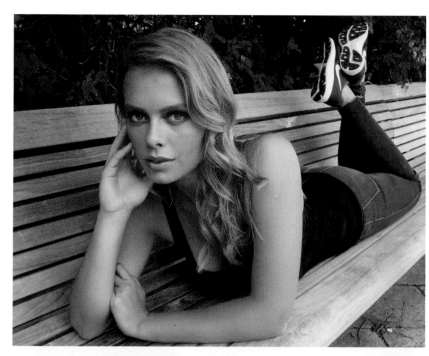

1.25

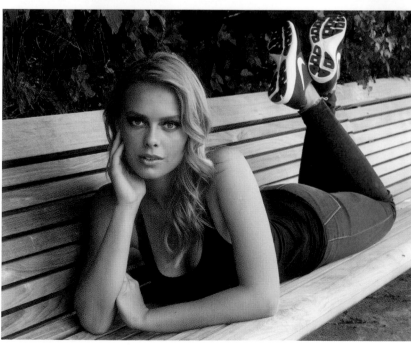

1.26

Camera Angle and Subject Height

We've just been introduced to how camera angle can be used as a tool to make certain areas on our subject look larger or smaller. We must consider a few other side effects of our actions when using perspective to change the appearance of the form when shooting full length.

To oversimplify the concept: A low angle makes someone look taller; a high angle makes someone look shorter.

To be specific, the length of the body actually looks the same, but when shooting from the high angle, the torso looks longer, while the legs look very short. They look disproportionate.

Let's take another look at an image from the previous section (shown here as **FIGURE 1.27**). When cropped, the angle looks great. When we move to full length in **FIGURE 1.28**, however, the body looks oddly shortened. Shooting

✓ 1.27

✗ 1.28

down on your subject from a higher angle may have a positive effect of drawing attention to the face and chest. Unfortunately, if you are shooting a full-length shot, this will make the subject look much shorter. In fact, your angle compresses the subject with generally unflattering results. I find that for this angle (when I am trying to emphasize certain features), I crop from the knee or above.

Shooting from a very low angle, as in **FIGURE 1.29**, makes the size of the subject's hips seems exaggerated. If I back up and shoot from the same angle, and use a longer lens (**FIGURE 1.30**), the subject looks quite tall and the proportions are relatively flattering. How does this happen?

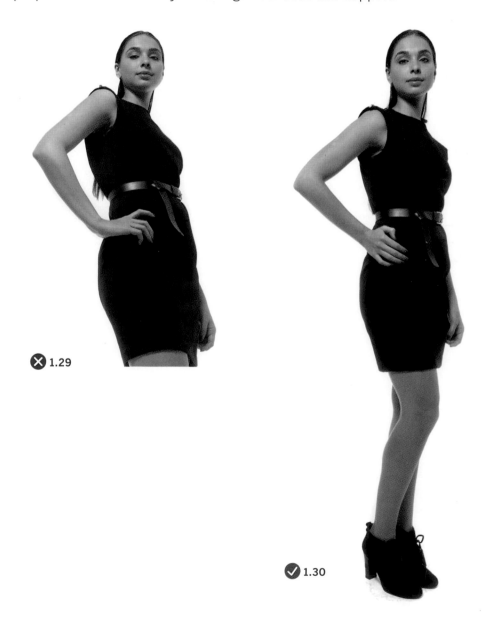

❌ 1.29

✅ 1.30

Think of it this way: When I am close and low to my subject using a wide angle, they will look very tall. I am looking up at them. The results tend to look distorted because whatever is closest to the camera (hips, waist, feet and so on) looks largest. Because I am so close to my subject with a wide-angle lens, *relative* distance is exaggerated. The hip/feet are much closer *compared to* the face and chest. The person looks tall but distorted (**FIGURE 1.31**). If I back up and use a longer lens, it's a totally different game. Yes, I am still shooting at the same low angle, but using a longer lens makes the person look taller and elongated. Now let's talk about relative distances. When I am farther from my subject, the hips/feet are not relatively that much closer to the camera than the face. When I back up and use a longer lens, it reduces the effects of perspective (**FIGURE 1.32**).

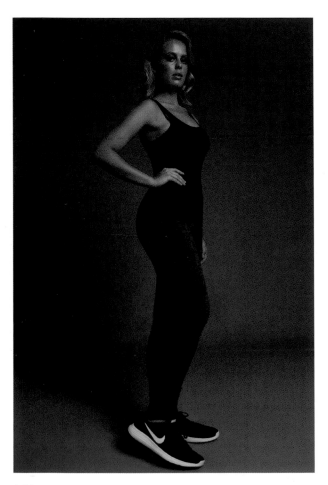

1.31

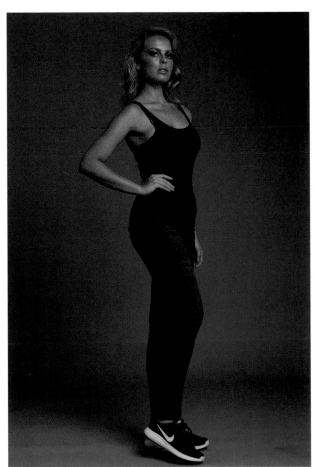

1.32

What does this mean to you? If you want your subject to look taller, you can shoot from a lower angle. Be cautious of shooting from too close and using too wide a focal length. Instead, try backing up and using a slightly longer lens while still shooting at a low angle.

Why It All Matters

Most people think posing is just body placement. If you put the person in a good pose, then it will flatter them and give the body a pleasing appearance. Not true! A good shot is reliant on your camera angle and lens choice, and each person will need a different combination of these elements. You may have your subject in a great pose, but it will photograph terribly because you are using the wrong camera angle or focal length. You may think the pose is all wrong, when, in fact, the problems are due to entirely different issues.

Let's take a subtle example. The pose in **FIGURE 1.33** may not be incredible, but in the first shot I've selected an angle too low (putting the foot too close) and a focal length too wide (24mm). The result? The foot looks very large and dominant in the frame and the head small and distant. When I back up, stand up, and select a 70mm lens, the distortion goes away and the pose is *much* more acceptable (**FIGURE 1.34**). Is it perfect? Not necessarily, but it certainly has become a significantly better shot with the attention back where it belongs—on my subject's face.

In short, a good pose isn't good until camera angle, body position, and focal length help it look good to the camera.

Whenever you are shooting, ask yourself where you want to draw attention on your subject. Attention could be on the head, the chest, the buttocks, or another feature. What can you do to bring the feature closer to the camera? You can change your camera angle or adjust the pose to bring that feature closer. Perhaps you want to exaggerate the effect of perspective. Choose a longer focal length. Where is the eye going in the pose? You have the power to harness the way your camera sees to control the viewer's eye and flatter your subject...so do it!

❌ 1.33

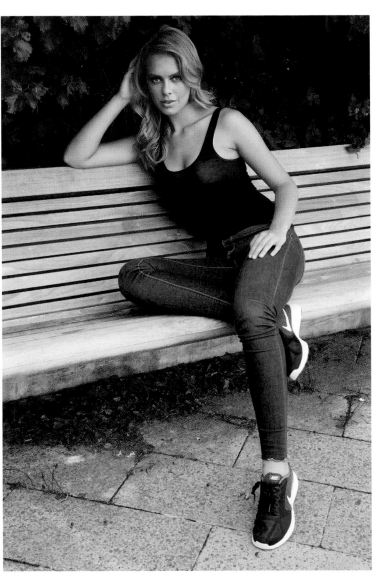

✅ 1.34

MASTERING *Your Craft*

THE CROP

Although cropping isn't necessarily about camera angle or lens choice, it definitely affects the way a viewer sees your photograph. A poorly cropped image can stop the viewer's eye, and making the pose look haphazard or abrupt. Later in this book, I will talk more about cropping at narrowing points, but let's quickly address some things to keep in mind when cropping.

- Avoid cropping at a joint, like the wrists, ankles, the middle of the knees, or elbows. It makes the person look severed and the crop look accidental, causing the eye to stop abruptly. Think of it this way—if it bends, don't crop in the middle of it!

- Avoid cropping at fingertips or toes. It's fine not to include the fingers or toes, but if you are going to crop them, be careful not to crop just a tiny amount. The viewer's eye tends to want to finish the form and struggles when just a bit is missing.

- If you crop, mean it! You don't need to include the entire subject, but if you are going to crop...crop with purpose. Either include the entire arm or crop way in. Crop for a reason—either to focus more on the face or to include an important part of the form.

- Avoid cropping where your subject looks wider. Watch out for cropping someone right at the hips or thighs if they are posed in a way that makes them look thicker in an unflattering way. You may need to modify the pose or just choose another crop.

I encourage you to go back through old shoots—the good ones and even those that didn't work out so well. After reading this book, see what problems you can identify so that you can prepare to correct them before the next shoot. Maybe you chose the wrong lens or the wrong angle. Maybe you suffer from posing pitfalls. Far too often photographers do not go back and analyze their own work. Read this book, review your work, and fix the issues next time!

CROPPING TO FLATTER YOUR SUBJECT

Let's explore how to flatter the face. Here, we have the same photo cropped six different ways. There are many more options, but let's take a look at these and address why they do or don't work. ■

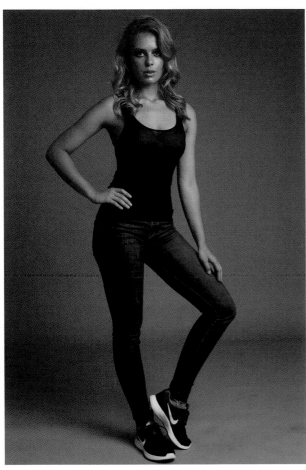

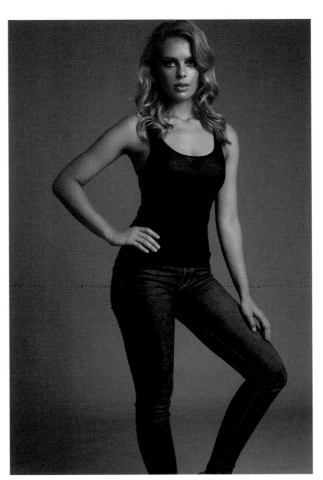

✓ Crop 1 This crop works because all elements are included in the frame. If part of the toe was cropped off, it would become problematic.

✗ Crop 2 Unfortunately, this image is cropped at a joint (the ankles), and the person has no base to stand on, making the shot look awkward and unstable.

✅ **Crop 3** This crop works well—the crop doesn't interrupt the image at any joints (left).

❌ **Crop 4** This crop through the arm is haphazard and breaks up the flow of the image (right).

Crop 5 This crop is neither right nor wrong. It is not particularly strong, but it is not breaking any major cropping rules (left).

✅ **Crop 6** This is a strong headshot crop because your attention is brought right into the face. If I had just barely cropped the top of her head, this may have been distracting. Instead, I've purposefully cropped in a bit more for a more intimate portrait (right).

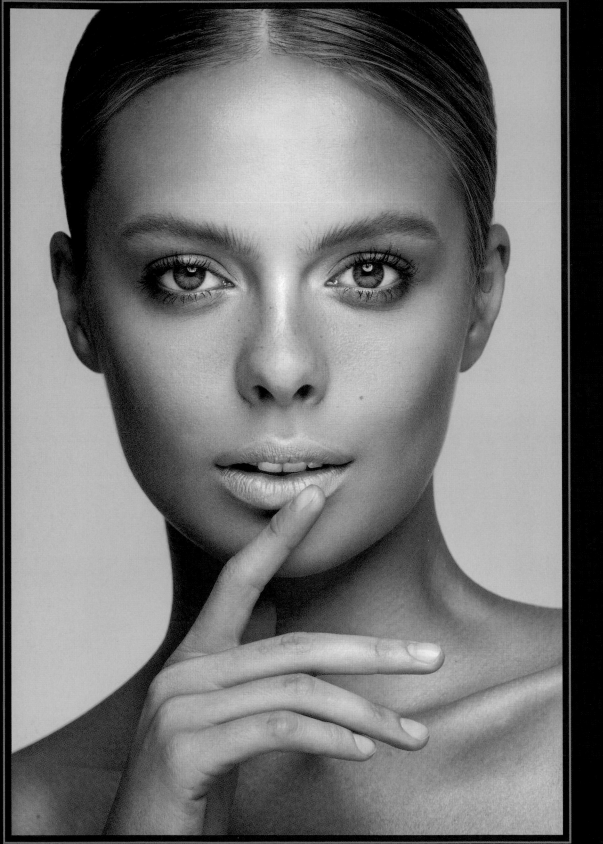

POSING *and* DIRECTING *the* FACE

Posing a subject's face involves a lot more than getting a good expression. What is your subject's "good" side? How do you define their jawline or eliminate a double chin? How do you direct the subject to create a connection with the camera?

There are many things to take into account when posing the face. You should be considering the eyes, the nose, the shoulders, the neck, the chin, and more. When you first begin shooting, you may think a headshot is the easiest portrait to shoot—it's just the head and shoulders, right? But photographing a close-up of the face means all the elements of posing the face are under even more scrutiny. No matter how incredible the pose, if the subject doesn't like their face in the image, they won't like the photograph overall.

In this chapter, we will look at what goes into posing the face and how to achieve success in directing this essential element of any portrait.

Directing

Directing is a very important part of posing and flattering our subjects. The way we communicate action to our subjects is what will help them achieve better body position or expression. Directing is our way to pull the best out of our subjects, even those who are uncomfortable in front of the camera.

Many photographers prefer to think of the act of posing their subjects as "directing." To some photographers or subjects, the term "posing" has a negative connotation of stiff, unrealistic, or uncomfortable looks in a shot. People think of "directing" as more of an organic collaboration between subject and photographer. Regardless of how you think of the terminology, you need to be constantly telling your subject what to do and what you are looking for. Lack of direction often makes people uncomfortable. When I direct, I use a combination of my words, my body, and my gestures to communicate what I'm looking for.

Mirroring

Whether I'm posing the head or entire body, when I direct my subject, I do the same pose for them to mirror. If I want them to stick their hip out, I'll stick my hip out. If I want them to turn their head to the left toward the light, I turn my head toward the light. I try to create the pose from the feet up to the head and hands. Obviously, I know that my subject may have a completely different body type and the pose I'm creating with my body may even look silly, but that's not the point. Rather, I'm showing them how to position their body in a way that is easy for them to interpret and re-create.

CAUTION **Do Not Touch Your Subjects!** I seldom touch my subjects, especially if I am just trying to achieve a slight adjustment to the pose. Instead, I use words, mirroring, and hand gestures. There is no reason for me to invade their personal space or make unnecessary physical contact. Sure, there may be a time when I want to fix a collar or move their hair. When I do so, however, I pause and ask permission first. Then I approach slowly and keep the contact to a minimum. I do this out of respect for my subjects, and 99 percent of the time everything I want to direct can be achieved without touching them.

Gesture

Through mirroring and hand gestures, I can tweak even the smallest details on my subject without having to use any words at all. Hand movements can be extremely powerful if used with care.

When I want my subject's face to be straight toward the camera, I place my fingers together in a vertical "karate chop" position with my hands lined up with the center of their face. I often begin posing with their face straight on, and then make necessary adjustments beginning with this position (**FIGURE 2.1**).

When I want my subject to turn their head, I use my thumb and index finger close together to create a shape as if I'm grabbing the subject's chin. From there, I move my hand to the left or to the right to indicate which way I want them to turn their head. Typically, I move my head as well for an extra level of communication (**FIGURE 2.2**).

When I want my subject to tilt their head, I use one hand to create a shape—like I'm picking up a jar from a shelf—as if to grab the sides of their face. I then rotate my hand from side to side to indicate tilt and the amount of tilt desired. Typically, I also move my head to indicate the direction and how to tilt (**FIGURE 2.3**).

When I want to adjust the shoulders toward or away from the camera, I position my hands as if I'm grabbing their shoulders. Then I move my hands toward or away from the camera, as if I'm using an elliptical machine, to indicate the distance and direction of the shoulders.

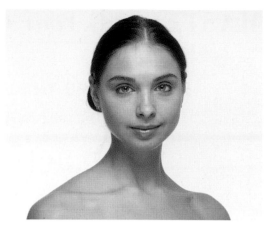

2.1 I directed my subject so that her face was photographed straight on, her chin aligned with the camera.

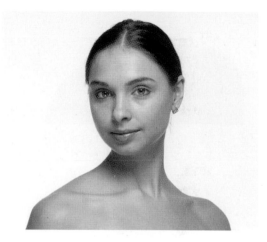

2.2 For this photograph, I asked the subject to turn her head to her right.

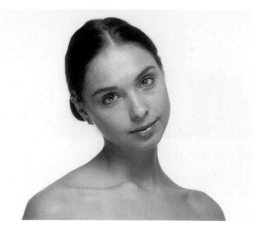

2.3 Here, I asked my subject to tilt her head to her right.

TILTING THE HEAD—FOR MEN

Having a subject tilt their head can sometimes add visual interest or engagement to a photograph. For example, with a female subject, if I have her tilt her head slightly toward the camera, it becomes more playful, soft,

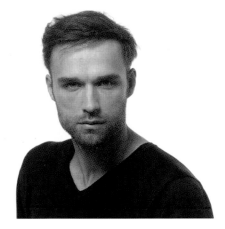

and feminine. If a man tilts his head toward the camera, the results are the same, and usually not desired. However, if a man tilts his head *slightly* at an angle or away from the camera, it can suggest that he is interested and engaged. Think of it like this: if you have a conversation with someone and they are intrigued with what you are saying or have a question, they tilt their head to the side slightly to show their curiosity. A subtle head tilt in a photograph can communicate similar interest. Even a minute change can take a subject from appearing bored to appearing engaged. Add a bit of intensity, such as a subtle squint, and the results are much more compelling. (See **FIGURES 2.4–2.6**.) ■

2.4 In this image, the subject looks straight on toward the camera, with no tilt to the head.

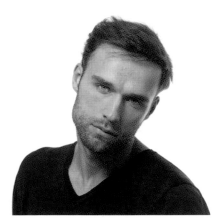

❌ **2.5** Tilting the head toward the camera results in a softer, more feminine look (above).

✔️ **2.6** Tilting the head slightly away from the camera creates more interest and engagement (right).

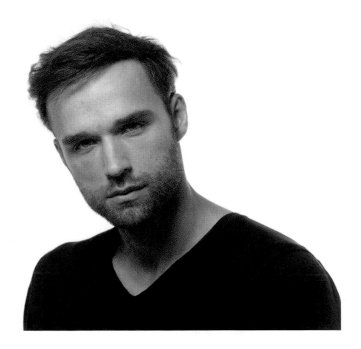

Verbal Direction

Though I don't always find verbal direction essential to posing, it certainly helps to clarify and punctuate a gesture, particularly when trying to achieve something more subtle or adjust an expression. I'll ask the subject to turn or tilt the head, move a shoulder toward me, drop a shoulder, lift the chin, and more. Be careful with your word choice—it makes a difference!

Learn to be clear with your direction by using directional language, like "up" and "down," "left" and "right." For example, I'll say to my subject, "Could you turn your head to *your* left." Yes, this change in direction may take a while for you to get comfortable with because it seems backward, given that their left is actually *your* right. In the end, it provides ease and clarity for your subject.

Your Subject's "Better Side"

You've undoubtedly encountered someone along the way who prefers to be photographed from one side of the face or the other. Why is that, and how do you figure out someone's "better side"?

Almost everyone has an asymmetrical face. One side of the face may have larger features than the other, or one side of the face may have a stronger jawline. So, which side is better? Unfortunately, it isn't that easy to determine and, in fact, even after 15+ years of shooting professionally, I can't always tell. Some people have good attributes on both sides, so it may be difficult to decide.

PRO TIP

The Right Atmosphere Be sure you cultivate the right type of atmosphere for the type of shot you are trying to create. Your job as a photographer will be a lot easier when posing and directing if the mood is right. You can create this atmosphere with the type of music you choose, the type of conversations you start, and the tone of your voice. Want to create high-energy photographs with a lot of movement? Perhaps using fast-paced music while speaking with excitement and energy in your voice will set the right tone. Trying to create more sensual imagery for a boudoir shoot? Perhaps more mellow music and speaking with a calm, steady voice will do the trick. These elements affect the way your subject feels, the energy of the room, and thus, the results you'll achieve.

Here, I'll provide some guidelines for determining the "best" side of the face, though know that this isn't necessarily for every situation. These tips will help get you started as you develop your own techniques.

Ask Your Subject

I have no problem asking a subject if they have a side they prefer to have photographed. I don't think this diminishes my photographic expertise in the subject's eyes. In fact, I'd rather ask and save myself time if the subject feels strongly about it. Some subjects will be very particular, and others won't. A subject may prefer one side to the other even if it isn't necessarily the best side, so take their answer with a grain of salt.

Where Their Hair Parts

Often, people will part their hair on the side of the face they prefer. Think of it like this: the part is a way to reveal more of one side of the face. Keep in mind, though, that people sometimes switch their part or have a natural part that isn't reflective of what they prefer.

Upturned Features

On some people, one side of the face has more upturned features than the other. For example, one edge of the mouth may turn up slightly or the eye is less droopy on one side. Typically, a person prefers to showcase the side with these upturned features because they make them appear somewhat happier and more youthful. Also take a look at the eyelids to see which is tighter for a similar result.

PRO TIP

Selfies Nowadays many of my subjects are used to looking at themselves over and over again in selfies and have often subconsciously (or consciously) determined their good side. If you check their social media accounts and see that one side of the face is showcased over and over again, this may be what they prefer. Furthermore, sometimes at your shoot you may see them grab a selfie, so see if you can tell what side they shoot from. As a photographer, professional or otherwise, should you rely on your subject's selfie abilities to determine how you will create your images? No! Obviously not, but it's one more thing you could consider.

The Left Side

Studies show that most people prefer the left side of their face. This isn't universal, but it has proven to be a pattern in several studies, and more often than not, I've discovered this with my own subjects. Of course, when you bring lighting into the equation, this may change.

Defined Features

Sometimes one side of the face has more defined features than the other. For example, the brow bone may be raised or more defined. Perhaps the jawline is tighter or more angular. Maybe the eye is a bit larger. This may not always be the case, but it is something I look for. Defined jawlines are almost always preferred by my subjects and typically are considered more beautiful.

Let's take a look at an example (**FIGURE 2.7**). I begin with my subject facing the camera subject straight on. What clues do we have?

2.7

2.8 The right side of the subject's face has the part in her hair and slightly more upturned features.

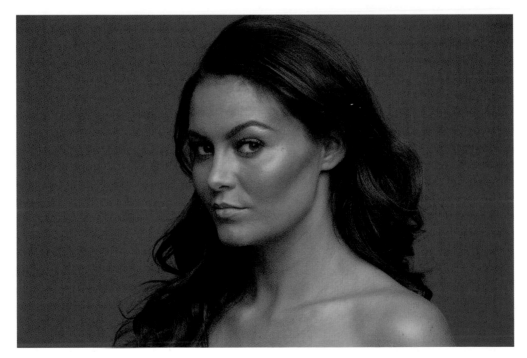

2.9 The left side of the subject's face has a more defined brow bone and jawline.

We begin by comparing the sides of her face, keeping the items we've discussed in mind. First, In **FIGURE 2.8**, the part in her hair is on the right side of her face (the *left* side in this photograph); also note that her lip and eyes are slightly upturned on this side. Both of these things are positive. Also, on the left side of her face (our *right* in the photograph), she has a slightly bigger eye and a more defined and dramatic browline.

Let's turn our subject in the other direction (**FIGURE 2.9**). We can now see that the jawline on the left side of her face is slightly more defined.

Which side is better? Both look great for her, but she prefers her left side. The defined brow and jawline were the winners for her. The point is, it is not always clear which side is better, nor should you only stick to shooting one side of the face. I often shoot straight on, a bit more to one side, and grab some shots of the other side, just in case.

Head Position

There are many ways to position your subject's head. Your subject could turn her face to the right, or tilt it to the left, with the chin up, for example. Many little tweaks can be made to get just the right angle, and every tweak will be different. Don't stress about it too much, as subtle adjustments are usually more effective than exaggerated head movements.

I think about my options in a grid, like **FIGURE 2.10**. This grid includes the subject looking straight toward the camera with her chin neutral, and down; her head to the left with her chin neutral, up, and down; and finally, with her head to the right with her chin neutral, up, and down.

What head position do you think worked for this particular subject? This will depend on personal taste, but I prefer my subject with her chin neutral or somewhat down. She has a relatively defined and broad jawline, so when she raises her chin, her jaw looks wider. I like her straight-on look, or positions with her head turned to *her* right, which reveal the left side of the face, because I prefer her jawline and defined brow bone.

PRO TIP

Chin up: Best for someone who has a smaller jaw or a bigger forehead.

Chin down: Best for someone with a broader jawline or smaller eyes.

Chin straight toward the camera: Best for someone with more symmetrical features.

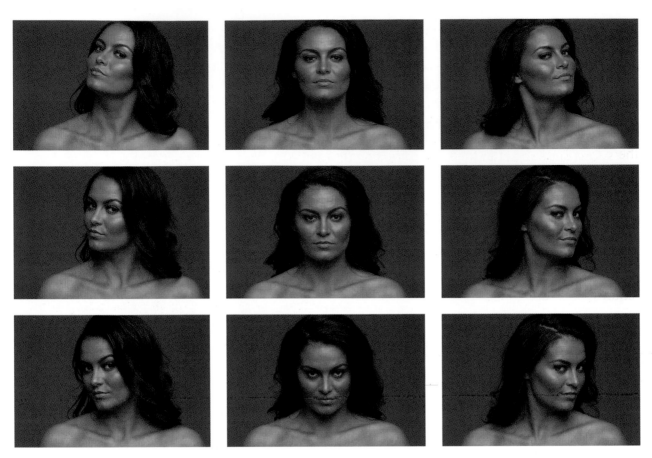

2.10 Head positions

If the subject has a smaller chin, you may want to raise it upward to make it look more defined or proportional. If the subject has smaller eyes, lower the chin to bring the eyes closer to the camera so that they appear larger. When doing so, be aware that downward chin placement may emphasize a large forehead. If someone has a very asymmetrical face, you don't want them to face straight toward the camera because it draws attention to uneven features. Everyone is different, and there is no ideal head position that works for all.

When I first sit down with a subject, I tell them to sit comfortably while I take a few frames to adjust my light. I let them know that these are throwaway shots and that I'm just getting everything set. This gets the subject used to the firing of the strobes, and it helps them relax in front of the camera. I run through the options on the grid in Figure 2.10 as I snap test shots, to see what angles look best. I don't devote more than a minute or so to this process, but it allows both of us to become more comfortable.

MASTERING *Your Craft*

FOCAL LENGTH

In Chapter 1, we discussed how your lens choice affects the way your camera sees your subject's body. The focal length you choose will also change the appearance of the face. As discussed, wider focal lengths exaggerate distance, whereas longer focal lengths compress distance. When shooting a close-up of the face, a wider angle will exaggerate the distance between the features, making the nose or eyes appear larger that features than are smaller or farther away.

There is no perfect focal length for a close-up shot. Remember to consider your distance to the subject, the focal length, and the crop.

In **FIGURE 2.11**, you can see a very tight shot, taken with a 50mm lens. I have completely filled the frame. The subject's face looks a bit wide, and her forehead and her eyes look large. When I take the same shot with an 85mm lens, with the exact same frame and crop (**FIGURE 2.12**), the features are much more proportional. A difference of 35mm makes a huge visual impact. (Note that when I physically back up, the exaggerated effects of those focal lengths become less noticeable.)

I find myself shooting tight headshots with either a fixed 85mm lens or my 70-200mm lens. Can you shoot head and shoulders with a wider lens? Certainly! If filling the frame at a very wide focal length, however, you'll need to be careful that the resulting distortion is used to flatter your subject, not make them look uneven or wider. Are there times when I shoot a much longer focal length (like 200mm) to compress the features? Yes—particularly, with a longer nose or bigger forehead. Focal length makes a difference! I typically shoot between 70mm and 180mm for tight headshots. ■

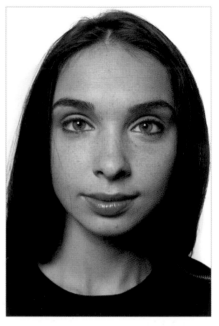

2.11 This headshot was taken with a 50mm lens.

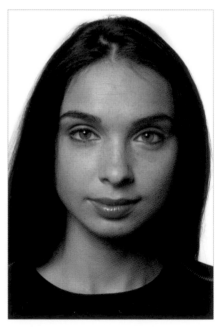

2.12 This headshot was taken with an 85mm lens.

Elements to Consider in a Headshot

The definition of beauty has changed throughout the centuries, and it varies from culture to culture, and from person to person. Nevertheless, there are a few things generally considered beautiful to everyone, and you will want to keep these standards in mind as you pose and position your subjects.

We find symmetrical features to be beautiful and alluring. If someone has very uneven features, you may not want to pose them straight on toward the camera with flat lighting because this invites the viewer to compare the sides of the face and discover imperfections.

When creating a flattering photograph of someone's face, several elements need to be considered to either bring out the best in that person or to avoid creating unwanted distractions. Let's break it down.

Chin and Jawline

Jawlines are often seen as beautiful, whether on a male or female. This doesn't mean they always have to be chiseled or angular. A softer, rounder face may still have definition in the jaw. When posing, some of the jawline may get hidden—due to hand placement, clothing, or a raised shoulder—but try not to hide the jawline completely.

Posing the subject's chin can create more flattering results, whether the subject is slender or fuller-figured. Through careful positioning, you can tighten loose skin on the neck and reduce the appearance of a double chin, making the subject look more slender and youthful.

There are two ways that I direct the chin.

CAUTION At some point in their lives, your subject may have learned about the magic of sticking their chin out in photos. Unfortunately, this typically means that they take it to an extreme when you are photographing them. Remedying this habit will take coaching, but your job is to get them to relax and to trust your direction for more flattering results.

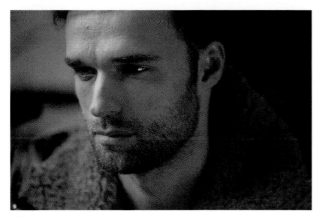

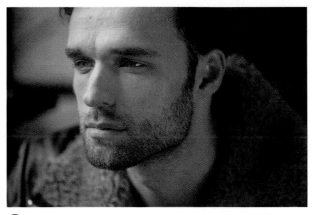

❌ **2.13** Our subject has a nice jawline, but it is a little soft in this shot.

❌ **2.14** When the subject sticks his chin out, the appearance of the jawline improves, but his head position looks awkward and forced.

Stick Your Chin Out and Down

Directing the subject to stick out their chin helps reduce many problem areas—the jawline gets tighter, skin tightens under the neck, and the appearance of a double chin is minimized. But sometimes subjects take this to an extreme. When they stick out their chin too far, the head position looks forced rather than natural.

Some people tend to lift up their chin too much. Direct the subject to bring down the chin. This makes the head position look more natural and comfortable. It also brings the eyes closer to the camera, creating more flattering results on the face. Finally, the downward chin may hide loose skin on the throat.

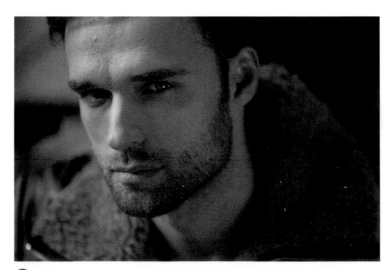

✅ **2.15** With his chin down, the subject's jawline stays crisp, and the head position appears comfortable.

The gentleman in this example has a very nice jawline, yet in the neutral position (**FIGURE 2.13**), it is less defined than it could be. I ask him to stick out his chin. When he does, the jawline gets more defined, yet he looks awkward and lacks connection to the camera (**FIGURE 2.14**). Finally, I ask him to lower his chin (**FIGURE 2.15**). Now he has a defined jawline, a more natural-looking head position, and an improved expression.

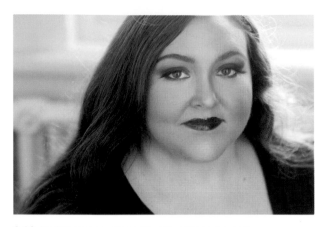

2.16 In this image, the subject's chin is neutral.

2.17 In this image, the subject has pressed her forehead slightly toward the camera.

Press Your Forehead Toward the Camera

Sometimes, no matter how hard you try to direct the pose, subjects look awkward because of the position of their chin. Another technique is to ask your subject to press their forehead toward the camera (**FIGURE 2.16** and **FIGURE 2.17**). This elongates the area underneath the neck while bringing the eyes closer to the camera. Of course, if the head position isn't perfect, you can direct the person to subtly raise or lower their chin for a more flattering angle.

Eyes

The eyes are the windows to the soul, and if the eyes are all wrong, the photo is a flop! Consider both the position and the expression of the eyes.

Avoid the Whites of the Eyes

When too much of the whites of the eyes is visible, the results can be creepy and unflattering. This happens when a subject is looking too far to the side and away from the camera, or too high. For this reason, you must pose the eyes.

If I ask my subject to look up, they often focus too high. This results in showing too much of the whites beneath their pupil. Instead, I give them a specific place to look—the bottom of the softbox, a piece of tape on the stand, a photograph on the wall, or even just my finger. I can watch the position of their eyes and move my fingers up and down, side to side, until I achieve flattering results. Then I tell them to keep the eyes in that position.

In **FIGURE 2.18**, my subject is looking too far to the side, and her eyes look strained and unnatural. To fix the problem, I give her a point on the wall to look at. The results (**FIGURE 2.19**) are much more flattering.

In **FIGURE 2.20**, I ask my subject to look at the light. Unfortunately, the light is elevated too high above her, so I end up seeing too much of the white beneath her pupils. To improve eye placement, I point out a specific position much lower, and her altered gaze creates a more flattering position for her eyes (**FIGURE 2.21**).

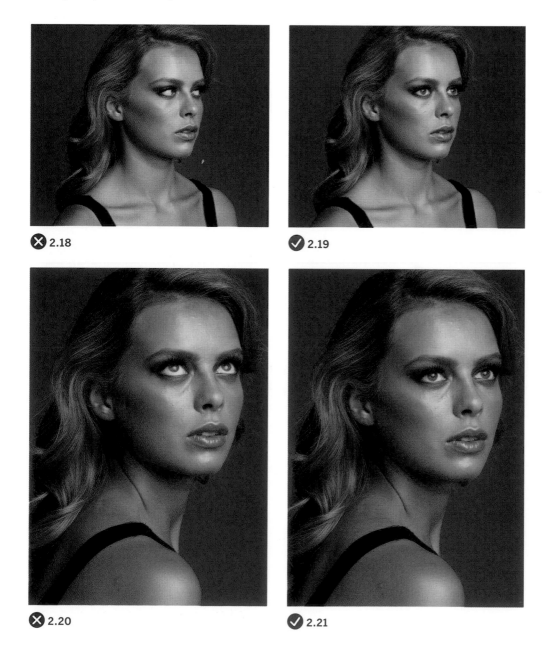

❌ 2.18

✓ 2.19

❌ 2.20

✓ 2.21

Create Engagement

Create engagement with the eyes. Avoid a blank or bored stare, especially for portraits. What is the purpose of your portrait? Can you direct the subject so that they exude this feeling or purpose through their eyes?

Creating engagement can occur with a genuine smile or perhaps with a slight squint. On "America's Next Top Model," Tyra Banks often instructed models to "smize," meaning to smile with their eyes. Not every shot needs to have a grin, but the eyes need to say something, whether it be joy, confidence, sadness, or something else revealing of the subject.

Shoulders and Neck

Placement of the shoulders can really add to or take away from a photograph. They can make someone appear broader or narrower, create interesting lines or a dull, flat shape. Especially when shooting a headshot, shoulder placement becomes a central tool in flattering the body.

Shoulders help define a subject's width. If positioned straight toward the camera, they will appear wider; turned in profile, the shoulders will appear narrower. The best choice depends on the subject's body type and body language. Let's look at some considerations for posing the shoulders in a headshot.

Arm Placement

When someone is turned totally to their side, watch out for the dead arm hanging loosely in a straight line on the side of the body (**FIGURE 2.22**). I typically try to create more interest by rolling the shoulder forward while pulling the elbow back, as seen in **FIGURE 2.23**. Notice how your eye can follow the line of the face to the shoulder, and down the arm.

Neck Length

In general, we tend to find a longer neck attractive. Avoid posing your subjects in a way that obscures the neck or makes the neck appear shortened.

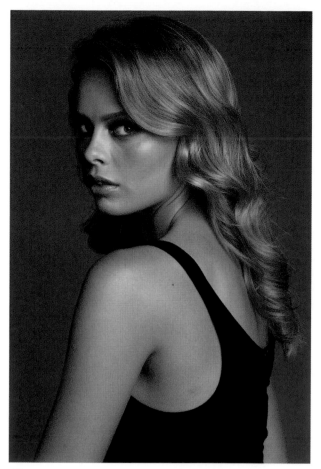

❌ **2.22** The placement of the subject's arm hides her bust, makes her body appear wider, and creates less interesting lines for the eyes to follow.

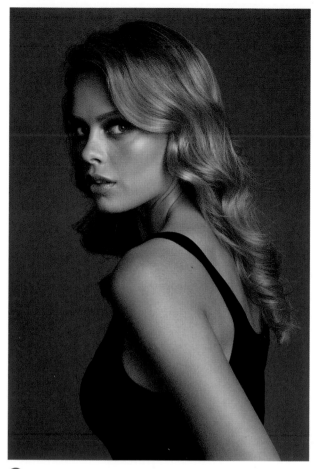

✅ **2.23** The arm placement creates a sharper shape to the shoulder and a beautiful line to follow down the arm, revealing her slender form and bust.

As with many of my suggestions, this particular tip is not a hard-and-fast rule, but something you can consider. It's based up a pet peeve of mine when shooting headshots. When a subject is square on to the camera, the shoulders can appear too broad (**FIGURE 2.24**). Then when the subject turns the chin to the side, the broadness of the shoulders becomes even more problematic. Because the eyes tend to be drawn to larger features in the photograph (and the head is made to appear smaller by being turned to the side), they will get stuck on the chest and shoulders. Also, when the head is turned to the side, the neck appears quite small and may even overlap with the line of the shoulder, breaking up otherwise clean, flattering lines (**FIGURE 2.25**).

What should you do? Try following the shoulder-to-nose line. If the head is turned to the subject's right, see where the nose is pointing. From there, rotate the shoulders to aim in the general direction where the nose is pointing. Suddenly you've narrowed the shoulders in a pleasing way and significantly increased the apparent length of the neck (**FIGURE 2.26**)!

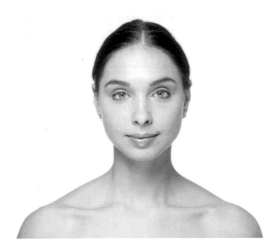

2.24 In this image, the subject's shoulders are broad to the camera.

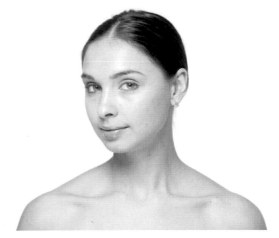

❌ **2.25** When the subject turns her head to the side, her face appears smaller, her neck appears shorter, and her shoulders seem broader.

✅ **2.26** By moving her shoulders in the same direction as the line outward from her nose, she is able to narrow her shoulders and lengthen her neck.

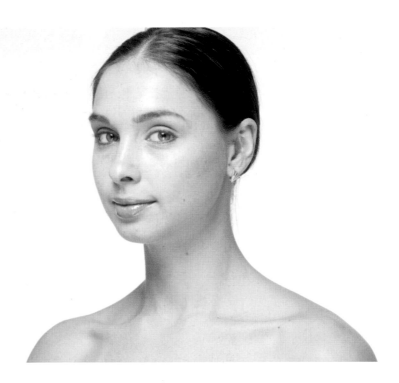

Raise the Shoulder

Sometimes you can add a bit of interest to a shot by raising a shoulder instead of letting it fall loose to the side. This may mean the shoulder is slightly raised toward the chin, or rolled forward to create a more intriguing shape.

If you do choose to raise the shoulder while bringing the chin into it, be sure that the shoulder is not completely blocking the jawline or the neck.

For example, in **FIGURE 2.27**, the subject's shoulder is raised for a more engaging expression and pose. Unfortunately, the raised shoulder is blocking both her jawline and neck. Furthermore, the viewer's eyes are primarily drawn to the area on the back of the shoulder, not to her face. To improve this shot, I slowly rotate the subject's body more toward the camera until the jawline and neck became visible (**FIGURE 2.28**). A raised shoulder can add femininity or visual interest, but you need to watch your angles and control what is visible to the camera.

PRO TIP

Where Does Your Eye Go? In any portrait or headshot, you should be asking yourself, "Where does my eye go in the pose? Where do I want it to go?"

In many headshots, bare chest and shoulders (for example, from wearing a tube top or strapless dress) pull attention away from the face, as this broad area of exposed skin can attract the eyes. To avoid this and improve results, change the shoulder angle, use a different crop, or add clothing, such as a scarf or cardigan.

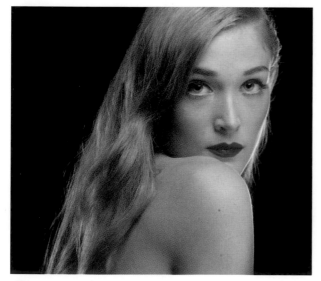

❌ 2.27

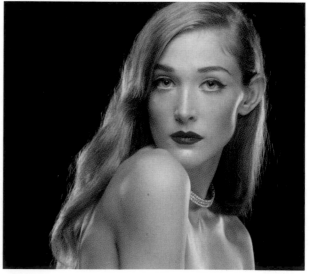

✓ 2.28

Nose

While you can't exactly pose the nose, there are a few things you should be aware of regarding its positioning. Depending on a person's features, they may have preferences for how they want their nose to be photographed. There are, however, a couple rules you typically don't want to break with nose placement.

Obscuring the Eye

Raising the chin so that the nose obscures the eye is not a flattering angle (**FIGURE 2.29**). When someone has a larger nose, this will draw attention to that feature. Typically, it is more flattering to have that eye visible, either by lowering the chin or rotating the head (**FIGURE 2.30**).

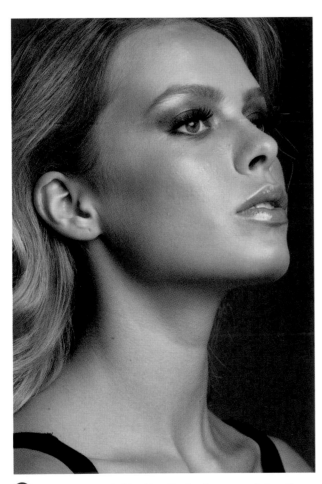

❌ **2.29** The nose is blocking the back eye—a distracting element.

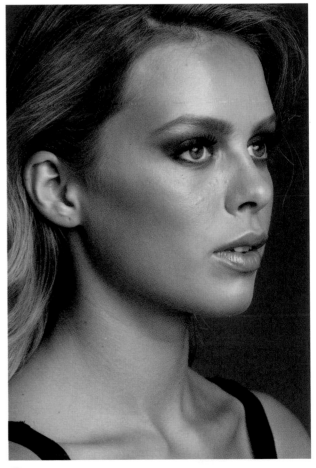

✅ **2.30** By lowering the chin or rotating the head, you ensure that the nose is in a more pleasing position.

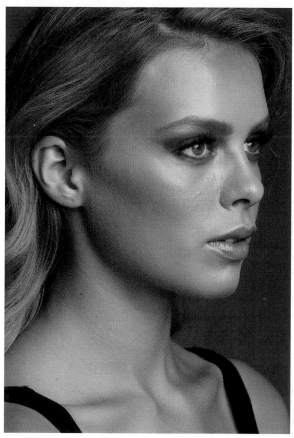

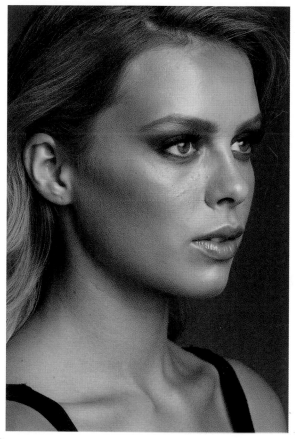

❌ 2.31

✅ 2.32

Breaking the Cheek Line

When rotating the subject's face to the side, you either want the entire nose to fit into the outline of the cheek or be completely over the outline. When just a tiny bit of the nose breaks the edge of the cheek, it disrupts the smooth line of the face (**FIGURE 2.31**).

This is a detail to pay particular attention to for subjects with a larger nose. People with very large noses often prefer to be photographed straight on, or with their nose completely within the line of the cheek. In profile, more attention is drawn to the length of the nose. By rotating the head slightly toward the camera, the nose will move within the line of the cheek (**FIGURE 2.32**).

FIGURES 2.33a–e offer a quick reference guide for posing the nose based on the orientation of the head.

✅ 2.33a

✅ 2.33b

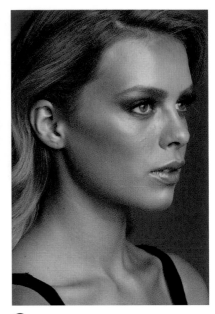

❌ 2.33c

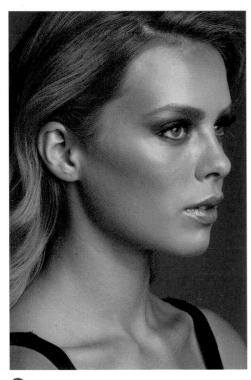

✅ 2.33d

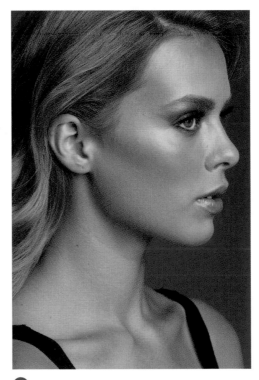

✅ 2.33e

MASTERING *Your Craft*

CAMERA ANGLE FOR THE NECK AND FACE

Changing your camera angle isn't just for photographing the body. For a headshot, the camera angle can have a dramatic effect on the appearance of your subject, but our core rules still apply!

Let's take a look at another example. **FIGURE 2.34a** is photographed from the subject's lip level; **FIGURE 2.34b** is photographed from the subject's eye level; and **FIGURE 2.34c** is photographed from above the subject's eye level. What changes do you observe?

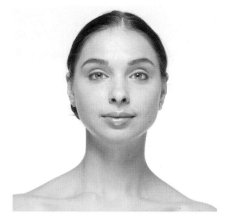

2.34a

Shot at lip level, the subject's neck looks longer, her eyes slightly smaller, and her nostrils a bit larger. She is looking down at us ever so slightly, and more attention lands on her lips and chin. Shot above eye level, her eyes look larger, her neck looks shorter, and her nostrils look smaller. Shot at eye level, the proportions are in between.

Of these three examples, which is right? Which is better for photographing the face? The answer is: Any of them! All of them! ■

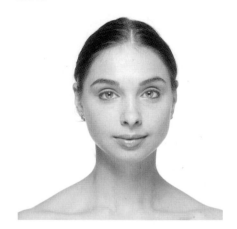

2.34b

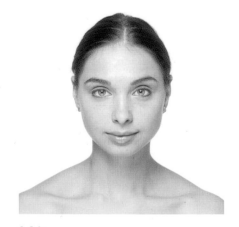

2.34c

Relaxing the Features

People hold tension in subtle ways that can undermine your image. Be aware of tension creeping into the shot, and eliminate it.

I ask my subjects to relax, starting from the top of their head and continuing down to their feet. I direct them with cues like, "Breathe in. Feel the tension melt from your body as you breathe out. Relax your head, through your shoulders, to your feet, and out through your hands."

If they require more directing, I start at the forehead, asking them to relax their eyebrows if they are raised or tense. Next, I ask them to relax their jaw. Sometimes nervous subjects bite down during their portrait, which flexes a muscle in the side of the face, making them look stressed.

In a serious shot, I don't want the lips tight or pursed. I ask my subjects to slowly exhale through their mouth and feel how relaxed their lips are at the end of the breath. This lip position is a good starting point. The lips can communicate a lot of emotion and should not be overlooked.

When I pose the shoulders, I'll have the subject shrug or give a little wiggle. Taut or raised shoulders are a sure giveaway of uneasiness. Raised shoulders also make people look heavier because this position shortens the neck.

When someone is nervous, they almost always show it in their hands—in a fist, gripping their body, or even picking at their fingers. I give my subjects a natural activity for their hands, such as holding onto a jacket, crossing their arms, or putting their hand in a pocket.

Putting It Together

Analyze **FIGURE 2.35** and **FIGURE 2.36** to see how we can improve the photographs.

In Figure 2.35, where does your eye go in the frame first? Is this where you intended it to go? My eye is drawn to the subject's hair and the shoulder on the right of the frame. It takes me a long time to get to her eyes—the most important part of the shot!

You can see the improvements in Figure 2.36. I move her chin toward the camera so the eyes do not show so much strain; then I rotate her shoulders to point toward her nose line. In doing so, more attention is drawn to her face, and her neck appears longer.

When I am shooting a fashion image and I want the subject to have a long neck, I'll shoot at a lower angle and have the subject bring her chin down to better connect with the camera. When I am shooting portraits, I tend toward shots that are at eye level or higher to create better connection with my subject. The key is to know how camera angle affects your subject. For example, if my subject has a larger forehead, I may not want to shoot above eye level because it will exaggerate this feature. However, if the subject has a double chin, shooting above eye level may help hide it.

I like to shoot from high above eye level, particularly with children and teens. When they look up toward the camera, their eyes look large and beautiful. Unfortunately, this perspective causes the body to become a background element.

To remedy this, I use a very narrow depth of field for this high angle. I can focus on the eyes while the rest of the frame melts away. In **FIGURE 2.37**, I've created an exaggerated example of this effect by shooting at 50mm from far above eye level. In this image and **FIGURE 2.38**, the subject's eyes look large and enchanting. Unfortunately, in Figure 2.37, I'm shooting at an aperture of f/11. Not only is the in-focus background distracting, but the shortness of the subject's neck is apparent, and her chest distracts from her face and eyes.

When I change my aperture to f/1.2 (Figure 2.38), the background melts away. The eyes become the dominant feature in the shot, and the chest and background are not as distracting.

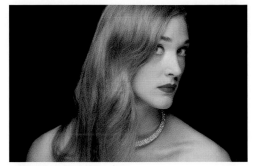

❌ 2.35

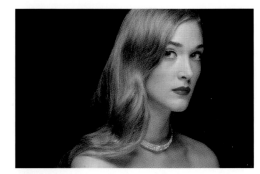

✔ 2.36

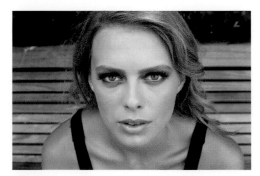

❌ 2.37

✔ 2.38

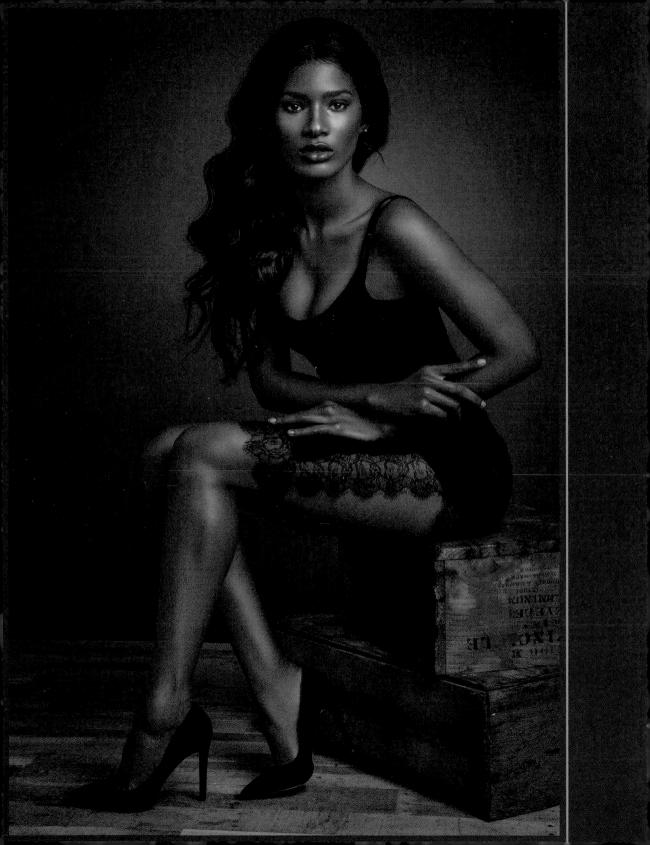

POSING PITFALLS

Posing is an art form. A pose can allow us to communicate the mood of the subject through body language. A pose can be used to flatter your subject by highlighting their strengths while downplaying any "weaknesses." Because there are so many variables in posing, you have a *lot* to think about when clicking the shutter.

Unfortunately, small details can ruin an otherwise beautiful pose. These problems can be unflattering to your subject or create distracting elements for the viewer. No matter how many poses you try to memorize or how beautiful your subject, the shots will be ruined if you don't pay attention to some common posing pitfalls.

Let's take a moment to explore some common posing problems, and how to fix them.

Poor Posture

Poor posture is one of the quickest ways to ruin a pose, as it can make a subject look shorter and heavier. Yes, you want your subject to feel relaxed or comfortable, but you certainly do not want them to slouch. This is true of sitting poses, standing poses, leaning poses...any poses.

There are several unfortunate consequences of slouching or bad posture that detract from your subject's features. Let's take a look at the issues so you can learn to identify and prevent them.

THE PROBLEM: Neck

When someone slouches, whether standing or sitting, their neck appears shorter. Typically, a longer neck is found to be more flattering in a portrait, making the person look more relaxed and more slender. When you can improve someone's posture, you often see a drastic change in the apparent length of their neck.

Let's take a look at an example with Leanne (**FIGURES 3.1** and **3.2**). In both images, my camera angle stays the same, as does her general body position. The biggest change? I've directed my subject to have better posture. I ask her to pull up through the top of her head and to relax her shoulders. Compare these two shots side by side. In the image with good posture, the length of her neck appears to nearly double. Talk about a little change going a long way!

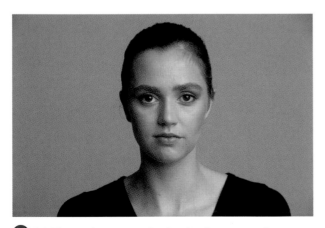

❌ **3.1** The neck appears shorter due to poor posture.

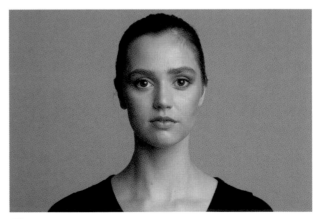

✅ **3.2** By improving the posture, we have helped to elongate the neck.

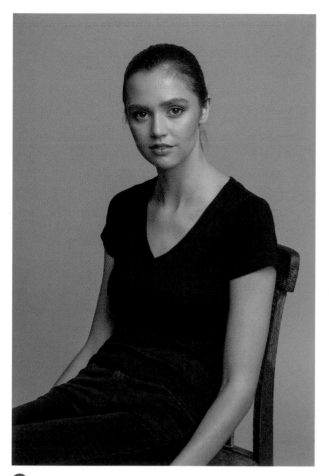

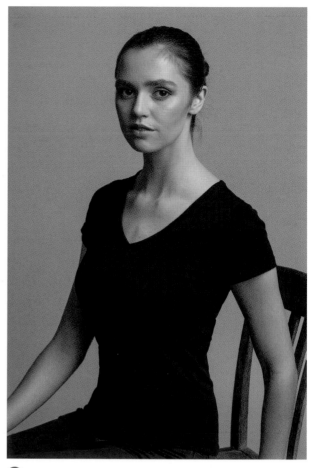

❌ **3.3** Poor posture causes the midsection to gather in an unflattering way. This may be skin or clothing, depending on the subject or styling.

✅ **3.4** By improving the posture, we can tighten up the midsection for a more slender appearance or less-distracting midsection.

THE PROBLEM: Midsection

When someone slouches, their midsection often gathers in an unflattering way, and you are likely to struggle with rolls in the fabric or skin in the stomach area. Elongating through good posture straightens and tightens, reducing this problem.

Let's compare these two shots of Leanne (**FIGURES 3.3** and **3.4**), who is a very slender subject. In Figure 3.3, our eye is drawn to her stomach. Not only does it appear to occupy more of the frame (pushed slightly toward the camera by poor posture), but our eyes are also drawn to the wrinkles in the clothes. When she improves her posture, everything tightens up and appears smaller. This issue is exacerbated with fuller-figured subjects.

THE PROBLEM: Reduced Height

When someone has poor posture, it makes them look shorter. Being short is certainly not a bad thing; however, you typically want to elongate a person for the most flattering shapes when capturing the form in a photograph. In a photograph, angles, combined with pose and lens choice, can really compress a person. In other words, a camera's lens can make the subject look squat, and posture worsens this problem.

Here are two more shots of Leanne (**FIGURES 3.5** and **3.6**). In one photo, she is standing, closed up, and with bad posture. Notice how the lines of her body and her height look shorter. Everything is compressed. When her posture is improved, she appears to grow several inches in height. The lines of her form are elongated, and it becomes easier to pose her in flattering ways.

THE SOLUTION: Improve Posture

What is the solution to this problem of poor posture and all its symptoms? To improve posture, of course! Sounds easy enough, but there are a few things you'll want to keep in mind. Be wary of simply telling a subject to "stand up straight" or "sit up straight." The results are often rigid, tense, and uncomfortable. The shot can end up looking too dry, too posed, or just too uncomfortable. This is where *your* directing and word choice really matter. You will find what works for you, but here is an example of how I direct my subjects.

❌ 3.5 Poor posture causes a subject to appear shorter in photographs.

✔ 3.6 When everything is elongated through improved posture, the subject will appear taller.

I may say, "Pull up through the top of your head and elongate" or "Feel a string pulling you upward through the top of your head." I direct with my hands, making it appear like I'm gently lifting them from the top of their head. I also mirror the action, showing in my own posture the type of elongation I am looking for. If my verbal direction happens to result in a tense pose, I may direct, "Great, now relax your shoulders."

Remember, posture is just as important for headshots as it is for full-length portraits, so you'll definitely want to check for this common posing pitfall and make tweaks to a pose to improve it.

PRO TIP

Aim for elongation in poses, which makes the limbs and body look longer, and *not* for compression or shortening.

Foreshortening

Foreshortening is when part of the body appears shorter than it actually is due to perspective (hence the name fore*shortening*). This common pitfall occurs when part of the body comes toward or away from the camera, and the camera's perspective makes it look shorter or even hides part of the body from view.

I see foreshortening ruining poses all the time, whether caused by the arms, legs, or even the position of the entire body. Basically, foreshortening is a type of distortion that leads to unflattering results, such as an arm appearing to be cut off or a body looking extremely short.

Let's take a look at what I am talking about, so you can start to identify some common foreshortening problems, and then learn simple adjustments that can reduce or eliminate the problem.

THE PROBLEM: Arm Pointing at Camera

One of the most common issues with foreshortening is when the subject raises their arm and it appears shortened or cut off. This occurs when the raised arm or elbow is pointed directly at the camera.

Let's take a look at this in action (**FIGURE 3.7**). Here, I ask Leanne to put her arm on her neck for a pose. The result? Because her elbow is straight toward the camera, the arm looks extremely distorted, the elbow very large, and the rest of the arm cut off. This happens in poses where the arm is raised to the face, neck, or hair. How do we fix it?

THE SOLUTION: Adjust the Arm

Simple adjustments to the arm can completely transform the pose and eliminate the problem. Move the arm to a position where it is not pointed at the camera. Try lowering the elbow or moving it off to the side.

In the following example, I've provided two distinct solutions (**FIGURES 3.8** and **3.9**). Lowering the elbow and placing the arm against the body eliminates the problem of foreshortening. Another, more dramatic, solution would be to raise the arm. This kind of pose would be more appropriate for something theatrical or perhaps fashion-influenced.

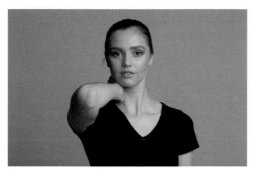

❌ **3.7** When the elbow is pointed directly toward the camera, it becomes foreshortened. Perspective compresses it, making it look shorter or cut off.

✅ **3.8** By lowering the elbow, we can eliminate the problem of foreshortening, as the elbow is no longer pointed directly to or away from the camera.

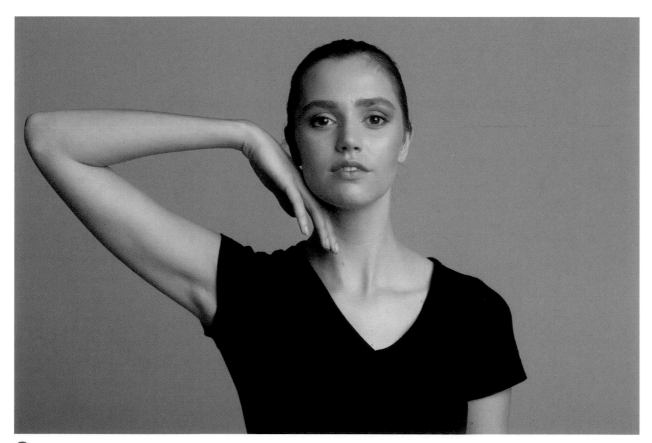

✅ **3.9** To reduce foreshortening, the elbow can also be placed off to the side, although this is more appropriate for dramatic or theatrical poses.

How about a subject sitting on the ground with their legs or knees toward you? The body appears shorter and compressed, and this can be even worse depending on the camera angle. You are missing the elegant lines, curves, and separation that usually help make a strong pose.

THE PROBLEM: Body Facing Camera

Let's take a look at another example of foreshortening. What if the subject is simply sitting in a chair facing straight toward you? For a headshot, no problem! But let's consider a 3/4 or full-length shot where the legs and knees are visible. Because of the subject's relative position to the camera, the legs directly face the camera and thus look cut off.

Let's take a look at an example of this problem with Leanne (**FIGURE 3.10**). Her pose, straight toward the camera, appears very boxy. In fact, you can barely see her thighs—they look very short because they are posed directly toward the camera. (Also, the left arm looks distorted due to foreshortening.) How do we make a change to the shot so that it's more flattering to her entire form?

THE SOLUTION: Adjust the Camera

You can start by changing your subject's position relative to the camera. For example, if you rotate the subject to the side in the chair, suddenly everything appears in proportion again because no appendages are coming straight toward the camera. Furthermore, you could just rotate the chair to the side a bit.

PRO TIP

When you have a subject posed (particularly when on location), try adjusting your camera angle around the subject and above/below the subject. How does this affect the appearance of the body? Different poses will look better from different angles, *and* different subjects will be flattered by different angles.

To fix this type of foreshortening, you can also adjust *your* angle. Sometimes the subject may already be in a beautiful pose that is flattering to them, but it is not working with your camera angle. Simply adjusting the angle up and down or side to side can completely transform how your camera is representing the scene.

This is a concept that really challenges your understanding of the role your camera plays in the appearance of your subject. It is *not* just about getting the right pose. It's

combining the right pose with the right camera angle with the right lens choice—all work together to interpret how your subject will look in the final frame.

Let's look at this in action. In this problem shot with Leanne, you may notice that the right leg is out slightly and both arms are on the thighs. I am going to keep her in the *exact same* pose and *exact same* position. The only difference is that now I am going to change *my* camera angle. By coming around to the side, I've eliminated foreshortening and created a much more flattering shape for the body (**FIGURE 3.11**).

❌ **3.10** Because the subject is facing the camera, with knees and arms toward the camera, all of the limbs suffer from foreshortening in this photograph.

✅ **3.11** By changing the camera angle to the side or rotating the subject, we are able to change the limbs' direction in relation to the camera. The legs and arms are no longer straight toward the camera, and foreshortening is reduced or eliminated.

THE PROBLEM: Subject Facing Camera

You've probably seen this pose a million times before (**FIGURE 3.12**). Perhaps you've even shot it yourself (I know I have!). The subject is on their stomach, legs kicked up behind them, possibly with the hands to their face. Unfortunately, depending on how this image is shot, the subject can end up looking like a disembodied torso with feet growing out of their head. Not a flattering look.

I've seen this pose most often with boudoir, children, and high school seniors. In this example, because Leanne is posed straight on toward the camera, I cannot see any of her body. Foreshortening completely disconnects her from her form, and the angle also causes the extremely distracting presence of feet behind her head. There is no elongation and quite a bit of distraction. Perhaps a closer crop would make this less disconcerting, but overall, we have some problems to fix.

THE SOLUTION: Rotate the Subject

Try rotating your subject to the side so you can see a bit more torso and body. You do not need to shoot completely from the side with the subject at their longest, but you should at least aim to have a hint of the subject's body in the shot. Again, this may also be fixed by slightly changing your angle relative to the subject.

In the example here (**FIGURE 3.13**), by rotating to the side so she is not directly facing the camera, the subject's body is visible and elongated. There is context to her torso, and the feet are less distracting.

PRO TIP

Foreshortening can happen with legs, arms, the body, and even the fingers and feet. Just do a little mental check of all of these elements—from the position of the entire body, down to the details on the fingers—in order to truly eliminate foreshortening in your shots.

❌ **3.12** The subject's body is posed to face straight toward the camera. For this reason, the body appears as a truncated, floating torso.

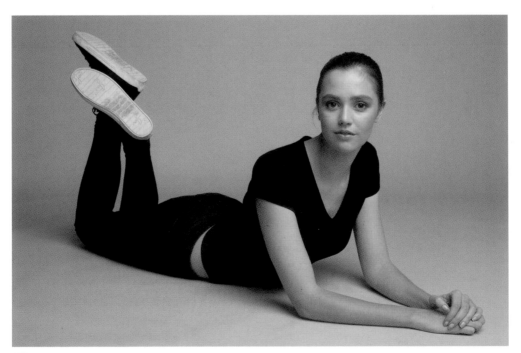

✔️ **3.13** By rotating the subject to the side or changing the camera angle relative to the subject, we are able to see more of the body. We have reduced foreshortening by ensuring that the entire body is *not* perpendicular to the camera.

Mergers

You don't want your subject to look like a blob; you want to see their limbs and flatter the shape of their body. Let's examine common mergers to see what to look for and how to fix them.

PRO TIP

One way to identify a problem with mergers is to imagine your subject in silhouette. If your pose makes them look wider, blob-like, or with an unusual shape, then a tweak in your posing may be required.

THE PROBLEM: Arms to the Sides Create Mergers

When a subject's arms are to the sides of their body with no space in between, it gives the illusion that the subject is wider than they are. To our brains, we measure the width of the body from one side of the arm to the other because the arms are merged to the side. Depending on the subject, this may add several inches to their width. This is particularly problematic when the color of the subject's sleeves is the same as the shirt, and where no separation is visible between torso and arms.

Ask yourself, "Is the placement of the arms helping to contour the body and give shape? Or, is the placement simply adding to width?"

In this shot of Leanne (**FIGURE 3.14**), her arms are tight to her sides with no separation. You can see how much wider her form appears because of the merger of her arms against her body.

Let's take a look at some solutions for dealing with the mergers caused by the arms against the sides.

THE SOLUTION: Create Negative Space

Try creating a bit of separation between the arms and the sides of the body. This tiny bit of "negative space" allows the viewer's mind to process the width of the subject so that they look more slender. This can be achieved by placing the hands on the waist, thigh, hips, neck, or anywhere else that gives some separation.

✕ 3.14 Here, the subject appears wider because there is no space between her arms and the sides of her body.

✅ **3.15** Subtle negative space between the arms and body helps to define Leanne's form and avoid mergers (left).

✅ **3.16** Triangles create more dynamic negative space and a strong pose while avoiding mergers (right).

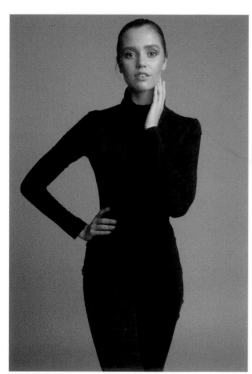

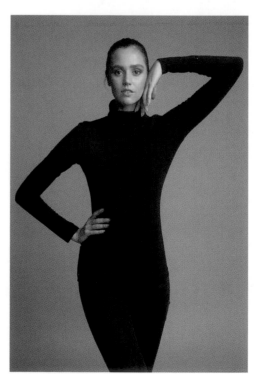

✅ **3.17** This pose utilizes negative space to avoid mergers but also uses the hand to draw attention back up to the face (left).

✅ **3.18** This use of negative space is theatrical and appropriate for dramatic shots, including some fashion imagery (right).

3.19 Mergers still occur when the subject is turned to the side. Here, the arm placement extends the width of her body by hiding the curve of her lower back.

PRO TIP

Negative space does *not* mean that you need to have hands on the hips with tons of space in between the arms and the body every time. Just a tiny bit of space will work—and will often look more natural.

In **FIGURE 3.15**, our subject has added a bit of space between the side of the body and the arms. You can instantly see her form again. This image, however, is a bit static. Whenever a pose is completely symmetrical, it will be more rigid and less dynamic. **FIGURES 3.16** and **3.17** both feature standard poses that help avoid mergers. **FIGURE 3.18** is a bit more dramatic and appropriate for something intended to be theatrical. Keep in mind that, even if the arms aren't tight to the body, mergers may *still* be a problem in your photograph.

Let's take a look at another example (**FIGURE 3.19**). Here, the subject is turned to the side, with her hand on her thigh and separation between her arm and the side of the body. Unfortunately, mergers are a problem again. Remember, you need to ask yourself if the arms are somehow defining the form or just making her look wider. When we imagine her in silhouette, the shape is not the most flattering we could achieve. In this case, the arm is extending the width of her body because it merges with her back. Yes, technically, there is space between her body and her arm—we just can't see it because of our angle. If I were to turn her toward the camera, I would be able to see this separation, but that is not the pose I want.

To be able to see her form, we need to pull the arm back a bit, to reveal space between her back and her arm, thus showing that beautiful curve. Another option is to keep her arm within the form, and thus not extending the width of the body.

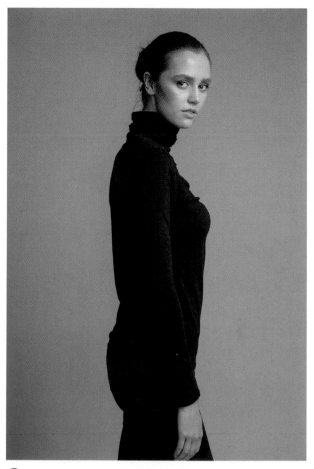

✔️ **3.21** By pulling the arm back and creating negative space, we avoid the issue of mergers.

✔️ **3.22** By placing the arm within the frame of the body, we are not adding to the apparent width of our subject.

Let's take a look at these two solutions (**FIGURES 3.21** and **3.22**). Both are completely valid ways to eliminate mergers for this pose.

THE SOLUTION: In-Body Posing

Putting space between the arms and the body is not the only solution for mergers. Negative space is perhaps the easiest, or most obvious, solution, but there are several other approaches that can yield stunning results.

For example, another solution is to pose the arms within the frame of the body. This often creates a quieter result. The key is to analyze the placement of the arms. Are they adding to the shape and interest of the image?

Are they flattering the shape of the body? Or, are they making the body look wider? In-body posing takes practice and is often a more advanced solution to mergers that requires a bit more finesse and expertise.

Here, we'll take a look at an example of in-body posing compared to "outside of body" (or negative space) solutions. In **FIGURE 3.23**, we see that we are suffering from mergers; crossing her arms makes her body appear wider and boxy. Let's try some more elegant solutions. In **FIGURE 3.24** by placing a hand on the thigh and hip, I have created separation with triangles, and added definition to her form. In **FIGURE 3.25**, I've posed her with both arms meeting inside the frame of the body. Not only do the arms give a nice shape to her form by tapering at the waist, but they also create interesting lines in the photograph. Notice that the arms are posed in-body.

Which solution do you prefer? Both are equally valid and create a different tone to the image. It is great to know both solutions are at your disposal.

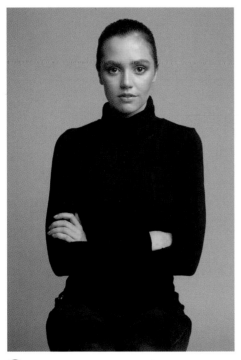

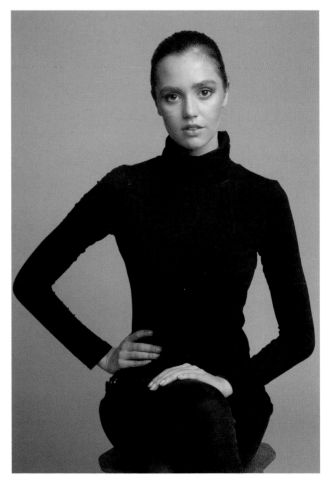

❌ **3.23** In this pose, the crossed arms create a very boxy look and mergers to the side of the body (above).

✅ **3.24** We can create negative space between the arms and the side of the body to help reveal her shape (right).

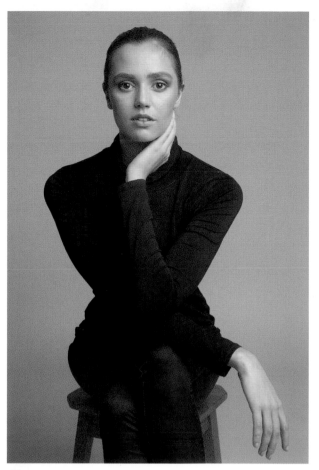

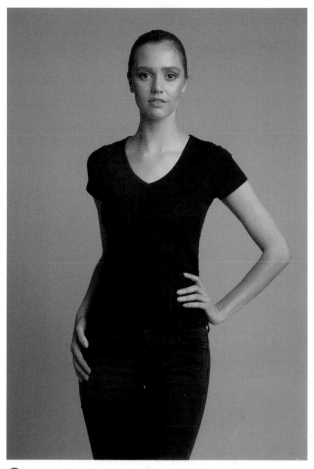

✅ **3.25** By placing the arms within the frame of her body, we can use them to create interesting lines. The arm placement in this example actually accentuates her waist.

✅ **3.26** By rolling her shoulder back and having the elbow bend in at the waist, we have reduced mergers and created a flattering use of arm placement.

THE SOLUTION: Using Arms to Contour

Another way to avoid unflattering mergers is to use the arms to contour the body. By posing the arms to mimic flattering shapes of the form, we may actually emphasize a subject's strengths. You will see this often in boudoir posing, where the arm follows the shape of the hips and waist to emphasize the hourglass feature.

Let's take a look at this in practice (**FIGURE 3.26**). On one side, we have used negative space to better flatter the body. On the other, we have allowed the arm to lie tight against the body and fall back to emphasize the waist. Because it enhances the appearance of curves, this method is used often when photographing women (though never when photographing men).

❌ **3.27** Baggy clothing can completely hide a subject's form.

THE PROBLEM:
Baggy Clothing Creates Mergers

Another major problem with mergers is created by the combination of posing and clothing. Baggier clothing makes it difficult to show your subject's shape and may result in poses with unavoidable mergers. While an oversized sweater may look great in person, it often is extremely challenging to create flattering results in a 2-D photograph. Baggy or ill-fitted clothing makes it hard to differentiate one part of the body from another, and in a photograph it often gives you that unwanted blob-like result. Furthermore, I find that fuller-figured subjects often select oversized clothing, which, unfortunately makes your job of flattering their form more difficult.

Although Leanne is very slender, this oversized sweater does not allow us to see her form (**FIGURE 3.27**). It will be challenging to pose her to create flattering shapes. Furthermore, even when she raises her arms to create negative space, it only makes her look broader (**FIGURE 3.28**). No negative space is visible at all.

THE SOLUTION: Adjust the Clothing

One option is to change a subject's outfit altogether. Typically, more form-fitted clothing will make it easier to work with a pose in order to enhance your subject. Baggy clothing will only fight you. This is one of the reasons I like to advise my subjects on the type and fit of clothing I recommend before their session. Of course, there are times that you simply cannot change the outfit. In such instances, I use A clamps to pin and fit the clothing. As long as they aren't visible to the camera, they will make your job easier.

❌ **3.28** Even the usual solutions for posing become very difficult with oversized clothing because the clothing hides all negative space despite any tweaks to the pose.

THE SOLUTION: Adjust Hands

Another option is to use posing and hand placement to create the body definition you want. Placing the arms or hands carefully can help visually define the waist or side of the body. I use this technique to help define a subject's form, especially when trying to emphasize an hourglass shape or give definition to a subject's silhouette.

In this example, Leanne places a hand on her waist (**FIGURE 3.29**), and the viewer's your mind starts to interpret where her body ends and the clothing begins. By putting both hands on the side of her body (**FIGURE 3.30**), the pose becomes more dynamic and her form is clearly defined.

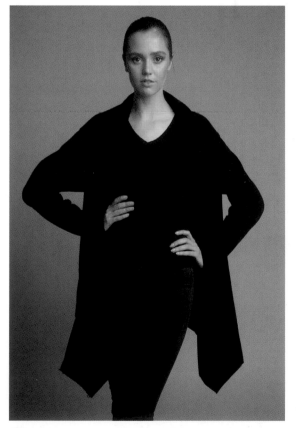

✅ **3.29** Placing a hand on the hip draws attention to the actual, and much narrower, width of the subject and helps to define her form.

✅ **3.30** Using two hands to define the outside of her form helps the eye determine the subject's actual shape, which was previously hidden by the clothing.

Poorly Posed Hands

Hands can add a great deal of interest and emotion to a portrait. They can frame a subject, direct the eye, and communicate the mood. Yet, just as hands can add to a photograph, they can also distract and detract. Poorly posed hands are a small detail that can have a very large, and negative, impact on your images.

Hands have been posed in countless ways, particularly in classical paintings, as yet another way to convey emotion in a still image. That being said, there are some rules to follow when posing hands that will result in flattering results, as well as common problems that can completely ruin a pose.

THE PROBLEM: Distracting Hands; Palm or Back of Hand Toward Camera

You don't want the hands to be distracting in a photograph. If they look too large or bright, or are drawing too much attention from your subject's face, then they probably are pulling down the overall quality of your image. This problem is caused by having the palm side of the hand toward the camera (**FIGURE 3.31**) *or* the back of the hand flat to the camera (**FIGURE 3.32**). Both can create distracting results. When the palm is toward the camera, suddenly there is a pale and relatively large area of skin that demands the viewer's attention. Let's fix that!

THE SOLUTION: Place Pinky Toward Camera

Typically, you'll want to have the pinky side of the hand toward the camera (**FIGURES 3.33** and **3.34**). This is the narrowest and most elegant side of the hand, and it typically produces more pleasing results, especially with hands near the face. Sure, there are exceptions to this rule, but for the most part, you'll see the pinky side of the hand toward the camera in a majority of shots with successfully posed hands. Whether the hand is near the face or waist, or even on the chest, see if the hand pose can be improved by showing the pinky side.

(Note: Thumbs break up the flow of a pose or can look rather stumpy, so be wary of them drawing too much attention in a hand pose.)

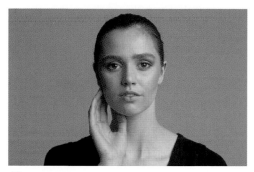

❌ **3.31** The palm is turned too far toward the camera, creating visual distraction.

✅ **3.33** By turning the pinky toward the camera, we have reduced the size of the palm and now see the most elegant side of the hand.

❌ **3.32** The hand is in a fist with the back of the hand toward the camera, which is not the ideal angle or position for the hand.

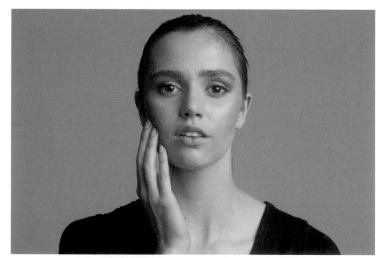

✅ **3.34** By turning the hand into a loosely closed hand with the pinky toward the camera, we have created much more elegant lines.

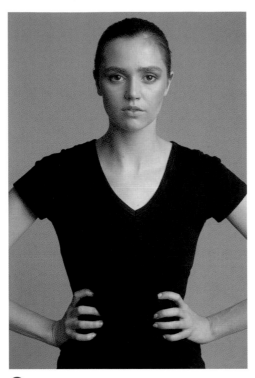

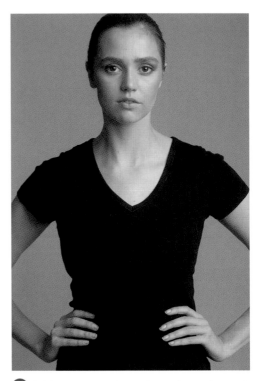

❌ **3.35** The hands are gripping too hard onto the side of the body, communicating tension or discomfort.

✅ **3.36** Softer hands are less distracting and communicate a relaxed subject.

THE PROBLEM: Tension

People show tension in their hands. If they are nervous, uncomfortable, or stressed, the hands will tell their secret. An entire pose may appear elegant and relaxed, but tensed fingers will completely ruin the mood of the photograph (**FIGURE 3.35**). Seek to have relaxed hands without tension unless you are trying to communicate frustration or anger.

THE SOLUTION: Relax the Hands

Once the rest of the body is posed, be sure to check the hands. Is the fist clenched? Is the subject holding onto a chair too tightly? Do they look like they are picking at their nails? If anything doesn't look relaxed and elegant, fix it.

In some situations, I'll ask my subjects to "raise your fingers, wiggle them around, now set them back down softly" as a way to coach more relaxation and elegance in the hands (**FIGURE 3.36**). Other times I request "ballet hands" while demonstrating a more elegant hand position.

If the hands look awkward, I may also try to coach the subject to move the hands with an action instead of just placing them on the body or face. For example, if the hands look too tense or unnatural on the face, I'll ask my subject to "trace around the outside of your face with your index finger" and coach them to pause when the hands reach an ideal location.

THE PROBLEM: Covering the Jaw

One of the things we perceive as beautiful in a photograph is a subject's neck and jawline. If the hand is posed against the face, completely covering the jaw and close to the camera, it is obscuring something beautiful about our subject (**FIGURE 3.37**).

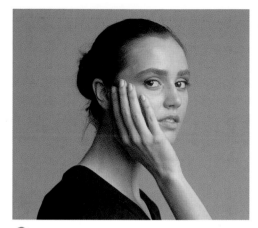

❌ **3.37** We consider the jaw to be a beautiful feature, yet here the hand has obscured the jawline.

THE SOLUTION: Adjust Hand Placement

There are several solutions to this problem, all achieved by slight adjustments in hand placement. First, you can lower the hand away from the jaw, setting it on the neckline or simply creating space between the hand and jaw (**FIGURE 3.38**). Furthermore, you can place the hand on the side of the jaw away from the camera, thereby revealing the jawline (**FIGURE 3.39**).

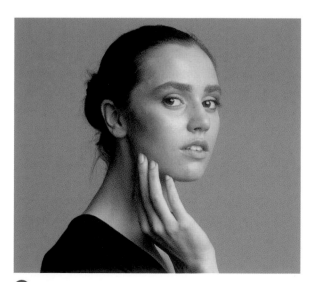

✅ **3.38** By lowering the hand, we can now see the jaw and the hand becomes a significantly less distracting element.

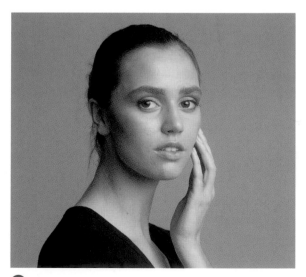

✅ **3.39** With the hand on the opposite side of the face, the jawline is no longer obstructed.

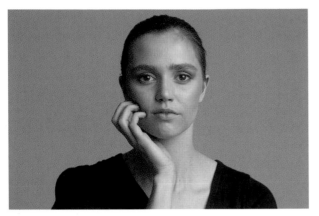 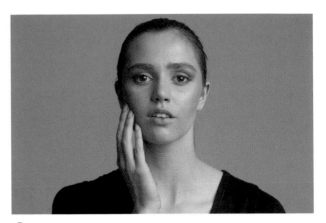

❌ **3.40** When the hands are gripping too tightly or pressed into the face, they make unflattering indentations.

✅ **3.41** The hands should be lightly placed on the body and face.

THE PROBLEM: Hands Pressed Against Face/Body

A subject may rest their face against their hands, creating unflattering indentations (**FIGURE 3.40**). Furthermore, when a subject places their hand on their waist or hips, sometimes they grip too tightly and create unflattering bumps.

THE SOLUTION: Gently Place Hands

Sometimes hands should be placed gently on the body instead of applying pressure. Similarly, the hands should be positioned softly against the face without pressing in or resting the cheek on them (**FIGURE 3.41**). The key to solving this problem is to be aware of it, and then make subtle changes to avoid unflattering results.

Bad Expression

You've gone through your checklist of things that can ruin a pose. You've improved the posture, adjusted your camera angle to avoid foreshortening, softened the hands, and created negative space. One more thing to consider for portrait photography is the subject's expression. No matter how beautiful the pose, a bad expression will render the image undesirable.

I've been shooting portraits for more than half of my life, and I've seen this truth in action. Let's say I have two shots. In the first shot, I have a

perfect pose and incredible lighting but a bad expression. The second shot is underexposed, slightly out of focus, with less than ideal lighting, but the expression is fabulous. Which does the client choose? *Expression!*

Technically, an expression may not be considered posing, but a poor expression is definitely a pitfall that can ruin an otherwise beautiful pose and photograph. In fact, I find good expressions and connection with the camera to be one of the most challenging elements of portraiture.

THE PROBLEM: Tense Serious Face

At times I am seeking a serious or pensive expression, but the subject's face reads neither emotion. Instead, the tension in their face communicates discomfort or even anger. I've seen this time and time again with subjects not used to appearing in front of the camera. This can manifest itself in several ways. For example, someone may hold their lips together too tightly or clench down on their jaw (**FIGURE 3.42**).

❌ **3.42** Tense lips show discomfort in the subject and break the desired mood of most portrait shoots.

THE SOLUTION: Relax Head and Lips

First, I ask my subjects to relax from the top of their head downward, by feeling like they are melting. I move my hands around and coach them to relax their forehead, unclench their jaw, loosen their lips, shrug their shoulders, and wiggle their fingers around. These are the most common areas where people bottle up their tension. I talk through each step and part of the body to be sure they have let go of the stress. Once they are like Jell-O (or as close as I can get them), I will work to improve the posture without reintroducing tension into the shot.

The very last step is to focus on their lips. If I am going for a real smile, I may ask them to chuckle out loud to themselves or I try to bring humor into the room with a joke, story, or music. If I am seeking a serious expression, I ask my subject to take a deep breath. When they exhale, I ask them to slightly part their lips and to remember that very loose feeling at the end of the breath (**FIGURE 3.43**). That feeling is where we begin our "serious" expression, and I can manipulate from there.

✔ **3.43** With a serious face, loose or relaxed lips give more desirable results.

THE PROBLEM: Deer-in-Headlights Look

Some subjects simply have the deer-in-headlights look in front of the camera (**FIGURE 3.44**). They freeze in place, don't know how to move or create an expression, and produce the emptiest of looks. This can be frightening for both photographer and subject. Fortunately, I've got a few more suggestions to achieve better results.

THE SOLUTION: Draw Out Emotion or Expression with Eyes

One approach is to invite the subject to look down and away from the camera. Find a way to break that too-tense connection with your lens and allow them to relax. Next, you may consider directing them like a model or an actor. Invite them to imagine a certain emotion, feeling, or mood. When they have settled into that emotion, direct them to look back at the camera and channel that emotion when they connect.

Another approach is to try to coach a bit more expression into the eyes. The eyes are the giveaway of a subject's discomfort. On "America's Next Top Model," Tyra Banks coaches models to "smize," or "smile with their eyes." I have found that inviting people to give me just a bit more smile with their eyes tends to light up their face and establish a more realistic connection (**FIGURE 3.45**). If you watch a tutorial by headshot photographer

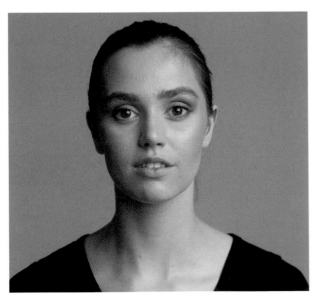

❌ 3.44

✅ 3.45

Peter Hurley, you may hear him refer to the "squinch" (squint and a pinch of the eyes). For a man, maybe you are coaching a bit of a smolder or channeling Zoolander. Either way, you goal is to bring life and expression to the eyes.

Expression Tips and Tricks

I'd like to share a few things I've picked up over the years that help me to get to know my subjects, connect with them, and improve expressions in my portraits. I've learned these tips after photographing hundreds of subjects, but also after being a subject myself.

One year for my birthday, I asked several of my incredible photographer friends to take my portrait. I wanted to commemorate the milestones of turning 30 and becoming a Canon Explorer of Light; I also wanted to learn from being on the other side of the camera. I learned empathy, tips for directing my subjects, and the *real* importance of these next three tips!

Tip 1: The Sweetest and Most Important Sound

If you are looking to connect with your clients but struggle to do so, I recommend checking out the classic self-help book *How to Win Friends and Influence People* by Dale Carnegie. I first picked up this book when interning for photographer John Harrington in Washington, D.C. Harrington is an expert on business, and he recommended this book to improve my interactions and success with my subjects and clients. I cannot tell you the incredible lessons I learned and have put into practice over the years. It is an easy read, and I recommend it for any and every photographer.

One quote that stuck with me: "Remember that a person's name is, to that person, the sweetest and most important sound in any language."

Learn their name. Use it to greet them. Use it when directing them. Use it in conversation. Use it to provide positive reinforcement.

Tip 2: Use Positive Reinforcement

As a photographer, it is extremely important to have your portrait taken. First, it is important to show that you value your own craft by having professional portraits of yourself for business purposes and for your family, and to capture other important moments in life. Moreover, for the purposes of this book, it is essential to learn empathy. By experiencing what it's like

on the other side of the camera, you learn what it's like to feel vulnerable and self-conscious, as well as what makes you feel confident and attractive.

During my series of portrait sessions, I learned the power of positive reinforcement. Hearing when I had a good pose or expression was encouraging and helped put me at ease. Being the subject in a portrait feels like an important job—you want to help the photographer and not be the reason for a photograph coming out poorly. When the photographer praises you, it gives you the feeling that you are contributing to the end result.

For example, when my friend Sue Bryce was shooting my portrait, I loved the way she would tell me "good girl!" when I'd follow a direction correctly or give her a desired expression. As simple as those little words were, they made me feel significantly more confident.

It can be extremely difficult to feel comfortable in front of the camera, but positive reinforcement really helps to bolster the spirit of the shoot and improves the connection between the photographer and subject.

Tip 3: Find Their Passion

To connect with my subjects, I try to learn more about them and their passions. I want to learn about what they do in their free time. I want to know what thrills them in life.

This is yet another important lesson I learned from *How to Win Friends and Influence People*. Carnegie writes, "Be a good listener. Talk in terms of the other person's interest. Make the other person feel important—and do it sincerely."

When I discover someone's passion, it helps me get to know them more deeply so I can elicit expressions of genuine happiness from them during the shoot. When someone gets me talking about photography, for example, my entire mood and mindset changes. It's difficult to get these types of expressions when talking about the weather or other mundane subjects; instead, find out what thrills your subject to wake up each day. For example, if I know someone is a dog lover, I can ask them to think about their dog as a puppy to achieve expressions of joy.

Furthermore, it is always useful to be able to get your subjects talking to maintain the momentum of a shoot. If you are reviewing images, fixing lights, or are otherwise occupied during a shoot, you can ask the subject to elaborate on their passion as a way to fill the dead air and to keep up their energy and excitement. In short, be genuine in caring about your subjects.

Now that we've reviewed these general tips, I'd like to share some commonly problematic expressions and how I work to improve them. Every person is different, so the more experience you have creating good expressions, the better your results will be.

TRAIN YOUR EYE

By now, your mind is probably spinning from all the things that can ruin a pose. Don't worry, with practice you'll be able to seamlessly identify and prevent these issues in your own photographs.

Yes, we've covered a lot, but now it is time to put it into practice. Your goals in this section, and in the other "Train Your Eye" sections, are to identify problems in a pose so that you can make adjustments to improve and flatter your subject. Take a look back at your work, and pick apart common mistakes you have made in the past. But first, let's examine some samples from my work. See if you can analyze each of these two images and determine the problem area, looking for posing pitfalls that can be avoided to improve the pose. On the next page, I'll clearly identify the issue and provide a solution to the problem. Please know that there are endless other solutions, but this provides one visual example of ways to fix these problems.

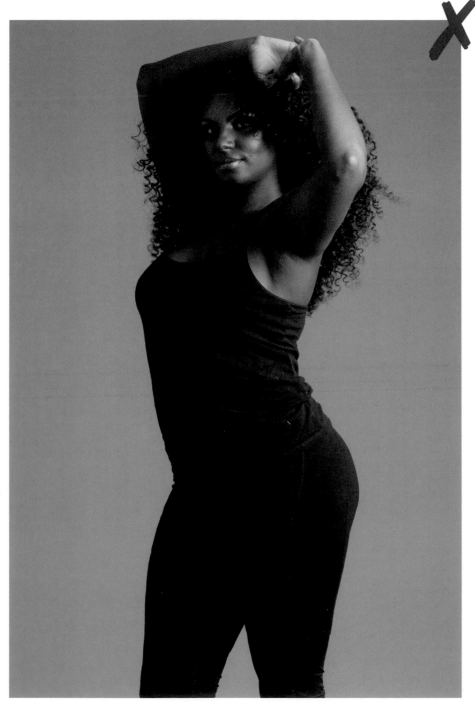

TRAIN YOUR EYE #1

Study **FIGURE 3.46** and see if you can identify the problems in the image.

3.46 Train Your Eye #1.

Let's see how you did. Compare **FIGURE 3.47** with the solutions in place in **FIGURE 3.48**.

❌ *Problems*

Hands: Placing the palm up and toward the camera creates a distracting area in the photo. The hands look unnatural, uncomfortable, and distracting.

Elbow: The subject's front elbow is pushed toward the camera. This creates foreshortening, making the subject look slightly distorted and drawing the eye directly to the elbow.

Hips: The hips are pushed slightly toward the camera, making them appear larger.

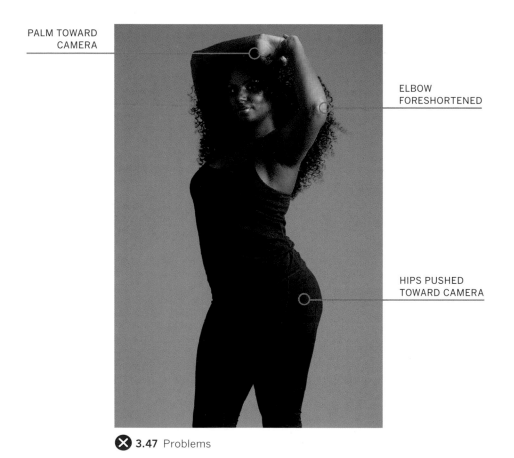

PALM TOWARD CAMERA

ELBOW FORESHORTENED

HIPS PUSHED TOWARD CAMERA

❌ **3.47** Problems

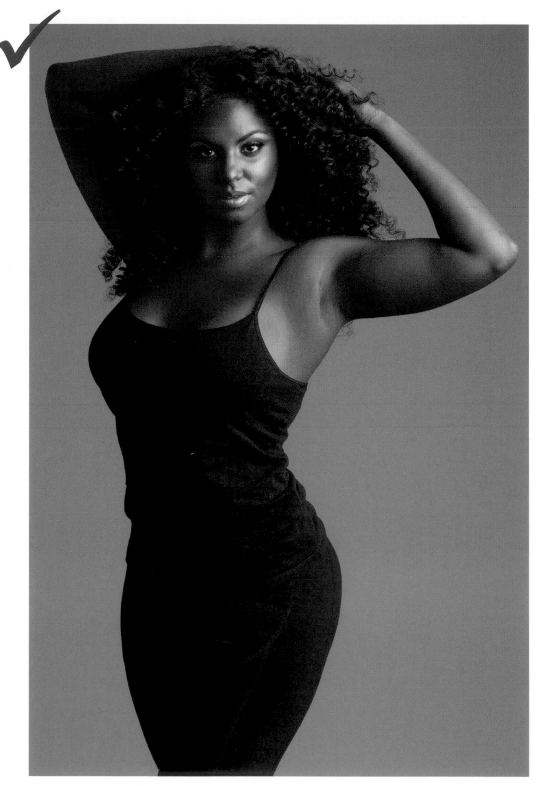

3.48 Solutions

✅ *Solutions*

Hands: The pinky side of the hands is toward the camera, and the hands are slightly obscured by the hair.

Elbow: The elbow is brought back out to the side, away from the camera, thus fixing the distortion.

Hips: The hips have been pushed slightly away from the camera, making them appear smaller and also emphasizing her curves.

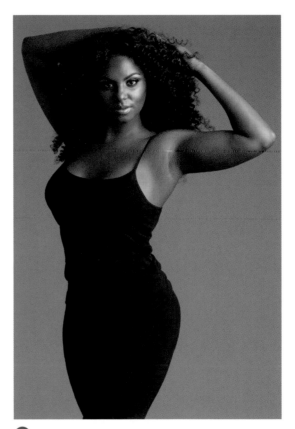

✅ **3.49** Solutions

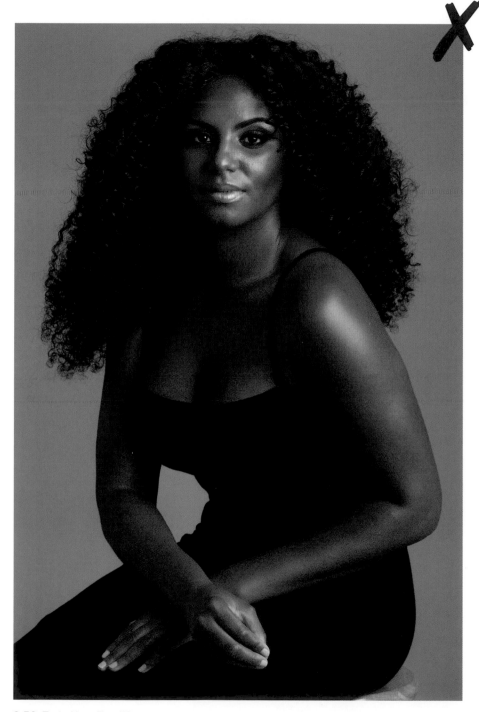

TRAIN YOUR EYE #2

Study **FIGURE 3.50** and see if you can identify the problems in the image.

3.50 Train Your Eye #2

Let's see how you did. Compare **FIGURE 3.51** with the solutions in place in
FIGURE 3.52.

❌ *Problems*

Hands: There is visible tension in her hands, indicating that she is uncomfortable.

Arm: Her arm is merged against her body. Hiding the line of her back gives the impression that she is wider than she actually is.

Posture: While her posture is not terrible, her shoulder is slightly raised and could be more relaxed.

✅ *Solutions*

Hands: Both hands remain relaxed now that the pinky side of the hand is toward the camera. They look elegant and do not draw unnecessary attention.

Arm: By placing her arm back, we have created negative space between the arm and the body. We can now see the curve of her back, and she looks more slender. Another solution would be to move the arm forward enough not to extend past the line of her back.

Posture: A subtle improvement in posture slightly lowers the shoulder.

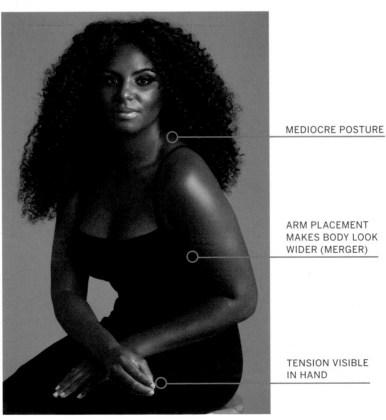

MEDIOCRE POSTURE

ARM PLACEMENT MAKES BODY LOOK WIDER (MERGER)

TENSION VISIBLE IN HAND

❌ **3.51** Problems

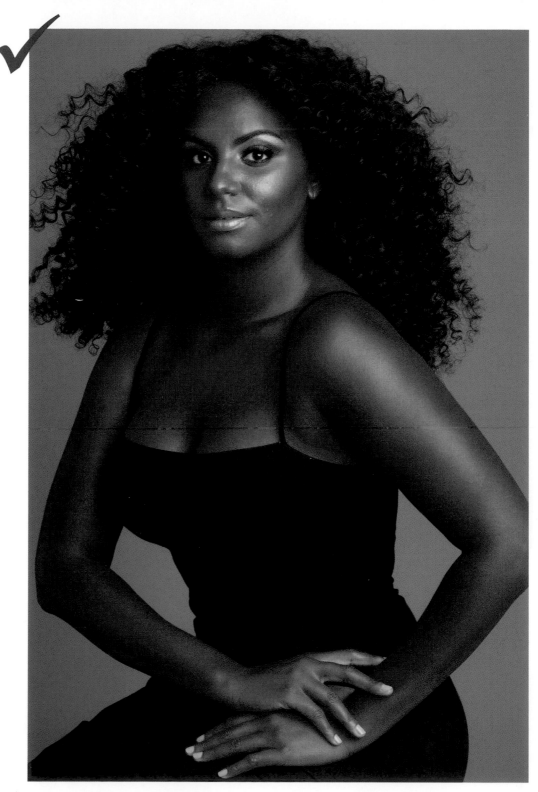

3.52 Solutions

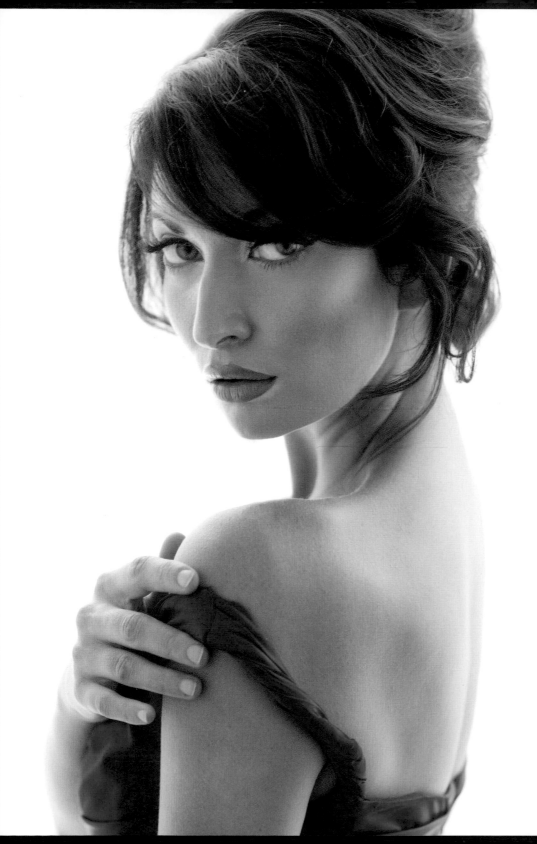

10 Steps to POSING SUCCESS *and* POSING VARIATIONS

Posing isn't just a formula. Like a dance, the core moves may be the same, but each dancer gives the performance something unique based on their body type and personal style.

I approach posing as a process. Well over a decade of practice has made this process instantaneous—I'm not checking off the steps in my mind; instead, I smoothly transition between steps as I shoot. This 10-step process helps me create endless variations in my portrait sessions without memorizing hundreds of poses. Instead, I only need to remember a few base poses. From there I can build on these base poses and never feel stalled for ideas.

If you can master this process, you'll always have enough material to create a large number of useable images with each portrait session. I've provided my suggestions, but I welcome you to research your favorite images online or other photographers you admire to come up with your own unique list of base poses.

10 Steps to Posing Success

1. Select a base pose (you can use the go-to poses at the end of each chapter).
2. Adjust the pose or change angles to draw attention to or away from specific body parts.
3. Check for foreshortening and mergers (adjust pose if necessary).
4. Ensure good hand position and posture.
5. Engage the subject to get a good expression.
6. Shoot!
7. Vary your subject's hands, expression, and shoulder placement.
8. Try different camera angles, camera positions, crops, depths of field, and lens choices for variety.
9. Repeat!
10. Analyze your images and learn from your successes and mistakes.

STEP 1: Select a Base Pose

Begin by selecting your base pose. This may be one of the five go-to poses you've memorized, or perhaps you've been inspired by images you've seen elsewhere. These poses will create the foundation of the shot, and you can make adjustments to build off of this.

For this example (**FIGURE 4.1**), my subject is posed on a rock underneath a willow tree. I didn't give her much direction other than asking her to sit comfortably. This pose has some issues that need to be addressed.

STEP 2: Adjust the Pose or Change Angles to Draw Attention To or Away From Body Parts

Take a look and analyze your shot and your subject. What is your eye attracted to in the pose? What looks largest? What is demanding the most attention? Is the attention where you intend it to be? If not, you will need to make some tweaks. Do you need to have the subject lean toward you or bring an asset closer to the camera? Maybe you need to get to a higher angle or move to the side to better control where the viewer's eye looks. Remember, whatever is closest to the camera will appear the largest,

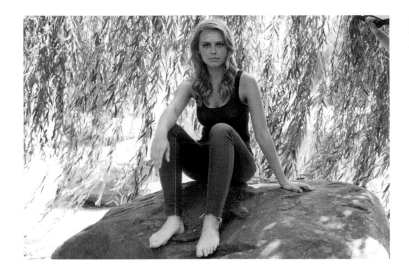

4.1 My subject has taken a seat on a rock for the base pose, which I will tweak to get the shot.

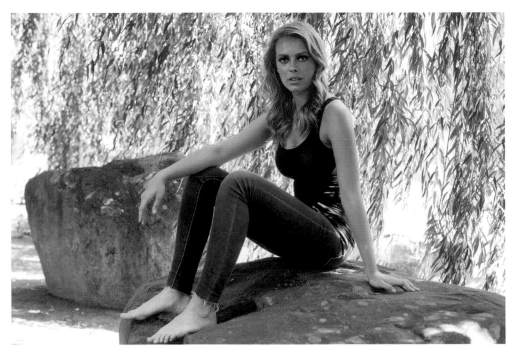

4.2 I adjust my camera angle to the side to create a more pleasing perspective and give better shape to the subject.

whereas whatever is farthest from the camera will appear smallest. You can control this by moving the subject or by moving yourself.

In this example, the subject's body suffers from foreshortening (legs coming toward the camera): her feet look large (they are close to the camera), and her body looks compressed. To fix these problems, I change my camera angle by moving to the side, which puts everything back into a more pleasing perspective (**FIGURE 4.2**).

STEP 3: Check for Foreshortening and Mergers

Take a look and see if your image or pose is suffering from any problems with foreshortening or mergers. Is anything coming toward or away from the camera, making the image look compressed (that is, foreshortened)? If so, adjust the pose or camera angle to remedy this. Are mergers a problem in the pose? Are the arms making the body look wider? Are there any unfortunate mergers coming out of the back of the head? If so, use negative space or in-body posing to fix the problem.

In **FIGURE 4.3**, I am able to reduce foreshortening by changing my camera angle. Unfortunately, her left arm is straight beside her body, creating a merger (no negative space visible), and both her feet are at even levels (creating a more stagnant shape). To fix this, I lower one leg and create a bend to the arm closest to the camera. Now the pose has been improved to avoid mergers and foreshortening, but there are more changes to make.

4.3 I adjust the pose to avoid mergers (with the arm beside the body) and reduce the stagnant look of even feet (dropping one leg down).

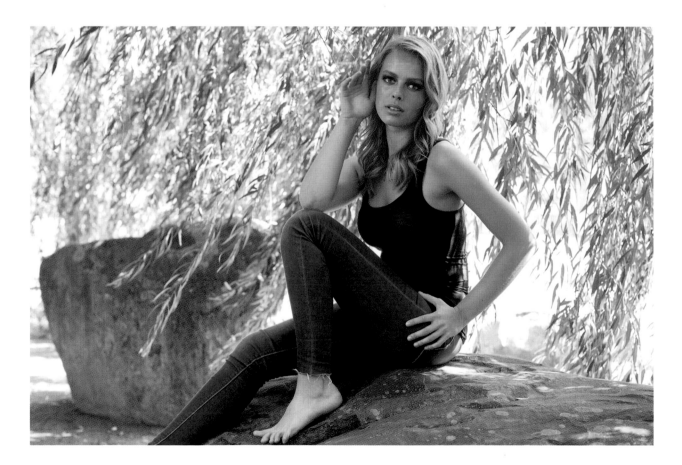

STEP 4: Ensure Good Hand Position and Posture

The pose is starting to look good, but watch out for two possible problem areas. First, make sure that the subject has good posture. Remember to have your subject pull up through the top of the head and elongate. If the head position or chin needs help, have your subject place their chin out and down.

Also, let's take a look at the hands. Are we looking at the pinky side? Are they relaxed and not showing tension? Make sure the hands are not distracting in the photo.

Analyzing the shot we are working with, there is still a problem with her hands. In Figure 4.3, the hand closest to the face shows too much palm (creating visual distraction), and the hand on the hip appears too large due to its placement. Thankfully, there are a few easy adjustments to improve the hand placement. First, rotate the hand next to her face so that the pinky side is toward the camera, creating a more elegant curve (**FIGURE 4.4**).

4.4 In this image, I've adjusted both hands so that the pinky sides face toward the camera, creating more elegant curves and less distraction from the hands.

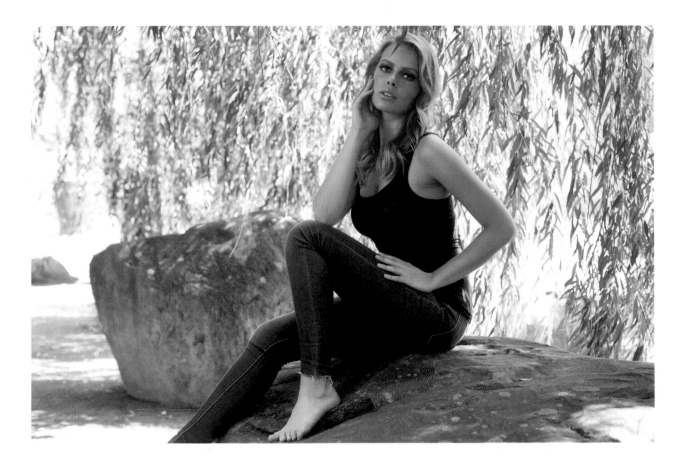

STEP 5: Engage the Subject to Get a Good Expression

Now it is time to engage the subject to elicit a good expression. Maybe you are seeking a laugh, and ask the subject to giggle aloud. Maybe you want a sad and pensive look, and you direct the subject to get that soft expression in their lips and eyes. Remember the importance of having the subject emote something that the viewer can connect to. A blank stare, bored look, or awkward expression ruins a shot with even the best pose.

STEP 6: Shoot!

Now you have a good pose, you've fixed major problems, and you have a strong connection between the camera and subject. Time to shoot! Get your focus on the eye closest to the camera, and make sure the composition and depth of field are what you want. Everything is taken care of in the posing department, so be sure the rest of your photographic elements are up to par.

This, of course, is just one shot, and you are going to want some variety.

STEP 7: Vary Your Subject's Hands, Expression, and Shoulder Placement to Create New Poses

Now it's time to introduce some variety into your photographs. How do you do this? Each time you vary the position of the head, hands, or feet, you've created a variation of your original shot. Each time you change the expression or where the eyes are looking, that's a new look to work with.

You've got your beautiful base pose in place, so what digits can you change to tweak the pose slightly? Can you move the hand from the hip, to the thigh, to the face, and across the chest? Each change creates a new pose, even if the base stays the same. Each time the hand moves, the expression changes. Sometimes she looks straight toward the camera. Sometimes she laughs into her shoulder. Other times she looks off into the distance. Each combination of hand placement and expression is a new shot.

In short, keep the base pose and vary the feet, hands, arms, eye contact, and expression for different combinations and variations.

STEP 8: Try Different Camera Angles, Camera Positions, Crops, Depths of Field, and Lens Choices for Variety

So far, everything we have discussed has been in regards to posing and changing the position of the subject's body. Now let's put the camera and photographer to work.

For each pose, you can create a great deal of variation in the shots based on your camera angle, lens choice, crop, and depth of field. Depending on the subject and environment, you can take this to the extreme and create some really unusual images.

You can change the following:

- the crop
- depth of field
- point of focus
- camera angle side to side
- camera angle up and down
- lens choice

Choose the base pose, and now change your angle. When you change your angle, perhaps change your depth of field. Now vary your crop. Maybe a change in lens would change the look of the shot.

Shot variety isn't all about changing the subject's pose. A single pose can look very different depending on the photographic techniques you apply. Of course, on location you have a bit more flexibility, but you can still make some basic adjustments in the studio as well.

Now it's time to revisit our core example for this segment. Take a look at how we are able to get 18 different shots without a lot of change to our subject. I vary the subject's hand placement and expression, as well as my camera angle and crop. For the most part, there are only subtle and minimal changes to my subject, but I've created a great deal of variety from a single pose (**FIGURE 4.5**).

PRO TIP

If you are in the studio and feel as if you can't vary the camera angle too much, consider envisioning the pose from a slightly different angle. Ask the subject to pretend they are on a turntable, and rotate around to provide a slightly different perspective. Of course, drastic changes in angle are not always necessary or flattering, but they might spark a creative approach to shooting a common pose.

4.5 Every single shot is from the same base pose. The subject is seated with her front knee up. From there, I've varied her hand placement and expression, and then changed my crop and camera angle. The result is 15 different shots from a single pose.

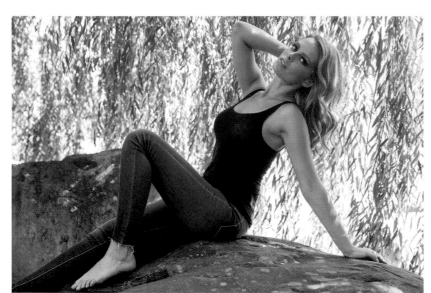

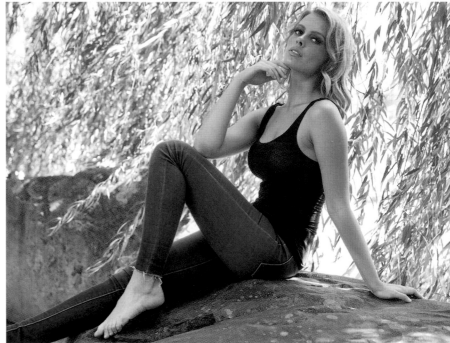

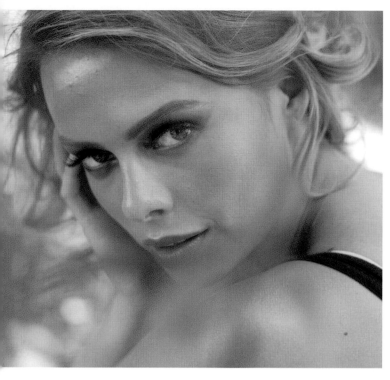
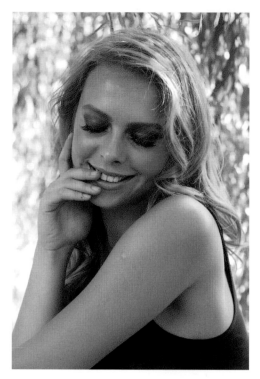

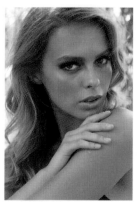
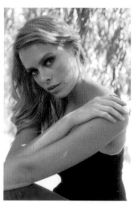
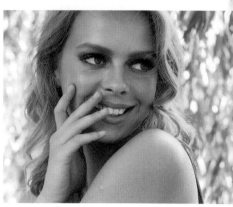
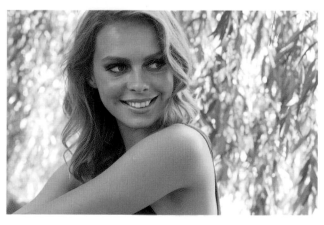
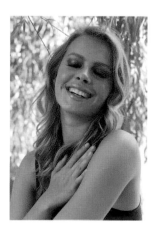

MASTERING *Your Craft*

Many photographers and photo educators refer to "the digits" in terms of posing. Don't confuse these "digits" with the digits of the fingers. Digits refers to any part of the body that can be moved without altering the core of the pose, such as hands, feet, arms, face, and expression. I recall photographer Jerry Ghionis referring to the digits like those in a phone number—vary each one independently and you have endless possible combinations. In **FIGURE 4.6**, you can see that all I've changed is the placement of the subject's hands, with a slight variation to the tilt of her head. Extremely subtle changes in the digits of the hands help me create variety to build on. From there, I can change the subject's expression and then move on to other camera adjustments. ◾

4.6 Making simple adjustments to the placement of the hands helps me create variety. From there we can change head position, eye contact, and more. Notice, however, that simply adjusting the hands creates many options to choose from.

STEP 9: Repeat!

Take everything you've learned and put it into action. Get that base pose, make tweaks to flatter your subject, look out for posing pitfalls, make sure your subject connects with the camera, vary the digits, put the camera to work, and repeat. Pick a completely different base pose, and run through these steps again. From each base pose, you can build dozens of different shots by varying the digits, camera angle, depth of field, and crop.

STEP 10: Analyze Your Images and Learn from Your Successes and Mistakes!

This final step is not really a step in posing, but a step in becoming a better photographer. You'll want to take a look at all the shots you've captured—not just the successes! What common problems and posing pitfalls did you encounter, and how can you avoid them in the future? What poses really worked, and should they be added to your go-to poses? Maybe they just worked great for the body type of that individual.

I often go through Adobe Lightroom to see which images succeeded and which images didn't make the cut (**FIGURE 4.7**). Sometimes you'll notice a repeated problem with a particular subject (like awkward hands) or become aware of repeated issues in your own posing.

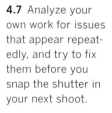

4.7 Analyze your own work for issues that appear repeatedly, and try to fix them before you snap the shutter in your next shoot.

Take the time to look at your work. When you learn to see the mistakes you are making after the fact, you train your eye to recognize common problems *during* the shoot...giving you the opportunity to make changes. I think this step is something so many photographers forget. You become a better photographer through practice and by identifying mistakes and problems so you can improve in the future.

Please keep in mind that, eventually, these steps will become second nature. With practice, you will know exactly what you can change in order to flow from one pose to the next and create endless variation. You'll have your own rhythm on a shoot, your favorite poses, and your own process that ensures success. For now, use this process to give you a great place to start your journey of mastering endless poses and maintaining your momentum in a portrait session.

MASTERING *Your Craft*

FLOW 1 Flow posing allows subtle adjustments to the pose to blend smoothly from one pose into the next while still achieving a lot of variation in the shot.

FLOW 2

FLOW POSING

Perhaps you've heard the term "flow posing." Flow posing is the ability to make small adjustments to move from one pose to the next without drastic changes. When shooting in a short time frame, flow posing is helpful to maintain the momentum of the shoot and get a lot of variety very quickly through subtle changes. For example, you wouldn't want to try a pose sitting on the floor, then stand the subject up, and then lean the subject against a tree. If you start with a seated pose, there are multiple variations of sitting shots that you can work through. With experience, you will begin to develop your own flow and rhythm in a shoot.

Let's take a look at a very basic example of flow posing. **FLOW 1–13** show different images that feature the same

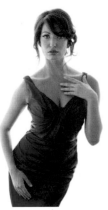

FLOW 3

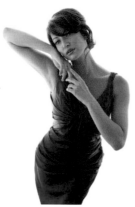

FLOW 4

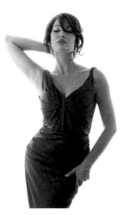

FLOW 5

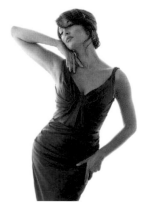

FLOW 6

camera angle. Only my crop and the subject's pose have changed. As you can see, I have not drastically changed the pose, but rather, made small adjustments in hand placement, eye contact, and body angle to move easily from one shot to the next, keeping a smooth flow that still results in variation.

As you can see, I begin with wider shots, with the subject creating a curve straight toward the camera (Flow 1). From there, I work that base pose by first changing her eye contact (Flow 2), and then making adjustments in hand placement (Flow 3–6). Next I rotate the subject to create different angles (Flow 7) with subtle changes to my crop and the subject's expression (Flow 8–13). Notice how each pose in the progression moves smoothly and with very small changes from one pose to the next. ■

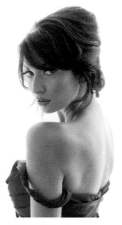

FLOW 13

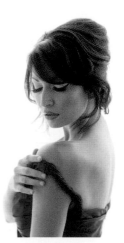

FLOW 12

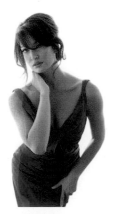

FLOW 7

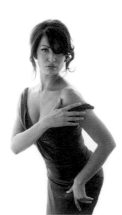

FLOW 8

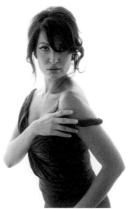

FLOW 9

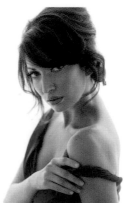

FLOW 10

FLOW 11

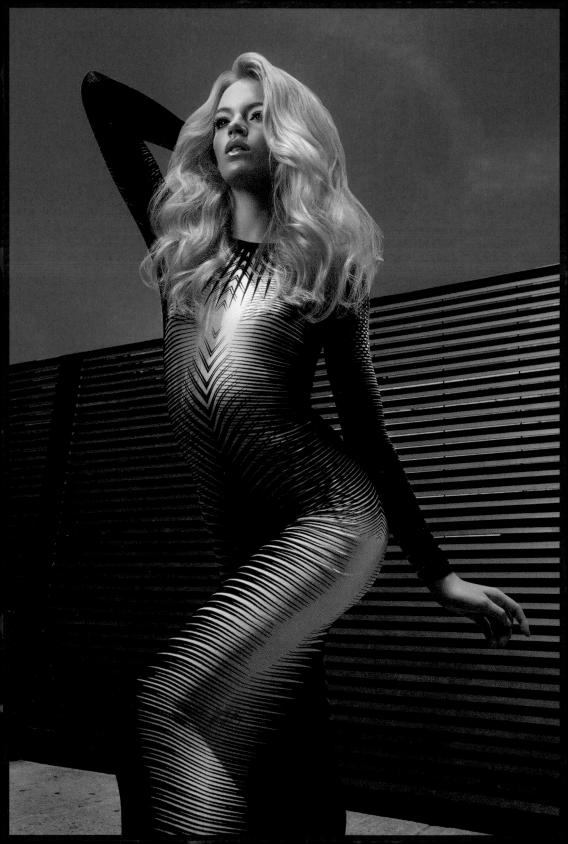

POSING WOMEN

Posing women in a flattering way can be challenging. Women come in various shapes and sizes, and just as no single outfit will flatter everyone, there is no perfect pose that is flattering to all women. You need as many tools in your photographic toolkit as possible to complement the different aspects of each individual.

In this chapter, I will share guidelines for photographing all types of women in various situations, including boudoir sessions, bridal sessions, and senior high school photos. These guidelines are simply a foundation that will bring out the best in your female subjects. Once you master posing, you can add other elements that will help flatter the form and draw attention to a subject's strengths. Lighting, depth of field, clothing, color choice, and much more can give you a great deal of power over the viewer's eye and your subject's appearance.

Guidelines for Posing Women

Let's take a look at some important guidelines to help your female subjects feel comfortable and confident while flattering their forms.

Emphasize Assets, Reduce Weaknesses

You've learned about camera angle, perspective, lens choice, and much more. Now it is time to put your knowledge into practice. Your job in posing is to draw attention *to* your subject's strengths while pulling attention *away from* any weaknesses. Remember that every person has a different body type and different features they want to showcase. I don't necessarily categorize women into different body types (apple, pear, column, and so on) and then apply certain posing rules to these shapes. Instead, I know that each person has a different shape to their form, and I try to create the proportions that they find aesthetically pleasing.

For example, with many female subjects, I lean their chest toward the camera to make the bust appear larger. If a woman has a very large chest and does not want to draw additional attention to this feature, leaning the chest forward would not be appropriate and may actually put her out of proportion. You have to consider this on a person-to-person basis. If your subject's midsection is a bit larger, perhaps leaning the torso toward the camera will make the upper part of the body look proportional to the lower half of the body.

As we've discussed, pose the feature you want to draw attention to *closer* to the camera. This can be achieved with the pose or the camera angle. If you've skipped directly to this chapter, you should go back and read previous chapters to understand this concept more completely. Also, the more you shoot, the more hands-on experience will help you understand how camera angle, lens choice, perspective, and posing work together.

Let's look at some examples, knowing that each person will have different strengths and weaknesses. In **FIGURE 5.1**, my subject is leaning against a wall. This pose is failing on many levels, so let's tackle some of the problems that are obscuring her strengths. This particular subject has beautiful eyes; a nice, slender form; and a long, elegant neck. Unfortunately, in this first shot, everything is working against her.

As you can see, my subject's hair is hiding her jawline and neck, making her head appear almost disconnected from the body. The hair is not only disrupting my eye's flow through the pose, but also concealing her beautiful features. I begin adjusting the pose by moving the hair. As a general rule, be aware of hair that completely separates the head from the body.

In **FIGURE 5.2**, the subject's hair is moved, revealing a beautiful neck and the lines of her body. Unfortunately, several more problems exist. The arm against the wall is hiding the curve of her lower back and creating a merger. You cannot see where the width of her body ends, making her appear thicker than she is and obscuring her beautiful curve. Another issue is a combination of the subject's body position and the camera angle. The subject's face appears distant from the camera, placing the attention more on the midsection and bust. Her beautiful eyes are not drawing much attention, and her head is pulled in, softening her jawline.

To achieve more flattering results, I've made several changes that really draw attention to her strengths (**FIGURE 5.3**). I've repositioned her arm so that I can see the beautiful curve and slender lines of her form. By placing one hand to her face, the viewer's eye is directed upward. I also ask my subject to lean her torso toward the camera and jut her chin out slightly. At the same time, I've raised my camera angle. These actions serve to bring more attention to her eyes. The final image does a lot more to flatter the subject than the first two.

PRO TIP

Clothing makes a tremendous difference to the shape of the human form, and it offers many tools that can help you flatter your subject. You can use clothing color and detail to direct the eye *to* strengths and *away from* weaknesses.

Clothing can also work against you. Oversized clothing will hide curves and obscure the shapes you've created with the pose. If the clothing draws attention to problem areas, posing alone may not be enough to improve the shot. You'll find more resources on this topic at ⎘ **Learnwithlindsay.com**, including tips and tricks for dressing your subjects.

❌ **5.1** The subject's jawline and neck are hidden by her hair. Furthermore, her hair placement makes her head seem disconnected from her body.

✔️ **5.3** Repositioning her arms helps reveal the curve of her back. Also, by having her lean her torso toward the camera, and by shooting from a slightly higher position, I am able to draw more attention to her face and eyes (above).

❌ **5.2** While the placement of her hair has been improved, her arm is hiding the curve of her back and making her look wider. Furthermore, her jaw is pulled in slightly and her head and eyes are distant from the camera (left).

Let's take a look at an example that shows a subject with a different body type. Here, we are going to focus on proportions. In **FIGURE 5.4**, I've chosen a pose and camera angle that create less-than-flattering proportions: the lower part of her body looks significantly larger than the upper part of her body. Let's address what is wrong. First, my subject is standing upright, with her hips slightly toward the camera, making them appear larger. Unfortunately, my low camera angle is also drawing more attention to her midsection. In **FIGURE 5.5**, I raise my camera angle and direct my subject to lean her torso toward the camera while pushing her hips as far away from the camera as possible. Notice the drastic change—the proportions of the body are improved, and there is much more balance throughout the frame.

❌ **5.4** The subject's body appears to be out of proportion because of her pose and my camera angle. The lower segment of her body appears much larger than the upper part of her body, and the eye is drawn to her hips and midsection.

✓ **5.5** In this shot, her form is much more in proportion, and the frame has better balance. I've raised my camera angle and directed my subject to push her weight and hips back while bringing her chest forward.

❌ **5.6** In this shot, we want to emphasize the subject's buttocks, so I use a lower camera angle to bring them closer to the camera. Unfortunately, they do not look as round or full as desired.

✔️ **5.7** By using a wider focal length (58mm), I can emphasize the effects of my pose. Here, I've asked the subject to lean her chest slightly away from the camera, while pushing her bottom toward the camera and arching her lower back to make her buttocks appear fuller.

Remember to draw attention to your subject's strengths. This could be their eyes, their curves, their smile, and so on. In the next example, my subject and I have decided to showcase one of her strengths in a dress—her buttocks. To begin with, I know that a lower camera angle can help bring her buttocks closer to the camera, thus making it appear larger in my frame. I've begun with my camera angle at around waist level, just barely above her bottom. In **FIGURE 5.6**, however, her bottom seems to be a bit flat and not as large as we'd like. I've got the camera angle right, now what about the pose?

For **FIGURE 5.7**, I've asked my subject to lean her chest away from the camera while arching her lower back and pushing her buttocks closer to the

camera. I've selected a wider focal length (58mm). Why? This lens choice will exaggerate perspective, and pushing her bottom toward the camera will make it appear larger than if I use a longer lens. In this shot, the bottom looks full and curvy. Notice that the arms have been placed so as not to hide these curves. I've used all my tools—camera angle, lens choice, pose—to draw attention where I want it to go in the frame.

While successful poses will vary from person to person, this example flatters *most* subjects who step in front of my lens. The idea is to push the hips and waist away from the camera, while bringing the chest and face toward the camera, all while emphasizing the waist and creating a narrowing point.

In **FIGURE 5.8**, my subject faces the camera. The hips appear broad, and there isn't much flow or curve through her form. Also, the viewer's eye is not drawn to the face. In **FIGURE 5.9**, the subject looks curvier and more slender, and the eye is directed to the torso and face.

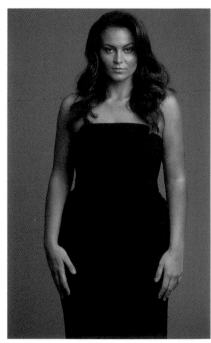

 5.8

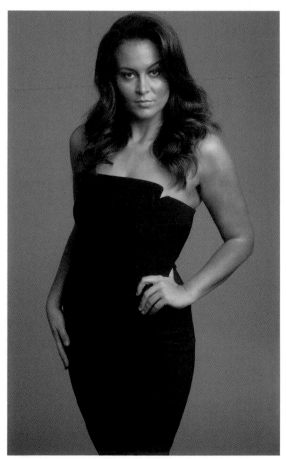

✅ 5.9

Let's take a step-by-step look at the process:

STEP 1 (**FIGURE 5.10**): Have your subject face the camera. Her hips will be square toward the camera, making her appear wide—this is not the most flattering angle; it's merely a place to begin.

STEP 2 (**FIGURE 5.11**): Direct your subject to step one foot behind the other, and point the back foot to the side. This narrows the hips by turning them slightly away from the camera. I recommend mirroring and demonstrating the foot position to your subject so that they understand the pose. By turning your subject to the side, you not only narrow the hips, you also reveal the curve of the lower back, which adds definition to the waist. This also creates a narrowing point toward the bottom of the body that makes the subject look more slender.

STEP 3 (**FIGURE 5.12**): Ask your subject to shift their weight onto their back foot and away from the camera. This defines the waist and makes the hips appear smaller since they are farther from the camera. Typically, I demonstrate this direction by bouncing my weight from my front leg to the back leg so that my subject can see the difference. The farther back the foot is, the more exaggerated the effect will be. If your subject is very slender, they don't need the hips and waist to be as far away from the camera.

STEP 4 (**FIGURE 5.13**): Have the subject lean their torso toward the camera. This further defines the waist; makes the chest, eyes, and face look bigger; and is flattering to the form. If a woman has a large bust, do not lean her as far toward the camera. Be careful not to forget to direct your subject to angle their chin out and down to maintain a defined jawline in the final pose.

Once your subject is in the right position, you can decide what to do with the hands to best flatter her. A hand to the waist may help define the waistline. A hand to the face may draw the eyes upward. An arm rolled back (contouring the form) may help to emphasize the curve of the body. There are many options and many ways to tweak this pose to flatter an individual—this is an excellent place to start.

5.10

5.11

5.12

5.13

Bend and Curve!

If it bends, bend it. If it curves, curve it. Straight lines create stagnant results. Elegant, timeless poses for women often employ a lot of bend, curve, and arch.

- Bend the wrist

- Arch the lower back

- Bend the elbow

- Curve the hip out

- Bend the knee over

Let's take a look at images from three different shoots: a portrait of a ballerina, a boudoir session, and a fashion shoot. Give your eye a moment to explore each frame. What do you see? Notice how your eye moves freely and smoothly around the pose. Each one of this shots utilizes bend, curve, and arch for the wrists, knees, and elbows. There are no straight lines or right angles, which disrupt curve and flow.

In **FIGURE 5.14**, the legs, wrists, and elbows have been bent to create a beautiful flow throughout the image. The eye can move and explore the form of the ballerina.

In **FIGURE 5.15**, bends and curves have been pushed to an extreme to accentuate the luscious shape of our boudoir subject. The knee is bent, the hip curves out, and the arms have been placed so that the eye will explore the shot from top to bottom.

In **FIGURE 5.16**, the bend to the wrists creates elegance and interest. As your eye follows the body from the face to the arms and hands, and down the legs, the pose creates pleasing visual lines in a continuous "S" shape.

PRO TIP

Wrists A bend to the wrist creates elegant lines and engaging poses. Look back at paintings from the Renaissance or those of Dutch Masters and see how carefully the hands and wrists have been posed. They are never an afterthought!

✔ **5.14** This shot has been retouched.

✅ **5.15** This shot has been retouched.

✅ **5.16** This shot has been retouched.

In **FIGURE 5.17**, my subject stands with no bends or curves. Her arms, knees, and lower back are totally straight. For this reason, our eye enters the frame on her face and exits in a straight line downward, with no curves or lines to hold the eye's interest. Furthermore, the natural curve of her bust is hidden by the placement of her arm.

Let's make a change. I ask my subject to bend her elbows to create interesting lines (**FIGURE 5.18**). Notice that the far elbow is bent enough to accentuate the negative space between the elbow and the lower back,

drawing attention to that curve. I ask her to roll her front shoulder forward slightly, pulling the elbow back, and keeping the hand gently on the thigh. The eye can now follow the beautiful, sloping line from her face, shoulder, and elbow to the hand. Furthermore, the front arm has been carefully placed to reveal curves—the eye has a beautiful curve to follow through the frame.

Remember: bending parts of the body haphazardly will not always improve the shot. You must pose carefully. In **FIGURE 5.19**, the bent elbow obscures the curve of the lower back and doesn't actually add any appealing curve to the form.

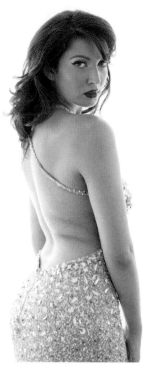

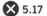 5.17

 5.18

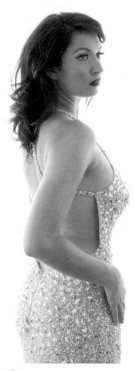

5.19

MASTERING *Your Craft*

WATCH FOR THE ARMPITS

There are times when you will want to bend an arm upward, but be careful that your subject's armpit is not being showcased in your image. If the viewer's eye is drawn to the armpit, you probably need to consider adjusting the pose, styling, or angle. For the most part, armpits are not very attractive and will distract from the purpose of the image. My personal pet peeve is the "smelling the armpit" pose, which has a subject's arm up with their chin turned into that arm (**FIGURE 5.20**). If you really want a shot with the arm raised high, obscure the armpit with long hair, turn the arm a bit more away from the camera, or use clothing that covers the skin. ■

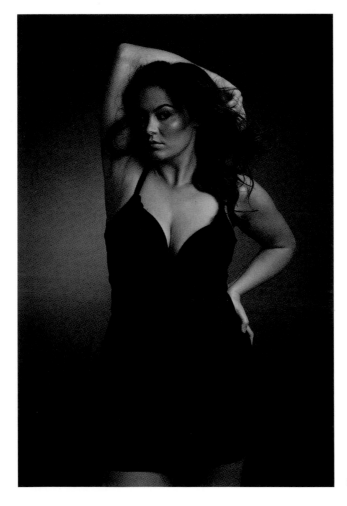

❌ 5.20

As noted, when photographing women, you should usually avoid straight lines, as they lack interest and prevent flow. You should also be cautious of too many right angles if you are trying to create a softer look. Try gentle angles instead.

In **FIGURE 5.21**, the subject's legs are bent at a 90-degree angle and both arms are straight. The pose is far too rigid. Her legs are symmetrical and at right angles, and her torso is at a right angle to her thighs. Thus, the path of the eye makes abrupt turns rather than flowing gently within the pose. Let's make some adjustments to help the eye flow better.

First, you can create asymmetry in the feet by bending one knee more (**FIGURE 5.22**) to break up the distracting right angle. Also, bending the arms helps create more interest in the frame. The arm on the waist is almost a 90-degree angle. Want to soften the pose? Place that hand on the thigh, opening up the angle for softer flow (**FIGURE 5.23**).

❌ 5.21

✔ 5.22

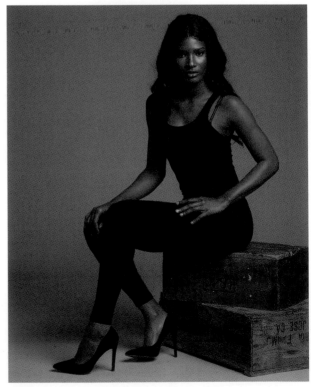

✔ 5.23

MASTERING *Your Craft*

SILHOUETTE

Another way to think about what shapes are flattering to the female form is to picture the body in silhouette. If I imagine the form in silhouette and it looks like a black blob with lots of mergers, it probably looks like a blob to my camera, too. If the body looks like a column (very boxy with no curves) in silhouette (**FIGURE 5.24**), it will probably look that way in the shot. This exercise will train you to visualize more interesting lines for the eye to follow in the shot (**FIGURE 5.25**). Do you need to add negative space to flatter the form? Do you need to introduce more curves and feminine lines? This may also be useful when considering proportion. When you think of the subject in silhouette, you can see which parts of the photograph are drawing more visual weight or occupying the most space in the frame.

Note: This technique won't work in every instance. Subtle, in-body poses won't translate in silhouette, but they still make beautiful images. ■

❌ 5.24

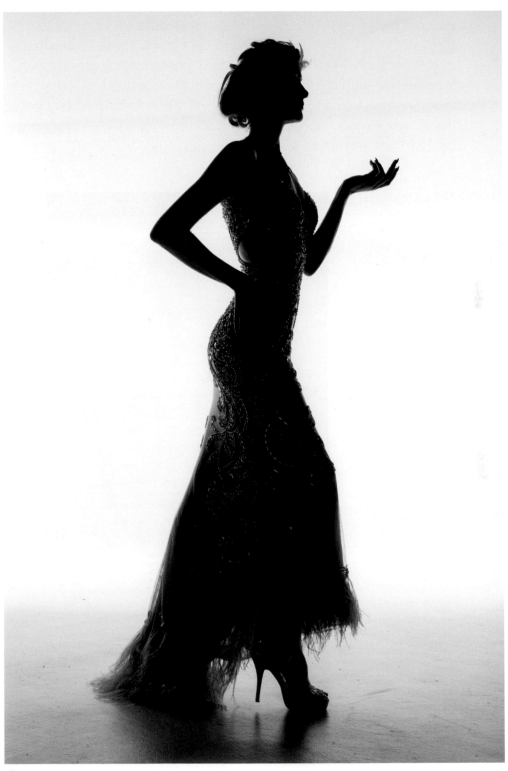

✔ 5.25

Bending, curving, and arching are applicable to all feminine subjects, whether the shoot is maternity or boudoir. **FIGURES 5.26** and **5.27** both feature bent knees, an arched back, and bent arms. These key elements flatter female subjects. I use some of the same poses for fine art nudes as I do for maternity and boudoir. Read Chapter 10, "Boudoir," to learn more about how posing affects the human form, even if you never plan on photographing women in lingerie. These techniques are applicable to everything from bridal to fashion.

PRO TIP

Posing for Age and Tone of the Image While these posing tips apply to all sorts of images of women, be aware that some particular poses are not appropriate for all ages, subjects, or tone. For example, you might pose a teenager on her stomach with her feet kicked in the air. This same shot may not appear appropriate for a more mature woman. Similarly, an extreme curve that may be appropriate for boudoir will likely not be appropriate for a girl in her early teens. The overall concepts remain true, but you'll need to modify each pose to fit the tone of the image.

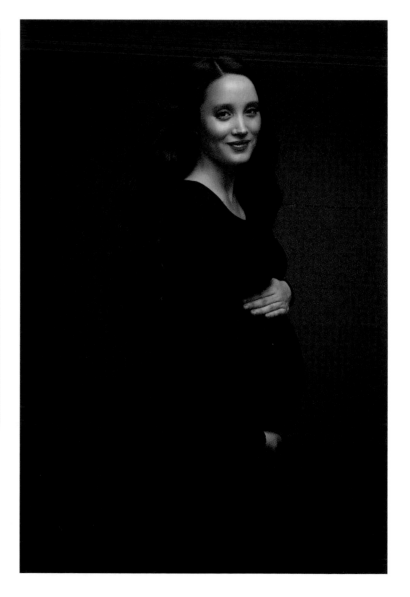

✔ **5.26** Here, the bend, curves, and arches accentuate the curve of her baby bump. Note: This photo has been retouched.

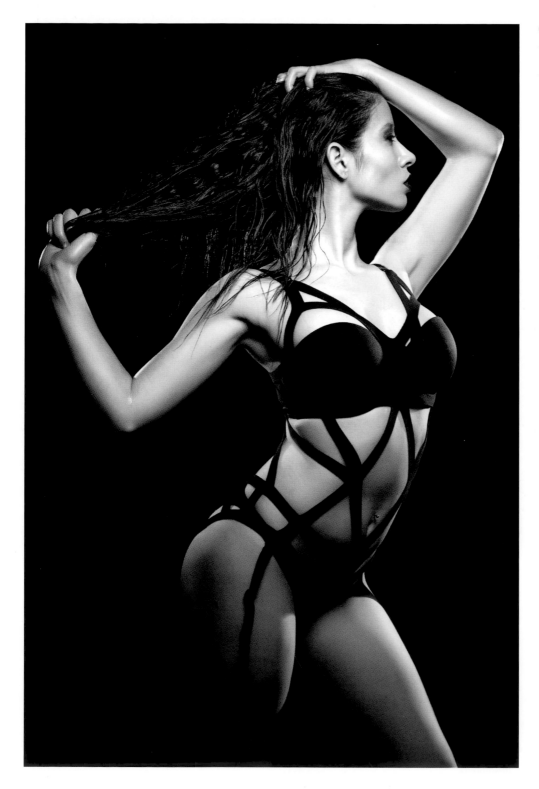

5.27 The most appealing boudoir images bend, curve, and arch throughout. Note: This photo has been retouched.

Create Interest with Asymmetry and Levels

Symmetry conveys strength and stability, and it is a tool that a subject can use to command their space (**FIGURE 5.28**). However, for most portraits, symmetry comes across as static, overly posed, or boring. Too much symmetry tends to trap the eye, giving it nowhere to flow throughout the pose.

Asymmetry, by contrast, creates interest and movement in your frame. It gives the eye diverse elements to explore. For a female subject, it is usually desirable to include beautiful lines and curves for the eye to follow. Even the most subtle elements of asymmetry can create interest, and the more asymmetrical it is, the more dramatic the pose becomes.

5.28 This image has been retouched.

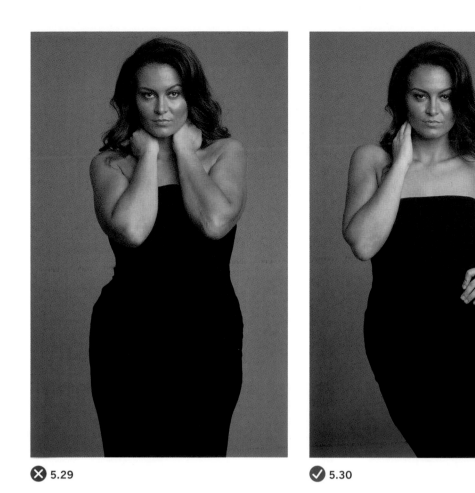

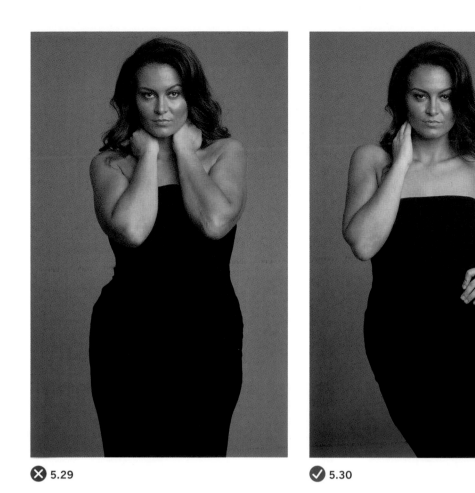 ❌ 5.29 ✔ 5.30

FIGURE 5.29 is a perfect example. I've seen this pose a million times, but it never seems to work. With both arms raised to the neck, the pose is too boxy, and it divides the subject in two. My eye either gets trapped on her midsection or stuck between her elbows. There is no flow; instead, there are two opposing segments of the body. I need a bridge to connect the eye to other parts of the frame or give me something to explore.

Introduce asymmetry to break up the monotony and allow the eye to escape. The easy solution in this instance is to lower the hand to the waist (**FIGURE 5.30**). My eye is instantly liberated from the two blocks of her body and can move freely throughout the form. Is the result the world's best pose? No, but it is a vastly improved starting point.

❌ 5.31

Here's an interesting way to think about asymmetry: if there are two of the same features on the body—hands, hips, shoulders, or feet, for example—consider placing them at different levels to create more dynamic poses. Varying the levels creates visual flow for your eye to follow throughout the frame. You could also shift the weight so the hips are not completely square and even bend a knee inward so the feet aren't even.

In **FIGURE 5.31**, my subject has placed both hands on her hips. Everything is symmetrical, from matching hand placement to even shoulders and level hips. The results are very static, boxy, and uninteresting. Our eye is boxed in the square shape on her torso.

Let's make a change to improve this. In **FIGURE 5.32**, I place one hand on her thigh and the other on her waist. Even with this basic change, the shot becomes more pleasing. The flow

✅ 5.32

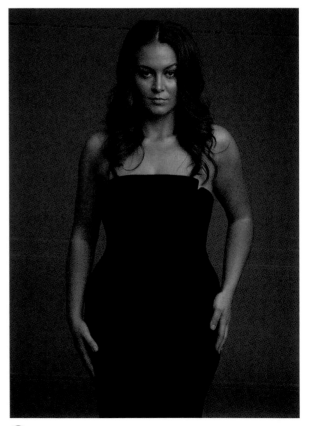

✅ 5.33

of the shot is more elegant and interesting. I could make this more dramatic by placing one hand to the face and the other to the thigh, or introduce asymmetry in other elements of her body. Notice, however, that even a subtle change can make a difference. In **FIGURE 5.33**, I've introduced the most subtle asymmetry possible, by having one hand slightly higher than the other; yet even this minute change creates more pleasing results.

In **FIGURE 5.34**, the subject is seated and turned to the side, but most of her features are symmetrical or at the same level. Her feet, knees, hands, and shoulders are even. In **FIGURE 5.35**, I've varied the feet and knees, lowered one shoulder, and put the hands on drastically different levels. The result? A much more interesting shot.

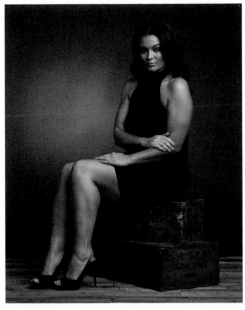

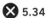 5.34

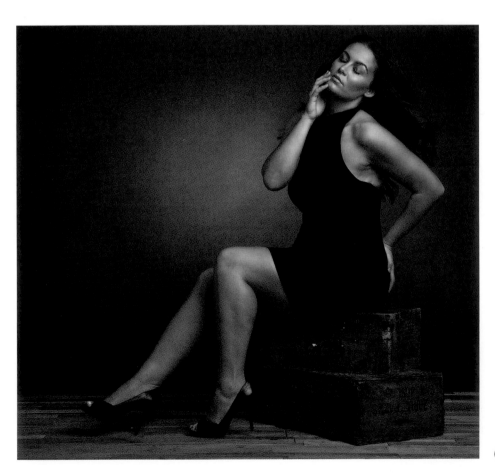

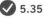 5.35

Pose Your Subject to Create Mood and Drama

A dramatic or exaggerated pose is often not appropriate in a portrait. What is the image about? What is the mood of your shoot, and how can this be reflected in the pose? In this book we address posing as a standalone concept, but it is all part of the interwoven fabric of a successful shoot.

There are photographs in which you want a pose to be subtle and understated. This may be appropriate for a romantic and ethereal portrait of a woman in a tulle dress cloaked in glowing light. But there are instances in which you want your subject to exude power and drama—perhaps in a bright red dress with dramatic lighting. The poses you choose are part of a greater vision for your image.

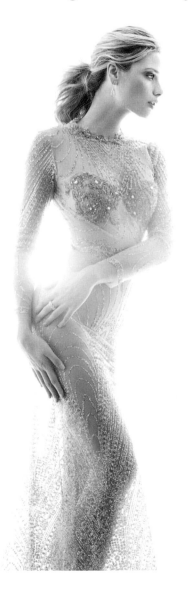

To create softer results, you'll typically want to opt for gentler lines and bends over right angles and straight lines. Instead of having both hands firmly on the hips, creating right angles with the elbows, maybe place one hand on the thigh and one across the stomach. For **FIGURE 5.36**, I want to create elegant lines. For an even more demure look, I could try both arms around each other, as if the subject is holding herself in a self-hug. The options are endless.

An hour later, I shoot **FIGURE 5.37**. This frame of the same subject has an entirely different mood. I use right angles and dramatic placement of the legs and hands. Neither pose is right or wrong; each simply reflects different goals. As you develop your own photographic style, you'll also develop a posing style. It may be natural and candid or over-the-top and dynamic; it all depends on the types of images you seek to create. If you decide to use dramatic poses in your work, asymmetry and level are powerful tools to achieve that goal.

5.36 This image has been retouched.

5.37 This image has been retouched.

Let's assume you *want* to create drama through posing. One way to do that is to use more extreme levels in the pose. As mentioned, when there are two of them (hands, hips, feet, shoulders), the more drastically different their levels are, the more dramatic the results. In a boudoir shot, when one hip is much higher than the other, one hand above the head and the other on the thigh, the results create more of a theatrical and exaggerated feel.

Take a look at how to apply this concept to create progressively more dramatic results. We begin with our subject in a less dramatic pose (**FIGURE 5.38**). Her feet, hands, and shoulders are at roughly even levels, and one hip is subtly raised. Because her arms are creating right angles, she appears strong.

To create a bit more drama in the pose, let's vary some levels. In **FIGURE 5.39**, I have the subject step one foot out to the side, raising one hip, and exaggerating asymmetry to create more drama. Because the right foot is not a natural pose, it introduces a bit of fantasy into the shot for a

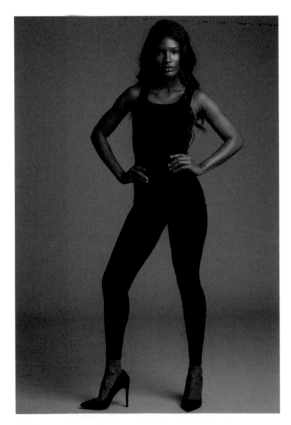

5.38

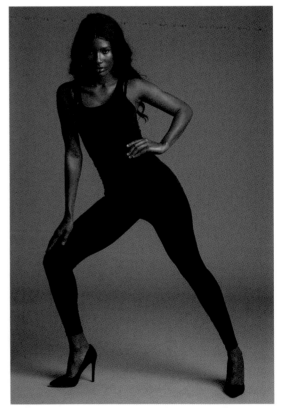

5.39

more striking body position. Furthermore, by having her place her hands at different levels—one on the knee and one on the waist—we are introducing more drama.

Now it's time to exaggerate this effect even more, this time by raising one foot (**FIGURE 5.40**). By elevating this foot on an apple box, we've exaggerated the pose and introduced more dramatic levels. For this example, the near-right angles of the knee and elbow exude strength and stability, while the asymmetry of features creates visual interest. Now the feet, hips, shoulders, and hands are all at different levels.

Finally, let's vary the levels one more time. This time, the subject is raising one arm even higher, above the head, in order to create a more theatrical pose (**FIGURE 5.41**). Is this pose practical for a portrait? Not necessarily. And you probably won't use this pose unless you're trying to achieve a more theatrical shot. This final body position is anything but subtle, but in this case, that is exactly what I'm trying to achieve!

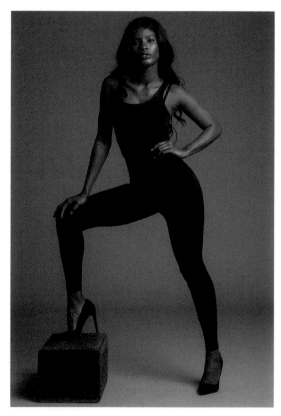

5.40

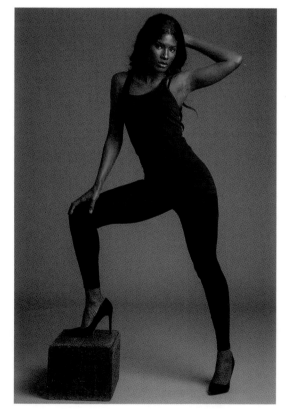

5.41

Be Wary of Photographing Legs Parted Wide

In my years of photography, I've seen this pose, with the legs spread wide, used over and over again, especially when trying to convey a bit of attitude for a subject. Earlier in my photographic career, I attempted this pose when trying to be edgy. My advice is to be very cautious of a pose with the subject's legs parted wide toward the camera. Leg placement and other lines in the shot draw your eye to one place—and this is probably *not* where the eye should be focusing in the image. This would certainly not be a go-to pose that I'd recommend for many subjects. In fact, I'd typically avoid it.

In **FIGURE 5.42**, not only is my eye drawn away from the subject's face, but the pose is also far too symmetrical and static. There is no bend to her arms, no curve in her form, and no attention to her strengths. Nothing seems to be working. To remedy this problem, I decide a complete change of pose is necessary (**FIGURE 5.43**). I turn my subject to the side, cross her legs, and gently drape her arms over one another. I try a higher camera angle to bring more attention to her face. The results are softer and more flattering as a portrait.

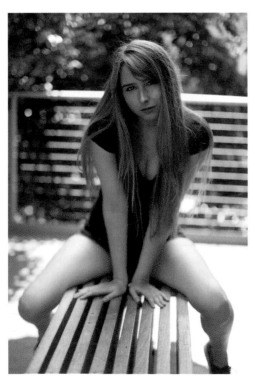 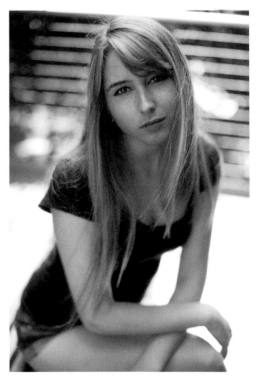

 5.42 ✅ 5.43

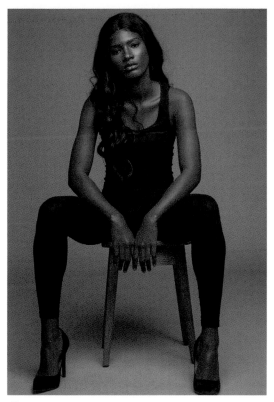

 5.44

✓ 5.45

Let's say, however, that I really do want to attempt the shot of my subject with more attitude, straight toward the camera, legs positioned a bit wider. This can work if directed carefully. In **FIGURE 5.44**, the position of the body creates very boxy results, and my eye is drawn between the legs. The pose causes the eye to feel trapped. To bring life and interest to the shot, I introduce asymmetry by asking the subject not only to lean to the side, but also to vary the level of her hands and shoulders (**FIGURE 5.45**). Give your eye a moment to dance around the pose. Your attention is held longer and the eye moves more freely.

Avoid Flat, Even Feet

Flat, even feet will create problems in your pose. In fact, many experienced photographers pose from the feet up. Why? Starting with the feet helps to build the foundation of a more flattering pose even if you are not including the feet in the shot. Foot placement can help to create a stable base, narrow the hips, and create curve.

When a subject stands flat-footed, typically the hips will be square to the camera (**FIGURE 5.46**). Ask your subject to turn a foot out, point a toe, or slide a knee in to avoid appearing flat-footed. They may lean out with their weight on one hip, pushing it to the side. They can stick out their hip while crossing a knee over. They can even push their weight onto the back leg, thus reducing the apparent size of the hips and waist. When the weight is even on both feet and both hips, the hips appear wider, making it difficult to introduce curve to the form.

A benefit of avoiding flat feet is being able to control how your subject distributes their weight. Let's adjust the pose to improve the results. I ask my subject to tuck one knee in, which lifts that foot slightly (**FIGURE 5.47**). Then I ask her to shift all of her weight to the opposite leg (the engaged leg). This results in a much more interesting pose that suddenly creates many curves for the eye to follow. The subject could also turn one foot out, placing their weight on the opposite hip (**FIGURE 5.48**). Notice how this particular pose commands the space a bit more because she literally occupies more of the frame.

You may have heard of the "S" curve when referring to women's poses. This can be achieved in several ways, but the most common is through exaggerated *contrapposto* (which means "counterpose" in Italian), a posing technique used in the world's most famous statues, including the *Venus de Milo*. The subject's center of gravity is shifted to one side, resulting in a supple "S" shape.

✅ 5.47

✅ 5.48

When a subject stands flat-footed, their gravity is centered. Their feet are even, and the hips and shoulder line up (**FIGURE 5.49**). To create contrapposto, a subject stands with most of the weight on one leg—the engaged leg—typically popping that hip out a bit. When doing so, the other knee bends inward (this can be exaggerated for a more feminine pose and narrowing point). You will also notice that the foot rises slightly (**FIGURE 5.50**). To achieve true contrapposto, the subject must also lean their shoulders toward the hip that has been raised. The higher the hip and the lower the shoulders, the more exaggerated and sinuous the curve. You can see how drastic the effect can be simply by shifting the weight and avoiding even feet. **FIGURE 5.51** demonstrates the famous "S" curve.

❌ 5.49

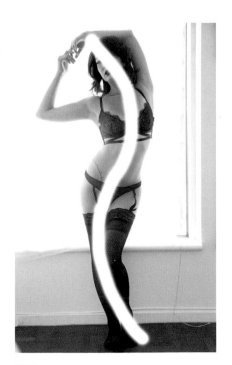

5.51

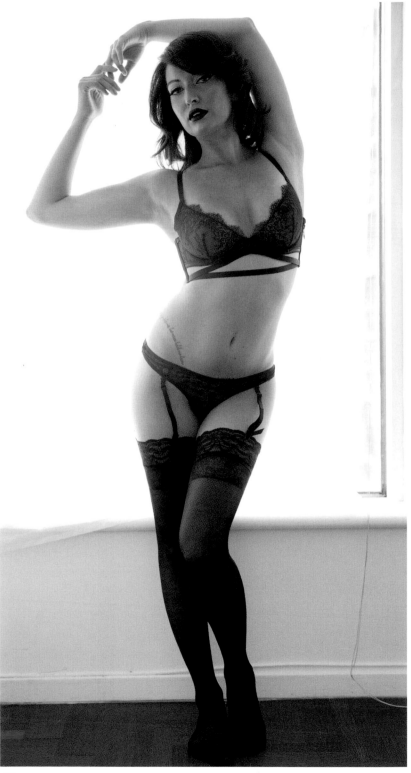

✅ 5.50

Use Narrowing Points to Create Curves and an Hourglass Shape

Learning to create narrowing points completely changed the way I direct and photograph women. I've learned to use this illusion to help my subjects look curvier and narrower and to give the impression of an hourglass shape. Even small changes can transform the way your subject looks. Typically, I create narrowing points at the subject's knees to emphasize the beautiful curves of the buttocks and thighs, and to slenderize the waist.

In **FIGURE 5.52**, my subject is posed with hips broad to the camera and one knee kicked open to the side. When you study the shape of her body, it appears wide and the eye gets trapped in her midsection. Her body appears to be a column or rectangle without much of the hourglass form.

Now I'm going to introduce curve to her form (**FIGURE 5.53**). Notice what happens when I ask her to take the knee that is currently pointed outward and bring it inward, across the other knee. Her form now appears narrower where her knees meet; suddenly, an hourglass figure emerges. The eye now follows pleasing, curvy lines. I haven't changed the camera angle, clothing, or lens choice. I've simply asked my subject to move her knee in, which makes all the difference.

> **CAUTION** You do not need to use narrowing points in every shot, only when trying to bring more curve to a subject's form.

✖ 5.52

✔ 5.53

Cropping

The concept of narrowing points is quite powerful when paired with cropping. When the subject stands flat-footed and square to the camera without a narrowing point, her form has a rectangular shape (**FIGURE 5.54**). It is very important to note the bottom of the frame. Our eyes follow the line of the hips straight down and out of the frame, making her appear wider and without curve.

Using the same crop in **FIGURE 5.55**, I've created a narrowing point by bringing a knee over. Not only does the bottom part of her body look much narrower, but it also has a curvy, rather than boxy, appearance. The results are much more feminine and appealing. Because we have cropped the bottom of the frame where the subject becomes narrower, our brains read the subject as more slender.

Let's pull back on the frame for a moment, just to see what is happening below our crop. In **FIGURE 5.56**, the subject is standing flat-footed to the camera. We can create the narrowing point in two ways, depending on what is most comfortable for your subject. You can bend one knee over the other, such as in **FIGURE 5.57**. Using this pose creates a narrowing point that you can see clearly at the bottom of the cropped frame (**FIGURE 5.58**). Notice the triangle shape the body forms between the hips and the knees (**FIGURE 5.59**). Another option is crossing the legs (**FIGURE 5.60**). Personally, I find this a little less appealing for the hips and less desirable for full-length shots.

❌ 5.54

❌ 5.55

❌ 5.56

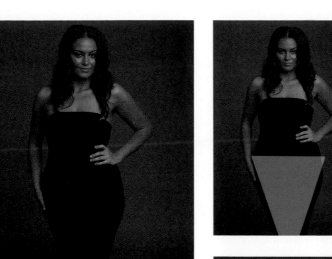
5.59

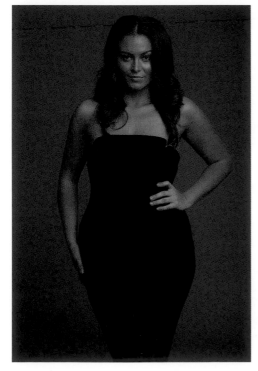
 5.57

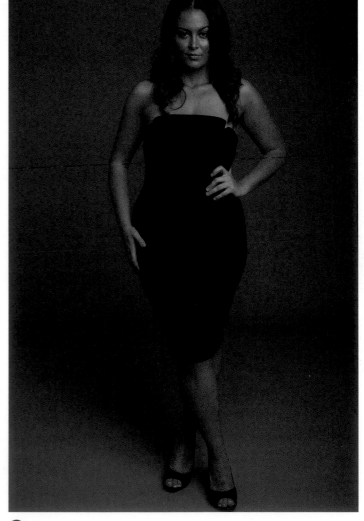
5.58

✓ 5.60

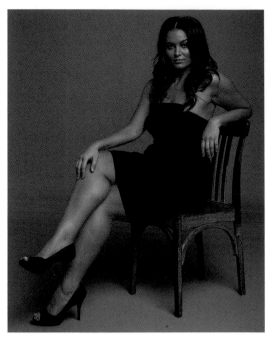

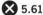 5.61

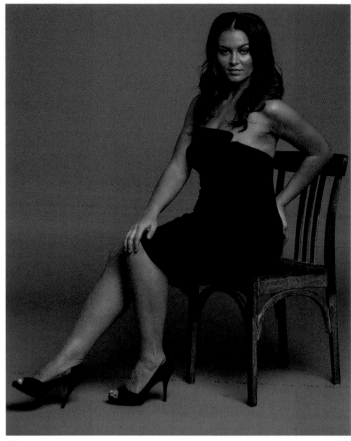

✓ 5.62

Up to this point, I've talked about narrowing points particularly for subjects who are standing, but it's also applicable in some sitting poses. I find that if my subject stacks one leg on top of the other while sitting, the results can be unflattering. In **FIGURE 5.61**, the subject looks beautiful, but crossing her legs makes her thighs look thicker. When she uncrosses her legs and the knees meet at a narrowing point, her legs look a bit more slender and the overall form of the pose improves (**FIGURE 5.62**).

Narrowing points are not essential for every shot, but if you are looking to create more pleasing curves, an hourglass shape, or a slenderizing effect, this technique may be the tool you've been looking for.

A Go-To Pose

Before wrapping up this section, let's take a look at how these concepts apply to one of my favorite poses for a woman in a dress. You can see the "before" pose in **FIGURE 5.63**, and the adjustments made to achieve a flattering body position in **FIGURE 5.64**. The subject crosses one knee far over the other, creating a dramatic narrowing point. Notice how this emphasizes the curve of the dress, which then continues out of the frame. I've applied many of this chapter's lessons to create the most flattering results possible: I've shifted the weight to avoid flat feet and create the narrowing point; I've bent the arms to create visual interest that pulls the eye through the pose; and I've used asymmetrical hand placement. Finally, I've leaned the subject's chest closer to the camera to define the waist and make the chest look fuller.

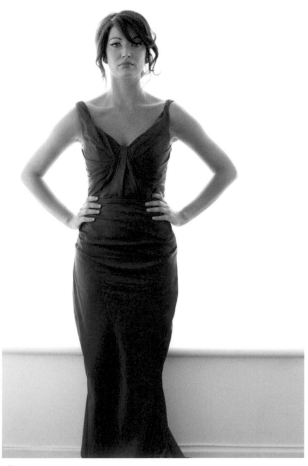

❌ 5.63

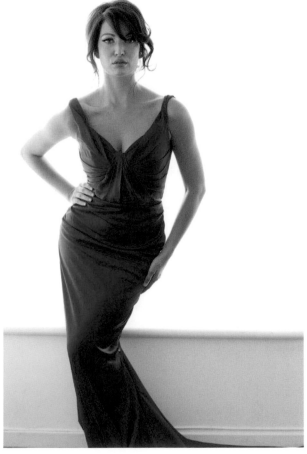

✓ 5.64

Movement

Adding movement to an image helps to transform your portrait from a still frame to an energetic moment in time that you have captured. I try to add movement as often as I can for full-length shots so that the results are not so static. Nevertheless, adding movement gets complicated. I've often found that when a subject moves with spontaneity, many of the more flattering elements of posing start to fall apart. I tend to carefully direct movement instead of just having my subject twirl or dance around. Here are a few tips for introducing movement into a pose while still maintaining control.

Bounce Step

If I want the subject to look as though they are in mid-step, I invite them to bounce back and forth from one foot to the other, over and over again **FIGURE 5.65**. I do not have them walk across the frame or toward the camera. When they walk across the frame, I find it much harder to capture the ideal movement or focus. Furthermore, it is extremely difficult to make subtle tweaks to hand position, body position, or expression while the subject is walking. The bounce from one foot to the other allows me to capture movement in the clothing, feet, and hair, but I still have the control to make slight changes in each bounce. I'm likely to say, "Great, now bounce again, but this time lean your chest slightly forward. Looking beautiful, but this time I want you to relax your back hand a bit more and give me a laugh." It is much easier to reset and try again.

Falling Through the Step

When I want a more dramatic step, like a knee lifted up or something more theatrical, I use the fall-through step (**FIGURE 5.66**). I invite the subject to lift their leg and slowly fall through the step. This way I have several opportunities throughout the pose to capture a moment since it is slowed down and exaggerated. Again, for each step I can make subtle changes. If you try this, be sure to have the subject avoid leading with their stomach or pushing their hips out. Instead, ask your subject to pull up through the top of the head, elongating the body and neck, and lead with the chest for the most flattering results.

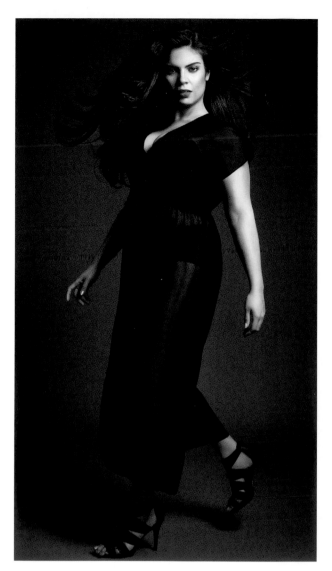

5.65

5.66

The Windup

When you have your subject twirl around freely, the results can be disas-trous. They can get dizzy, knock over a light, step out of light, or make it nearly impossible to capture a frame in which their body and expres-sion look good. Trust me, I've tried it. Instead, I have my subjects wind up (**FIGURE 5.67**). I start by posing them facing the right direction. I pose roughly where I want the hands, face, and body to be located, and then ask

them to wind up. They keep their feet in the same position, twist their body around, and then snap back into place. This is when I capture the shot. I get movement, and some spontaneity, but maintain control.

The Fan

One great way to add movement to a shot is to introduce a fan for blowing the hair (**FIGURE 5.68**). This can inject more life into your scene, and there is no need to get an expensive tool. In my studio, I use a variable-power floor dryer that is available at any home improvement store. On location, I use a mini leaf blower that works wonders.

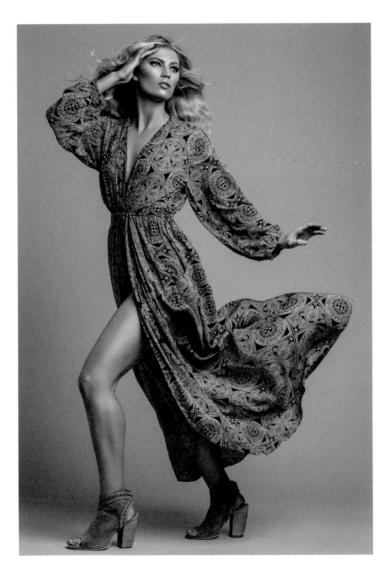

5.67

5.68

Let's see how you did. Compare **FIGURE 5.70** with the solutions in place in
FIGURE 5.71.

✖ *Problems*

Body Position: Her hips are pushed far toward the camera as she leans
back on the railing, making her midsection look wider.

Symmetry: Both legs are side by side, as are both elbows on the railing,
creating a static pose.

Legs: The legs are side by side, making the body appear very square and
without curve.

Foreshortening: The hand and forearm closest to the camera are protruding
toward the camera, making them appear shortened.

FORESHORTENING
OF ARMS

LEGS SQUARED
TO CAMERA

HIPS PUSHED
TOWARD CAMERA

✖ **5.70** Problems

5.71 Solutions

✅ *Solutions*

Body Position: She pushes her hips and waist away from the camera, making her midsection appear more correctly proportioned. Also, leaning her torso toward the camera draws more attention to her face.

Symmetry: She has lowered her right hand to hook into the pockets, giving more variety and interest to the frame.

Legs: When pushing her weight back, she has also created a narrowing point with her legs, creating the illusion of a curvier form.

Foreshortening: By turning the arm in toward her body, she has corrected issues of foreshortening.

✅ **5.72** Solutions

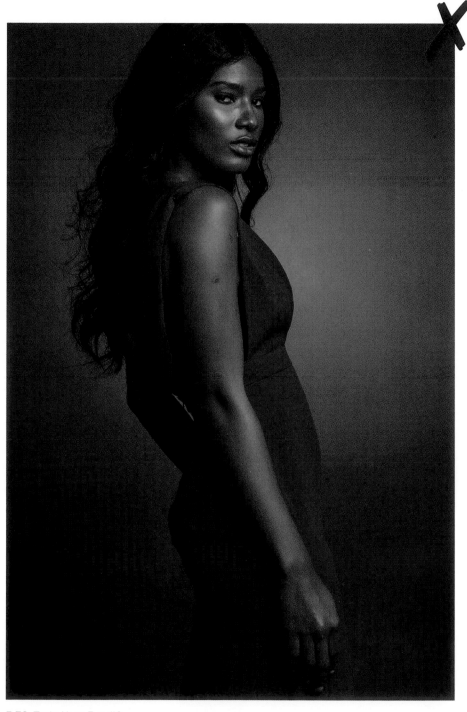

TRAIN YOUR EYE #2

Study **FIGURE 5.73** and see if you can identify the problems in the image.

5.73 Train Your Eye #2

Let's see how you did. Compare **FIGURE 5.74** with the solutions in place in **FIGURE 5.75**.

❌ *Problems*

Bend: The subject's arms and legs are straight and create no visible interest.

Curves: The subject's back is obscured by arm placement.

Symmetry: Both arms and legs are approximately even on either side, creating a pose that lacks flow.

Angle: The camera angle does not work with the pose because the arm and midsection are closest to the camera.

✅ *Solutions*

Bend: The subject adds a more defined bend to the far arm, emphasizing the curve of the back by revealing negative space. She also bends her front knee, creating more defined curves.

Curves: As she leans forward and arches her lower back, the curve of the back becomes more defined.

Symmetry: Asymmetry creates visible interest. One arm is bent, the other mostly straight. One knee is also raised while the other is straight.

Angle: The camera angle emphasizes the curve of her buttocks and lower back, creating beautiful curves even with our slender subject.

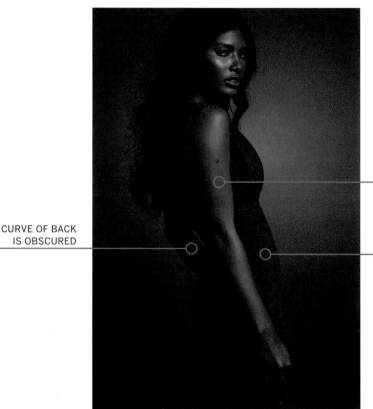

STRAIGHT ARMS LACK VISUAL INTEREST

CURVE OF BACK IS OBSCURED

CAMERA ANGLE EMPHASIZES ARM AND MIDSECTION

❌ **5.74** Problems

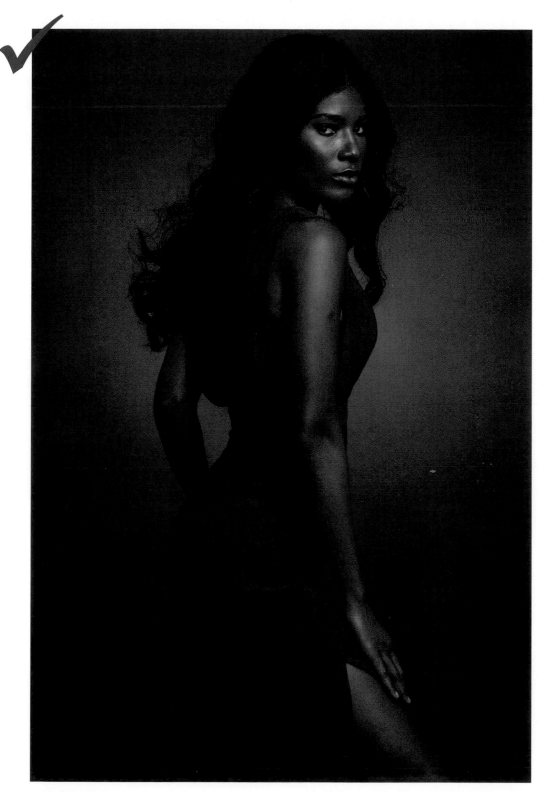

5.75 Solutions

5 GO-TO POSES

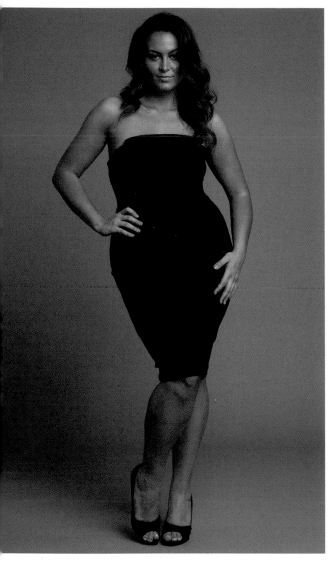

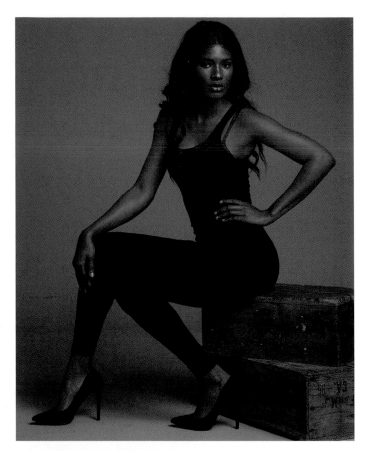

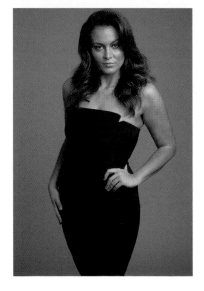

POSE 1 One knee is tucked across the other, creating a narrowing point and a slightly raised heel. One hand is on the waist, and the other is on the thigh (above).

POSE 2 One foot is back, with the subject's weight pushed to the back foot. The chest is leaning forward. One hand is on the waist, and the other is contoured to the body (right).

POSE 3 Our subject is seated with one foot flat and one leg bent back at an opposing angle. One hand is on her knee, and the other is on her waist (above).

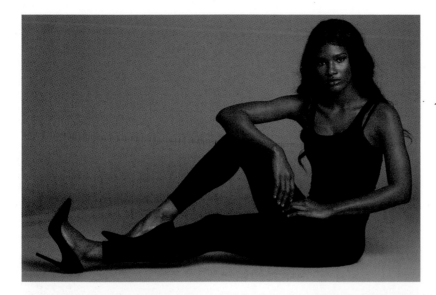

POSE 4 Our subject is seated with one leg out, her back knee up, and her back elbow resting on the knee. Her front hand is resting on her thigh (left).

POSE 5 The subject reclines on her side with the top knee bent over to the ground. Both arms meet in front of the body, with her hands gently placed on top of one another (bottom).

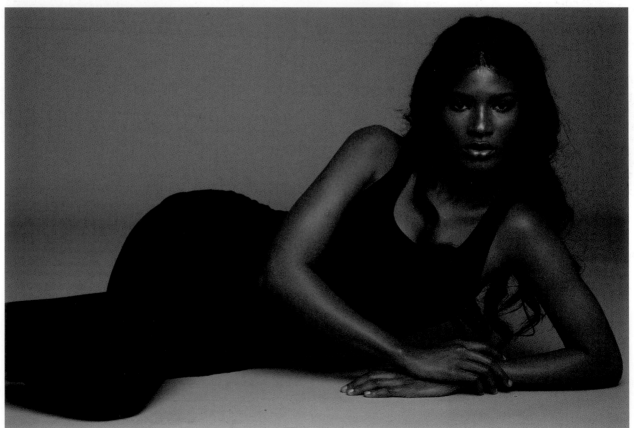

CHAPTER 6

POSING MEN

Why do people always forget about the gentleman? Although men don't always like to be posed, it doesn't mean they don't need to be posed. Men like to look comfortable, cool, and confident—and posing is one way to communicate this.

Far too often, men's posing is treated as an afterthought. Many photographers are intimidated to do more than ask a man to "stand there and look comfortable," fearing he may look too posed. Unfortunately, that's not doing much to help your subject shine or to create an engaging portrait.

Give your male subject direction. Build solid structured poses, use anchors for comfort, and exude confidence when doing so; this helps to create the types of images your clients desire. Let's take a look at what we can do to achieve our goals.

Guidelines for Posing Men

These important guidelines to help your gentleman subjects feel comfortable and confident while flattering their forms.

Structured, Stable Poses

With men's posing, you want to create structured, stable poses. Avoid curves. Create triangles. Avoid gentle sloping shapes. Create strong lines and foundations.

I once heard photographer Jerry Ghionis refer to posing as architecture, and I feel this metaphor is apt. Feminine architecture has arches and curves. Masculine architecture has strong lines, triangles, and firmer structure. Traditional posing often adheres to these guidelines. Let's take a look at what I mean.

In **FIGURE 6.1**, I haven't exactly created curves, but the pose has sloping lines and gentle shapes. Because of this, the pose is soft and a bit more feminine. With a few changes, I can modify this pose to create structure (**FIGURE 6.2**). Notice how the body language is much more masculine with the use of negative space and limbs to create triangles (**FIGURE 6.3**).

Next, let's talk about body shapes. While there are endless poses for women, often their bodies create an "S" curve. For men, their bodies often take the shape of a "C" or "V."

When I first heard this guideline, I got confused and caught up in constantly trying to re-create these shapes. Don't! These letters are simply intended to illustrate a point. If it helps you remember, great! If it overwhelms you, focus more on structure than letters.

❌ 6.1

CAUTION These guidelines for genders are not set in stone. I often shoot women's fashion portraits using a lot of triangles and structure. I enjoy the strength and strong shapes these techniques create. However, here I'm taking a more traditional approach to posing without making it look and feel dated. Sometimes gender roles are not clearly defined, and there are reasons to break the rules of posing to communicate an underlying idea. Learn the rules, know the guidelines—and break them when appropriate.

✓ 6.2

6.3

In the V body shape, the man narrows at the waist from broad shoulders. This is a common pose for fitness images and is also used with men in suits. While their hips and waist are turned away (making them narrower), their shoulders are turned back toward the camera (making them broader). You can see the V shape that results (**FIGURE 6.4**).

When facing straight on toward the camera, a man's shape is often square (**FIGURE 6.5**). For a full-figured man, I typically turn the subject to his side, with his front foot pointed toward the camera (**FIGURE 6.6**) to create the V shape. This narrows the midsection. Then I rotate the shoulders toward the camera (**FIGURE 6.7**). When you crop at the narrowing point, the V shape is readily apparent (**FIGURE 6.8**).

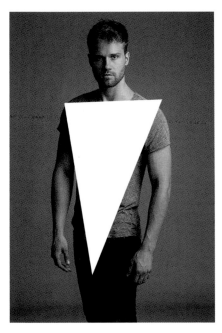

6.4 One traditional shape for a man is his hips and waist turned away (making them narrower), his shoulders turned toward the camera (making the chest appear broader). Here, you can see the resulting "V" created by the body.

6.5

6.6

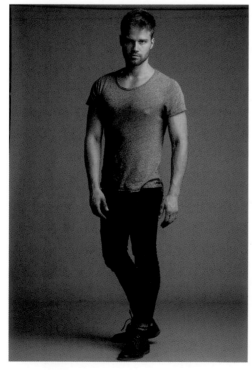

6.7

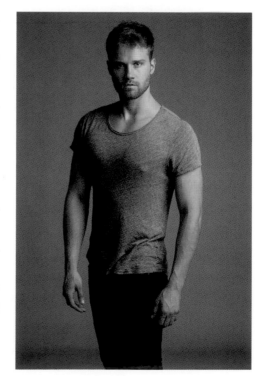

6.8

Next, let's talk about the "C" shape. The C shape can be achieved in many different ways (sitting, standing, leaning) and can be subtle or clearly defined. Using a C pose creates a pleasant visual flow for your eye to follow throughout the pose, yet it does not rely on feminine curves to do so. The pose can have flow while maintaining structure. Typically, both the torso and lower part of the body lean toward one side, creating that C shape. **FIGURES 6.9–6.11** show three different examples.

6.9

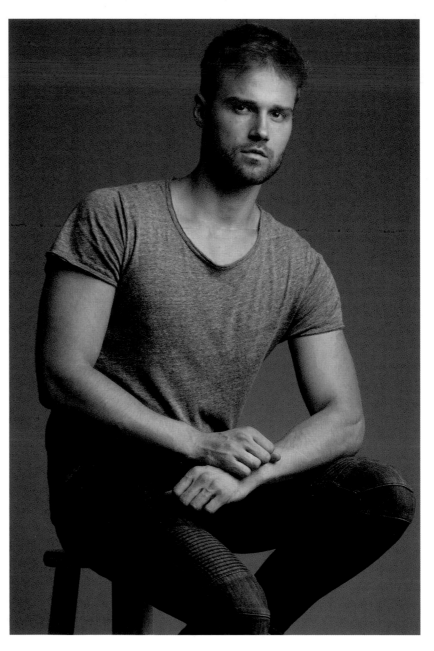

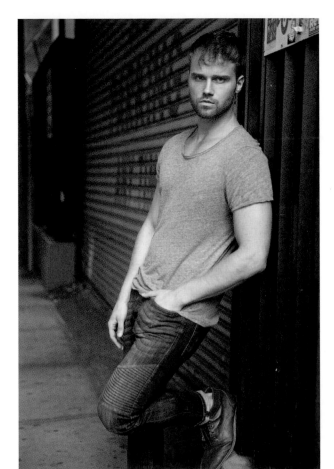

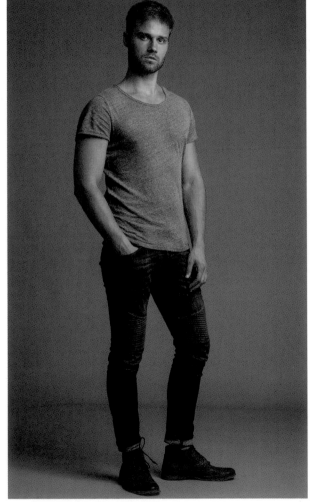

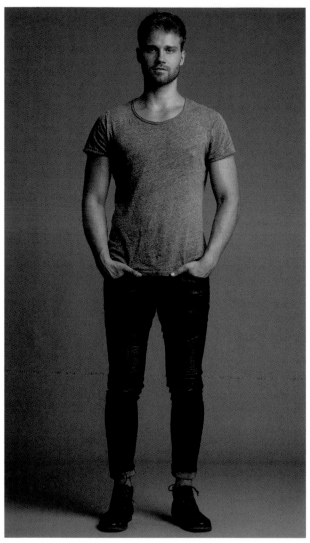

6.12

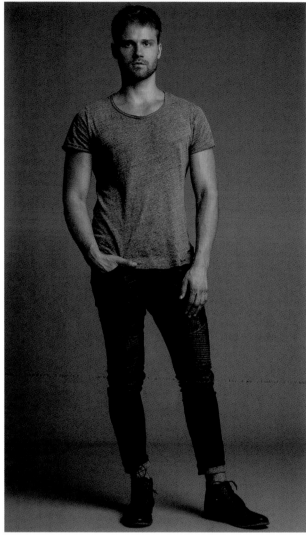

✓ 6.13

With men, sometimes you can get away with the subject standing flat-footed, hips even. However, this usually will not result in a very interesting pose, as it can feel a bit static and rigid (**FIGURE 6.12**). When your subject is standing, have him shift weight onto one leg or another. The result is a pose that looks more natural and comfortable (**FIGURE 6.13**). If, however, the subject leans too far and sticks out his hip too much, the pose can create curves and start to look more feminine (**FIGURE 6.14**). The body position moves toward *contrapposto*, a pose used in Greek and Roman sculpture for both men and women. Today, the contrapposto pose is generally avoided in men's posing.

Using an Anchor or Prop

You may find it useful to pose a male subject with a prop or something to anchor him. Imagine you've got a male subject standing in front of you in a suit against a gray background. How many poses can you think of? A few may come to mind—crossing the arms, one hand in the pocket, taking a step—but there really isn't much variation. Inexperienced subjects, especially, often look stranded or uncomfortable just standing there. Professional models may be able to act and improvise, the average male subject...not so much.

My suggestion is to find something for male subjects to interact with. Give them something to do. Help them feel like they aren't just standing there, abandoned. Anchor them. When you give them stairs to sit on, a wall to lean against, or a chair to pose with, they begin to relax and act more naturally. In fact, you'll notice many male subjects will be able to improvise or contribute pose ideas as they interact with the prop or scene.

Using props can make male subjects feel more comfortable, but they can also help create many new poses. For this reason, I like to keep a couple of useful props in my studio, including a wooden chair (timeless, versatile) and wooden apple boxes (to elevate the foot). For many male portraits, I seek opportunities to step outside the studio so that I can utilize a diverse range of environmental elements—from steps, to walls, to trees, or other props, such as a car.

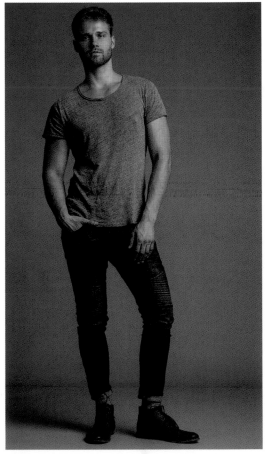

❌ 6.14

PRO TIP

Visit Antique Shops You can often find some really beautiful rugged apple boxes, wooden chairs, and stools that are great for posing. They have more character than the traditional posing tools you may find at a camera store.

In **FIGURE 6.15**, the subject stands in an alleyway. He can cross his arms (**FIGURE 6.16**) or put his hand in his pocket (**FIGURE 6.17**) to create some variety. Yet when he starts to interact with the wall and ledge (**FIGURE 6.18**), he looks more confident and comfortable, thus creating many more variations in his poses.

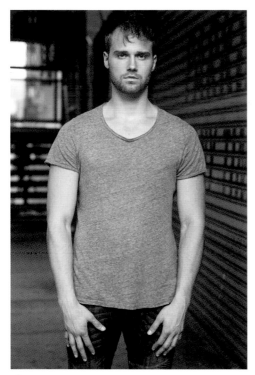

❌ 6.15

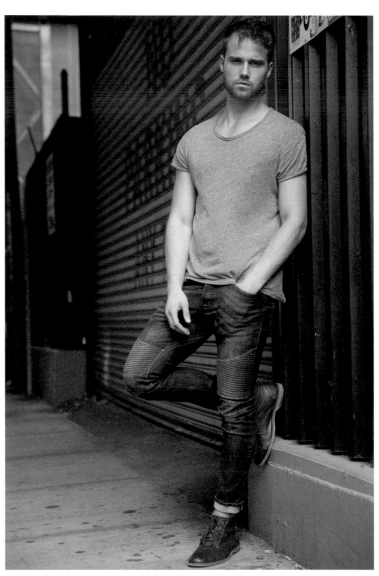

✅ 6.16

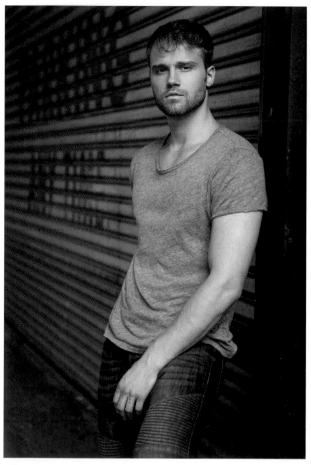

✅ 6.17

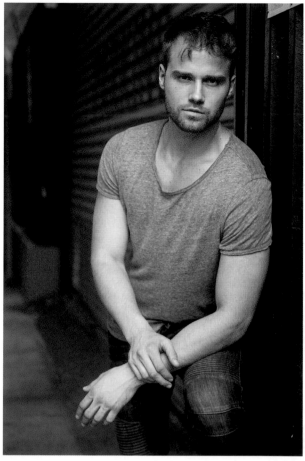

✅ 6.18

PRO TIP

Props If there is a prop of significance to your subject, consider including it. It could be an instrument, a piece of sports equipment, a car—something that resonates with his identity. Using a personal prop can help the subject feel more comfortable in front of the camera.

A chair is also a great solution. Ask him to sit on the chair or straddle it for a more casual pose. He can lean back in the chair to look comfortable or lean forward for a more aggressive look (**FIGURE 6.19a–f**). The options are endless. Here are just a few to get you inspired.

6.19a–f Posing in a chair allows the subject to feel comfortable and confident. By giving him an anchor (the chair), he also has the ability to create more pose variation. Add a box and the options increase even more.

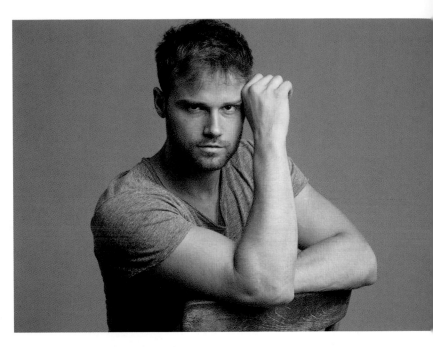

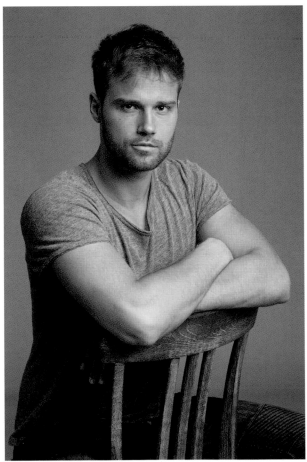

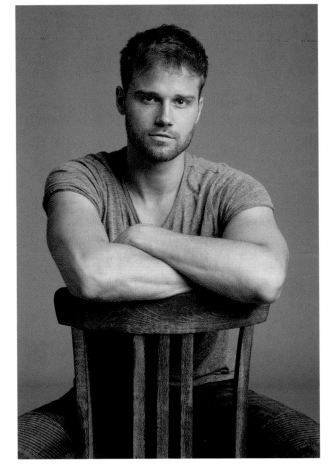

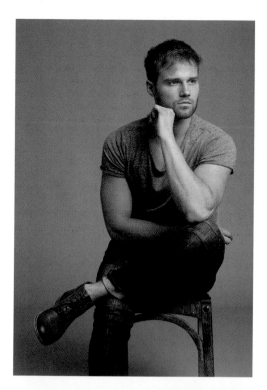

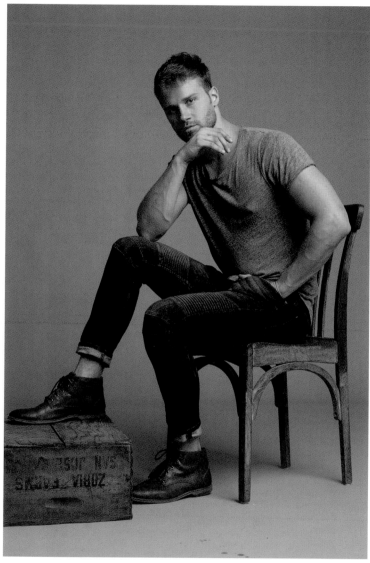

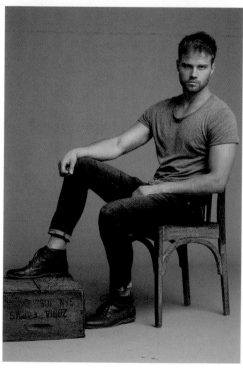

MASTERING *Your Craft*

JAWLINE

If you have selected a pose or head position that pulls the chin back or softens the jawline, make an adjustment to improve it. This is particularly true when a subject sits in a chair. If he sits back too far and pulls in his chin, even the most slender subject may appear to have a double chin.

In **FIGURES 6.20–6.23**, notice the jaw and area under the jaw. From straight on, you can see the slight gathering of skin that results when the chin is pulled back (Figure 6.20). When the chin is extended slightly outward, the problem is solved (Figure 6.21). In Figures 6.22 and 6.23, you can see a side view of these poses, where the results are even more pronounced. ■

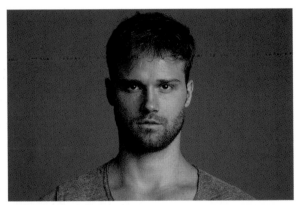

6.20

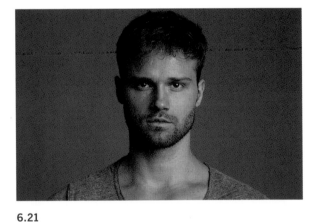

6.21

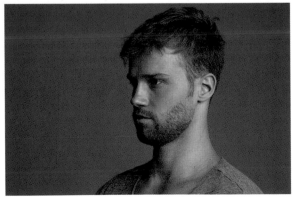

6.22

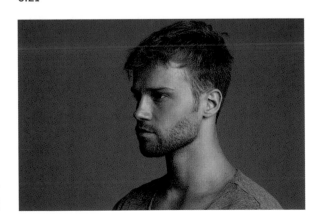

6.23

Shoulders Define Broadness

Posing a man's shoulders helps to define his broadness to the camera's view. Based on the angle of the shoulders, you can make a man look broader or narrower to complement his physique or balance his relative size in a group.

When your subject faces straight toward the camera, his shoulders will be at their broadest and widest. If you turn the shoulders away from camera, he will begin to look narrower. Neither shoulder position is better or worse, but the poses are useful visual tools to use to your advantage. Body type will play a big role here.

When the subject's shoulders are turned to the side (**FIGURE 6.24**), he looks weak and diminished. When his shoulders are turned toward the camera in a "V" pose (**FIGURE 6.25**), he looks broader and stronger.

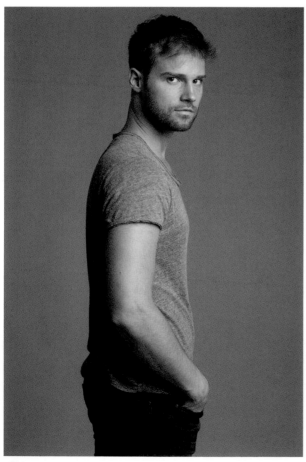

❌ 6.24

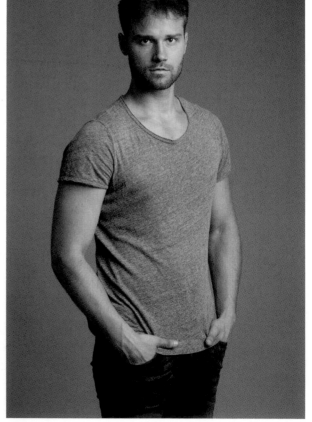

✓ 6.25

The key question here is how far toward the camera should his shoulders be turned? It depends on the man's body type, his physique, and even his attire.

For example, let's say that you have a very slender subject. If you rotate his shoulders away from the camera, they will look even narrower. Unfortunately, this pose may make him look a bit puny, and most men won't appreciate the results. Facing him more straight toward the camera, however, will make him look broader in stature and potentially a bit stronger as a result. His width will give him more of a visual presence, while turning him away will diminish him.

Now let's examine the opposite situation. For a man who is quite broad, it might be beneficial to angle his shoulders and hips slightly away from the camera. Imagine you are photographing a male subject who is a bit heavier or who is fit but has very broad shoulders. Rotating the shoulders slightly away from the camera will make him appear more slender.

Is there a correct shoulder position that works for everyone? If only it were that easy! Just know that shoulder position is a tool you can and should utilize to affect the apparent wideness of your male subjects.

Let's take a look as our subject rotates his shoulders away from the camera (**FIGURE 6.26**). Notice the change in broadness.

CAUTION This is not to say that every fuller-figured man should be turned away from the camera. That is not the case at all. If you turn a heavier-set man completely to the side, it will draw more attention to problem areas by showing his midsection in profile. It really depends on the subject and finding the right balance to fit each individual. At times, a man with extremely broad shoulders may appear to have a smaller head or disproportionate body, while angling the shoulders to the side reduces the apparent breadth.

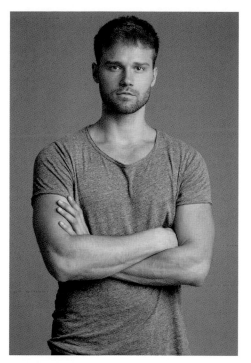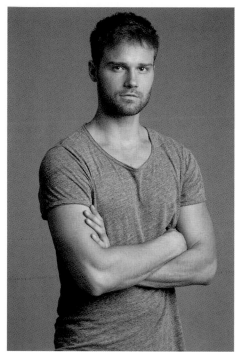

6.26 The placement of the shoulders determines the subject's apparent width and broadness. Because everyone's physique and body type varies, the ideal position of the shoulders varies as well.

If you want to slenderize a woman's midsection, push the hips back. With men, though, this creates feminine body language. Instead, try having your subject step forward, and then lean forward with his chest. His chest is then closer to the camera and the midsection farther away. The perspective changes are similar, but with more masculine results.

Now that we've talked about the angle of the shoulders, also remember "the lean." Having your subject stand up straight or lean back slightly may visually communicate dominance and strength. This can be good, but you must also remember the rules of perspective. When he leans back, as in **FIGURE 6.27**, his midsection is closer to the camera, making it appear slightly larger and drawing more attention to that region. With the exact same pose but leaning forward, suddenly more attention is drawn to his face and he looks more slender (**FIGURE 6.28**). Which pose is correct? It depends on your goals for the image. Typically, the pose in Figure 6.28 is more flattering for a portrait and more approachable, whereas Figure 6.27 might be good for an image intended to communicate power or control.

6.27

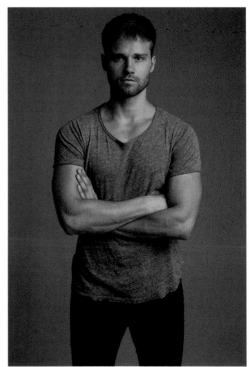

6.28

Hands and Feet: Direct Them!

Help your subjects pose their hands and feet. By default, men will stand flat-footed, with their hips straight toward the camera. They either put their hands in their pockets or hold their hands together in front of them. The results? Static and uninteresting. Your job is to direct them! Let's take a look at some useful approaches to posing the hands and feet.

Hands

The No. 1 rule for posing a man's hands: give him direction! In other words, give the hands something to do.

More than a decade ago, I photographed several group portraits of the groomsmen at a wedding. I didn't know how to pose the men, so I basically asked them to just stand there, turning in toward one another for a symmetrical composition. I didn't even think about their hands. Looking back, I realize they all clasped their hands together in front of them as if censoring their naughty bits (**FIGURE 6.29**). These are definitely not award-winning photographs (for the hand position, among many other reasons).

I now always carefully consider giving the hands something to do in the shot. It can be fixing a collar or putting a hand in the pocket, but I am sure to purposely pose this important element. Well-posed hands communicate mood, direct the eye, and give interest to a photograph.

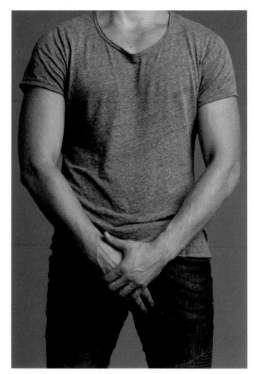

❌ 6.29

When I say pose hands, I am not suggesting that every shot has to look like Rodin's *The Thinker*, with the hand to the face in a thoughtful pose. In fact, this pose can appear over-posed and contrived. Instead, I opt for giving the hands a purpose in the shot or some motivated position.

I've selected 10 different hand poses (**FIGURES 6.30a–j**) to inspire you on how to position hands.

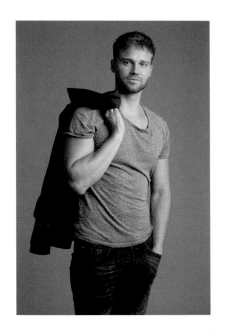

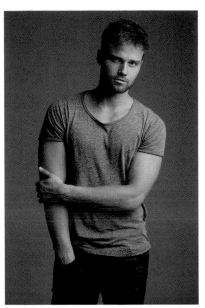

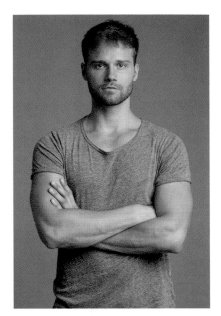

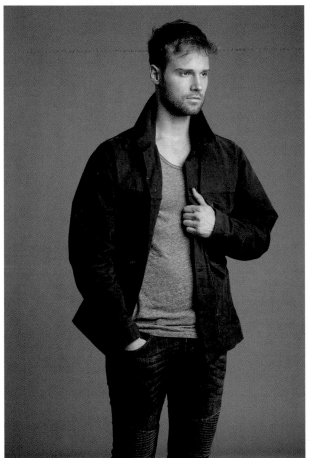

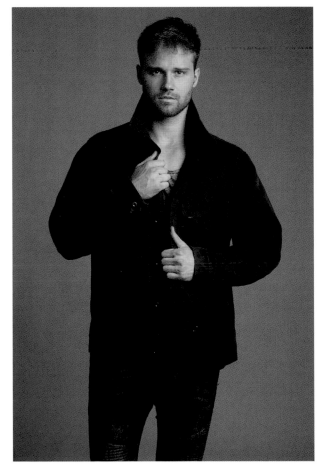

✔ **6.30a–j** Well-posed hands communicate mood, direct the eye, and give interest to a photograph.

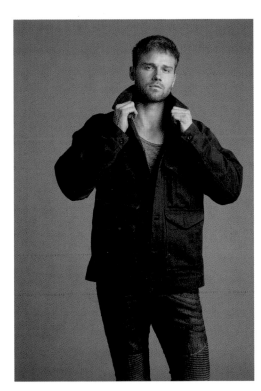
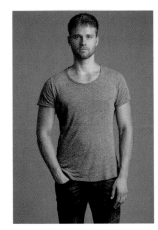
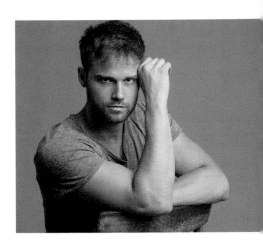
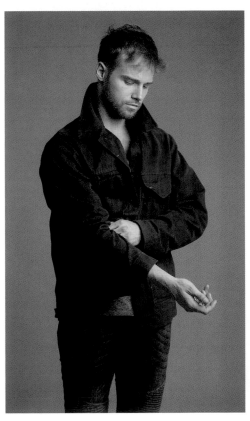
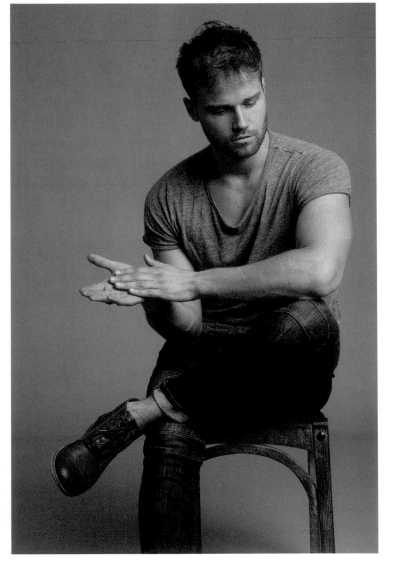

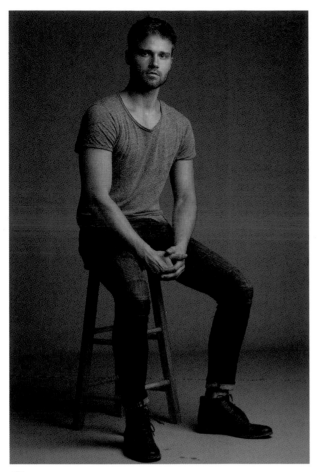

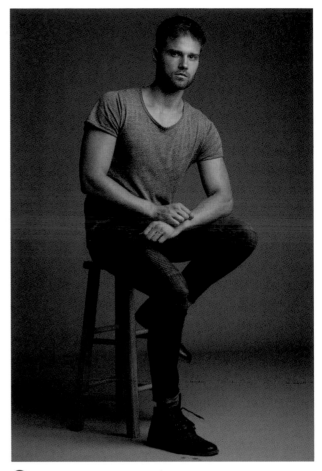

❌ **6.38** When the feet are even, the pose is static.

✅ **6.39** Varying the level of the feet and knees creates a more dynamic and stronger pose.

Direct and Tweak

Most men don't like feeling or looking overly posed. For this reason, when photographing men, I recommend giving them a general direction, see what they come up with, and then tweak to improve the pose. This helps yield more natural results that often exude more comfort and better involve the subject in the portrait process. Micro-posing (posing each leg, finger, and so on) is often unnecessary and can elicit uncomfortable expressions.

When you give a general direction, this also gives the subject the opportunity to participate in the portrait process. They can contribute to the pose and even create a body position you wouldn't have thought of.

In most cases, the subject will choose a pose that is most natural, and thus comfortable, to them—one that is a reflection of their personality. This doesn't mean the pose is perfect. In fact, it likely suffers from at least one of the posing pitfalls we've discussed, meaning you'll have to run through this list of potential problems before clicking the shutter.

Let's take a look at this approach in action:

I've decided I want to get a shot of my subject sitting comfortably on the floor. Instead of giving him an exact posing idea, I'll give him a vague direction: "Take a seat, and lean on your side comfortably, like you are watching TV." I'll give him a moment to pose, and then make adjustments to fix any problems. Is there any foreshortening? How is the posture? How could I make the pose more flattering while still keeping him comfortable?

In this case, my subject naturally sits with one leg up. For him, leaning on his side produces a more comfortable result (**FIGURE 6.40**). From here, let's examine any problems. First, the arm closest to the camera is straight on toward the camera, creating a bit of foreshortening. To fix this, I can angle the arm in toward his body. Next, I've lost his back arm. Although this doesn't ruin the pose, moving the arm around to the front brings better structure and proportion to his body (**FIGURE 6.41**).

PRO TIP

Direct and Tweak (for Women) You can certainly take this approach with women as well. Feel free to direct your female subject and treat it more like acting. See where she goes with an idea or emotion, and then make adjustments to allow the pose to look better to the camera.

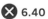 6.40

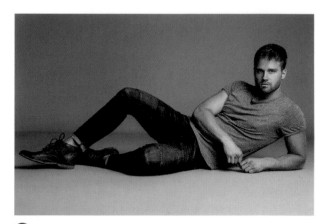

✔ 6.41

MASTERING *Your Craft*

ARMS ON THE CHAIR

Be aware of how you pose the arms on a chair. If you lean the arms over the back of the chair, it can make the shoulders look slouched (**FIGURE 6.42**). This same pose, however, can be used to beef up the biceps by putting pressure on the muscles (**FIGURE 6.43**). ■

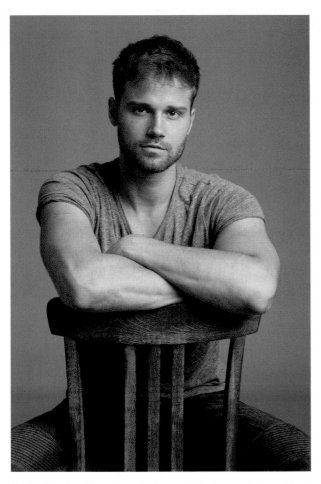

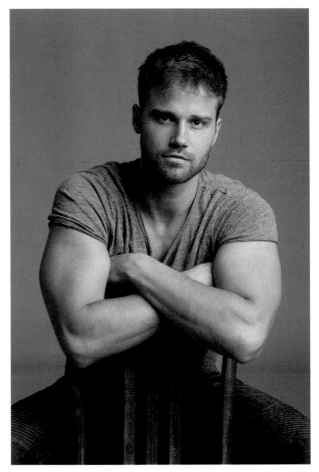

6.42 The shoulders have better positioning and the subject looks relaxed.

6.43 The shoulders are a bit more slouched, but the pose is more aggressive and allows the subject to place pressure on his biceps to make them look larger.

Watch Out for the Crotch

If you direct a man to sit for a pose, you may need to tweak the pose so that the eyes aren't drawn between the legs. This may mean changing the angle of the body, adjusting the camera angle, or placing the hands in such a way that they obscure that area. Sometimes it may not be distracting; other times it may draw too much attention. In **FIGURE 6.44**, I've invited the subject to take a seat leaning forward. Unfortunately, when he leans forward his hand placement looks very awkward and distracting. Furthermore, the camera angle and hand placement direct my eye between his legs. To fix this problem, I tweak the pose by adjusting the position of the hands (**FIGURE 6.45**). The change creates structure in the pose and more natural hands, while also obscuring the crotch.

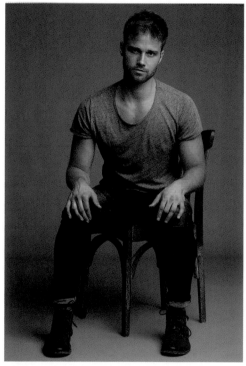

✖ 6.44 In the first shot, the hands look awkward and need to be tweaked. Furthermore, the eye is drawn to the crotch (above).

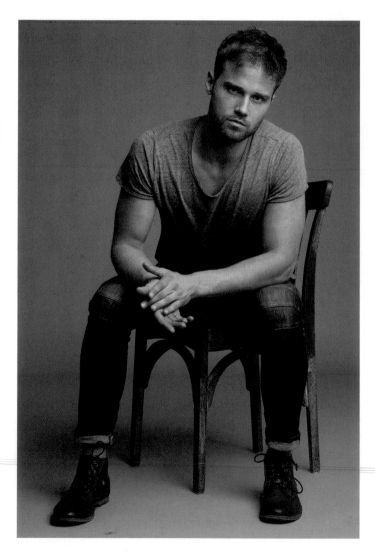

✔ 6.45 Tweaking his initial pose produces much more pleasing results (right).

The Head Tilt

Avoid tilting a man's head toward the camera. While tipping a female's head toward the camera can appear playful or thoughtful, depending on the expression, the same isn't generally true for men. Typically, the result looks awkward or a bit too feminine (**FIGURE 6.46**). Keep the head tilt neutral (**FIGURE 6.47**) or even slightly away from the camera if seeking a more standoffish pose (**FIGURE 6.48**). Be aware that tilting the head away from the camera only works with certain faces, and it will depend on each subject.

❌ 6.46

✅ 6.47

✅ 6.48

TRAIN YOUR EYE

We've discussed creating structure; shoulder, foot, and hand placement; and more. Now let's test your skills. We will review some sample poses and see what we can do to make improvements for stronger, more confident, and more flattering poses.

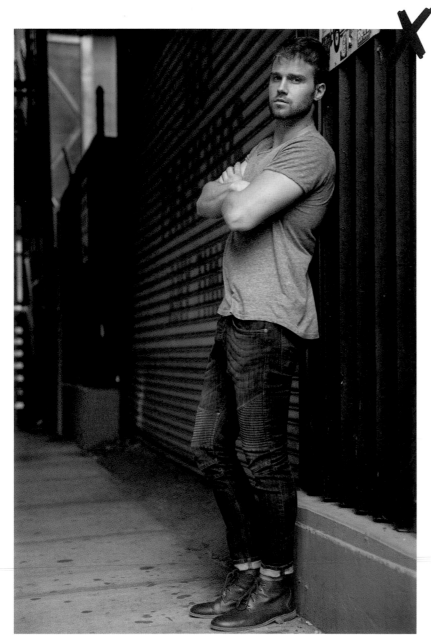

TRAIN YOUR EYE #1

Study **FIGURE 6.49** and see if you can identify the problems in the image.

6.49 Train Your Eye #1

✅ *Solutions*

Shoulders: We've turned the subject toward the camera for a broader, stronger look. Also, he is leaning more on his arm instead of his back (which is more flattering to the midsection).

Camera Angle: The angle is slightly raised, combined with the subject leaning toward the camera. This draws more attention to the face and chest.

Feet: The subject's back foot is raised and his knee bent for a more dynamic pose.

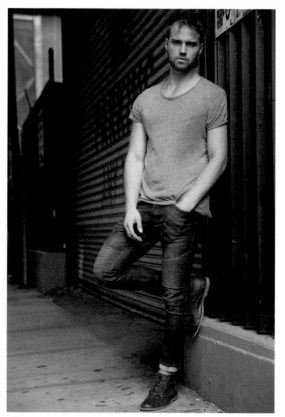

✅ **6.52** Solutions

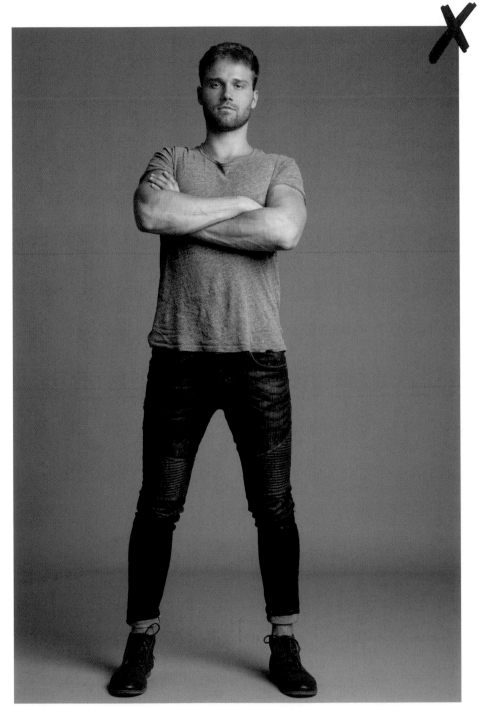

6.53 Train Your Eye #2

TRAIN YOUR EYE #2

Study **FIGURE 6.53** and see if you can identify the problems in the image.

Let's see how you did. Compare **FIGURE 6.54** with the solutions in place in
FIGURE 6.55.

❌ *Problems*

Shoulders: The subject stands square to the camera, with shoulders raised too high, creating tension and looking too posed.

Camera Angle: The angle is too low, placing emphasis on the midsection. Furthermore, the subject is leaning back slightly.

Feet: The subject's feet are too far apart, looking over-posed. Also, he stands flat-footed, creating a stagnant pose.

✅ *Solutions*

Shoulders: We've turned the subject subtly to the side for a less square pose. His shoulders are relaxed and lowered for more flattering results.

Camera Angle: A slightly higher camera angle, combined with the subject leaning toward the camera, makes for a more flattering pose.

Feet: One foot is turned to the side and knees are slightly bent, making for a more relaxed, believable pose.

SHOULDERS SQUARE
TO THE CAMERA

LOW CAMERA
ANGLE EMPHASIZES
MIDSECTION

FLAT FEET

❌ **6.54** Problems

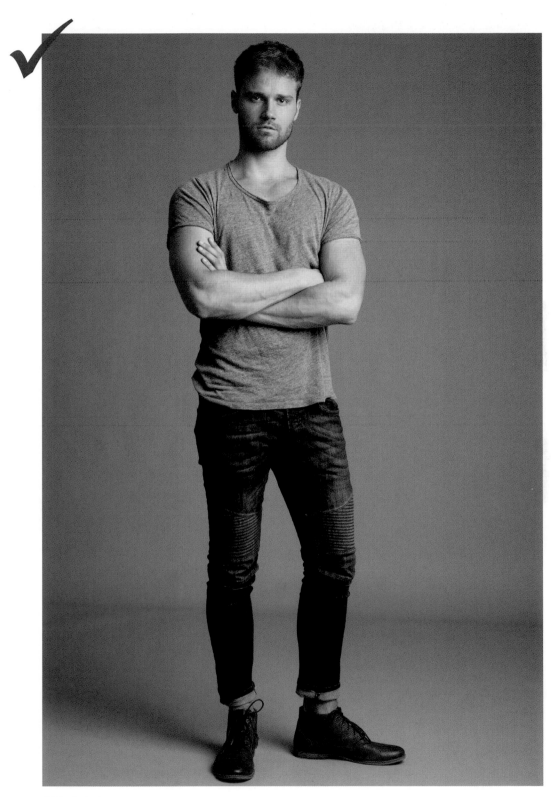

6.55 Solutions

5 GO-TO POSES

POSE 2 Standing with jacket thrown over the shoulder, back hand in pocket.

POSE 1 Leaning against a wall, front hand in pocket, back knee bent with foot on the wall.

POSE 3 Seated on stool with one knee up, resting on forehand. Arms at right angles making strong lines and triangles.

POSE 4 Seated on chair with back knee up on the back of a crate or box, back hand resting on knee, and front arm resting on thigh (above).

POSE 5 Straddling a chair, arms crossed on the back of the chair (left).

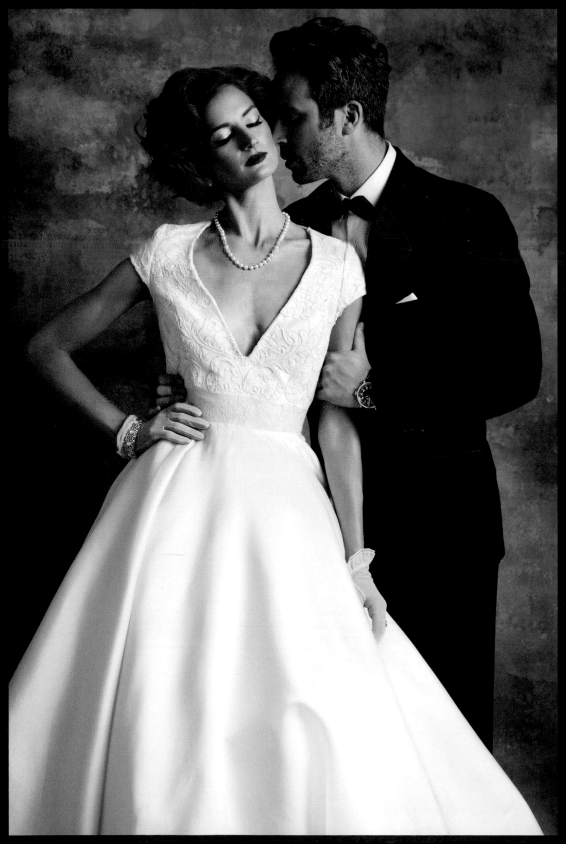

POSING COUPLES

A couple's portrait is an opportunity for you to capture the relationship between two people. You can create an image that represents their joy, romance, and unique bond. It is a special and important opportunity, particularly for engagement sessions and portraits on the wedding day.

While creating a stunning image can be quite rewarding, it also offers several challenges. Not only are you required to flatter two subjects at the same time, but also, expression and body language need to convey the connection between the subjects. Often you must make a variety of different shots, poses, and expressions in a very short period of time, while working under pressure.

For subjects who are not used to being in front of the camera, you'll need to work to create visual flow to avoid static results that are common in many couples poses. In this chapter, I'll cover not only my favorite tips for successful couples portraits, but also common problems that arise and how to fix them. Couples with uneven heights? Lack of connection? Unwanted double chins? I've got solutions! We'll talk about working with a bouquet, kissing shots, and more.

Finally, I'll show you my approach to creating endless variation in shots so you'll never feel uninspired, especially when time is of the essence. I'll show you how to come up with dozens of different images with minimal adjustments!

Guidelines for Posing Couples

While you can't forget all the posing essentials for men and women when photographing couples, there are a few other considerations to keep in mind to create flow and apparent connection between the couple.

For Romance: Create Multiple Points of Interaction

Body language can communicate a great deal about a subject, and this becomes even more apparent in images of couples. By creating multiple points of interaction within the pose, you reinforce the concept of romantic connection between the couple. In other words, your couple should generally be touching at multiple points of their bodies in your images.

In most instances, a single point of interaction (hand on shoulder, holding hands) suggests friendship or familial relation. Multiple points of interaction or intersection evoke romance. Don't just wrap one arm around the waist or drape it across the shoulder. Find a way to bring the other person's hand up to the arm, shoulder, or face. Have them kiss or tilt their heads together.

Let's take a look at some examples of this in practice. In **FIGURE 7.1**, the couple is intersecting in only one place (with his hand on her hip). In **FIGURE 7.2**, their torsos and faces overlap, and her hand reaches to his face. The connection is communicated much more successfully in the adjusted pose.

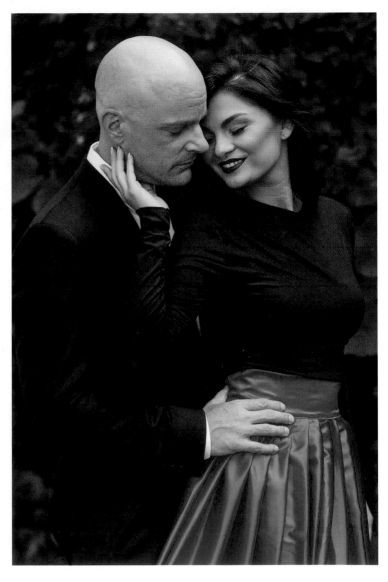

❌ **7.1** This image lacks romance because the couple's only physical connection is his hand on her hip (above).

✅ **7.2** This image communicates romance in the way the couple is intertwined (right).

In **FIGURE 7.3**, the couple is touching only at the shoulders. They look distant from each other, as though they are business colleagues rather than a couple. The adjusted image (**FIGURE 7.4**) is significantly more successful at conveying their relationship. She holds onto him with her hands, and he wraps his arms around her. Their heads tilt together. The connection and romance are clear.

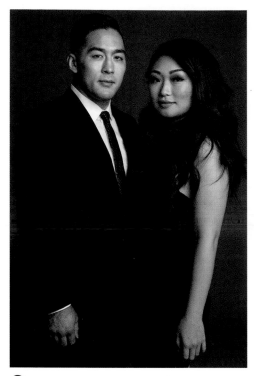

⊗ 7.3 The lack of intersection in this image makes these two appear like business colleagues (above).

✓ 7.4 By introducing several points of interaction, the romance and connection become clear in this shot.

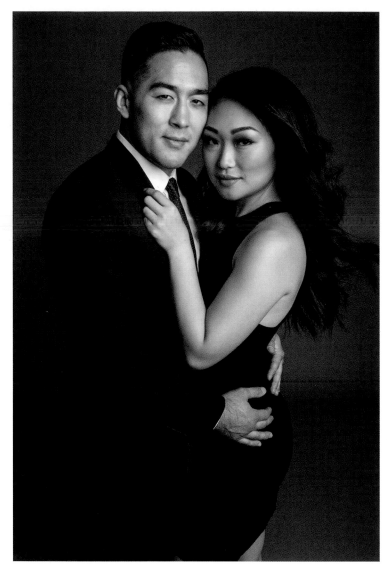

Does that mean a couple must always be intertwined? Certainly not. There are times when you may just want the couple to be holding hands while walking down a path (**FIGURE 7.5**). This can be playful or thoughtful, but if you are going for romance, multiple points are still recommended.

The Kiss

If one point of interaction is a kiss, be sure the couple is not pressing their lips together too hard or that one person isn't awkwardly puckering their lips to the side of the face. Typically, the moment before the kiss has more

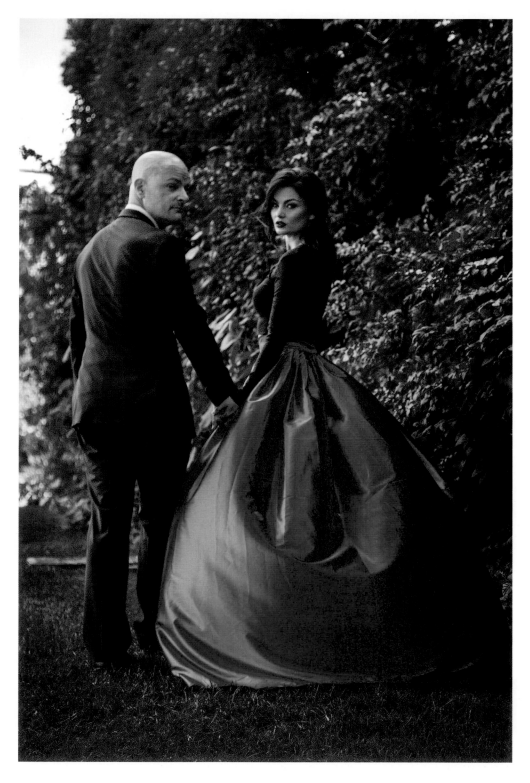

7.5 You do not always need to have your subjects intertwined, particularly for moving or more playful shots.

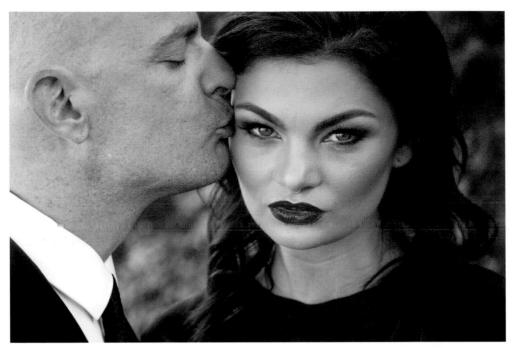

❌ **7.6** People naturally pucker their lips, but this gesture photographs in an unflattering way.

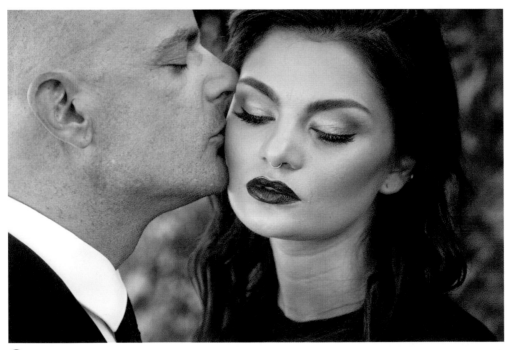

✓ **7.7** Relaxed lips or the moment before a kiss is usually more visually pleasing.

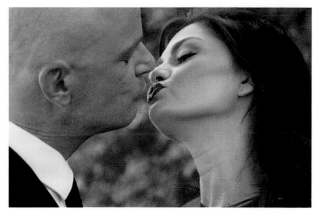

❌ **7.8** Watch out for duck-face kisses, which look awkward and unflattering. More relaxed lips are preferable.

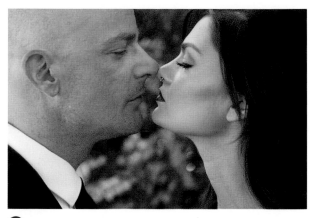

❌ **7.9** Don't have the noses meet, as this lacks flow and looks too posed. Try tilting the heads instead.

emotion and anticipation—and it photographs better. The kiss should be gentle to avoid a duck-face look (**FIGURES 7.6** and **7.7**).

Kisses can be a tricky thing. **FIGURES 7.8–7.10** show a few other kiss poses to avoid.

Tilt the Head, Close the Space

As discussed, body language helps to communicate mutual support and romantic connection. When there is too much space between the couple, it breaks the body language of togetherness. I am not saying that your couple should always be pressed close together, but watch for space that doesn't flatter and, instead, symbolically divides.

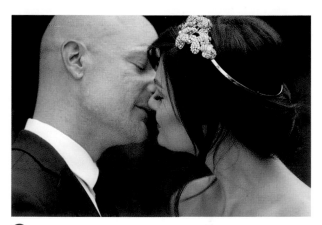

❌ **7.10** Avoid having one person's head blocking the other. There may be some overlap, but watch your angle to keep it minimal.

Most importantly, when possible, tilt the subjects' heads together. Even the most subtle of head tilts can make a huge difference in body language. Too much space between the heads or heads tilted away from each other suggests repulsion (definitely not our goal in a couple's image). Conversely, a subtle tilt of the subjects' heads toward one another creates a visual representation of togetherness and attraction.

In **FIGURE 7.11**, the subjects are close together, with heads slightly apart. But notice how the most subtle head tilt in **FIGURE 7.12** results in a big difference

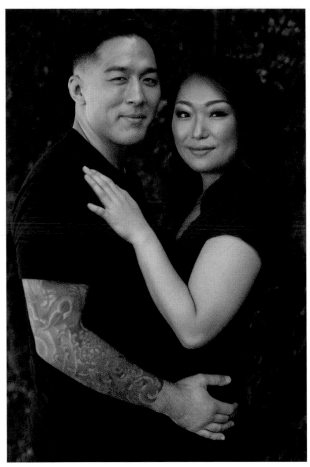

7.11

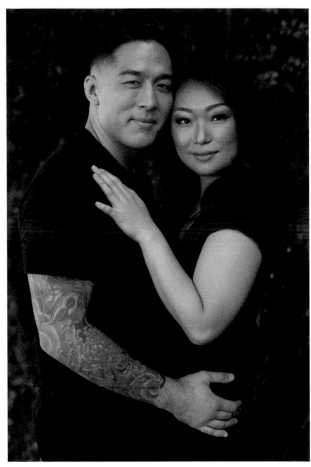

✓ 7.12

in body language. They look more affectionate toward each other. It doesn't need to be extreme, but this is a small detail you'll want to pay attention to.

Sometimes space between a couple can work for a high-fashion look. Typically, however, it makes them look disconnected. In **FIGURE 7.13**, the couple looks playful, and you could get an acceptable shot out of this pose. But when you close the space, the connection between the couple becomes clear (**FIGURE 7.14**). Is the first shot wrong? No, but it communicates a different attitude.

Finally, be aware of the position of the legs when posing couples. Couples sometimes pose with their torsos together, with an awkward spacing between their legs and midsection. This is often a result of standing flat-footed. It is your job to direct them. Remember, flat-footed poses are seldom the most flattering.

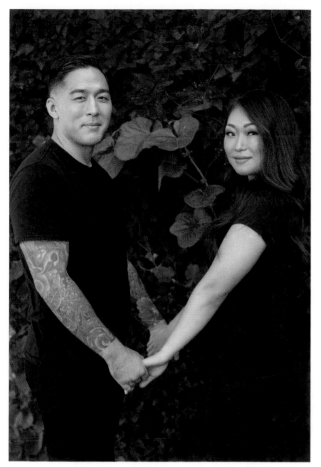

7.13

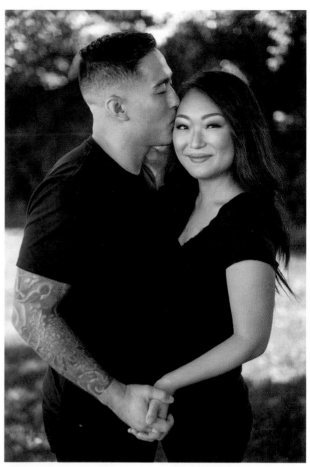

✓ 7.14

Ask the man to step his front foot toward the woman, and then direct the woman to bend her front knee toward the man, while pushing her hips back. This inward body language communicates their relationship and reduces undesirable negative space. It also creates more flattering body shapes.

In **FIGURE 7.15**, the couple is standing flat-footed, with space between their midsections. Because of this, their hips are square to one another. To improve the pose, I have him subtly move his front knee in, while she bends her front knee toward him, thus pushing her hips back (**FIGURE 7.17**). You can see the foot position in **FIGURES 7.16** and **7.18**, and the results in **FIGURES 7.15** and **7.17**. The gap has been narrowed to create togetherness, and the apparent size of her hips has been reduced.

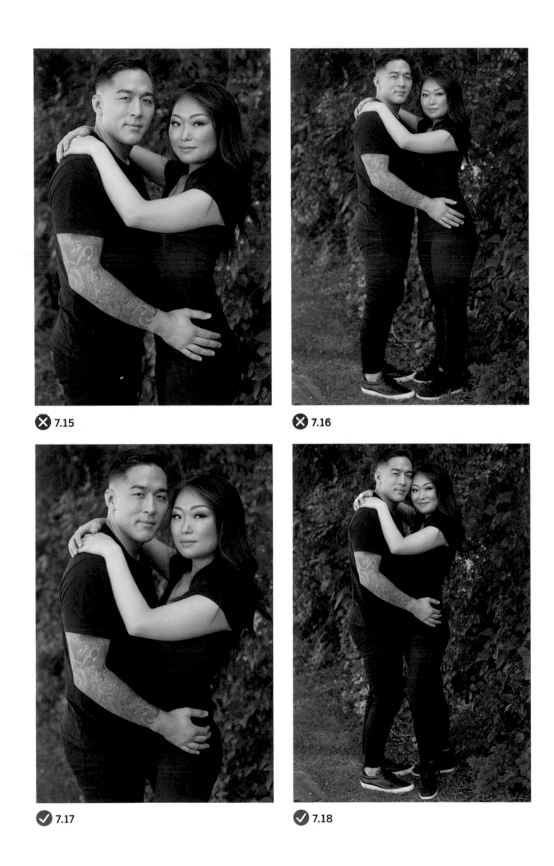

❌ 7.15

❌ 7.16

✅ 7.17

✅ 7.18

MASTERING *Your Craft*

THE BOUQUET

Be aware of the placement of the bouquet. You don't want it to obscure the bodice of the dress, nor do you want the arm to appear dead at the side of the body (**FIGURES 7.19** and **7.20**). A slight bend to the arm (an obtuse angle with a gentle curve) with a little negative space will be the most elegant and flattering (**FIGURE 7.21**). ■

❌ 7.19

❌ 7.20

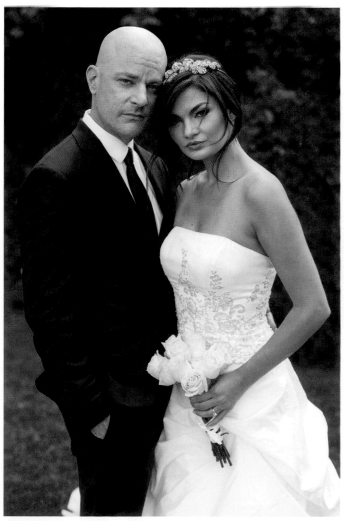

✓ 7.21

Go Asymmetrical—Avoid Mirrored Poses

Seek to create asymmetry in a couple's pose. By doing so, you introduce a more visually appealing and complex path for the viewer's eye to follow. This can bring more elegance and flow to the pose. Symmetrical poses, conversely, can create a boxy and stagnant look. Your eye becomes trapped.

Let's take a look at some problems with symmetry, and then tweak the poses to improve them.

For example, you won't want both the man and woman to put their hands on each other's hips (**FIGURE 7.22**). Nor would you want their hands on each other's shoulders. It lacks a feeling of believability, comfort, and flow. By having the woman place her hand on his chest or shoulder, suddenly the eye can follow a much more interesting path (**FIGURE 7.23**). Notice how the

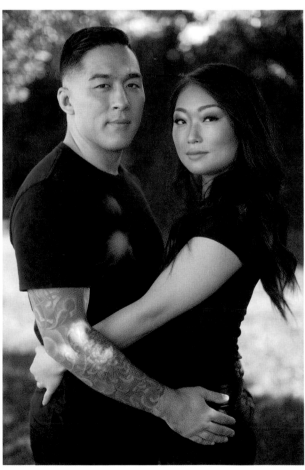

❌ 7.22

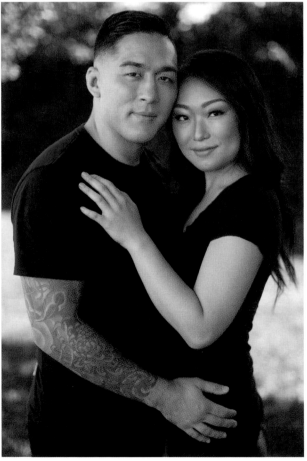

✅ 7.23

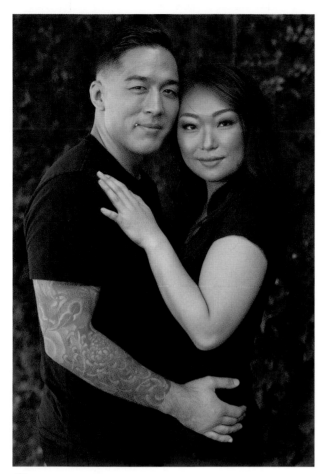

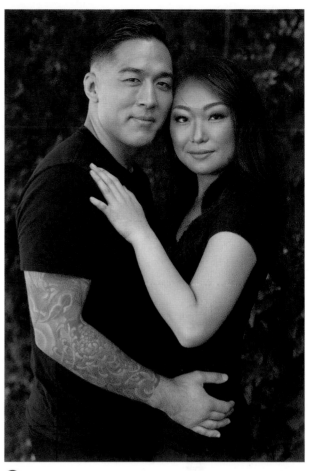

❌ **7.24** Be aware of the dreaded "arm squish" that makes a woman's arm look thicker than usual.

✅ **7.25** This problem can be remedied by having the subject lift her arm slightly away from her body.

eye can move more freely in the pose, which appears a bit more natural and less stagnant. Asymmetry results in visual movement.

Arm Squish

Be aware of the "arm squish." When the woman raises her arm, as seen in **FIGURE 7.24**, it may look thicker than usual. This is caused by the woman holding her arm tight against her body, causing it to spread out. It makes no difference how slender the woman is—the arm will look significantly wider than usual. If you see this problem, invite the subject to lift her arm away from her body by an inch (**FIGURE 7.25**). Even this slight adjustment will make a huge difference. Be careful, though, as raising the arm too far from the body will look awkward.

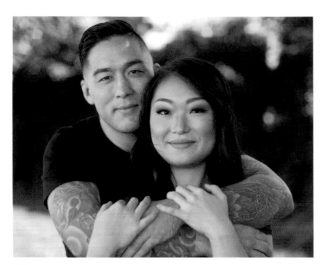

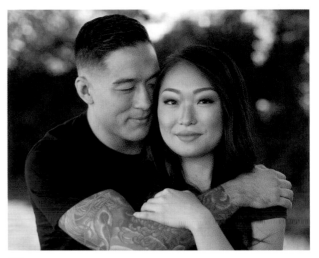

❌ **7.26** In this shot, stacking the hands becomes a distraction.

✔️ **7.27** Varying hand placement creates a much more visually pleasing result.

Avoid Stacking

In general, you'll want to avoid stacking the arms and/or hands. If the arms are stacked upon each other or the hands all piled up, it creates a visual distraction that draws and holds the eye (**FIGURE 7.26**). Typically, stacking limbs and hands also creates a very blocky pose without any flow or interest. Instead, make subtle changes to vary hand placement or tweak limb position so everything isn't piled up (**FIGURE 7.27**). This is true with couples portraits, couples maternity shots, family portraits, or any photo with more than one person.

Equal Proportions

In a couples portrait, you'll want to create visual balance between your subjects. One person should not dominate the visual space in the image,

CAUTION **Watch the Eyes** Sometimes posing a couple gazing into each other's eyes makes for an awkward photograph. Either their eyes look a bit crossed, or they struggle to focus at such a close distance. Instead, when a couple is meant to be close together, direct their eyes to look in a different direction. Perhaps looking at the ears or shoulder will yield more pleasing results and cause less strain on the eyes.

nor should one person diminish the other or look distorted in the frame. If one person looks extremely large and nearly hides the other person, you'll need to make some adjustments in your frame. This disproportion may be a result of the pose selected, your camera angle, your lens choice, or a combination of all of these factors. Let's take a look at how you can fix it.

First, let's take a look at where the posing has caused uneven proportions. In **FIGURE 7.28**, the woman's head appears as if it is peeking out behind her husband's body. He dominates the frame while she looks diminished and hidden. In **FIGURE 7.29**, my camera angle stays the same, but I reposition the female subject to improve proportion. She now has equal visual weight and importance in the frame.

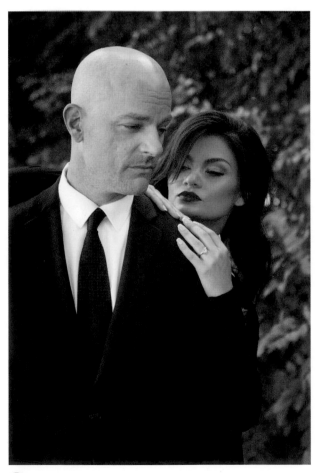

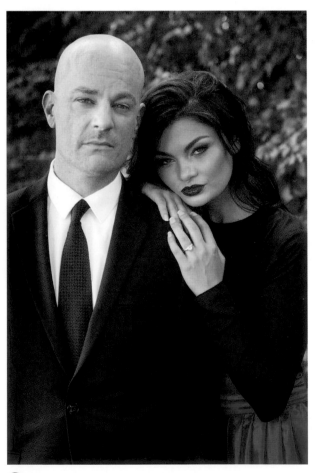

❌ **7.28** In this image, the woman is hidden because of her position.

✅ **7.29** By adjusting her pose slightly and moving toward the camera, she becomes more visible, and the proportions in the frame are improved.

Disproportion may also be caused by camera angle and lens choice. In **FIGURE 7.30**, I am shooting with a wider lens (24mm) and am much closer to the male subject. Whatever is closer to the camera appears larger than objects in the background, and this is exaggerated with a wider lens. As you can see, the male subject's head and body overshadow our female subject, who appears much smaller in the background.

In **FIGURE 7.31**, without moving the positions of my subjects, I adjust the camera angle so that both subjects are equidistant from the camera. Because of the similar distance, the issue with proportion has been resolved.

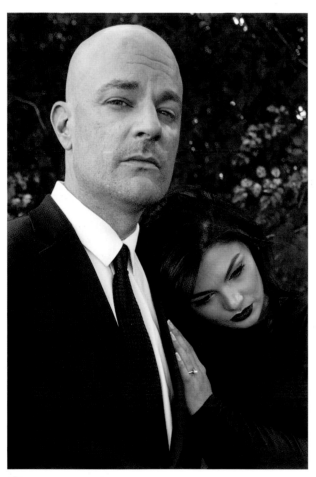

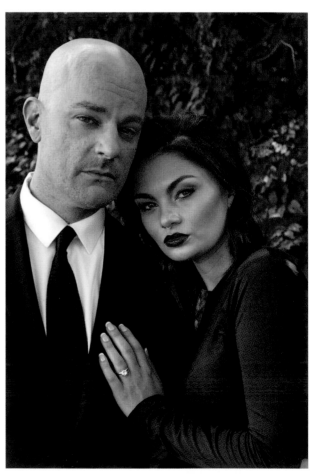

✗ 7.30 Lens choice and camera angle can cause undesirable proportions and distortion. Because I'm shooting with a wide-angle lens close to the male subject, he appears much larger in the frame, while the female subject appears smaller.

✓ 7.31 By changing the camera angle and making sure the subjects are an equal distance from the camera, I have corrected issues with proportion.

MASTERING *Your Craft*

DISTORTION AND PROPORTION

Problems of distortion and proportion are exaggerated by being close to your subjects with a wide-angle lens. To prevent these issues, you may try backing up, using a longer focal length, and keeping both subjects approximately equidistant from your camera. These same issues pop up when photographing more than one person together.

This doesn't mean you can't have a photograph in which either the man or woman is the centerpiece of the shot, and the other is an accent in the frame. For example, in **FIGURE 7.32**, the bride is in focus and takes up more of the frame, but the image is still successful. She does not look distorted. Instead, we have made a visual choice to focus our attention (through depth of field, composition, and eye contact) on the bride. Posing, combined with composition and a narrow depth of field, can allow you to draw the focus to one subject over the other, without someone appearing hidden or diminished. ∎

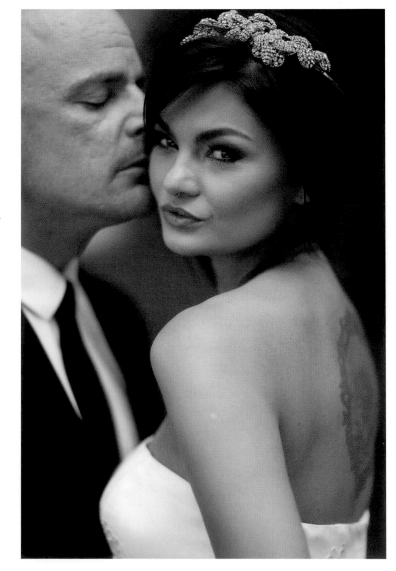

7.32 Your couple does not always need to occupy equal space in the frame for the pose or image to be successful. In this image, more attention is paid to the bride. Depth of field, the pose, composition, and eye contact serve to emphasize the bride in the frame.

Uneven Heights

There may be times when you pose a couple with drastically different heights. The height difference may cause a disconnection between your subjects, making it difficult to place their heads on similar levels. Sometimes subjects try to balance the heights, which can result in slouching, hunched shoulders, or the shorter person craning upward—all unflattering results.

There are three simple ways to balance your subjects' heights for more pleasing results.

1. Ask the couple to sit.

To help even out the relative heights of a couple, having them sit can give you many options. The taller person may be seated with the shorter person standing beside them. If both are seated, the shorter person can prop themselves up on one knee or find other ways to slightly elevate themselves. Sitting offers a variety of options to close the height gap!

2. Use the "step and lean" equalizer.

For a standing pose, ask the taller subject to stand a few feet behind the shorter subject. Next, have them take a large step forward so that the front foot is equal with their partner. Finally, have them lean their chest forward. Doing this makes them shorter by several inches but without requiring them to slouch or hunch over. Even in a full-length shot, this height difference is not apparent, especially if you line up the feet.

You can see a perfect example of this technique in these bridal images. In **FIGURE 7.33**, the bride stands quite a bit taller than her husband. I've asked her to stand two steps back, to step her front leg equal to her husband, to kick the weight back onto her back leg, and to lean her chest forward. The resulting image evens out their heights and is extremely flattering to her form (**FIGURE 7.34**).

3. Utilize perspective.

Use the tricks of perspective to your advantage when working with people of drastically different heights. Place the shorter subject closer to the camera using a slightly wider lens. By putting them closer to the camera, they will now appear larger and/or taller.

 7.33

✔ **7.34** By backing up and stepping and leaning forward, the bride appears several inches shorter, thus reducing the height difference.

In **FIGURE 7.35**, I've chosen a 50mm lens. In the first image, where the couple is holding hands side-by-side, you can see the difference in their heights. If the husband wants to appear taller in this shot, I employ my knowledge of perspective. I tweak the pose by placing him in the foreground and her a few feet back from the camera. By moving closer to the lens, he appears taller. By moving farther back, she appears slightly shorter. Furthermore, I've directed her to shift her weight back and chest forward (making her a few inches shorter). The results? A more pleasing shape to the bride and more height for the groom (**FIGURE 7.36**).

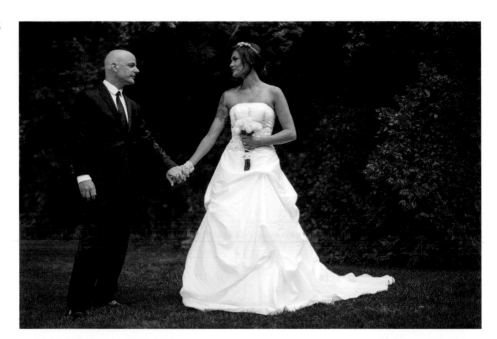

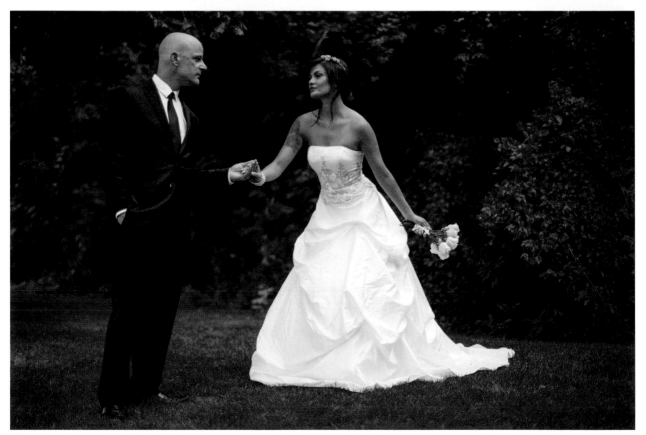

✅ **7.36** Utilizing perspective helps reduce apparent difference in height. By placing the shorter person closer to the camera and the taller person farther away, you can use a wider lens and make use of the tricks of perspective to even out height!

"Making the Rounds" for New Pose Ideas

When photographing couples, you have to consider both flattering each subject and capturing their connection. Now, let's compound that with the stress of taking portraits on a couple's wedding day. These images are some of the most important of their lives; you are expected to create a variety of shots (for an album, slideshow, wall cluster, and so on) in a very short time frame. Don't worry, I've got some solutions for you.

Over the years, I've developed an approach that helps me quickly create a variety of shots with just a few simple adjustments in poses. I call my approach "making the rounds." I move my female subject around the male subject in four different positions. Within each position, I'll vary their expressions, limbs, my camera angle, lens choice, and depth of field. The results? Dozens of different images achieved within just a few minutes.

Let's take a look at my approach to get you started with posing couples. Once you've mastered this, you can experiment with other unique poses and scenarios. In the meantime, this approach will establish a strong base and ensure that you get several great shots quickly.

The Four Bases for "Making the Rounds"

As mentioned, in "making the rounds," the man remains roughly in the same position while the woman moves around him. Let's take a look at the four base poses to get us started with making the rounds.

PRO TIP

Flow Posing The concept of flow posing is the idea of flowing (moving slowly) from one pose into the next. You make small adjustments and changes to the body and expression instead of just memorizing poses and abruptly moving into new poses. Flow posing has been taught for years. This section is my approach to getting many variations from a pose without having to memorize dozens of different starting points.

Base 1: Woman in Front of Man

In this base shot (**FIGURE 7.37**), the woman stands with her back to the man's chest. First, make sure her position isn't completely obscuring or diminishing the man. I usually start with his hand to her shoulder, kissing the side of her head.

Base 2: Woman Facing Man

Next, she can turn to face the man, chest to chest (**FIGURE 7.38**). I typically begin with his hand to her hip, her hand to his upper chest, and their heads tilted together.

Base 3: Woman to Side of Man

Next, I'll bring my female subject around to the side of the man (**FIGURE 7.39**). Here, I typically begin by having her hook her arm within his and tilt her head toward his shoulder.

Base 4: Woman Behind Man

Finally, I have the female subject step behind the male subject (**FIGURE 7.40**). Here, I usually begin by having her place her hands upon his shoulder, being sure not to hide her body or make her look like a "floating head."

Now that we have these four base poses, we can begin to create a bit more variety. Let's take a look.

Creating Variety Through Digits and Expression

For each of the following shots (**FIGURES 7.41a–h**), I easily flow from one pose to the next, barely moving the man. Using simple base poses, I can create variety by varying placement of the digits (hands, feet), and the facial expressions of the subjects. For example, I can have him kiss the side of her head, and then have them tilt their heads together. I can have them look at the camera, look at each other, and then close their eyes. She can place her hand to his chest or face. Open the eyes; close the eyes. Eye contact; no eye contact. Kiss; no kiss. Remembering a few simple options opens up a great deal of variety.

Keeping the camera in one place, let's take a look at this in action.

7.37 Base 1: Woman in front of man

7.38 Base 2: Woman facing man

These are the four base poses I begin with: the woman in front of the man with her back to him, the woman facing the man, the woman to the side of the man, and the woman slightly behind the man. You can create endless variations of these four poses.

7.39 Base 3: Woman to side of man

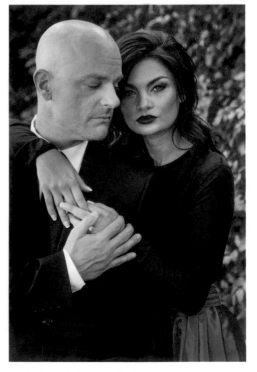

7.40 Base 4: Woman behind man

Changes in the Photographer's Settings

So far, I've made adjustments to the pose and position of the subject. I've varied expression, hand placement, and overall poses. Fortunately, that's not all I have available to create shot variety. From these basic poses, I can change the following: camera angle, crop, and focus.

1. **Camera angle:** You can move around the subjects. While the woman is making the rounds around her man, you can also move around them. Every different position reveals a different take on that same pose, and may show you a unique perspective. Get a lower angle. Get a higher angle. Move, move, move to discover variety.

2. **Lens choice and crop:** Choose a different lens or focal length, or change the crop of your frame. Even the same pose and same angle can yield drastically different results when you adjust your crop. Try mid-length, full-length, and close-up.

3. **Depth of field and focus:** Changing your depth of field changes the center of interest in a photo. Try one shot with a narrow depth of field focused on the man, and another on the woman. Focus on the ring on her finger. Using different points of focus and changing depth of field, you can create completely different takes on the same pose.

So, how to create endless variety? For each pose, I start to move around my subjects while switching my depth of field, my focus, and my crop. Once I've worked one pose, I can vary an expression or hand placement for more variety. Then I proceed to move around, change crop, vary focus, adjust depth of field, and more. When I'm ready, I "make the rounds" and switch the subjects' position, then repeat. One reason I call this technique "making the rounds" is that, not only do I move my female subject around the male subject, but I also move around both subjects!

When I put this into practice for a real couple's session, I am able to get the following 39 images from the four base poses within a 5-minute timeframe (**FIGURES 7.42a–h**, **7.43a–p**, **7.44a–h**, and **7.45a–g**). Here, you can see the wide range in images this technique can produce, without any drastic adjustments to posing.

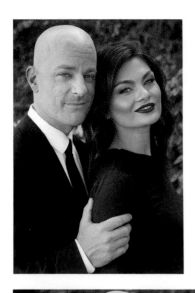

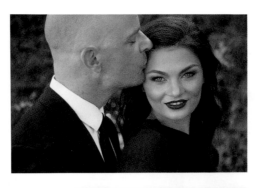

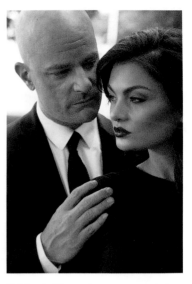

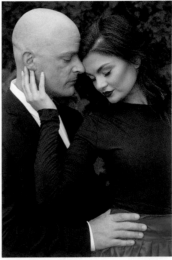

7.42a–h These images were taken with a base pose of the woman standing with her back to the man's chest.

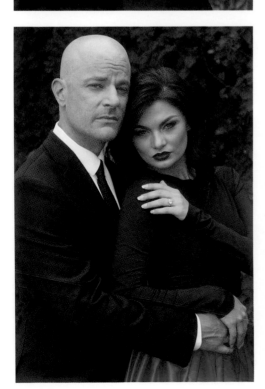

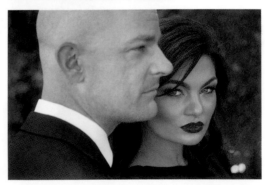

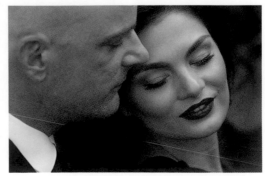

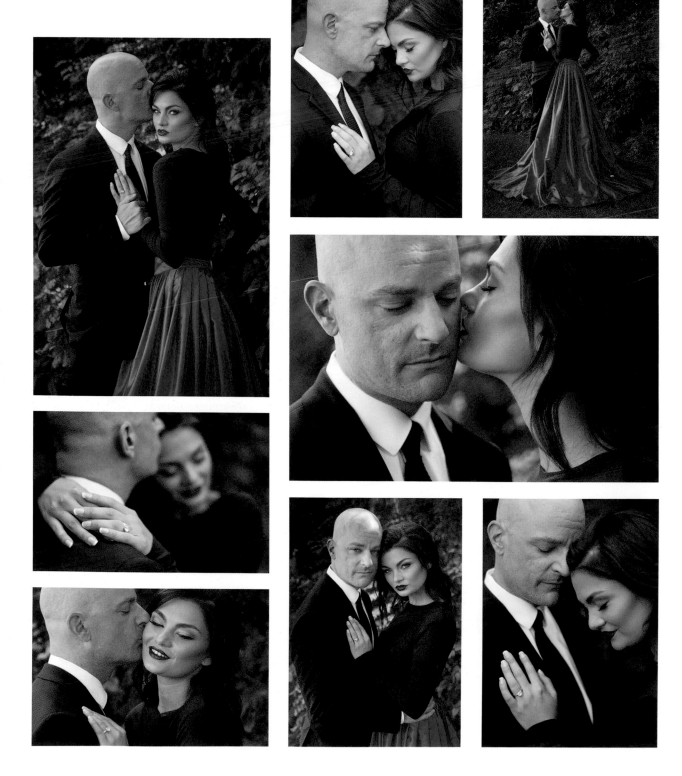

7.43a–p These images were taken with a base pose of the woman and the man facing each other.

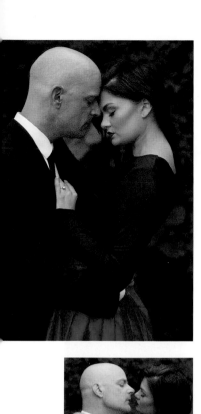
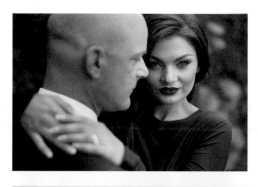
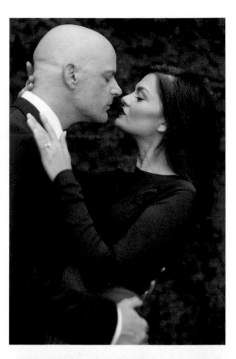
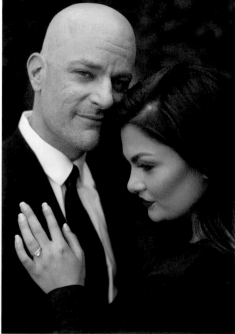
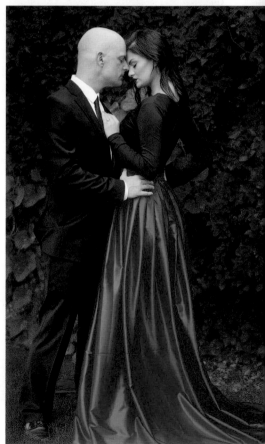
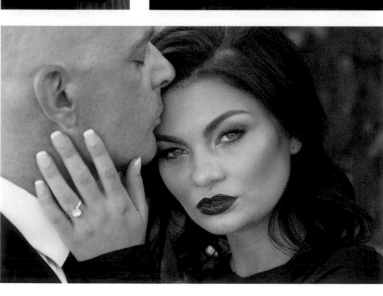

7.44a–h These images were taken with a base pose of the woman standing off to the side of the man.

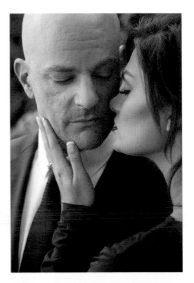

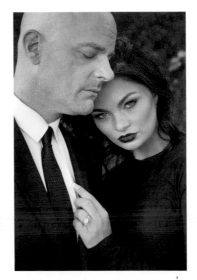

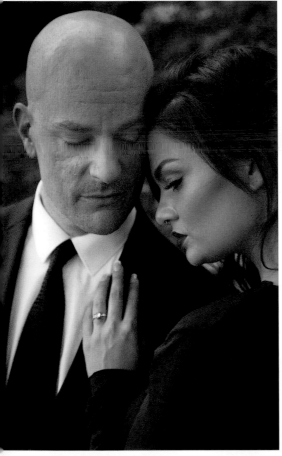

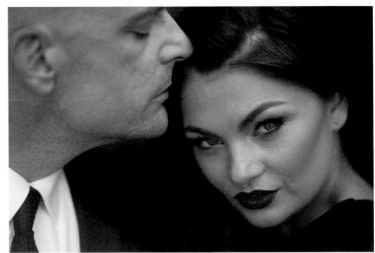

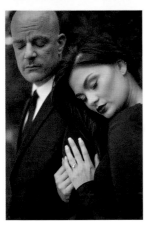

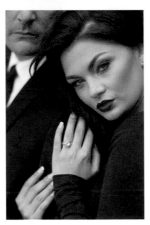

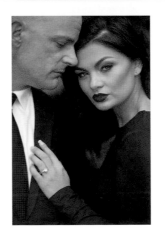

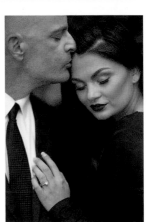

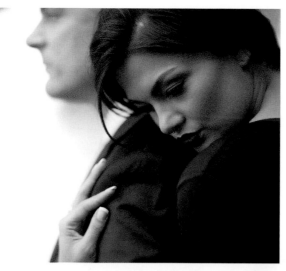

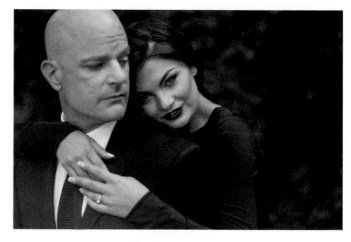

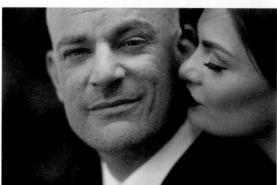

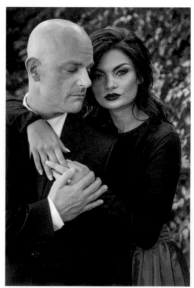

7.45a–g These images were taken with a base pose of the woman standing behind the man.

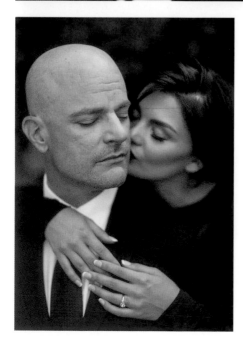

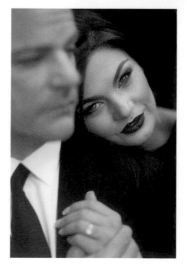

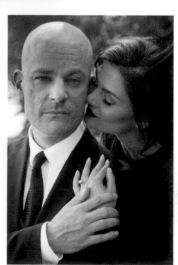

MASTERING *Your Craft*

DOUBLE CHINS

There is a lot to think about when photographing a couple...but don't forget the chins. Remember, keep the chin out and down when possible. If a couple is close together for a kiss, be sure neither person is pulling their chin back. In **FIGURE 7.46**, he kisses the side of her head, but because the couple

❌ **7.46** (right)

✅ **7.47** Be cautious of creating double chins in your couples poses. Sometimes you may need to adjust a kiss pose, for example, so that one person isn't pulling their chin back too far (below).

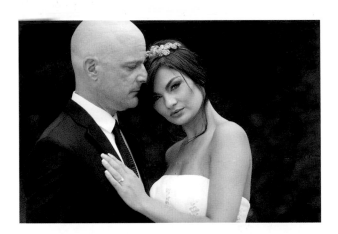

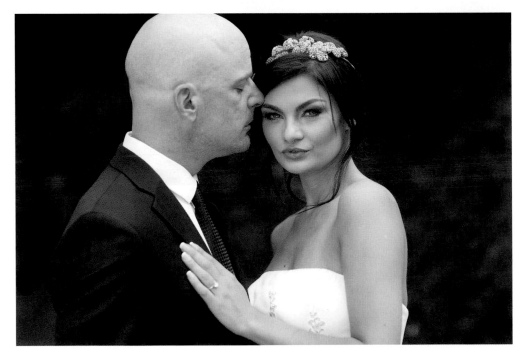

is a bit too close, the man appears to have a double chin. If necessary, put a bit more space between their heads so that the chin is stretched outward to reduce problem areas (**FIGURE 7.47**). Furthermore, if there is a pose you want to shoot but you simply cannot adjust the pose to eliminate the double chin, try obscuring the problem. Perhaps the bride reaches up and gently touches the groom's face, thus slightly hiding any unflattering results. You can see this before/after solution in **FIGURE 7.48** and **FIGURE 7.49**. ■

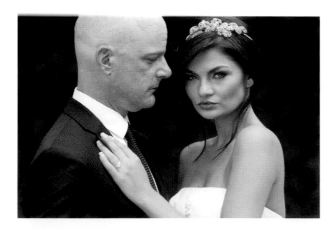

7.48 (left)

7.49 When creating a pose that results in a double chin that you cannot seem to fix, consider using a carefully placed hand or caress to hide the problem area (below).

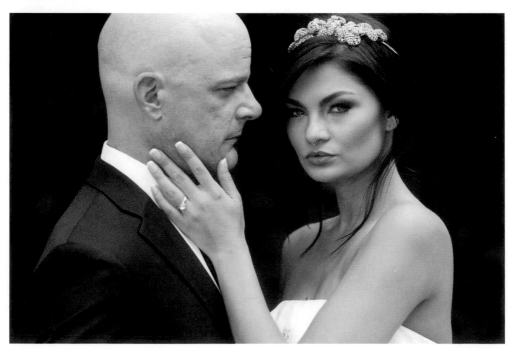

Quality and Expression Over Quantity

Remember that quantity has *nothing* on quality. More poses and more variety doesn't mean better images. Sure, once you hear about flow posing or "making the rounds," you may feel as if it's your job to get 50 different photos. This is not true at all. Certainly, some variety with excellent quality will help you with sales, but if you fail to capture genuine interaction and expressions, then the images fall flat.

Furthermore, don't feel the need to always be exact with your posing. Invite the subjects to move, to dance, to kiss, and to interact. You may find that more candid shots are your favorites of all. With time, you'll develop your own techniques to get genuine interaction between subjects based on their personalities and your shooting style. Some photographers may choose to pose a precise female "S" curve and traditional male stance. Others invite the couple to tease one another on the edge of a kiss. Others will invite the couple to dance or tickle one another. Your approach will come with experience and learning to read your couple. Don't let the concept of posing or flow posing limit the possibilities or reduce your attention to the interactions of your couple. Use these posing techniques as a place to start, and don't forget the supreme importance of expression.

TRAIN YOUR EYE

Now that we've looked at the many considerations for photographing couples, it's time to put our knowledge into practice. Let's see if you can determine the problems and solutions.

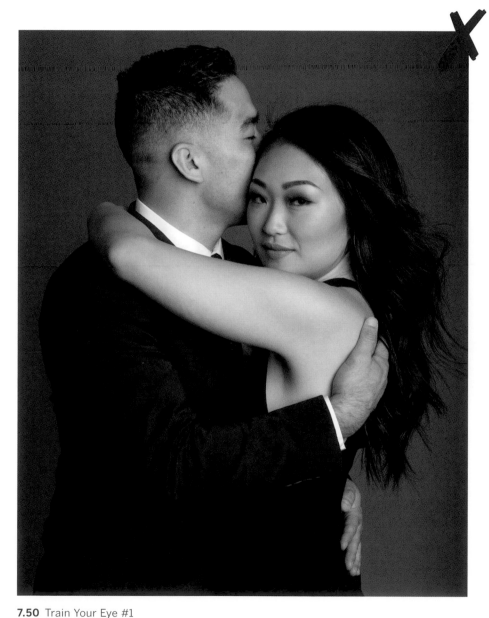

TRAIN YOUR EYE #1

Study **FIGURE 7.50** and see if you can identify the problems in the image.

7.50 Train Your Eye #1

Let's see how you did. Compare **FIGURE 7.51** with the solutions in place in **FIGURE 7.52**.

⊗ *Problems*

Arm Position: Her arm is raised, becoming a distracting element in the frame. Not only does it draw a lot of attention, but it also obscures her face.

Face: His face is hidden by hers, and thus we are unable to see any connection or emotion.

Feet: It appears as if they are both standing flat-footed and square to one another.

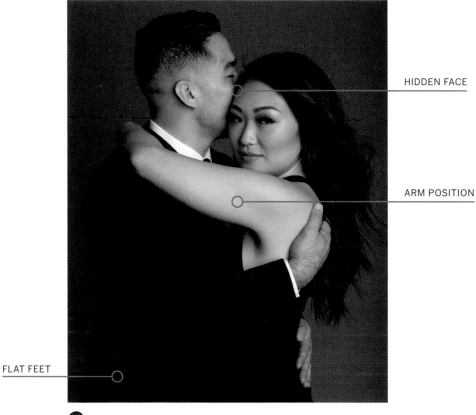

HIDDEN FACE

ARM POSITION

FLAT FEET

⊗ **7.51** Problems

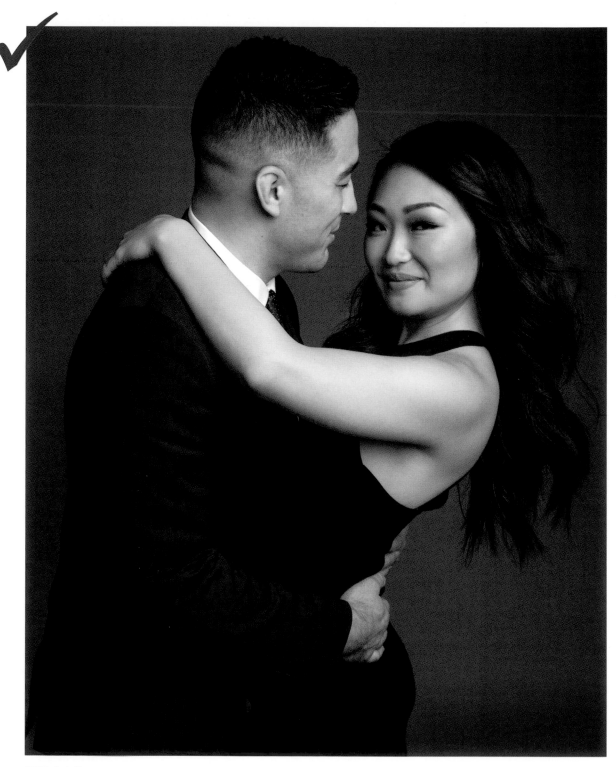

7.52 Solutions

✅ *Solutions*

Arm Position: By slightly lowering and bending her arm, we create a more flattering curve and shape to the arm. Furthermore, now we are able to see her face, jaw, and neck.

Face: By pulling their torsos slightly apart, we can now see his face as he looks at her affectionately.

Feet: By adding a bit of a bend to their knees, we're able to bring their mid-sections closer together, and he can now slightly dip her, giving the pose a bit more flow and movement.

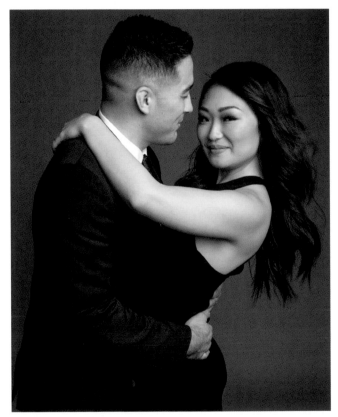

✅ **7.53** Solutions

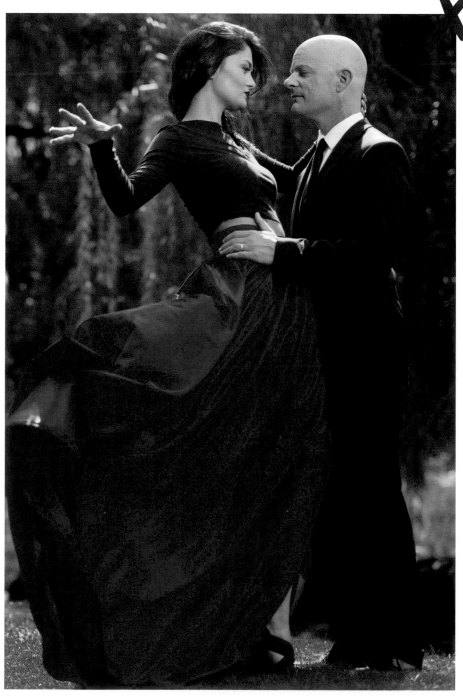

7.54 Train Your Eye #2

TRAIN YOUR EYE #2

Study **FIGURE 7.54** and see if you can identify the problems in the image.

5 GO-TO POSES

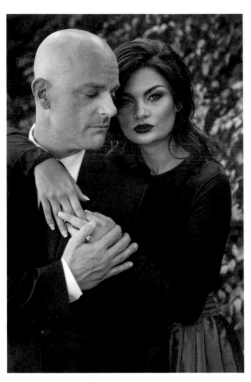

POSE 1 She stands behind and to the side, with her arms wrapped around his shoulders.

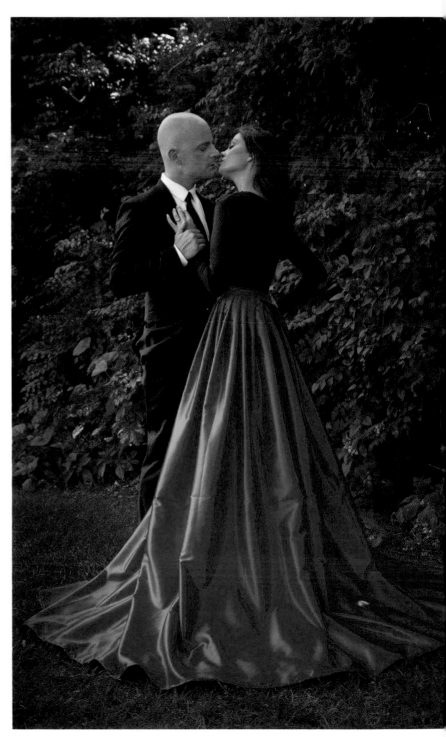

POSE 2 They face each other just before kissing. Her right hand is on her hip, her left hand to his chest. His hands are to her hips and holding her raised arm.

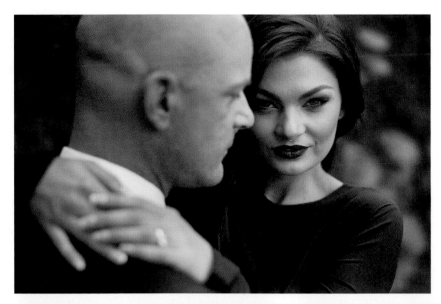

POSE 3 She places her arms loosely over his shoulders and neck while she looks at the camera.

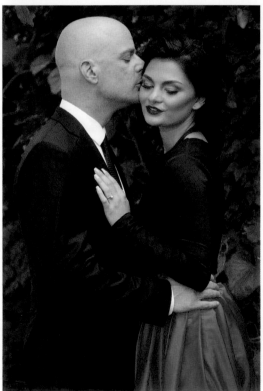

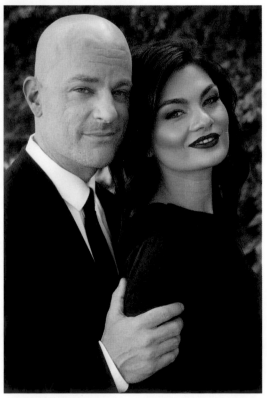

POSE 4 They face each other, his hand on her hip while he kisses her head. Her hand is on his shoulder.

POSE 5 He stands behind her with her back to him, with his hand to her arm.

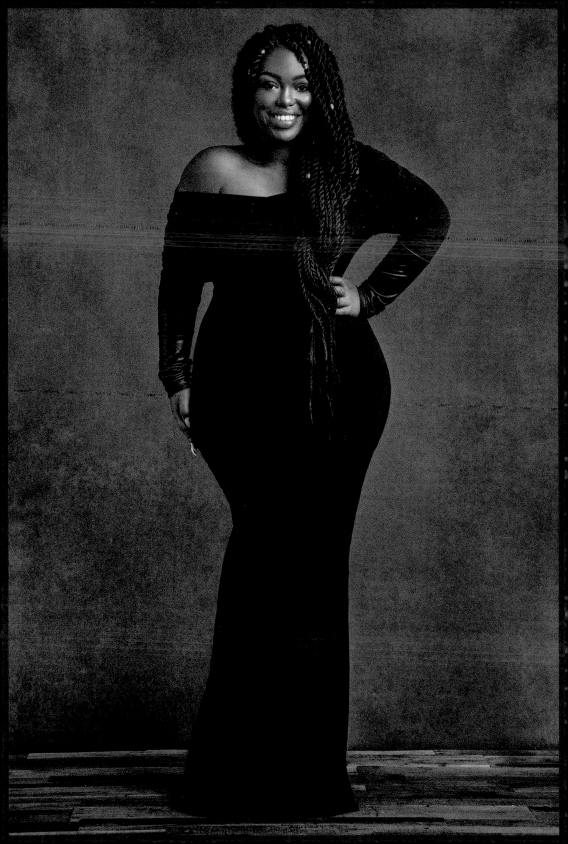

CURVES

Every single woman, of every shape and every size, deserves to look and feel incredible in a photograph. This is why it's so important for photographers to understand every element of their craft—especially posing. The photographer's job is to use our photographic toolkit to bring out the best in a subject to help them appreciate their own beauty. Many fuller-figured subjects have been wounded by a bad photo experience, or they have been trained to believe they can't look good in a photograph. As photographers, we can change that perception.

When photographing fuller-figured subjects, it's important to keep in mind that everyone is different. No single pose is universally flattering, and there is no single perfect camera angle. You can't take a cookie-cutter approach to photographing curvy subjects. In this chapter, the subjects range from U.S. size 12–24, and each subject has a unique shape.

The guidelines discussed in Chapter 5 certainly apply here, and are as important as ever. Think of this chapter as an addendum to Chapter 5, it's an extension of considerations that will help ensure success and confidence for all involved. These guidelines are not hard rules that must be utilized for every person; they are tips to keep in mind to help with visual problem solving.

Guidelines for Posing Curves

Use these guidelines to photograph curves and fuller-figured women in a way that helps them look absolutely incredible. Show their individual strengths, and let your confidence feed their confidence. Now let's dive in!

Exaggerate Pose and Perspective

When photographing a curvy or full-figured woman, posing can make or break a shot. There are many things to keep in mind when trying to flatter your subject. For example, refer back to the section on perspective in Chapter 1. If you want the hips and waist to look smaller, push them away from the camera. If you want them to look much smaller, push them much farther away from the camera (or try a different camera angle). Sometimes I'll even have subjects push their hips far away and lean down a wall for balance. In other words, I take the lessons we've already discussed, and go a bit more extreme!

You've heard that the camera adds 10 pounds, but the camera can also be used to remove 10 pounds, or more. Let's start with what we've already discussed: Whatever is closer to the camera will appear larger. Whatever is farther from the camera will appear smaller. In this first shot, **FIGURE 8.1**, our subject has pushed her hips toward the camera, creating several problems. Her hips and midsection look much larger, and she has no negative space between her arm and her body. We've also hidden her neck. In **FIGURE 8.2**, I've asked my subject to push her hips away from the camera as far as possible while staying balanced. I've directed her by demonstrating the exaggerated pose. You can see the difference in the result!

Let's consider some examples of exaggerating pose and perspective to achieve more dramatic results. I'll begin with a pose that I use often for women—one foot back, weight kicked onto the back foot, chest leaning

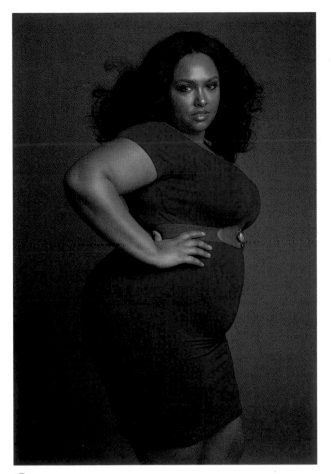

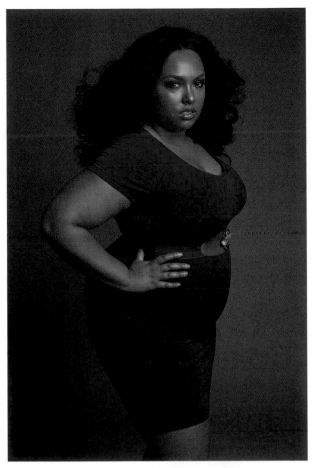

❌ **8.1** With the hips pushed toward the camera, the model's midsection and bottom look larger. There is no negative space between her arm and her body, and the pose hides her neck.

✅ **8.2** I direct my subject to push her hips as far away from the camera as possible, making them appear smaller and creating a more pleasing body shape in-camera.

forward (**FIGURES 8.3–8.5**). Use this pose for fuller-figured subjects; just exaggerate it to produce more pleasing shapes. To an onlooker, the pose may appear awkward and exaggerated, but it looks good in the image!

Look at our subject's feet. In Figure 8.3, our subject stands with her feet side by side (an unflattering pose). Posing straight on toward the camera makes her appear wide, and the position of her feet (flat) makes her appear square. To improve the pose, have her place one foot behind the other, slightly kicking her weight onto her back leg (Figure 8.4). This narrows the

For 3/4 shots of curvy women, I often find myself shooting from a much higher angle than usual. Whatever is closest to the camera looks largest, and by getting at a high angle, I bring the subject's face and chest closer to the camera, giving them more emphasis in the shot. Furthermore, whatever is farther from the camera (her hips and waist) will look smaller the higher my angle. In **FIGURE 8.10**, I am shooting from an angle about even with the subject's midsection, making it garner a lot of visual attention in the image. In **FIGURE 8.11**, however, I am quite a bit higher than eye level. Look how tiny the bottom portion of her body becomes! My higher-than-normal angle helps me achieve this pleasing result. Just remember that you'll need to determine what height is appropriate to flatter each individual subject.

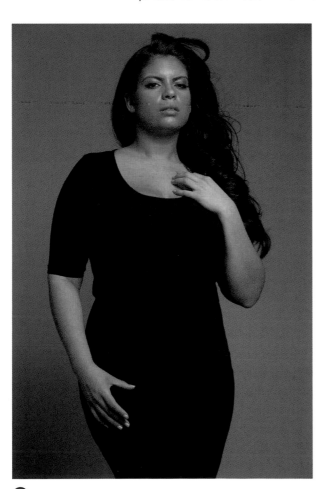

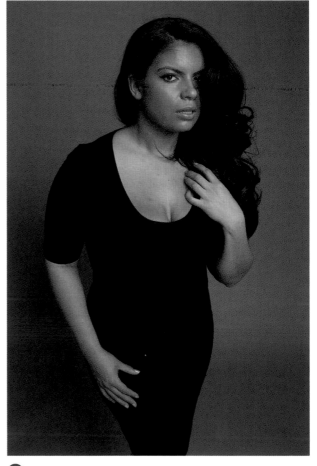

❌ 8.10 A low angle puts more emphasis on the midsection of the subject.

✅ 8.11 For curvier subjects, I tend to shoot at a higher angle than normal to make better use of perspective. Here, my camera angle is quite a bit higher than eye-level.

Choose Clothing Carefully

Yes, I know this is a posing book. We aren't concentrating on lighting, hair and makeup, or styling. Nevertheless, it is very important to at least touch on the topic of clothing. If your subject is dressed incorrectly for a portrait shoot, it will make posing them in a flattering way more difficult. Let's examine a few great clothing guidelines that will ease your job as a photographer.

The Fit

Subjects who are uncomfortable with their bodies often wear clothing that simply does not flatter them. Some wear extremely oversized or loose-fitting clothing to hide their form. Unfortunately, in photographs this only exacerbates the issue. With baggy clothing, no matter what you do in posing, the form is hidden! Baggy clothing will cause mergers and make it harder to create narrowing points. You won't be able to create negative space when needed, nor use the outlines of the body to create any flattering shapes.

This doesn't mean that the clothing should be skin-tight either. Clothing that is too tight draws attention to less flattering shapes created by the fit of undergarments. Clothing should fit the form. If an article of clothing is too baggy, use mini A-clamps and pins to improve the fit for the photo shoot.

Let's take a look at **FIGURE 8.12**, which shows the clothing my subject is wearing upon arrival to her shoot. While this outfit may be comfortable on the street, the loose-fitting sweater will make finding flattering poses more difficult. Loose clothing tends to make subjects look wide.

PRO TIP

For styling a fuller-figured subject, there are several websites that rent beautiful clothing that might be a fantastic option for your client or your photo shoot. Check out Rent the Runway (renttherunway.com) for up to size 22 gowns and chic pieces; and Gwynnie Bee (gwynniebee.com) for everyday, ready-to-wear lines up to size 32.

Our eyes are drawn to areas of contrast. For example, in Figure 8.12, our eye is drawn to the line where the subject's shirt meets her jeans. Unfortunately, this is at the widest part of her body. In **FIGURE 8.13**, the subject is in a similar pose, but wearing a form-fitting dress. She looks significantly slimmer, and it will be easier to pose her form.

For **FIGURE 8.14**, my subject has asked to be photographed wearing an oversized black sweater on top of her outfit. No matter how many different poses I try, it is extremely difficult to see the edge of her body. Even using her hands to define the waist does little to flatter the form.

Your subject, however, does not always need to be wearing form-fitting clothing. In fact, flowing dresses and fabric can be a great solution for dressing the lower half of the body, as long as the waist remains defined. In **FIGURE 8.15**, the dress is flowing, but still fitted to the form. This creates a beautiful and dramatic result.

Undergarments and Shapewear

One subject that is often overlooked is proper undergarments. They can make a profound difference in the way your subject looks and photographs! I'm not only talking about wearing a bra that gives proper support, but also using shapewear to lift and tighten the form. For example, Spanx or similar shapewear can help smooth the form to make clothes fall in a more flattering way in your images. I consider it an absolute must, and I include it in my pre-shoot preparation guide. Proper undergarments can transform the look of an outfit, which means significantly less retouching in Adobe Photoshop to smooth edges (the fewer times you have to say "Don't worry, I'll Photoshop it!" the better).

⊗ **8.12** While these clothes are fine for everyday wear, the baggy sweater will make posing more challenging because it hides negative space and the outlines of the subject's body.

✓ **8.13** While keeping the pose the same, the more form-fitting clothing makes it easier to pose and shape our subject.

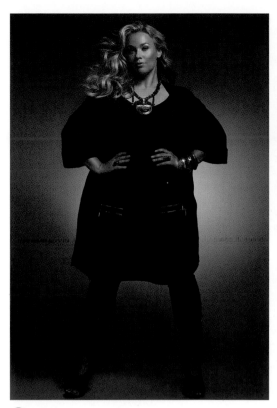

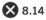 8.14

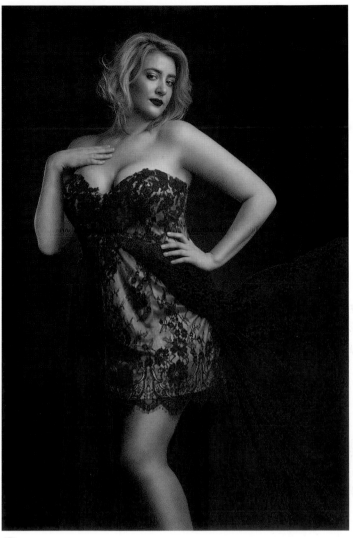

✔ 8.15

Shapewear helps a subject look curvaceous rather than lumpy. It doesn't necessarily make them look skinnier, but it does make the curves smoother and more visually pleasing.

Color

The colors you choose can make some poses more or less flattering. For example, a light color or bold pattern may make one pose look unflattering, whereas the same pose in a solid color may be visually pleasing. The idea that black is slimming is based in truth. Do I feel that all fuller-figured subjects need to dress completely in black? Absolutely not! In general, though,

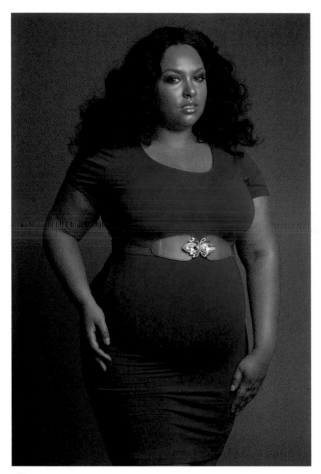

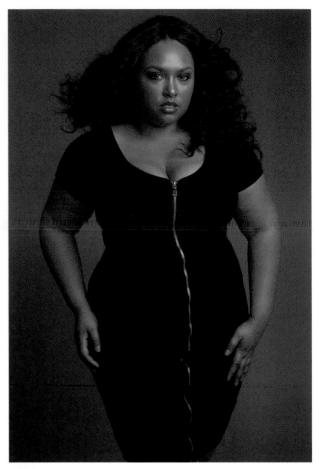

❌ **8.16** The blue dress is a beautiful color, and the definition to her bust and her waist are exaggerated in a flattering way. Unfortunately, there is a distracting shadow beneath the midsection.

✅ **8.17** The black dress hides the shadow beneath the midsection and creates a more slimming result, though the bust and waist look less defined than they do in the blue dress.

solid and darker colors may call less attention to broad or thick areas of the body.

Let's look at an example. My subject looks beautiful in her blue dress (**FIGURE 8.16**). I've chosen this dress because I love the color on her. Notice, however, the shadow near her abdomen. In a black dress with a similar pose and the same lighting (**FIGURE 8.17**), that shadow is nearly eliminated to the camera's view. The blue dress combined with the belt emphasizes her bust, but the black dress is much more slimming. These are all considerations to make when selecting just the right outfit for your subject.

To learn more about clothing for curvy subjects, visit
🔗 **learnwithlindsay.com**!

Define the Waist

Our subjects don't need to be slender to have a gorgeous shape. It doesn't matter whether your subject is a size 2 or 22; a defined waist is generally considered aesthetically pleasing. Finding ways to define the waist is generally a must with fuller-figured subjects. Our job is to add definition to help emphasize curves and femininity. A defined waist can create an hourglass figure and more pleasing lines for the eye to follow.

Clothing Choice

Clothing choice can help define a subject's waist, as in **FIGURES 8.18** and **8.19**. Options include a carefully placed gathering of fabric, the cut of a dress, or the addition of a belt. In these examples, the subject appears to have a defined waist, but this shape is created by the cut of the dress: the contrast point and the fabric tie appear just below the bust. Depending on the subject, I often select clothing that ties or gathers around the waist, or tops and dresses with an empire cut. Any outfit that is form-fitting at the bust, but then flairs out below the waist, can emphasize the appearance of narrowing at the waist.

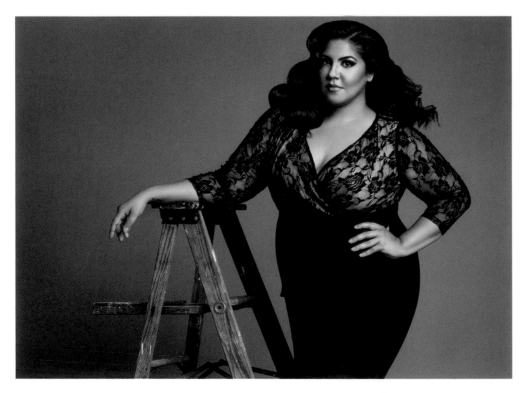

✓ **8.18** In this image, the waist is emphasized by the cut of the subject's clothing. Note that the skin has been retouched in this image, but the body remains untouched.

Here's another example: In **FIGURE 8.22**, the subject places her hands on her natural waist, with the hands toward the outside of the body. While this does define the waist slightly, there is quite a bit of space between the hands. Our brains interpret this distance and perceive the subject to be wider. No problem—we can make an adjustment to the pose!

In **FIGURE 8.23**, I've invited my subject to slide her hands farther forward and closer to one another. This tricks the eye into perceiving a narrower waistline. Because the space between the hands is smaller, our brains interpret her to be more slender at the waist. Voila! We have a waist and a flattering shape created by a pose!

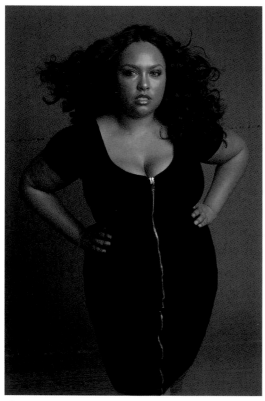

 8.22

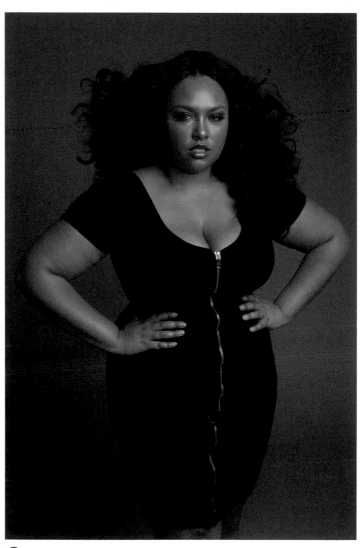

✔ 8.23

Posing the Arms Within the Frame of the Body

Mergers occur when the arms are tight to the body, making the body appear wider than it actually is. This can be fixed by creating space between the body and the arms or by posing the arms within the frame of the body.

In-body posing can be another great way to help create the illusion of waist. Ask your subject to cross the arms inward to give the impression of tapering near the waist. While the waist is not actually visible or defined, the eyes perceive an hourglass shape as they follow the arms posed within the frame of the body.

While in-body posing can be useful, some fuller-figured subjects may find in-body posing a bit difficult because of some of their features. Feel free to give it a try, but remember to adapt since every subject will be different. If bringing the arms in, for example, creates too much tension in the bust or makes the subject look wider, you may want to back off the approach enough to release the pressure.

Whether you're achieving pleasing shapes for the subject's body through clothing choice, hands on the waist, in-body posing, or another approach, adding definition to the waist will almost always improve the results for photographs of fuller-figured subjects.

Create Visual Balance

One of the tricks of photography is creating balance in your photographs. Where does your eye go when you look at the shot? Is that where you want it to go? Are you controlling and directing the viewer's eye within the photograph to support the goal of the photograph? In a portrait, our goal is typically to flatter and to bring attention to the subject's face.

Direct the Eye

When photographing curvy subjects, sometimes poses or shots may suffer from lack of balance. Our eyes may be drawn too much to the midsection or bust, which will make the overall balance of the shot seem off. I'm not saying that a person shouldn't appear to have one area of their body that is larger than another—everyone's build is different and it's fine to showcase diversity in a body type—but make sure to cater the pose to the subject to avoid drawing attention to the wrong places.

For example, if your subject is much fuller on the bottom portion of her body than the top, you can add visual balance to the top of the image. If you don't want to make a subject's hips look wider, then you wouldn't want your subject to wear a shirt that ends at the hips, or place her hands in her pockets, which draws attention to the hips. These elements direct the eye to the midsection and away from the face—typically not what you want from a portrait.

As another example, you may have a subject with a full bust that grabs a bit too much of the viewer's attention. What can you do to balance the shot? Perhaps a flared skirt can provide some visual balance, as will avoiding a deeply plunging neckline that draws the eye to that area.

There are several ways to create visual balance, including variation in clothing, hair, and hands. Remember: if your eye is going where you don't want it to...fix it! You need to find a way to draw attention back to the face and create more balance in the image.

Clothing

A viewer's eyes will be drawn to areas of the clothing with embellishments (lace, buttons), patterns, bright and light colors, or areas of contrast. Use this knowledge to draw attention to or away from certain parts of the body. For example, if you want to draw attention away from a full midsection, a look with a solid, dark color would be preferred to a richly colored pattern in most instances.

Hands

As discussed previously, hands are like arrows. They create a subconscious "look here" signal to the viewer, regardless of where you place them on your subject. Want the viewer to look at the chest? Place the hand on the chest. Want them to look at the hips? Place the hands on the hips. Use hand placement as a way to balance your frame. For example, if a curvy woman happens to love her buttocks and wants more attention drawn there, a hand on the bottom is just the ticket! That being said, let's talk more about balance. If a subject has very wide hips and doesn't want attention drawn to the hips, do not place her hands on the hips. Instead, placing the hands more toward the chest or face would help to create balance in the shot.

Hair

Through my years of shooting curvy women, I've discovered that hair can be a useful tool for providing balance to a shoot and bringing more attention to the subject's face. Instead of having hair flat against the face and body, use a fan to create volume. Not only does this create a glamorous look, it also draws attention upward toward the face and balances the top and bottom of the frame. When your subject has long hair, be sure that it does not completely obscure the neck. I use a variable-power floor dryer to help blow the hair away from the face. These dryers are versatile and inexpensive—and they work great!

Compare **FIGURE 8.23**, the shot in which the hair is lying flat, and **FIGURE 8.24**, the shot in which the hair looks full. In Figure 8.23, the viewer's eye is drawn to the lower two-thirds of the shot, including the midsection and hips. The upper portion of the frame, including the subject's face, grabs less attention. In Figure 8.24, however, we've added a great deal of volume to the hair by using the fan. Since the hair takes up a lot more of the frame, it creates visual balance, and draws the viewer's eye upward.

Let's take a look at one more example, one that combines all of the elements. **FIGURE 8.25** is unsuccessful. My eye is drawn directly to the subject's hips, making her appear wider. My eye then becomes trapped in the area around her midsection because there is no waistline to break up the shape of her body. Finally, my eye is drawn to the lighter tones of her arms, but it takes me forever to make it to her face. Once there, her hair is flat around her neck, and I quickly lose interest. Overall, the balance is off. I'm stuck focusing on her midsection and her arms, not her face.

FIGURE 8.26 utilizes clothing, hair, and hand placement to make the image more balanced. The dark clothing downplays the shape of the subject's body, and the

✖ 8.23

✔ 8.24

 8.25

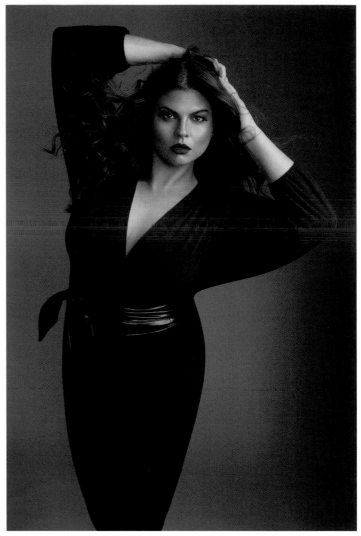

✓ 8.26

plunging V-neck brings more attention to her face and chest. The hands are placed toward her head, directing the eye upward. The blown-out hair also demands more attention and adds visual weight to that part of the frame. These choices slenderize our subject, but more importantly, they bring attention where it belongs—to her stunning face!

As you look at these examples, remember the core question we have been asking ourselves: Is the eye looking where it should; and, if not, what can we do to direct it more successfully? Find ways to create more pleasing visual balance with posing, hand placement, hair, and clothing.

MASTERING *Your Craft*

SOLVING THE "SEATED" PROBLEM

When you photograph a person seated, there are potential problem areas, which are especially prevalent with curvy subjects. As previously discussed, our subjects may feel compelled to lean back in a chair or couch, creating terrible posture, a short neck, and hunched shoulders. For this reason, I often pose my subjects in chairs without backs, or I have them lean forward. Be hyper-aware of your subject's posture.

When our subjects are sitting, often the skin or rolls in their midsection gather. With form-fitting clothing, this may be objectionable to our subjects, as they won't feel as flattered. As you sit reading this sentence, perhaps you see the same result occurring with your own body. With fuller-figured subjects, this posing problem becomes even more important to tackle. So, what can we do?

First, we can elongate. Ask the person to sit up tall, move toward the end of the chair, and elongate a leg, and you will see this problem reduced. Another option is to pose them in a way that helps to obscure this problem area. Let's take a look at an example.

In **FIGURE 8.27** our subject sits back in the chair with good posture. Unfortunately, her midsection and stomach appear pronounced, particularly accented in this form-fitting dress. Furthermore, her body position makes her look very boxy and short, with her legs tucked in. A majority of attention falls on the middle of the body. To improve this pose, I have my subject scoot forward on the chair and elongate her body by putting one arm back and one leg forward (**FIGURE 8.28**). Not only does this stretch out the midsection, it also makes

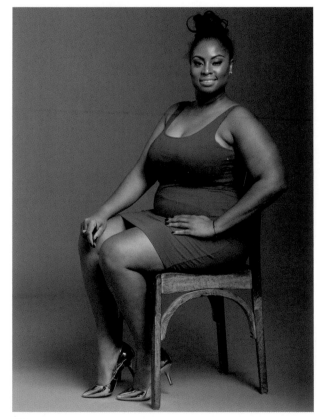

✖ **8.27** When a subject sits, typically the midsection gathers and creates unflattering shapes.

her appear much taller and longer to the camera as your eyes follow the lines of the body. Try this yourself at home. Can you feel how this elongates the body and tightens the midsection? Also, because our subject has turned slightly toward the camera, the contour of the stomach is less visible and thus more flattering. Sometimes even a slight rotation of the subject's body or tiny adjustment of camera angle can reduce the appearance of rolls, bulges of skin, or other distracting elements.

If you or your subject still finds the midsection problematic, try placing an arm over the midsection to obscure it. In **FIGURE 8.29**, you see that her body looks longer and the attention is back on her face, rather than the midsection. Also notice the use of a narrowing point by having the legs narrow where the knees meet, instead of stacking one on top of the other, which would make them appear wider! ■

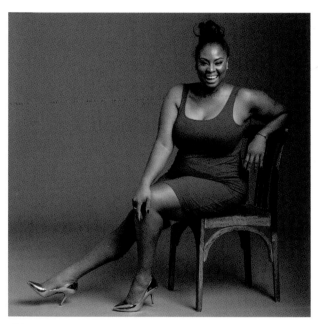

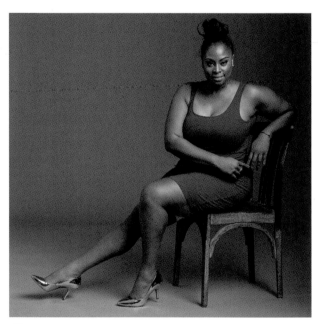

✅ **8.28** By moving the subject forward, we are able to elongate her body. Stretching one leg out and one arm back improves her posture even more. This pose stretches and tightens her midsection, reducing the bulging shape to the camera's view.

✅ **8.29** If you still find the midsection distracting, consider carefully posing or placing a hand to obscure the problem area.

Cropping and Narrowing Points Are Your Best Friends

Without narrowing points, curvy woman often look wide instead of curvy. If they have the curves...show them off by creating narrowing points or by cropping your shot to create more dynamic shapes!

Narrowing Points

As we talked about in the guidelines for photographing women, narrowing points can be a useful tool for creating an hourglass shape or making the subject look narrower to the viewer's eye. For photographing curvy subjects, this tool will be more important than ever. In fact, I'd call it one of the most effective weapons in my photographic arsenal for creating shots of curvy women.

Narrowing points also apply to a seated subject. If the subject's legs are stacked, one on top of another, or appear side by side while seated, the subject will appear wider. Joining the legs at the knees and bending one leg, with the other straightened out, will create a seated narrowing point.

In **FIGURE 8.30**, my subject has some great curves to work with, yet I'm not really showing them off. My eyes exit the frame within a rectangular shape, making the lower half of her body look boxy instead of curvy. I'm simply not doing her justice.

But when I bring her knees together (**FIGURE 8.31**), I create a tapering point to her legs at the bottom of the body. Suddenly, all I see are curves! Furthermore, my eye now exits the frame at a narrowing point, creating a more dynamic triangle shape that makes her appear narrower. This is what narrowing points are all about!

Cropping

The combined elements of camera angle, narrowing points, and selective cropping are indispensable. As I bring up cropping while talking about curvier and fuller-figured subjects, I am not saying only to shoot headshots of your fuller-figure subjects. Don't crop out problem areas or areas you aren't comfortable posing. It's unfair to your subjects. Early in my career when I was extremely inexperienced with posing, I often just shot the head and

⊗ 8.30

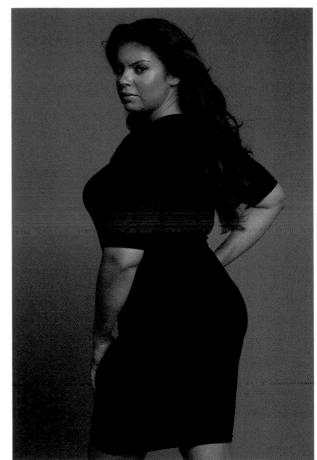

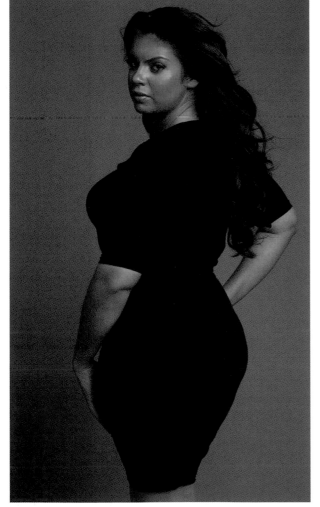

✓ 8.31

shoulders of subjects if I felt overwhelmed. Now I can see how foolish and unjust this was. When you study this book and this chapter, you should have all the tools you need to create stunning full-length and mid-length shots of your curvy subjects.

Know how cropping can affect your image. Generally, you want to crop at a narrower point of the body. For example, you are better off cropping just above the knees rather than at the hips or mid-thigh. When you crop at a wider area, the viewer's brain will not be able to extrapolate the subject's true form.

Here are two different crops of the same image (**FIGURE 8.32** and **FIGURE 8.33**). Each crop creates a different effect, and you'll have to choose what is most effective for your intended photographic goal. In Figure 8.32, we've cropped just below the hips at a wider part of the subject's body. To the viewer's eye, she appears more wide than curvy. Figure 8.33 is cropped at a point where her body narrows, and the viewer's eye follows the curves of her body in a more pleasing way. If the shadow beneath the midsection is problematic to you, you may prefer the tighter crop. Typically, however, cropping at a narrower point will yield more flattering results.

In **FIGURE 8.34** and **FIGURE 8.35**, my bold and beautiful subject wanted to try some bodysuit images for her modeling portfolio. In Figure 8.34, the pose suffers from many issues—the camera angle is too low (emphasizing the midsection), her chin is out (the skin beneath it is soft), her legs are side by side (making her appear boxy and narrow), and her arms are merging, creating no separation or flow to her form. To improve the shot, I use cropping, perspective, and narrowing points. I ask her to create a narrowing point by crossing one knee in front of the other. Next, I ask her to lean more toward the camera while placing her hands on her waist to create negative space. By cropping just above the

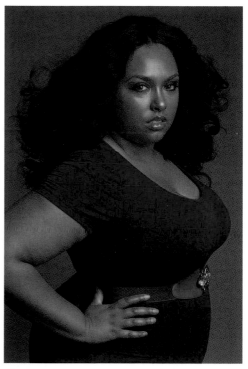

❌ 8.32

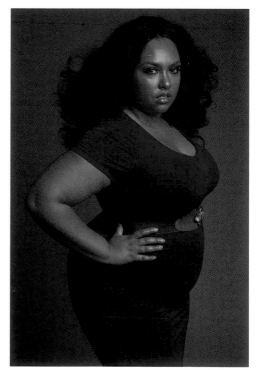

✔️ 8.33

5 GO-TO POSES

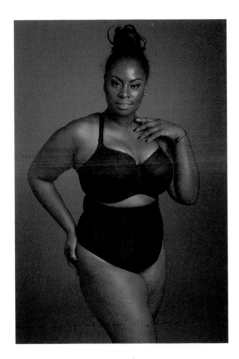

POSE 1 Legs meet at a narrowing point with the subject slightly turned to the side. One hand should go on the hip or waist, to define the waist, with the other to the waist, chest, or face. A higher camera angle with the chest leaning forward is usually preferred.

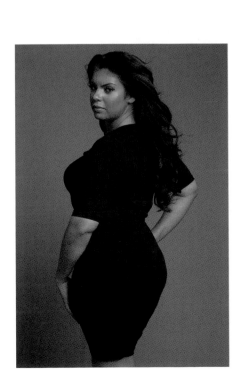

POSE 2 The subject is seated away from the back of the chair. The arm closest to the camera is either on the waist, thigh, or elbow. One leg should be extended outward, with the other hand extended on a knee. The arm can be straight or have some bend to it.

POSE 3 The subject is turned away from the camera with the knees meeting at the bottom at a narrowing point. The far arm is bent, leaving negative space between the arm and the side of the body. The arm closest to the camera should not obscure the chest, and a slight bend is preferred. To emphasize the bottom, it can be posed closer to the camera.

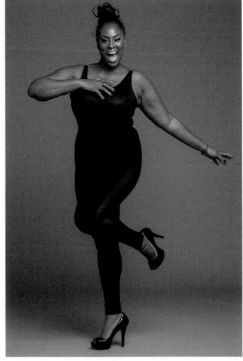

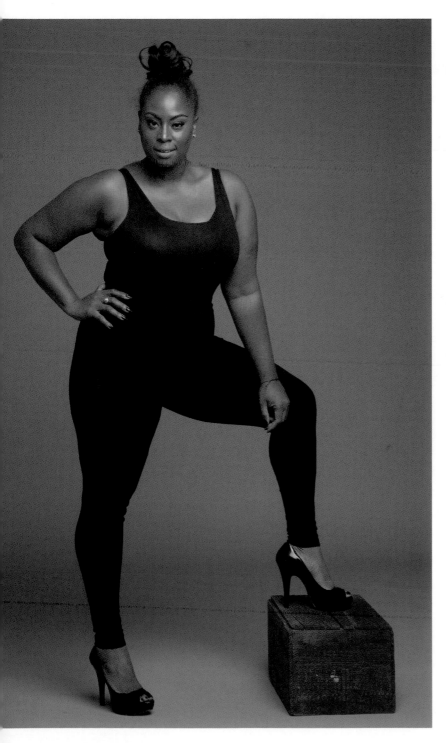

POSE 4 The subject steps while raising the knee closest to the camera. The subject should have good posture and lead with her chest. Do not push the stomach toward the camera. The arms help to control the mood of the shot. Here, one arm is back and flowing, while the other is to the chest.

POSE 5 One knee is up on a box. The arm on that side is placed on the knee or thigh, while the other hand is on the waist. The torso should be rotated and leaning to create the most flattering shape for the subject's body type.

FAMILY PORTRAITS

A successful family portrait means paying attention to the big picture as well as the small details. Are you flattering each individual? Have you created body language that shows affection and intimacy? Have you created a balanced composition with visual flow for the eyes?

If you think of each individual part at once, it may seem overwhelming. As with any major task, it becomes more manageable when you break it down into smaller steps.

With my guidelines for posing families, I will show you how to build a family portrait so that you flatter each person, create dynamic shapes with body and head placement, create a balance in your images, and more.

Guidelines for Posing Families

In a family portrait, your composition is the placement of your subjects. Let's take a look at the elements that work together for successful family portraits.

Build with Triangles

With family portraits, triangles are your best friend. After reading this chapter and taking some practice shots, triangles will begin to appear before your eyes!

When posing a family, avoid having the heads in a line either vertically or horizontally. Having them all lined up looks either like a totem pole or a criminal lineup—neither is particularly desirable for a family portrait. Furthermore, when the heads are all lined up, the image lacks visual interest and flow. The eye enters the frame, moves across the line of heads, and then exits the frame. There is nothing to hold the viewer's interest. It's like an image of a person standing as straight as a column—boring!

For every shot, there are multiple options for placing each person within a triangle structure. These solutions apply whether you're shooting three people or 13 people. Each additional family member in the composition will create even more triangles. When you start to see the triangle options, you'll always know where the next person should go to maintain balance. We will discuss this in the next guideline, but first, let's take a look at what I mean by triangles.

In **FIGURE 9.1**, the women's heads are lined up vertically, and the pose looks awkward. Everything is a bit too stacked. Your eye enters at the top of the frame and exits at the bottom without any flow.

In **FIGURE 9.2**, I've made a slight adjustment to place their heads in a triangle shape. By moving the mother off to the side just a bit and repositioning the head of the standing daughter so it is lower, the shot is completely transformed. Does the triangle always need to be this defined? No. It can certainly be much more subtle than this particular composition, but you'll typically want to stay away from lining up the heads.

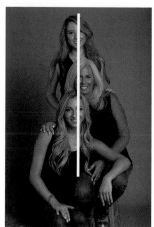

9.1 Avoid lining up heads vertically. Instead, seek to place heads in a way that creates a triangle. This results in more interest and flow in the composition.

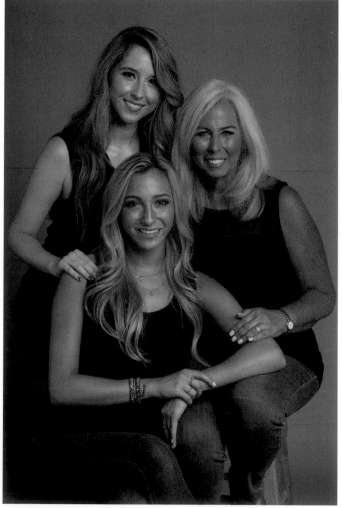

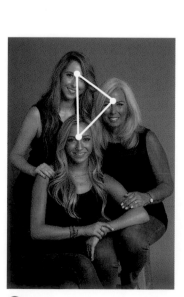

9.2 Notice the triangle that has been created by the placement of the heads.

CAUTION With smaller family groups of three or four people, lining up the heads in a row is a little less objectionable. When you get into larger groups of four or more, the lack of compositional flow becomes a problem. Do you have a mother and two sisters whose heads you want to line up? I don't recommend it, but it's not a terrible photo. However, when you add in more siblings, parents, and grandparents, the line-up looks like a lazy, unplanned composition.

The same is true for lining up the heads horizontally, which is the most common mistake I see with group and family posing. Shots where everyone stands side by side may work in a small group, but in larger groups it comes across as stagnant. This is apparent in **FIGURE 9.3**. The heads are lined up, and the pose causes the bodies to look wider. By bringing the pose in closer and creating subtle triangles with the head placement, the pose will have improved flow and the subjects will appear more affectionate toward each other.

Placing the heads in a triangle is also effective with larger groups. At some point, depending on group size, this may become somewhat impractical, but it can easily be achieved with six, seven, eight, or even more people.

Let's take a look at this concept with the entire family (**FIGURE 9.4**). There are triangles *everywhere*. Can you see and identify them? First, you can see the triangles created by the position of their heads (**FIGURE 9.5**). In **FIGURE 9.6**, not only are their heads placed to create several triangles for visual flow, but the entire pose has created a triangle composition. In short, if you are posing families, think triangles!

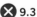 9.3

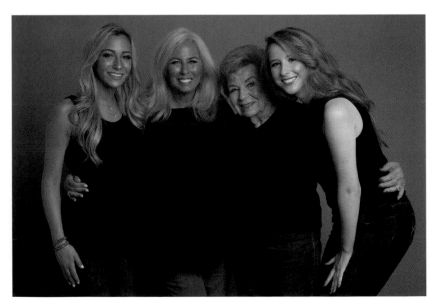

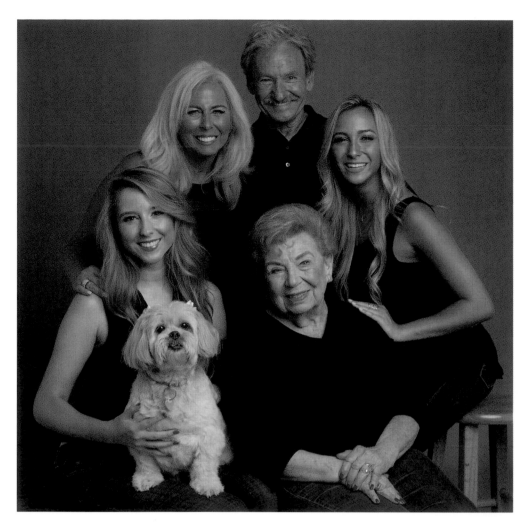

9.4

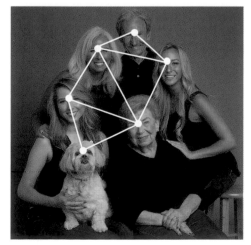

9.5

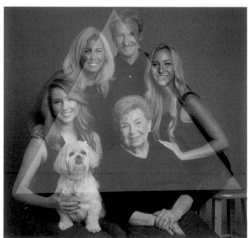

9.6

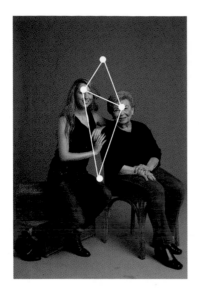

9.9

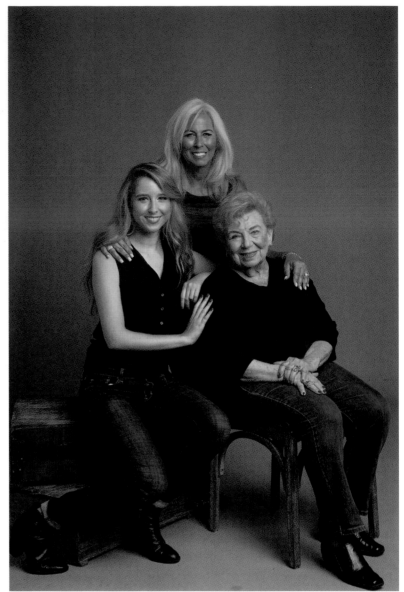

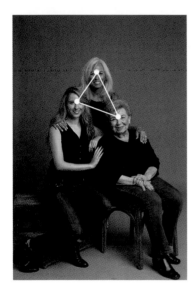

9.11

9.10

Fourth Person

When I go to pose a fourth person, again I envision my triangles (**FIGURE 9.12**). Where could I pose them to create visual balance in the shot without too many people clustered in one place? I have several options. Someone could stand off to either side or could sit on the floor. You can see the two other options in **FIGURES 9.13** and **9.15**, and the resulting triangles in **FIGURES 9.14** and **9.16**.

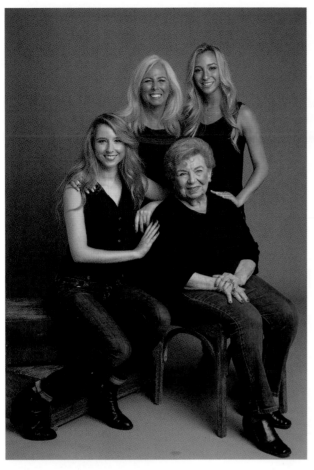

9.13

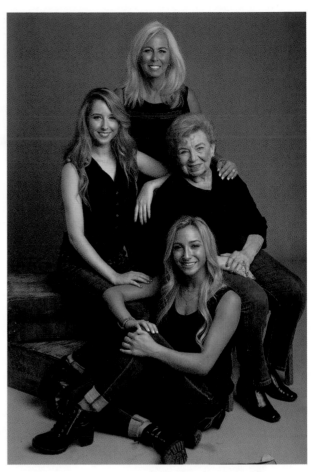

9.15

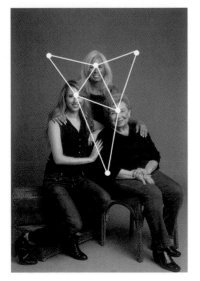

9.12

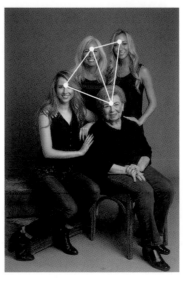

9.14

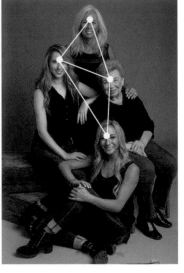

9.16

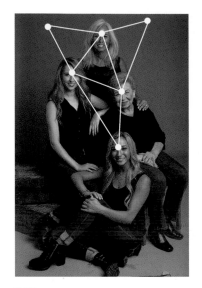

9.17

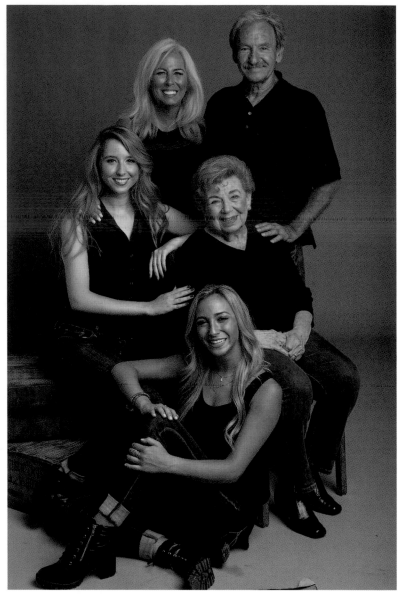

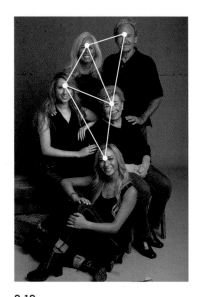

9.19

9.18

Fifth Person

Again, it is time to envision the triangles. Where can I put another person to create triangles, and still have balance in the composition?

For these shots (**FIGURES 9.17**, **9.18**, and **9.19**), I decide another person standing would help maintain the balance I have achieved. When I add in the father, you can see how I am able to build beautiful triangles. Try to

previsualize triangles to find a good fit for the next person. You can see how this process would continue to work if we were to build more people into the frame.

Sixth, Seventh, Eighth, and So On

Just keep building triangles. Use stools, chairs, and boxes to vary the heights and insert people where they fit best. You can now begin to envision where additional people may be able to fit as you extend the frame.

Balanced Composition

In a family portrait, the pose is the image's composition, and you don't want your image to feel too off-balance. If all the tall people are on one side, or several family members are clumped together on one side of the pose, it creates an unbalanced and visually unappealing shot. If the goal of a family photo is a feeling of togetherness, then an unbalanced composition can destroy this.

Let's start with a successful example to illustrate what I'm talking about when I refer to balance. In **FIGURE 9.20**, the image has a nice overall flow to the frame. No one person dominates the scene, nor does anyone feel left out. One side of the frame isn't grabbing more visual attention than the other side. We've achieved balance, and there are many different poses and compositions that can do the same.

That being said, let's take a look at some images that lack balance.

CAUTION Be aware of couples. When building a pose with a larger family, you'll want to place a couple near each other. A husband and wife should not be separated on opposite sides of a composition. For this reason, you may want to build your composition with couples in mind.

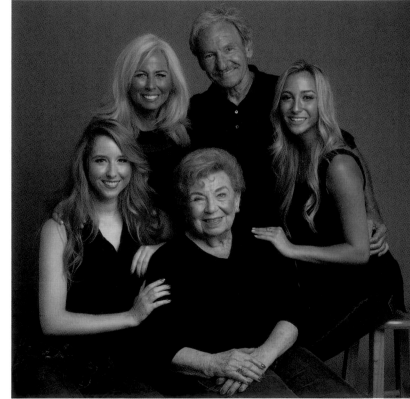

✅ 9.20

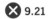 **9.21**

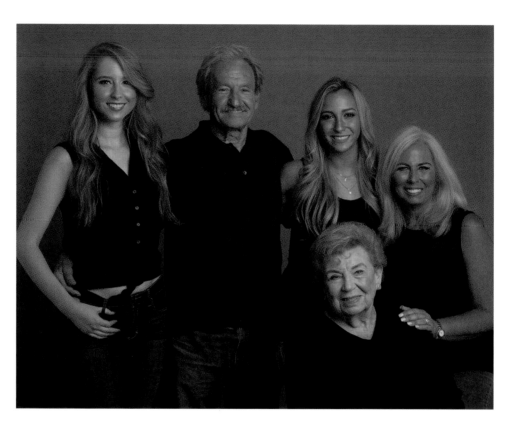

In **FIGURE 9.21**, what is the flow of the photograph? Does everyone draw equal visual attention, and does the viewer's eye move freely throughout the pose? Definitely not. This image suffers from several balance problems.

First of all, Grandma looks diminished in this photo because she is placed in a lower-side corner, and less of her body is visible as compared to the rest of the family. Next, because there are almost no triangles created by the placement of the heads, the eye enters from one side of the frame and exits right out the other side. Nothing holds the attention or provides flow. Also, since most of the group is standing on the left and sitting on the right,

the balance is conflicted. Personally, my eyes bounce from Grandma to the granddaughter on the left and back again, almost completely missing everyone else in the frame. The pose seems accidental.

Let's say that I try to fix the balance by moving the grandmother to the center of the frame (**FIGURE 9.22**). Unfortunately, the problem is still not fixed. Now the grandmother doesn't look as hidden and the composition is more centrally balanced, but there are still two awkward levels of heads. Grandmother is on a level by herself, with the heads of everyone else lined up. The pose still appears disjointed.

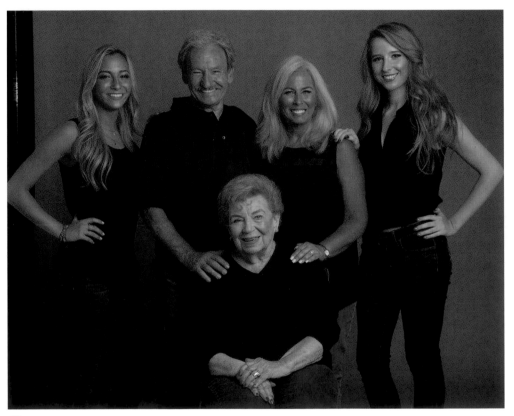

❌ 9.22

CAUTION Be careful when posing tall people. Sure, you can stand them in the back of the pose so that they are not blocking anyone, but it may also be appropriate to have them seated. Sometimes if they are too tall, a standing pose may cause them to appear even more disjointed from the rest of the family.

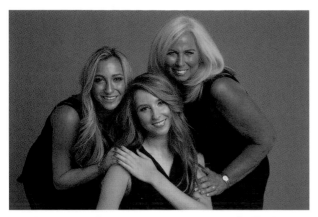

❌ 9.25

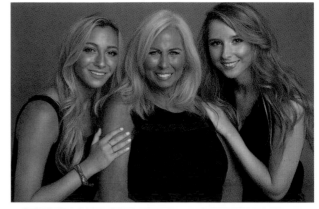

❌ 9.26

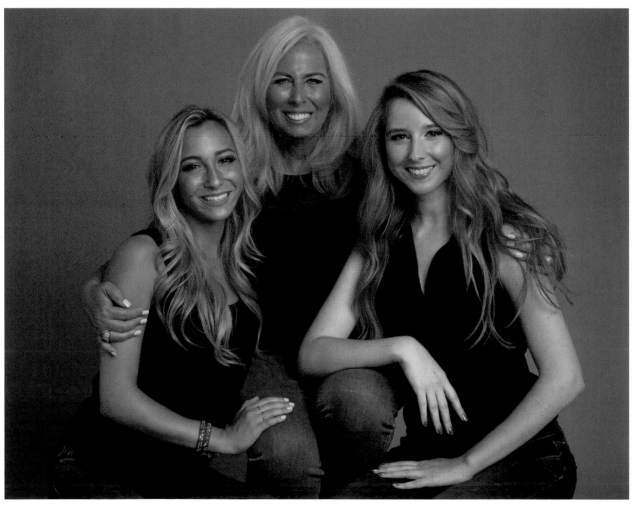

✅ 9.27

CAUTION Watch for the slouch! When balancing the heights of your subjects, if slouching is a problem, direct them to bend the knees, step and lean, or seat them on chairs and stools that vary in height. This is why I keep different sizes of boxes, stools, and chairs in my space. It makes it significantly easier to pose subjects in such a way that the heads have unity (without everyone trying to make themselves shorter).

In the improved shots, you'll notice the change in body language resulting from careful placement of the hands to create visual flow and unity. Let's take a look at that element next.

Hand Placement

Use the arms and hands to create more unity in the group. This could be a hand on the shoulder, a hug, hand-holding, hands placed on the arm, and more. A well-placed hand interaction can make a massive difference in a pose.

In **FIGURE 9.28**, we've created the base for a successful pose, but the finishing touches just aren't there. The subjects look separate and lacking in affiliation. The pose also looks a bit stagnant, with no elements that lead the eye from one person to the next. Now, I carefully place the hands (**FIGURE 9.29**). The hands serve to visually unite the individuals. See how the hands make it easier for your eye to move throughout the frame.

Lean In

To put the finishing touches on this pose, I've asked everyone to lean together and tilt their heads (**FIGURE 9.30**). Leaning in creates a body language of togetherness and adds that final bit of affection we want to express. Make this a practice for family portraits. For tighter compositions and poses, try asking everyone to lean in closer. The family members in the back should lean forward. Also try tilting the heads inward. Even a subtle lean can help make a more successful image!

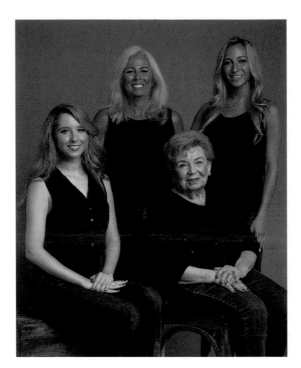

❌ 9.28

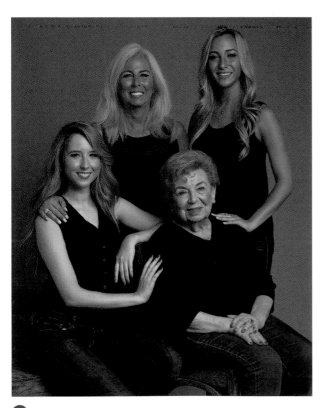

✅ 9.29

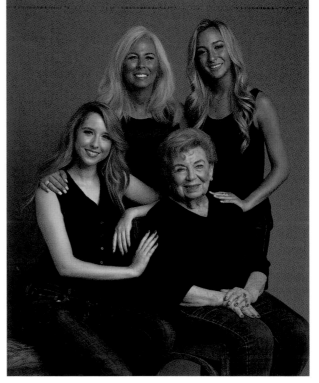

✅ 9.30

Fingers and Shoulders

When trying to show togetherness, careful hand and arm placement can be a great tool. That being said, be aware of some common posing pitfalls. For example, avoid having anyone wrap their arms around someone's shoulders. This usually creates an unflattering hunch to the shape of the neck and arms. Also, when the subjects are wearing suits or button-up shirts, the resulting wrinkles are unsightly.

Be careful that the tips of the fingers don't peek out over a shoulder or from around the waist. Exposed fingertips look like distracting little nubs (**FIGURE 9.31**). Instead, when you see the fingertips you should also see the entire hand all the way to the wrist. Moreover, the hand shouldn't be pointed straight toward the camera—this causes foreshortening. Change the angle of the hands for more pleasing results (**FIGURE 9.32**).

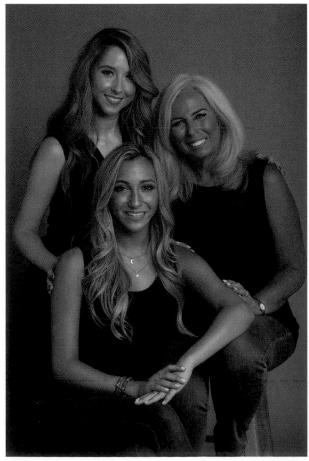

❌ 9.31

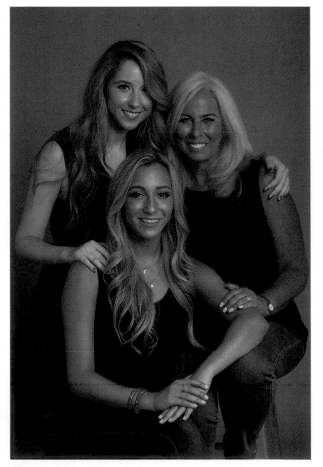

✅ 9.32

MASTERING *Your Craft*

OVERLAP

When posing a family, you don't want everyone to be posed completely independently of one another without any interaction. Sure, this may give the photo a rock album cover look, but that doesn't work for family portraits. It creates a disjointed result. Your goal is to create unity and togetherness, and overlap of bodies and limbs helps to achieve this.

Ask yourself if you can overlap the shoulders. How about the hand on a shoulder, or the hand leaning on someone's knee? What type of interaction can you add? Even overlapping to avoid empty space can drastically improve a pose and convey the togetherness of the group.

Yes, you can go for a more fashion-forward pose in which everyone isn't squished in and hugging, but even with this type of pose there should be some visual balance and overlap (**FIGURE 9.33**). ■

✕ 9.33

Expressions

Although we want to build structure into our poses, everything doesn't need to look overly posed. Find ways to get people to relax and interact naturally, and even get some candid shots. Children, for example, can whisper a secret to each other. They can sneak up on the father and tickle him. There are ways to get genuine expressions and interactions. It all comes with practice and anticipation of your subjects.

You'll also want to read the dynamic of the family. Is each person very independent, and is the family a bit more formal? Or are they very relaxed, comfortable, and affectionate? You will need to determine how they interact, and perhaps reflect this in your poses and compositions. With more independent, adult subjects, give everyone a bit more personal space and individualized poses. With younger children or in a family that is more physically affectionate, close up the space and use body language to communicate this.

Don't Forget Perspective

The wrong perspective can make or break a family portrait pose. Your pose may be great, but it could appear all wrong if you choose an incorrect perspective, camera angle, or lens. Some people in the family may look disproportionately large, or the space between them may appear exaggerated.

To make it easy on yourself, think of it this way: everyone should be roughly the same distance from the camera, so try to use a longer lens when possible to compress the distance.

Let's take a look at potential problems with perspective in action and the solutions available to correct these issues.

As we've discussed, whatever is closest to the camera appears larger, and whatever is farther from the camera appears smaller. This is exaggerated when using a wider-angle lens—people in the foreground will appear *much* larger and people in the background *much* smaller. In **FIGURE 9.34**, I am shooting at 24mm. As a result, the distance between family members is exaggerated and people closer to the lens appear larger. In **FIGURE 9.35**, the grandmother and granddaughter in the foreground appear much larger in the frame, whereas the rest of the family appears smaller and more distant in the background.

In short, if you find yourself struggling with perspective issues, try standing slightly farther back with a longer lens, and then keep your camera angle and height neutral (neither closer nor farther from any one part of the group).

Depth and Depth of Field

Too much depth is problematic from a posing standpoint, but it will also create issues with depth of field. You may find it challenging to get the faces in the first row and background completely in focus if there is too much depth to the composition.

Consider compressing the depth as much as possible. Move everyone in closer, reducing the distance from front to back. Lean everyone in the back forward to line up their faces on a similar plane with those in the front. This will not only help eliminate distance, but it will also help create more accurate proportions in the group. In addition, you can use a longer lens to compress distances, thus reducing the problems of perspective and distortion. In the next example, I'm using a 35mm lens kept in the exact same position from one photo to the next.

In **FIGURE 9.38**, I have an acceptable pose, but people in the back row are a few feet behind those in the front row. Because of perspective, the heads of the people in the back row look smaller and more distant. To fix the problem, I direct the back row to move in closer and lean their chests forward. This closes up the distance and helps to reduce the problem caused by perspective (**FIGURE 9.39**).

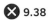

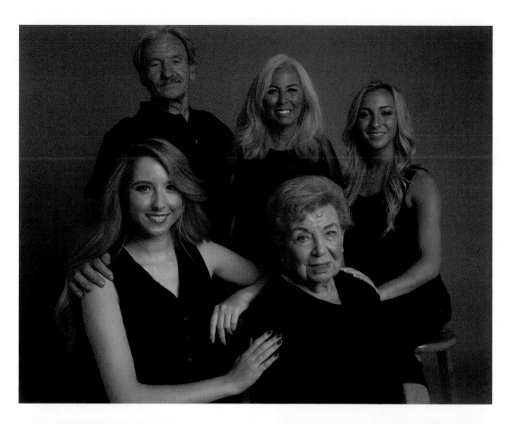

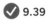

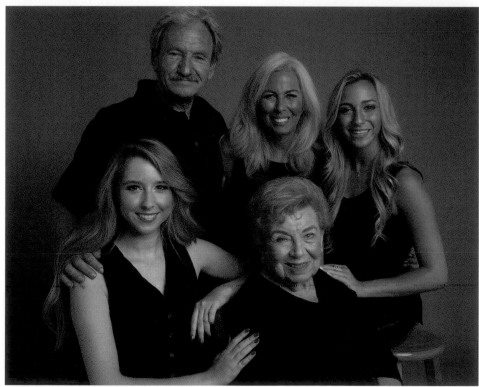

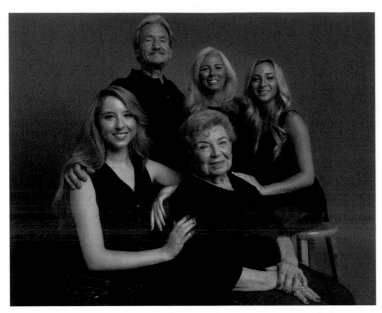

❌ 9.40

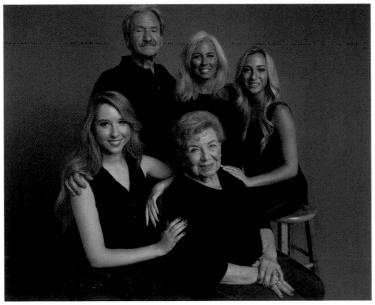

✅ 9.41

Lastly, don't forget that your camera angle and height can make a difference. Let's say that for some reason you get down a bit lower with your camera angle, or maybe your group is standing on stairs slightly above you. If everyone is standing, then you will be emphasizing the midsections of the people closest to the camera and all of the heads will appear smaller.

Let's take a look at this family example. Because the front row is sitting, my low camera angle makes the people seated look larger and the people in the back row appear smaller (**FIGURE 9.40**). To fix this problem, I stay the same distance from the subjects, with the same focal length, but I simply raise my camera angle. Suddenly, the slightly skewed perspective has been corrected (**FIGURE 9.41**).

TRAIN YOUR EYE

Posing families can be overwhelming, and there are so many moving parts to get right. That is why it is important to practice and train your eye. You'll need to watch for things like the overall flow and balance of the pose, head placement, hand placement, body language, and more. Let's put your new knowledge into practice.

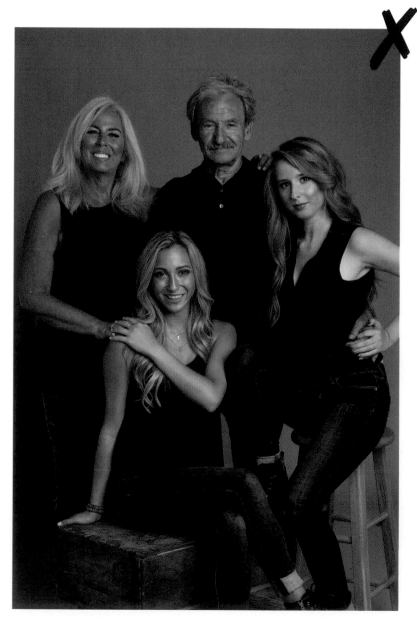

TRAIN YOUR EYE #1

Study **FIGURE 9.42** and see if you can identify the problems in the image.

9.42 Train Your Eye #1

Let's see how you did. Compare **FIGURE 9.43** with the solutions in place in **FIGURE 9.44**.

✖ *Problems*

Togetherness: There is an overall lack of flow and togetherness in the image. The family feels a bit disjointed.

Hands: The hands of the father and daughter are too stacked. This is distracting, as is the arm placement. The mother's fingers on the father's shoulder look like nubs.

Heads: The head angle is neutral, and they should lean in slightly.

Arm: The arm of the daughter in the center is locked and too straight.

Other: The raised leg of the daughter on the right looks awkward and blocks her sister. There is no connection between the two.

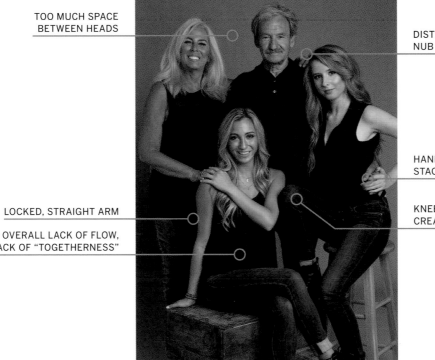

TOO MUCH SPACE
BETWEEN HEADS

DISTRACTING
NUB FINGERS

HANDS TOO
STACKED

LOCKED, STRAIGHT ARM

OVERALL LACK OF FLOW,
LACK OF "TOGETHERNESS"

KNEE BLOCKING ARM,
CREATING AWKWARDNESS

✖ **9.43** Problems

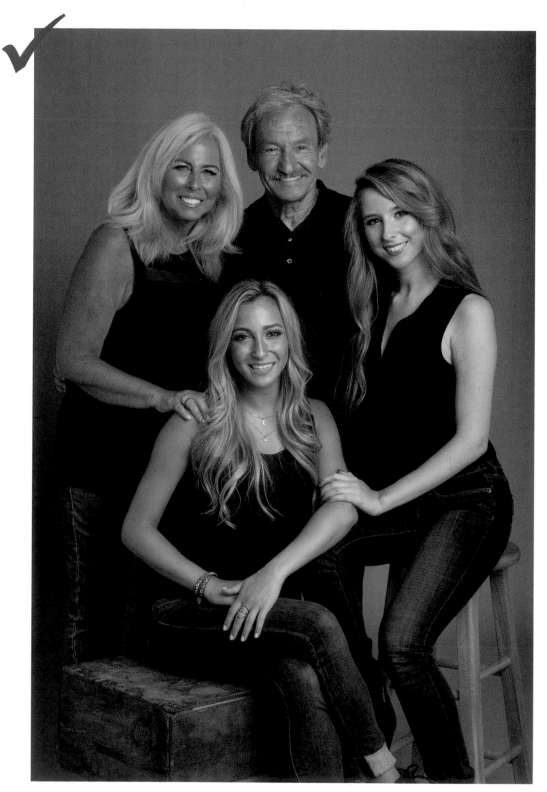

9.44 Solutions

Let's see how you did. Compare **FIGURE 9.47** with the solutions in place in
FIGURE 9.48.

❌ *Problems*

Balance: The composition of the pose does not have visual balance. The grandmother is low and to the right of the frame, and everyone's heads are lined up behind her.

Body Language: This pose lacks togetherness. The daughter on the left is turned away, making her appear separate from the others. The spacing between heads is odd, and there is no tilt inward.

✓ *Solutions*

Balance: The pose now makes a triangle composition. The hands are well-placed to create flow throughout the frame. No one feels excluded, and no one is grabbing too much attention.

Body Language: All undesirable space has been closed, and everyone is leaning inward for a more affectionate pose.

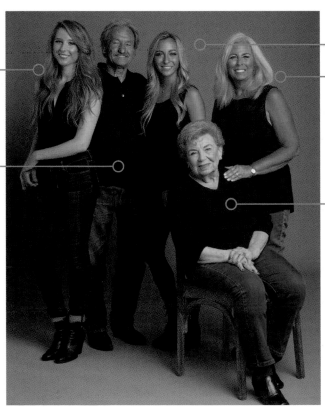

BODY LANGUAGE
TURNED AWAY

UNBALANCED
COMPOSTION,
NO VISUAL FLOW,
LACKING "TOGETHER"
BODY LANGUAGE

ODD SPACING

HEADS ALL LINED
UP (NO TRIANGLES)

GRANDMA FEELS
SEPARATED

❌ **9.47** Problems

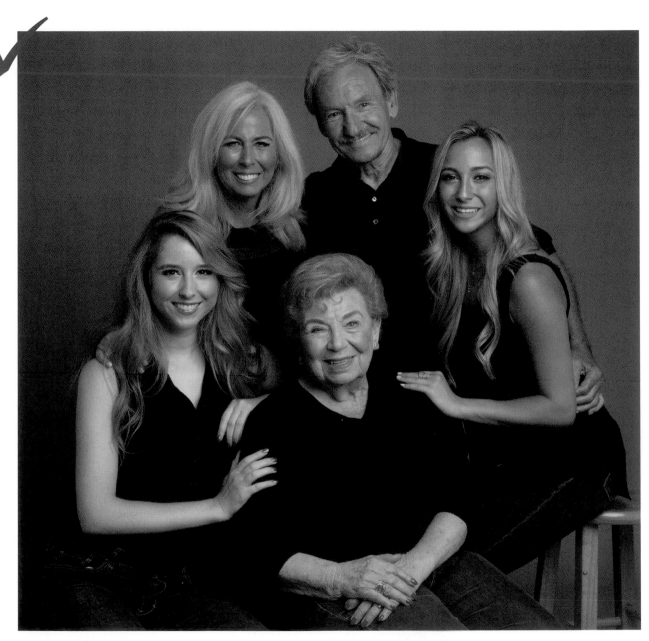

9.48 Solutions

5 GO-TO POSES

POSE 1 (4 People) People are placed in two layers: seated and standing. Heads are staggered to create triangles, and hands are placed to unite the group.

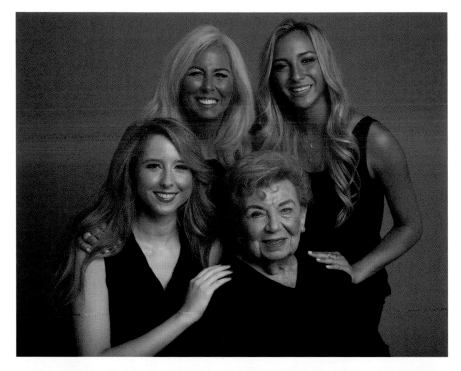

POSE 2 (3 People) The mother is centered and slightly raised. The siblings are seated lower, with arms interacting with their parent's knees.

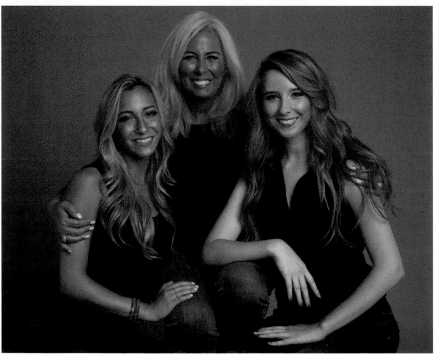

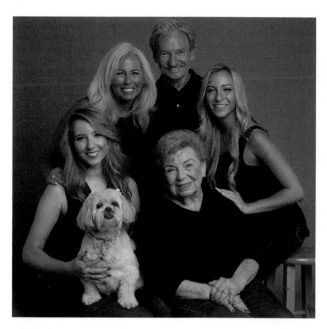

POSE 3 (5 People) This composition creates a triangle. Three people are sitting at different levels and two are standing; all heads are staggered.

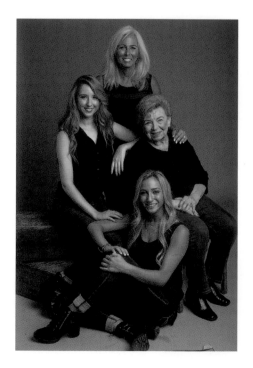

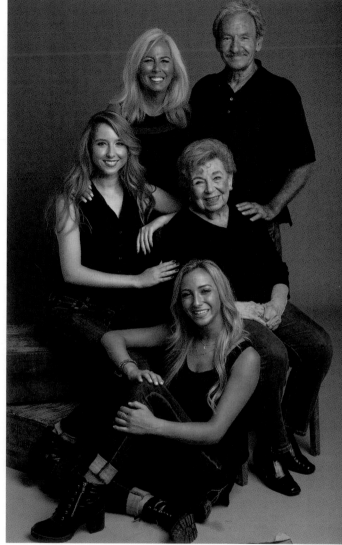

POSE 4 (5 People) Two people are seated in chairs. Two are standing, with one centered, one to the right, and another sitting on the floor.

POSE 5 (4 People) Two people are seated in chairs, one standing centered, one sitting on the floor.

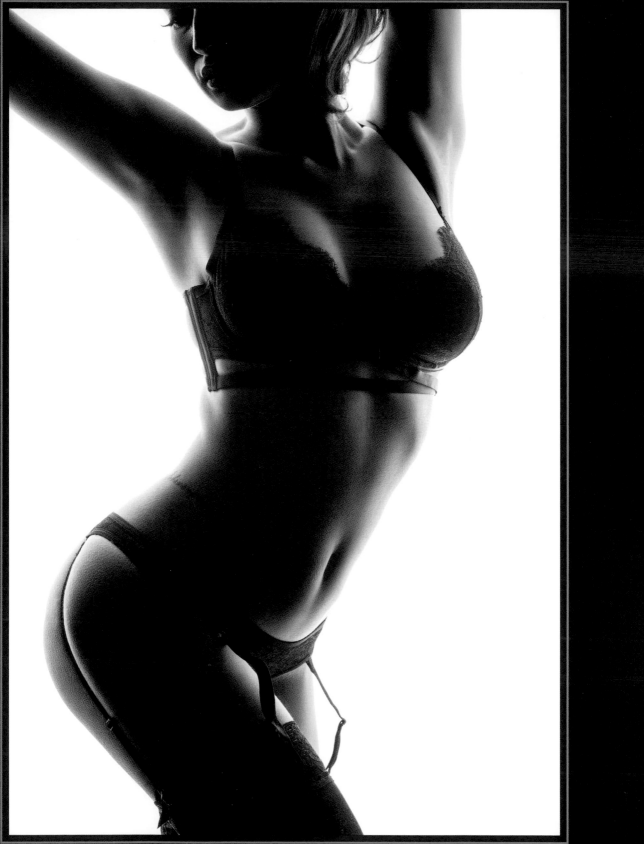

BOUDOIR

For a boudoir session, posing and expression are paramount. Your job is to flatter every curve, create allure, and make the subject's body look its absolute best. Luckily, you have this book and this chapter to prepare you for the challenge.

Boudoir posing is feminine posing, with everything pushed to an extreme: more curve, softer hands, more extreme camera angles. Although it can be challenging, you and your subject can work together to create striking imagery showcasing her form.

A boudoir session can make your subject feel extremely vulnerable. More than ever, you must master your skills of directing and posing to make her feel comfortable. The elements of asymmetry, hand placement, and creating curves have never been more important!

Guidelines for Posing Boudoir

In this section, we will examine five important factors that can be used to help flatter all the curves and edges of your boudoir subject.

Bend, Curve, Arch!

If you can bend it, bend it! If you can curve it, curve it!

Emphasizing curves through posing is essential with boudoir. Add curve to the hips, bend the knee, arch the lower back, and more. Ask yourself, "What can I do to create more pleasing curves?" Then push it to an extreme.

There are endless ways to add curve depending on the base pose you select. Here, I've provided some helpful tips for introducing feminine and flattering curves in your images. Please note that you are not limited to these suggestions; they are just meant to get you started.

Curve with Contrapposto

There are a number of ways to create a stunning curve to the form. One way is to cross a knee over. Another is to stick the hip out. Another is by shifting the subject's weight to one hip. This technique has been used for hundreds (even thousands!) of years to create pleasing curves and a visual flow to a pose. It is called "contrapposto."

Contrapposto, or counterpose, is an Italian term that describes one of the poses seen frequently throughout Greek, Roman, and Renaissance sculpture to give more visual flow and realism to a standing subject. For women, it is often exaggerated to achieve an "S" curve throughout the form. Famous works like the *Venus de Milo* and Michaelangelo's *David* have utilized this posing device. So what does it really mean?

In short, the subject typically rests the weight on one leg so that the hip juts out slightly. The subject then leans a shoulder toward that outward hip. Typically, there is a bit of a bend to the knee that is opposite to the hip jutting out. This pose can be used subtly or exaggerated for the purpose of creating a curve. The results are elegant with a stunning flow of an "S" curve.

Imagine drawing a straight line through the shoulders and another line through the hips. When the subject stands flat-footed, these lines run parallel (**FIGURE 10.1**). You can recognize contrapposto if you envision those lines; they angle inward toward each other on one side of the body (**FIGURE 10.2**).

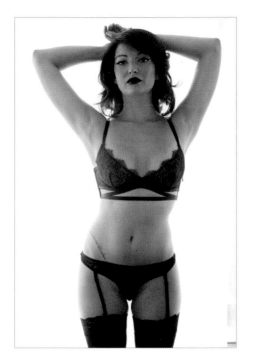

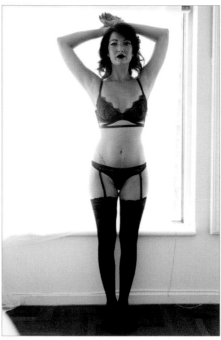

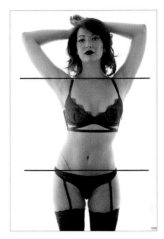

❌ **10.1** Imagine two straight lines, one drawn from shoulder to shoulder, and another drawn from hip to hip. When a subject stands flat-footed, these lines are parallel.

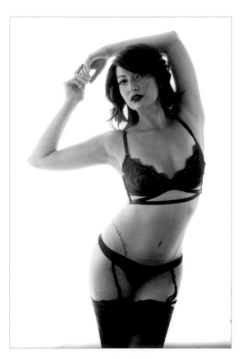

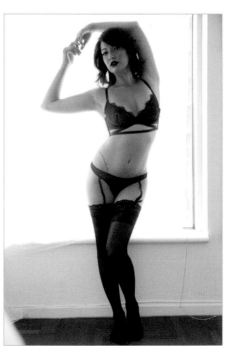

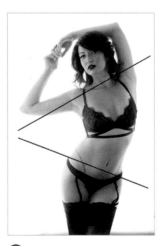

✔️ **10.2** In contrapposto, imagine the same lines in the shoulders and hips. These lines point inward toward one another to intersect. The closer they intersect to the body, the more dramatic the curve and shape of the pose.

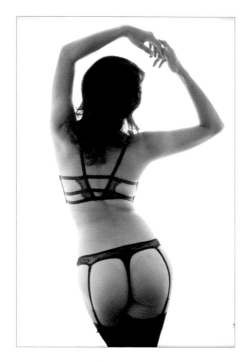

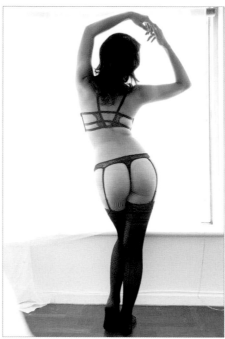

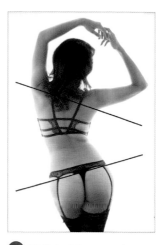

✅ **10.3** In this example, notice how we've created curves by considering how the lines created by the feet, shoulders, and hips interact.

If you struggle to add curve to your standing subject, simply envision these lines, and then adjust the pose to make the lines meet. Take a look at the feet, shoulders, and hips in **FIGURE 10.3** and try to achieve similar results. This posing technique looks good when viewed from the front or back of the subject.

Curve by Arching the Back

Another way to introduce curve is to arch your subject's back. If the goal is to create as many curving lines as possible, arching helps to achieve this result, whether the subject is sitting, standing, or even lying on a bed. Arching the back can help create a beautiful curve for the eye to explore the form. Let's see this in action.

CAUTION Be careful that your subject doesn't stick out her stomach when arching the lower back. Arching the lower back should instead help to emphasize the buttocks and create another pleasing curve.

In **FIGURE 10.4**, our subject reclines flat on the bed. She has some subtle curves to her form, but I know more can be achieved. Arching her back not only raises the chest and creates more sensual body language, but it also creates another curve on the lower back (**FIGURE 10.5**). I've also bent the knee to continue that curve from her lower back to the hips, buttocks, and thighs.

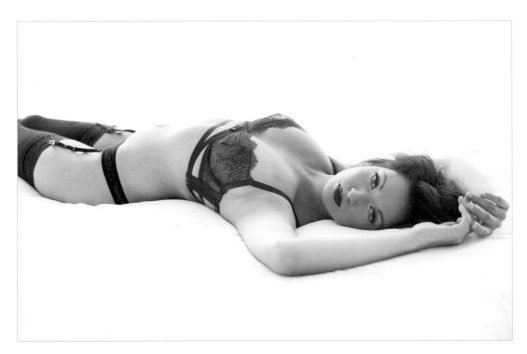
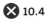

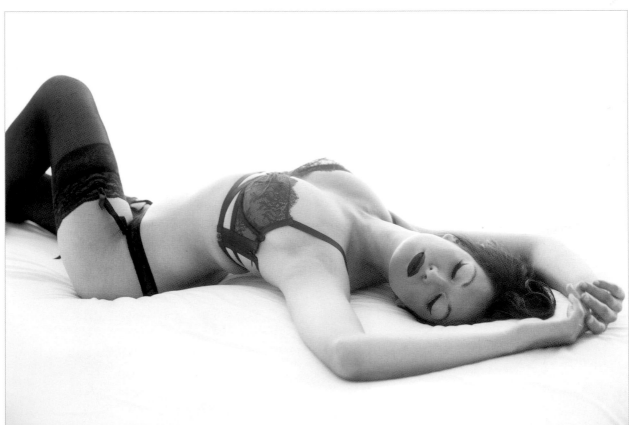

✓ **10.5** Adding a curve to the lower back can be done through a subtle or dramatic arch, making the body appear more sensual and curvy.

The amount of curve to the back depends on the desired appearance of your subject and her comfort. Holding an arched back for an extended period of time can become extremely uncomfortable; keep this in mind when photographing more than just a few shots at a time.

When I get just the right pose, I'll try to relax my subject's expression and hands to capture a few frames in which everything comes together. Then I'll often ask my subject to remember the pose and just relax for a few seconds. Once she's rested her muscles or had a moment to stretch, I'll invite her to get back into that pose. I'll make a few subtle tweaks to get her back to that perfect position, and then we've got the shot.

❌ 10.6

✅ 10.7 Adding a subtle arch to the back gives the eyes more pleasing curves to follow, while also defining her waist and, in this instance, emphasizing the chest (right).

Relax, Repeat Because you are emphasizing curve and often have your subject holding less-than-natural positions, she may become uncomfortable or strain her body. For this reason, give your subject breaks to rest and regroup. When someone holds an uncomfortable position, the tension may become visible in the expression and hands—this can easily ruin a shot!

Adding a subtle arch to the back can be flattering for standing subjects as well. In **FIGURE 10.6**, not only is the subject not arching her back, but the curve is completely hidden. The results are much more flattering when she arches her back, as in **FIGURE 10.7**. Her chest looks fuller, her waist looks more defined, and we've revealed the curve that allows the viewer's eye to follow the pose more smoothly.

Bend the Arms, Wrist, and Knee

Straightened limbs look rigid and achieve the opposite of creating curve. The eye gets stuck and locked into stagnant lines. Ask yourself if there is anything else you can bend to break up straight lines and add more interesting shapes for the eye.

A subtle bend to the wrist can suggest elegance. Bending the arm creates triangles for visual interest and flow. Bending a knee can introduce a curve to the thigh and buttocks that had not previously existed.

In **FIGURE 10.8**, the subject's pose achieves almost no curve. The knees are straight, the arm tight to the side, the back not arched. The results? A pose that completely lacks interest.

To improve the pose, add more bend and curve. First, by bending the knee closest to the camera, I introduce that beautiful curve from her lower back, to buttock, to thigh. This vastly improves the visual flow of the image (**FIGURE 10.9**). A subtle bend in the front arm gives just a bit more of a smooth leading line to the face, down the body and to the thigh. Last, a bend in the back arm adds a bit of drama and interest to the shot.

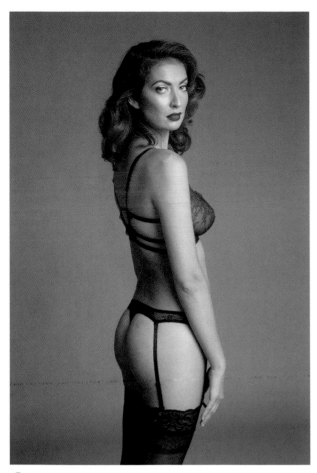

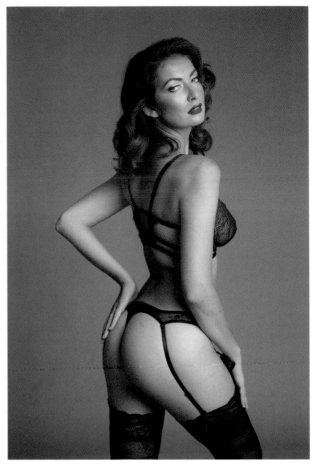

❌ **10.8** This image is rigid and stagnant, with straight lines and few curves.

✅ **10.9** Bending a knee and elbow can create far more visually appealing results. This image provides several dramatic curves for the eye to follow—from the eyes, through the back, the buttocks, and to the thigh.

Of course, some people prefer a bit more natural approach to posing. No problem! Make the bends and curves more subtle. Let's revisit a similar image with similar weaknesses. In **FIGURE 10.10**, the only curve that exists is her lower back to her buttocks. Both arms are straight, and in fact, one arm is hiding the curve of her chest. In this instance, let's introduce more subtle curves, like those in **FIGURE 10.11**. By bending that front arm, I add interest by revealing the chest. The small bend in the back arm creates subtle negative space and yet another curve.

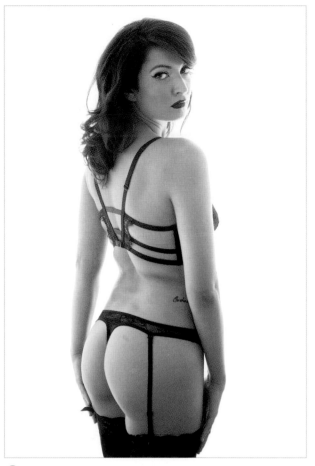

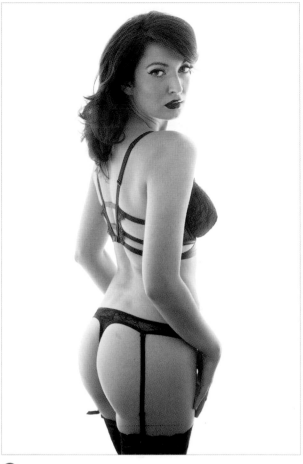

❌ 10.10

✅ 10.11

Bend the Knee, Avoid Even Feet

When in doubt, make sure one knee is bent. If the feet are totally even and the knees totally straight, I can almost guarantee the image isn't working as a boudoir shot (**FIGURE 10.12**). When the feet are even—sitting, standing, or lying down—the pose is stagnant and boring. When the knees are not bent, you are missing great opportunities to create curve.

In **FIGURE 10.13**, our subject reclines on her side, knees relatively straight and feet relatively even. It's not a terrible pose, but the legs look wider (stacked on each other) and we are not taking advantage of her beautiful hips.

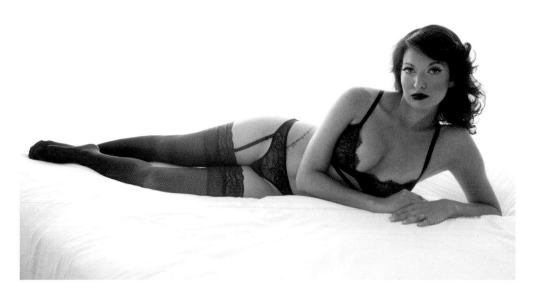

❌ 10.12

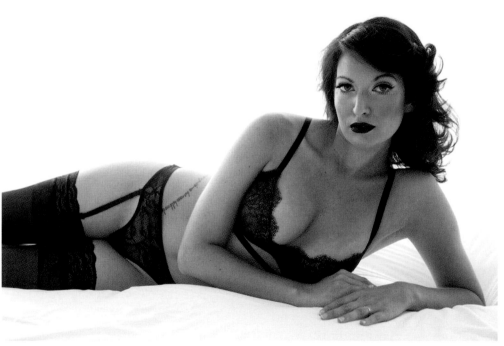

❌ 10.13

Watch what happens when we bend the top knee over (**FIGURES 10.14** and **10.15**). Suddenly, the legs look narrower, the hips look extra curvy, and the eye moves more freely throughout the pose. Just a simple bend of the knee transforms the shot.

If the subject is standing, bend a knee in. Sitting? Bend one knee up. Just give that knee a bend.

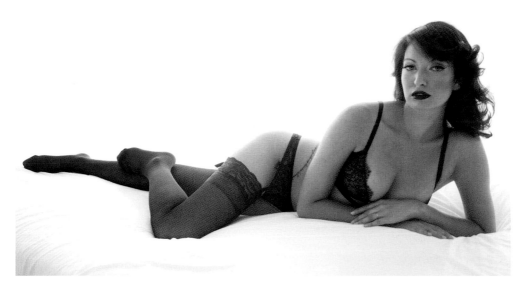

✓ 10.14

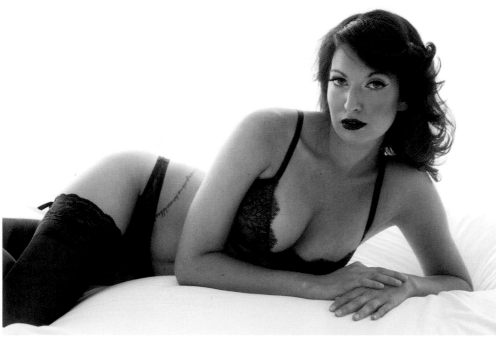

✓ 10.15

Furthermore, in boudoir you never want your subject to be standing flat-footed. This prevents you from creating curves and restricts the sensuality of the image. A flat-footed stance is stagnant and creates boring poses. This is a problem in all posing, but it destroys a boudoir image. So let's fix it! Whether sitting, standing, lying on the back—make sure the feet are at different levels for more interesting results.

Have your subject go up on toe, when facing the side. Drag the toe to the inside of the other foot. If the subject is lying on her back, vary the position of the feet; if you see that they are roughly in the same position, make an adjustment. The more drastically different the levels and positions of the feet are, the more dramatic the pose will be.

Here's the most basic example. Our subject stands flat-footed, and everything is square and lacking curve (**FIGURE 10.16**). Her hips are square to the camera, and there is no flow to the image. In the next image, she simply bends her knee in, and by dragging one foot inward at a different level, changes the pose completely (**FIGURE 10.17**). Her form now has more curve and flow.

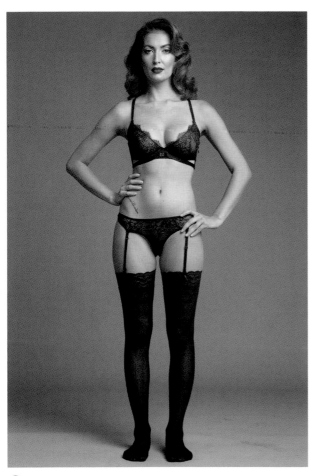

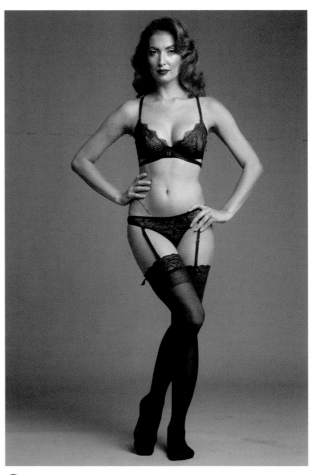

❌ **10.16** Flat-footed poses result in very unflattering results in boudoir.

✅ **10.17** Simply bending a knee over or dragging a foot inward produces drastically different results and a more visually compelling pose.

Elegant Curves When your subject is posed to the side, I recommend bending the knee closest to the camera. This creates an elegant curve from the thigh and lower back. It also hides the area between the legs, creating a classier and more elegant result. In most of the examples I've used in this chapter, I've also bent the knee inward for a standing pose (again, achieving a classier result). The knee and leg may be bent outward; just do so with care in order to maintain a level of comfort for your subject and overall classy taste level for your imagery.

Showcase Strengths, Downplay Weaknesses

In this book, we've explored how your job as a photographer is to highlight your subject's strengths and draw attention away from a perceived weakness. In boudoir, this becomes more important than ever.

Note: I once heard a photographer refer to the chest and buttocks as boudoir photographic "treats," so we will use that shorthand in this segment. I wouldn't, however, necessarily recommend using this term with your subject.

Keep these two fundamental elements in mind:

Strengths

Do your best to draw more attention to and flatter the "treats," that is, chest, buttocks, curves, or other attributes unique to that individual. Can you find ways to bring the chest or buttocks closer to the camera? Can you pose her to make the chest or buttocks plumper or fuller?

Weaknesses

If there is a problem area, be sure to draw attention away from that area or consider obscuring it. If there are rolls in the skin, can you lengthen the body to reduce them or use an arm to hide them? Would a lingerie change fix the problem? Will a different pose draw less attention to this area? Sometimes you can tweak a pose, and other times it must be abandoned altogether.

If a subject is standing with her buttocks to the camera, remember that whatever is closest to the camera looks largest. Want to make the bottom look bigger? Push it more toward the camera. In **FIGURE 10.31**, my subject is standing flat-footed, with her body—shoulders, hips, and feet—all aligned. In **FIGURE 10.32**, she crosses her knee over, arches her lower back, and leans her chest slightly away from the camera, defining the waist and pushing the buttocks closer toward the camera. The results are more flattering to her form, creating an hourglass shape and adding definition to the booty.

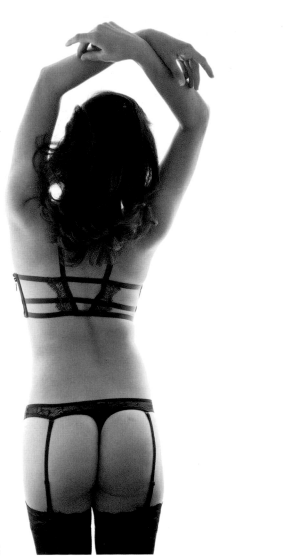

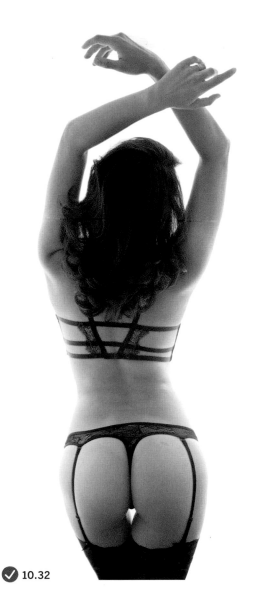

❌ 10.31

✅ 10.32

Hands Caress the Body and Direct the Eye

When I think of boudoir, hands are not the first body part that come to mind, but they are one of the most important elements photographically! Hands are critical in helping set the mood in a boudoir image and directing the eye in your pose. Poorly placed hands is one of the easiest ways to ruin a boudoir pose. But elegantly posed and placed hands can be the icing on an already sexy cake.

Hands should be soft, as if caressing the body. Just placing the hands often looks stagnant and over-posed, so instead, I often direct the hands into movement. For example, I'll ask my subjects to move their hands across their body in order to create more believable and even softer poses. I may direct the hands to move slowly up the thigh, leading with the middle finger. Other times, I'll direct subjects to move a hand gently across the chest or slowly across the lips, or to lightly sweep away a piece of hair from their face. All of these movements help to create natural-looking hands and a feeling of sensuality in images. Avoid simply having hands grip the hip or waist, and instead use them more purposefully to set the mood.

Hand placement also helps to direct the eye in the frame. The hands act as subtle arrows to say, "Look here!" Combining the elements of focus, depth of field, and hand position can really help direct the eye.

For example, when the hands are placed on the hips, it draws the viewer's eyes to the hips (**FIGURE 10.33**), while making them appear wider. This is not incorrect hand placement, but be aware of how this placement affects the viewer's eye.

> **PRO TIP**
>
> **Voice** When I am directing for boudoir, I tend to use a tone of voice that reflects the mood we are trying to convey. If I want soft and elegant hands, I direct the hand placement using a smoother, gentler tone of voice. I use my voice to help the subject channel the mood we are trying to achieve.

> **CAUTION** Don't forget our posing pitfalls about hands! When posing your subject, be sure you avoid showing too much of the palm or thumb-side of the hand. Keep the hands relaxed and elegant.

Conversely, when the hands are hooked in the undergarments and placed on the chest, the eyes are directed to those areas, and the flow of the image is quite different (**FIGURE 10.34**). In my opinion, this second image directs the eyes to the chest and creates more flow around the form of the body. If the subject places her hands to the lips, thighs, or chest, that's where the eyes will travel.

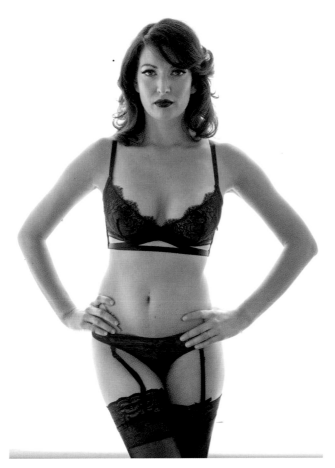

10.33

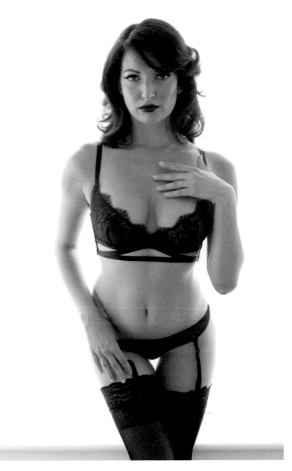

10.34

Camera Work

Don't leave all of the work of creating a variety of poses up to the subject. Work the camera to get the most out of a single body position!

In boudoir, you don't need a lot of different poses to create endless variety in your shots. When you vary your depth of field, camera angle, lens choice, and camera position, each different crop can become a completely different shot. So don't feel compelled to constantly try different poses with your subject. Remember a few key poses, vary the digits—and the rest of it is camera work!

A single pose in boudoir can yield dozens of different results when you really put in your camera work. Here are some suggestions to help you get started.

MASTERING *Your Craft*

BOYFRIEND SHIRT

If a woman is uncomfortable posing her hands, I find it useful to give her props or lingerie that she can interact with. For example, the boyfriend-shirt look (white, slightly oversized button-up shirt) can be an excellent solution. It's sexy and flirtatious, and it gives her tons of natural ways to occupy her hands with the shirt. Furthermore, for a woman who is a little less comfortable baring it all, this is a more modest and playful way to begin a boudoir session (**FIGURE 10.35**). ◼

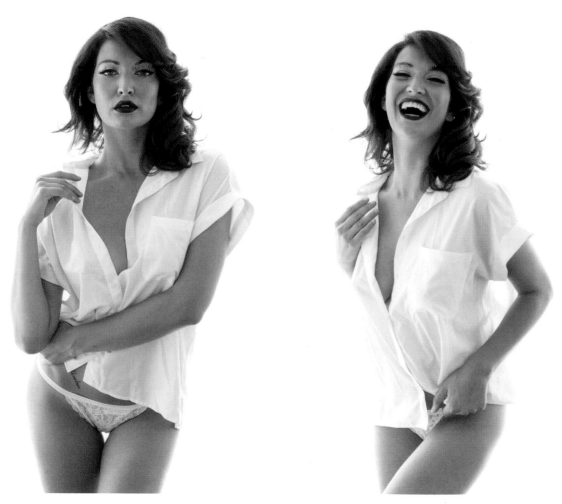

10.35 A boyfriend shirt can be a great prop to help give your subject an easier, and more playful, way to pose the hands while also having a more modest look.

Steps to Boudoir Variety

- Find a beautiful pose.

- Vary the digits and expression (hand placement, eye contact, head position, and so on).

- Try different crops, lens choice, and depths of field to create variety.

- Change your camera angle.

- Repeat all steps interchangeably to produce endless results.

If you do this over and over again, you constantly reinvent the same pose and never run out of options. Make a single good pose really work for you!

In this next series of images, I've started with a single base pose. The model is reclined on her back with the knee closest to camera bent and the arm closest to the camera raised above her head. Her back is arched and her head and eyes are looking toward the camera (**FIGURE 10.36**).

Now let's see what we can do to vary the digits.

Hands and Arms

- Hand to the lips

- Hand to the chest

- Hand to the neck

- Hand touching the stockings

- Hand tucked in the underwear

- Arm bent, raised above head

- Arm bent beside head

- Arm bent to the side of the body

CAUTION **Don't Do It All at Once** Don't feel as if you need to get the entire pose perfect all at once. Start with the base. Find a strong starting point for the hands. Work to add more bend, curve, and arch. Adjust the hands to direct the eye. Tweak as necessary.

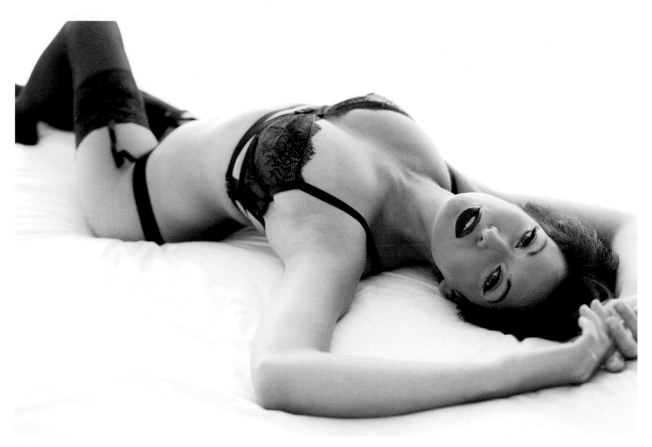

10.36

Eyes

- Eyes looking toward the camera

- Eyes closed

- Eyes looking in the distance, away from the camera

I can also vary the crop, point of focus, depth of field, and angle around the subject.

I repeat these steps and variations to create more than a dozen results through subtle adjustments in the subject's hand and head placement (**FIGURE 10.37**). Her body position and legs stay the same, while my camera does most of the work to capture different perspectives.

10.37 The body position and leg position are consistent for each shot. I've created variation by changing the position of the hands, the expression, and the eye contact. Most importantly, variation has been achieved with camera work—by changing the angle, lens choice, point of focus, and depth of field.

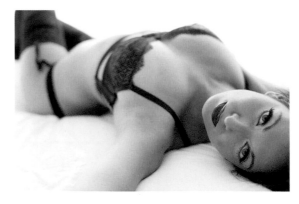

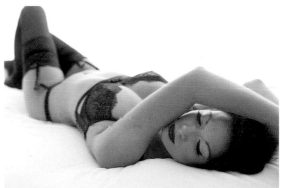

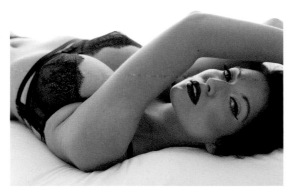

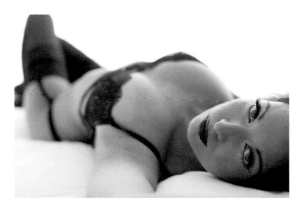

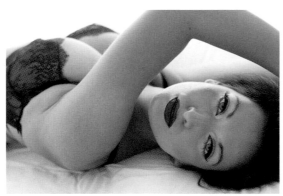

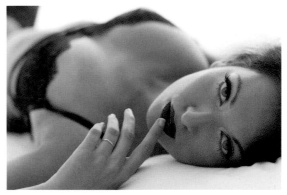

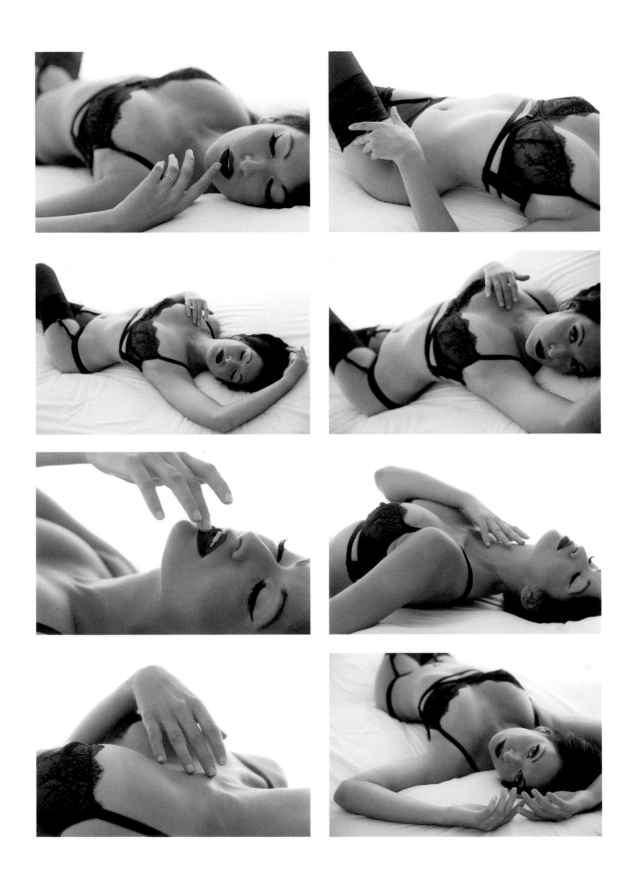

TRAIN YOUR EYE

In this chapter, we've built upon the foundations for flattering a woman's form but pushed those concepts to an extreme to create as many feminine curves as possible. We've learned about drawing attention to strengths, while directing the eye away from perceived flaws. This is a lot to take in, and it will take practice to create a boudoir session where all of the elements come together. Don't worry! Your practice starts here! Take a moment to analyze the original image for problem areas so you'll be able to identify issues on the day of your shoot and achieve stunning boudoir results.

TRAIN YOUR EYE #1

Study **FIGURE 10.38** and see if you can identify the problems in the image.

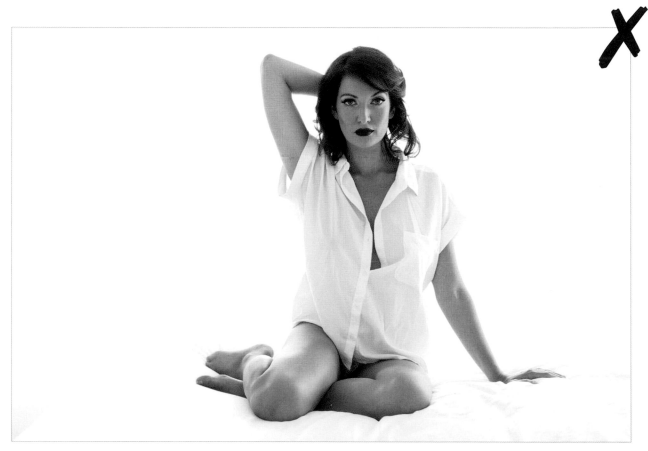

10.38 Train Your Eye #1

Let's see how you did. Compare **FIGURE 10.39** with the solutions in place in **FIGURE 10.40**.

❌ *Problems*

Foreshortening: In her seated position, both knees protrude forward, making them look thicker and shorter.

Curves: This image has a distinct lack of curves to the form. The curves of the hips are not visible; neither is the bend in the legs, nor the gentle curves in the arms. The overall shape of the body is quite boxy.

Other: One of the darkest shadows in the image is in the area just between the legs, creating visual distraction in this high-key image. Furthermore, we've covered most of the skin, hiding many areas that would be more pleasing to look at and make for a more alluring image.

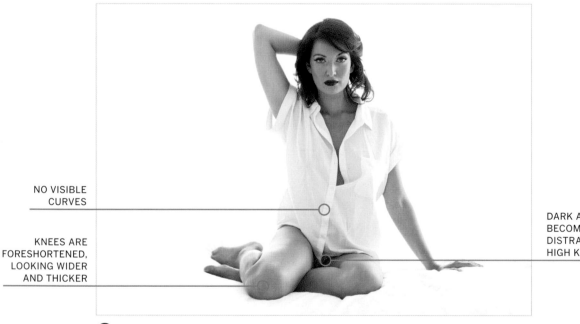

NO VISIBLE CURVES

KNEES ARE FORESHORTENED, LOOKING WIDER AND THICKER

DARK AREA BECOMES DISTRACTION IN HIGH KEY IMAGE

❌ **10.39** Problems

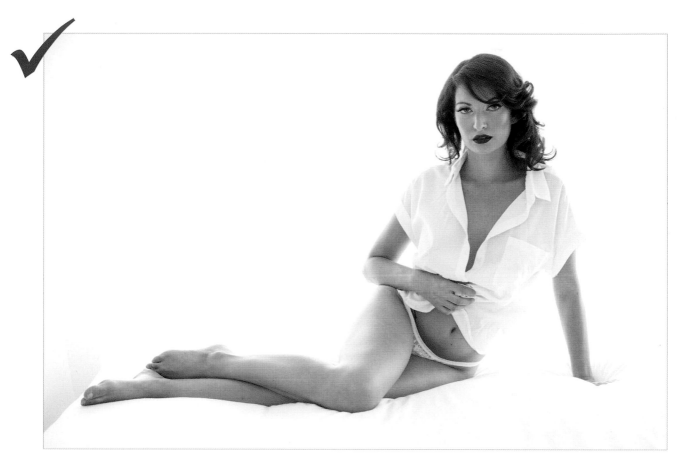

10.40 Solutions

✅ *Solutions*

Foreshortening: By repositioning the legs parallel to the camera, she elongates her body, which is more flattering to her form and also corrects the foreshortening.

Curve: By bending the top knee/leg over, we've created a flattering curve from her hips to the thigh and throughout her knee.

Other: We've used the hand on the left to reveal more skin and have a more gentle hand placement, giving a bit more flirtatious look to the image. The leg position has also reduced the darker area that was distracting in the previous image.

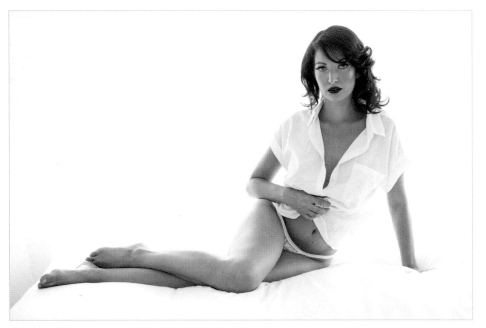

✅ **10.41** Solutions

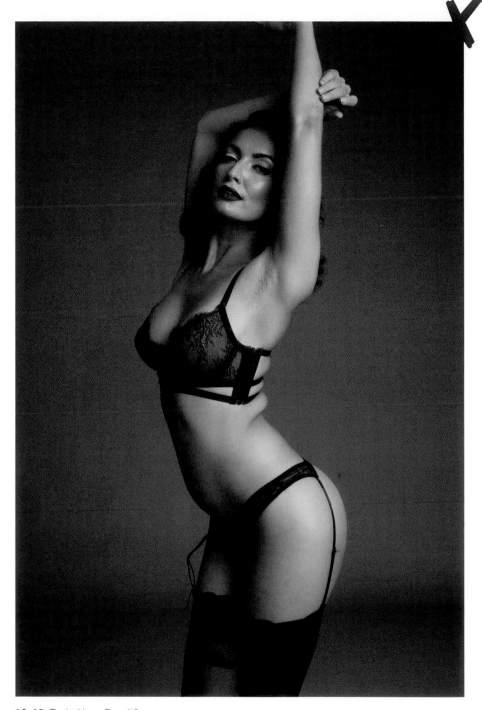

TRAIN YOUR EYE #2

Study **FIGURE 10.42** and see if you can identify the problems in the image.

10.42 Train Your Eye #2

Let's see how you did. Compare **FIGURE 10.43** with the solutions in place in **FIGURE 10.44**.

❌ *Problems*

Body/Camera Angle: The stomach is in profile, which is unflattering to even the most slender subject. The hips are pushed out toward the camera, making a less pleasing shape than when pushed to the side.

Problem areas: The pose has created an unflattering roll of skin in the middle back.

Legs: Because the legs appear side by side, they appear thicker and do not produce an interesting shape at the bottom of the frame.

Crop: The frame is cropped at a joint (the wrist), resulting in an abrupt end to the pose.

✅ *Solutions*

Body/Camera Angle: The subject has been turned to face straighter toward the camera. This fixes several problems, creating a more flattering shape to the stomach, making the hips curve to the side, and obscuring the roll of skin on the back.

Legs: With the angle change, the legs stay in roughly the same position but narrow at the bottom of the frame to create more curves.

Crop: The elegant curve of the wrist has been included.

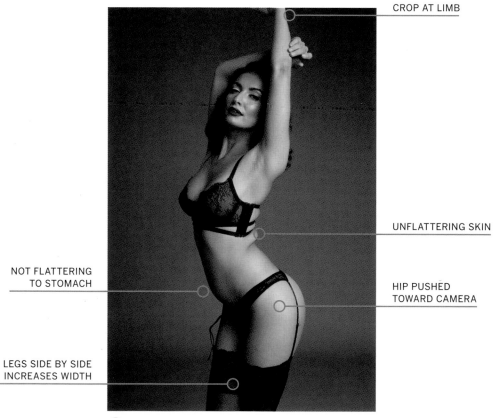

CROP AT LIMB

UNFLATTERING SKIN

HIP PUSHED TOWARD CAMERA

NOT FLATTERING TO STOMACH

LEGS SIDE BY SIDE INCREASES WIDTH

❌ 10.43 Problems

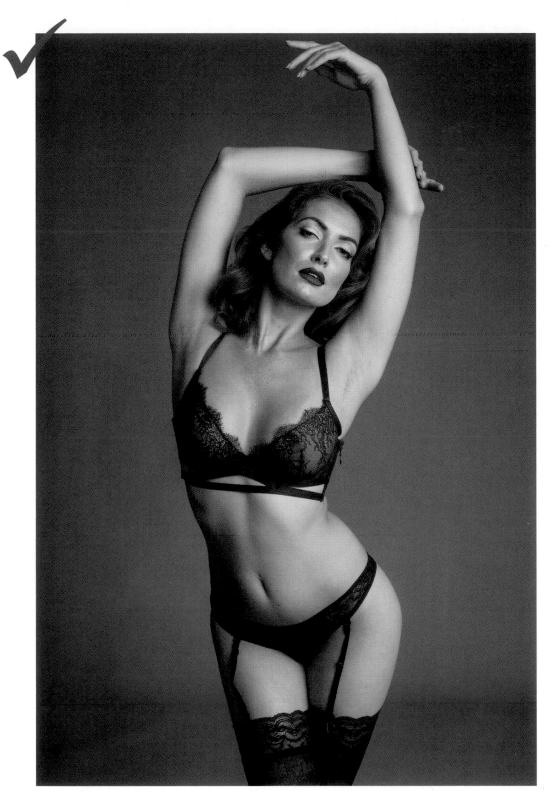

10.44 Solutions

5 GO-TO POSES

POSE 1 The subject lies on her side, with the top knee bent over to the ground. Her hands meet together in the front, leaving the chest unobscured.

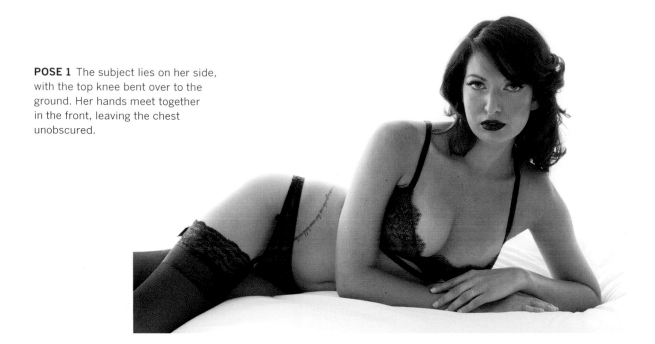

POSE 2 The subject leans on her hip, top knee bent over and torso up. One hand is extended out to the side, while another is tucked behind the head or free to move to create variety in the pose.

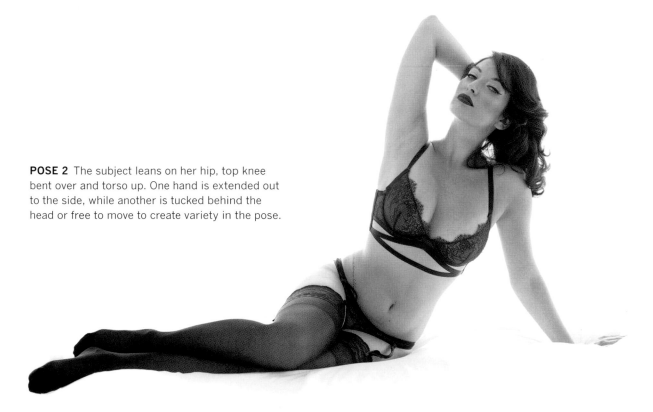

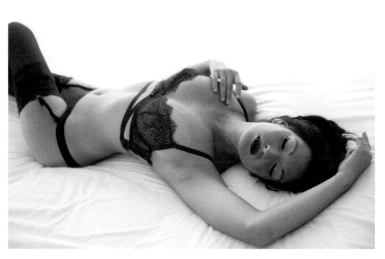

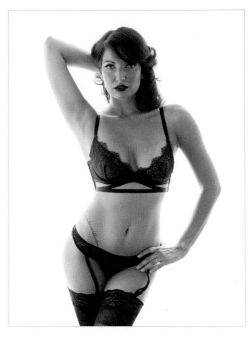

POSE 3 The subject reclines on her back. The knee closest to the camera is bent, and the back is arched. The arm closest to the camera is elevated above the head, and the back arm caresses the chest (though both arms are free to pose to create variation).

POSE 4 The subject stands with one hip out and a knee crossed over to create a narrowing point. One hand is on the hip, while the other is behind the head. Hands can be adjusted (to chest, lingerie, face) to create variation.

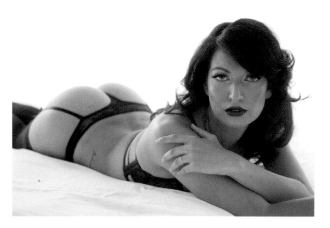

POSE 5 The subject lies on her stomach with her buttocks elevated. The front, or right, arm is extended outward with the left arm crossed over. The arms can be modified to reveal the chest.

BONUS POSE 6 The subject lies on her side, top knee crossed over, and bottom arm supporting her head. The top arm is contoured to the body to create curve. The subject may also lay her head on the bed and vary the arms.

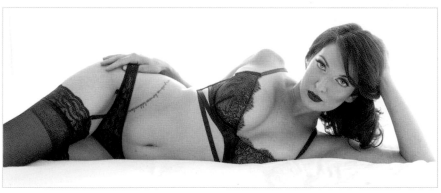

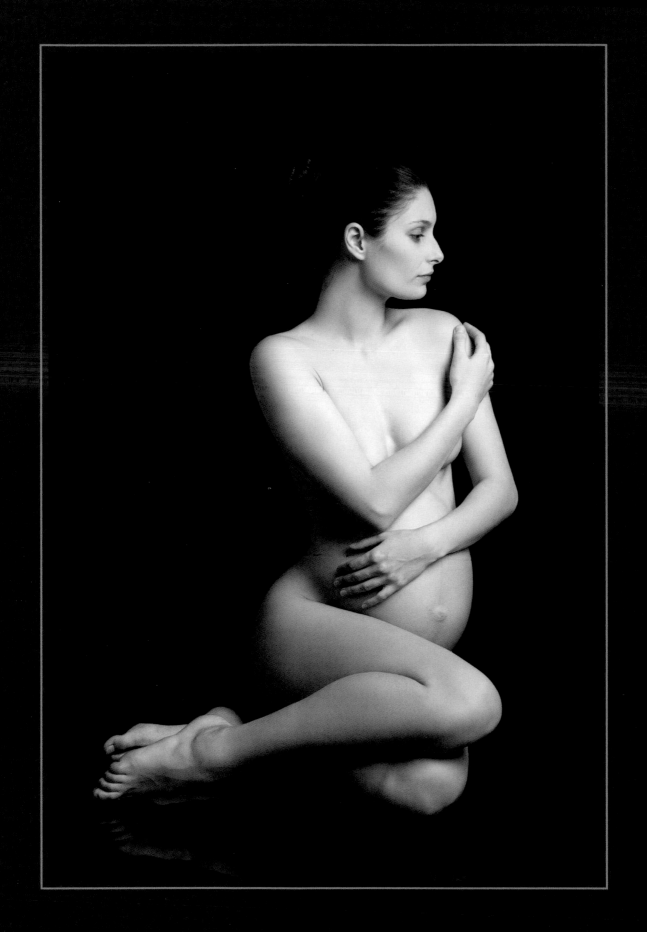

MATERNITY

Maternity portraits are an opportunity for you to create an image that becomes a timeless keepsake for the mother and family. Posing these images not only helps draw attention to your subject's beautiful baby bump, but also helps your subject look her best. And just because she is pregnant, it doesn't mean all the other guide-lines for posing women go out the window. Adding curve, having negative space or contouring, and slenderizing your subject are still good practices, especially since she will likely have some extra weight she is not used to.

Guidelines for Maternity Portraits

Here are some special considerations that will help you achieve stunning imagery in your maternity session.

3/4 or Profile to Emphasize Bump

If your subject is tasking you with photographing maternity portraits, you'll want the baby bump to show. Particularly for a woman earlier on in her pregnancy or with smaller bumps, the best way to showcase this new curve is to turn your subject to 3/4 or profile. As you can see, the pose in **FIGURE 11.1** makes it challenging to see the shape of her stomach, yet when we turn her 3/4 to the side (**FIGURE 11.2**), you can see her form more clearly.

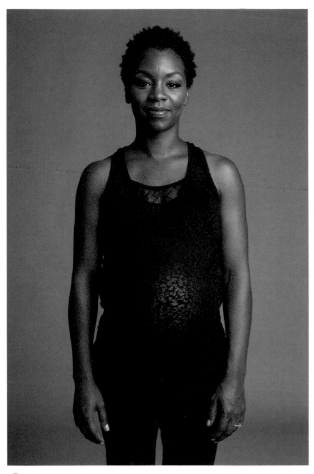

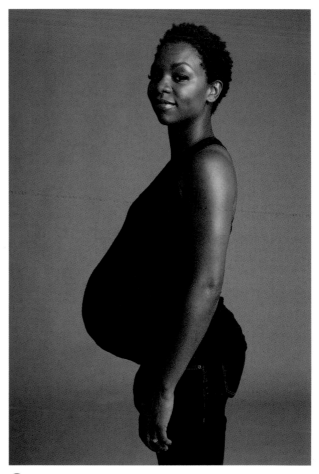

❌ **11.1** The subject faces the camera, making it difficult to see her baby bump.

✅ **11.2** When the subject turns to the side, the shape of the stomach is more clearly defined.

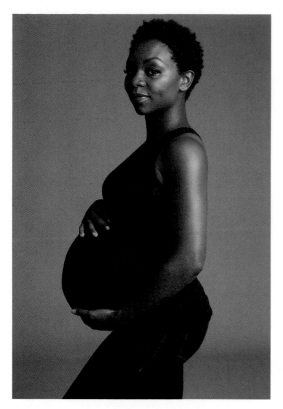

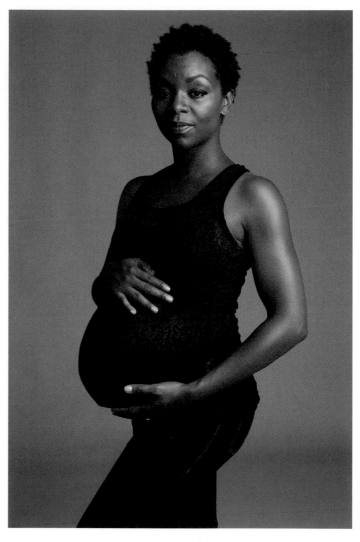

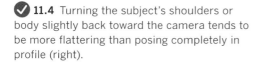
11.3 In full profile, your subject lacks depth and connection with the camera. This pose is best used for silhouettes (above).

✅ **11.4** Turning the subject's shoulders or body slightly back toward the camera tends to be more flattering than posing completely in profile (right).

When you turn the subject to the side, there are extra considerations to keep in mind. First, make a conscious decision of whether the subject will be in full profile. At full profile, often the curve of only one breast will be visible and the baby bump will appear its widest (**FIGURE 11.3**). This is not wrong (it looks great when you are shooting silhouettes), but you need to be aware of the results. You may want to turn the chest back toward the camera slightly to show the shape of both breasts, or perhaps turn the subject slightly toward the camera to make the midsection look less pronounced (**FIGURE 11.4**).

Next, when turning your subject to the side, be very careful of mergers. Wherever you place the hands, try not to extend the width of the body or

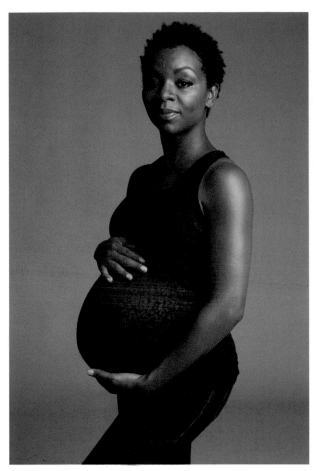

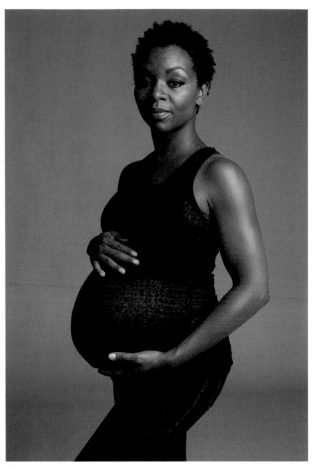

❌ **11.5** Here, the subject's body looks wider and we have hidden the curve of her lower back (her arm has created a merger).

✓ **11.6** By pulling the arm back slightly, we have created negative space and a more flattering arm position for her form.

hide the curve of the lower back with the arm (**FIGURE 11.5**). You'll want to use these curves to create feminine lines. Remember, you can use in-body posing by pulling the arms within the frame *or* pull the arm back to create negative space, as seen in **FIGURE 11.6**. By including this negative space between her arm and her lower back, she will look more slender, and you'll have revealed yet another beautiful curve.

Bend or Elevate the Front Leg

In earlier chapters, you've learned about the importance of avoiding flat, even feet. The same holds true with maternity sessions.

When posing your subject to the side, generally you will want her to bend the knee closest to the camera. This creates an additional flattering curve from your subject's thigh, butt, and lower back. If the subject is flat-footed, the pose loses its flow and becomes very stagnant. Moreover, a flat-footed pose may make a subject look wider, depending on the position of the legs (**FIGURE 11.7**).

Notice that, in **FIGURE 11.8**, by raising the front leg, we have introduced a beautiful curve *and* a narrowing point for our subject that improves the overall appearance of the form and pose. For some women, particularly late in their pregnancy, it may be challenging to raise the front knee or a toe for an extended period of time. Be aware of your subject's comfort and consider providing a box to place her foot on for elevation, as shown in **FIGURE 11.9**.

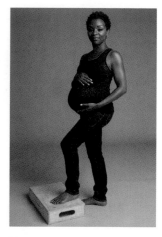

11.9

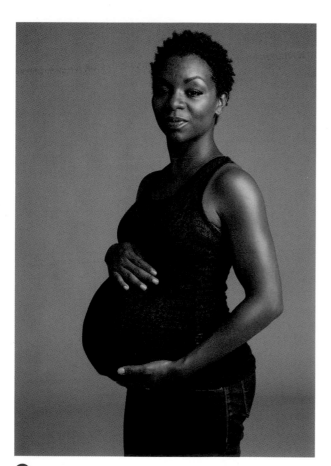

❌ **11.7** Standing flat-footed creates a stagnant pose and makes the subject's thighs look wider.

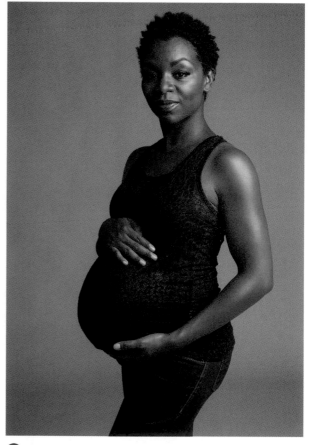

✅ **11.8** By bending the knee closest to the camera, we have created curves and a narrowing point.

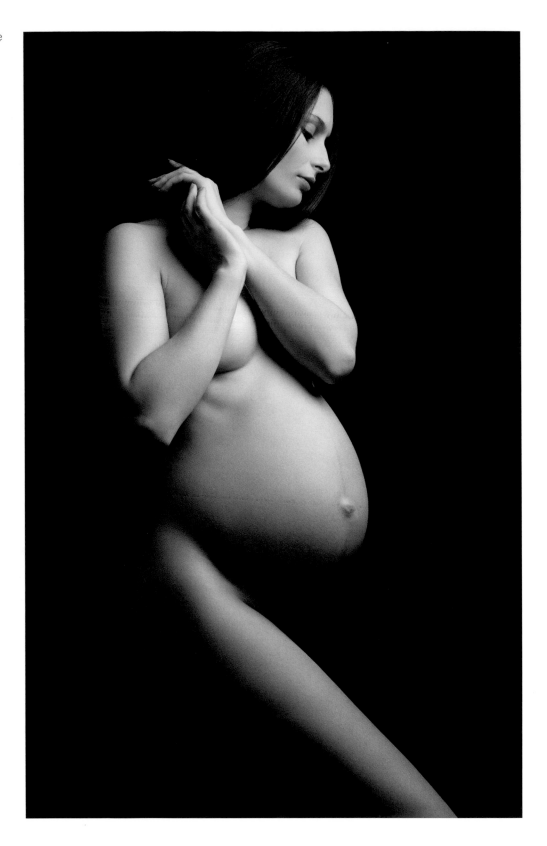

11.10 By bending the knee closest to the camera, you help to "censor" your subject in nude maternity images.

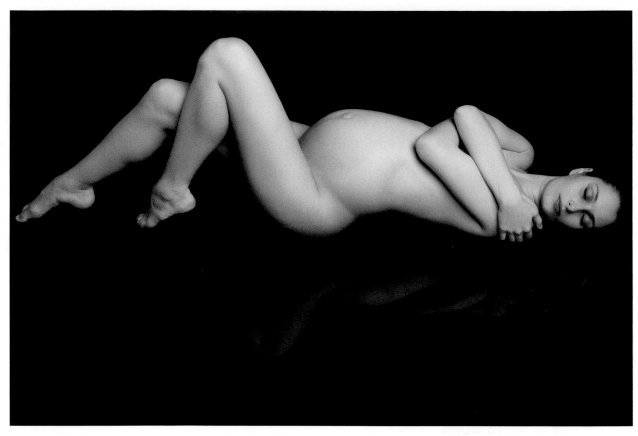

11.11 Bending the knee closest to the camera is great for standing, sitting, and lying-down poses.

Also be aware that leg placement becomes incredibly important for nude or implied nude maternity images. The curves of the subject are even more essential, and bending the front leg helps to obscure private areas from the camera, as seen in **FIGURE 11.10**.

While the examples I've used so far for bending the knee have all been roughly the same pose, this suggestion applies whether the subject is sitting, standing, or lying down (**FIGURE 11.11**). Typically, you'll want to bend the leg closest to the camera to accentuate curves and create more elegant lines throughout the pose.

PRO TIP

Very wide or loose-fitted dresses make it difficult to see the curves created by bending the knee or creating a narrowing point. I often use small clips to make the dress more form-fitting around the stomach and legs. I position the clips hidden from the camera's view. This makes it much easier for me to shape the curves and work with narrowing points.

Use Arms to Contour

You can use your subject's arms and hands to contour and draw attention to the curve of the baby bump. This technique is particularly useful to emphasize a smaller bump and to create pleasing visual lines, and it is essential if you choose to pose the subject straight toward the camera. The idea of contouring is that the hands and arms are used to outline the stomach and create additional beautiful curves for the viewer's eyes to follow.

When shooting the subject straight on, often the outward curve of the stomach is hidden (**FIGURE 11.12**). The placement of the hands helps to define the shape of the stomach and also acts as body language to communicate maternal protection, as the arms are wrapped around the stomach. In **FIGURE 11.13**, the arm placement draws more attention to her beautiful shape.

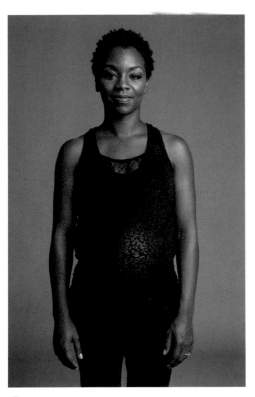

❌ **11.12** With the subject facing the camera, it is difficult to see the shape of the baby bump (above).

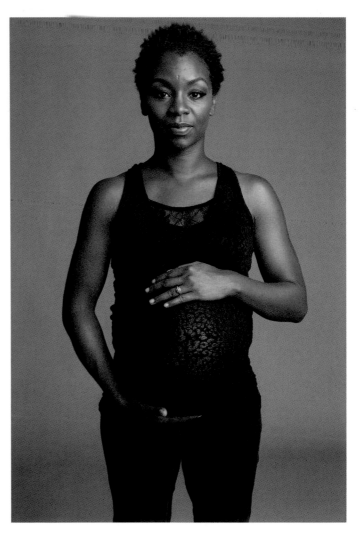

✅ **11.13** By contouring the stomach with the hands, the form becomes more visible (right).

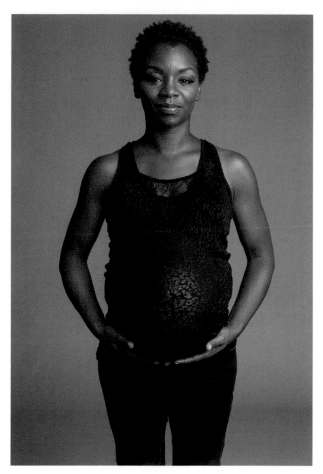

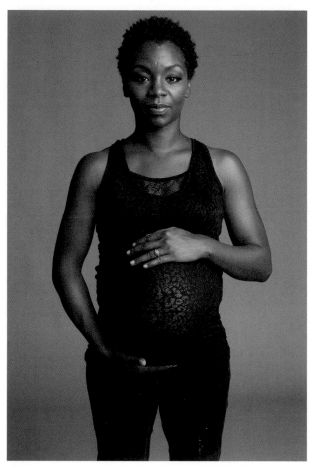

11.14 While both hands can be placed at the same level, typically this is not as effective or flattering a way to show the woman's shape. If hands are placed at the same level, be sure to maintain some negative space between the arms and the sides of the body.

✓ 11.15 By placing one hand above the stomach and another below it, the hands more effectively shape the subject's form.

When using the hands to contour, typically the hands are placed at different levels to create interesting visual flow—one above the bump and one below, as seen in **FIGURE 11.15**. This helps to define the complete form. You can place both hands at the same level (under the stomach as seen in **FIGURE 11.14**), but this tends to work best with an exposed stomach, or poses in which the shape of the bump is already clearly visible.

Also note that you will still want to maintain negative space between the arms and body, particularly if both hands are placed beneath the stomach. If her arms are close to her sides, she will look wider.

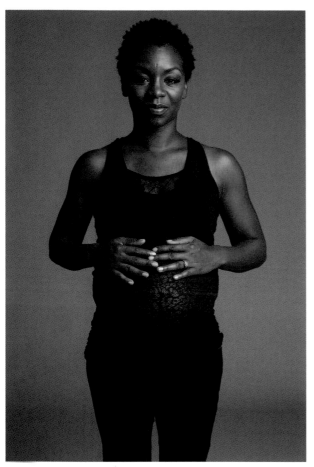

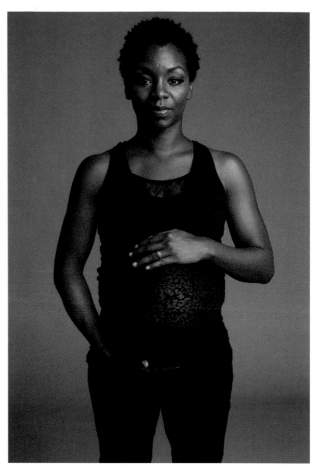

❌ **11.16** Stacking hands on top of each other creates a distracting visual element.

✅ **11.17** Varying hand placement creates more visual interest in the frame.

Because you want the hands to contour her shape, generally you will *not* want to have the hands stacked together on top of the stomach, as seen in **FIGURE 11.16**. Stacked hands draw a lot of attention, and the arm placement does not flatter the subject's curves. You can see in this example that the hand placement is not adding to the photograph or the appearance of the subject. Varying the hand placement, by contrast, leads to more pleasing results (**FIGURE 11.17**).

CAUTION Don't forget that tense hands can ruin a shot. Always keep the hands relaxed, and ideally, with the pinky side of the hand facing toward the camera.

MASTERING *Your Craft*

If the subject is turned to the side, usually the arm closest to the camera is placed below the subject's stomach. Wrapping the front arm over the stomach may also raise the shoulder (**FIGURE 11.18**). The back fingers pointing toward the camera from beneath the stomach are distracting, as well. Placing the hand closer to the camera below the stomach (**FIGURE 11.9**) creates a longer and more elegant line. The hand farther from the camera can be placed above the stomach. ■

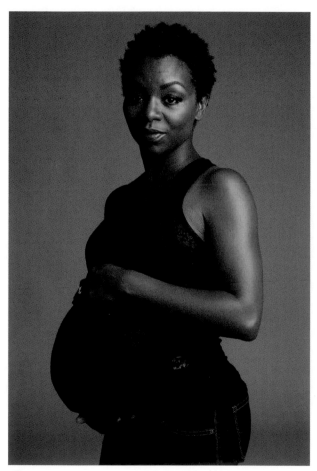

❌ 11.18

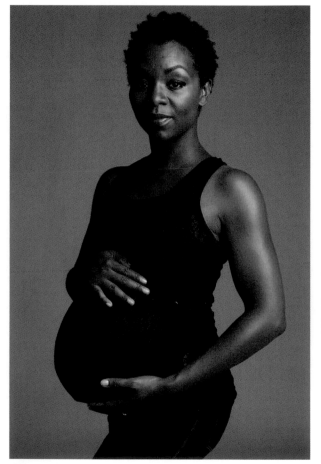

✓ 11.19

All Rules of Posing and Perspective Still Apply

Just because a pregnant subject may look wider, it does *not* mean that she wants to look heavier or without other feminine curves. You can still use all the rules of posing, lens choice, and camera angle to bring out the best in your subject.

In your shoot, you may want your subject to lean her torso closer to the camera and push her hips back slightly to bring more emphasis to the face and chest. This is especially true of women in later stages of pregnancy, when their bump is clearly defined. Try arching the lower back to create a beautiful curve. Stick the chin far out and down to reduce any double chin

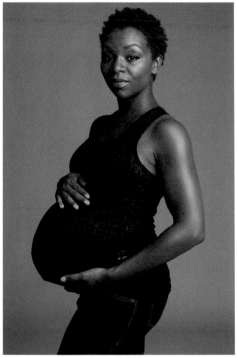

❌ **11.20** Here, the low camera angle puts more emphasis on her midsection and makes her look a bit thicker.

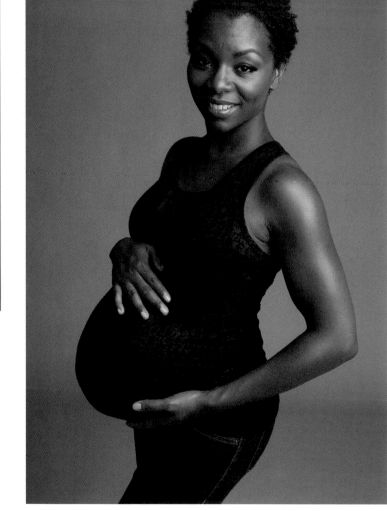

✅ **11.21** As the subject leans toward the camera, more attention is drawn to her face and chest while her midsection and thighs appear narrower.

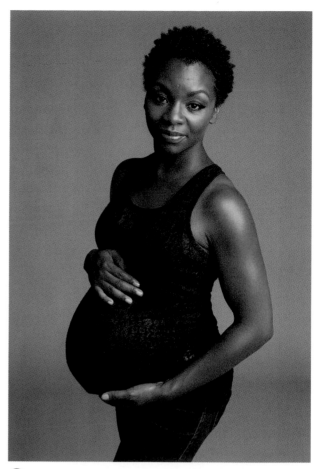

❌ **11.22** The subject has poor posture, and her arm is merging with her body to make her look wider.

✅ **11.23** The subject elongates to improve posture and creates a small bit of negative space to show her curves and actual width.

from the extra baby weight. Get at a high angle if you want to slenderize. Watch out for arms tight to the body that may create "arm squish" (that is, the arm looking wider or flabbier than it is).

In **FIGURE 11.20**, the subject has an acceptable body position and pose. Yet in **FIGURE 11.21**, a subtle lean toward the camera brings more attention to her face and torso, while also slightly thinning her form.

Let's examine **FIGURE 11.22**. The subject has poor posture and a merger to the side of her body (the arm starts just as the body ends, adding several inches in apparent thickness to her form). If we remember our essential rules of posing, these issues can be remedied, as seen in **FIGURE 11.23**.

MASTERING *Your Craft*

Don't forget how to create endless pose variety! Even with maternity sessions, I recommend finding a base pose, then varying the digits. Remember to use a couple of base poses standing, some poses sitting and/or lying down, and a few poses that include the partner. After you find your base pose, change hand placement and expression to create new looks. From there, you can change your focal length and crop to give yourself even more variation in final images. Take a look at the next example. The base pose (**FIGURE 11.26a**) is our subject seated (with the front knee bent, as recommended) and hands contouring the stomach. Next, I have her move her hands from the chair to her neck to her stomach. I've also varied her eye contact with the camera (**FIGURES 11.26b–f**). Even with very little movement, I've achieved several different poses in a matter of seconds! ■

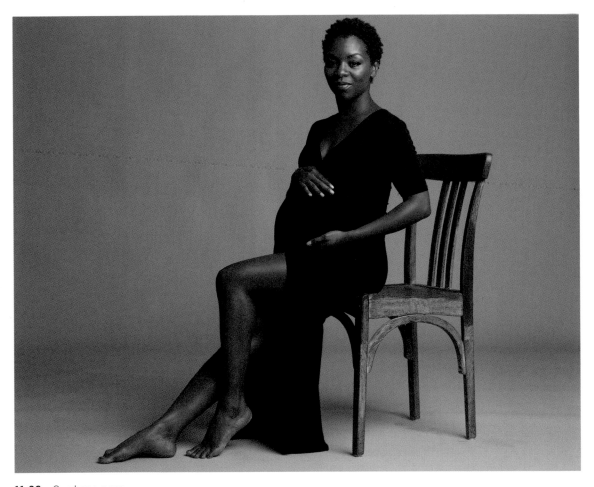

11.26a Our base pose.

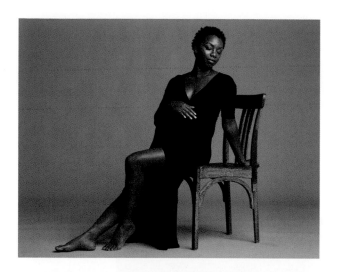

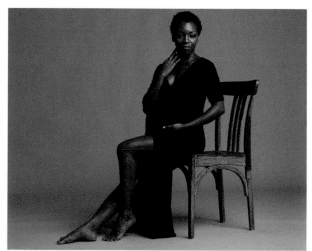

11.26b–f By finding a base pose and then varying the hand/arm position in conjunction with the expression, you can create a wide variety of poses in seconds.

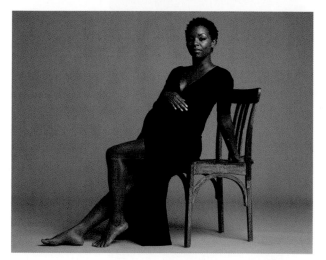

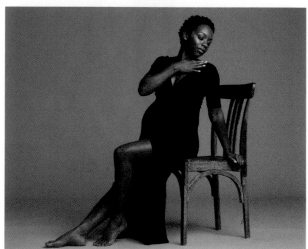

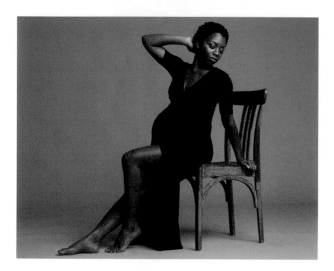

When shooting a nude maternity session, the partner can be an excellent addition to show the relationship and to create variety. You can also use his pose to help censor the shot for a subtler or more implied nude, as seen in **FIGURE 11.29**.

When including the partner, there are a few things you'll want to consider. First, you don't want them to be too diminished in the frame. Although the mother may be the center of interest, she shouldn't be hiding her partner or making them look small in the frame.

✅ **11.29** Utilizing the father in a nude maternity session can be beautiful for symbolism and capturing their relationship. You can also create implied nudes through careful positioning of the arms.

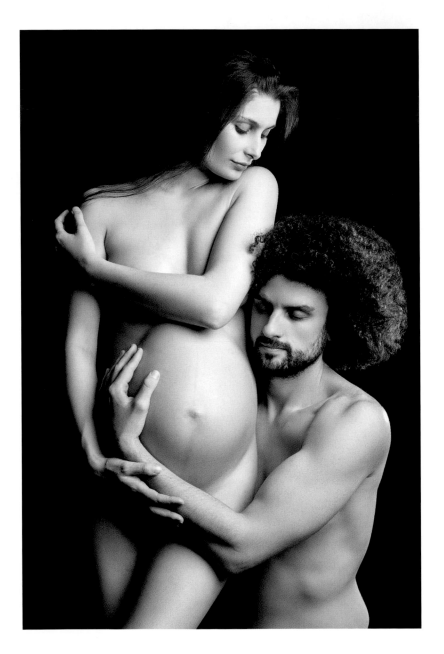

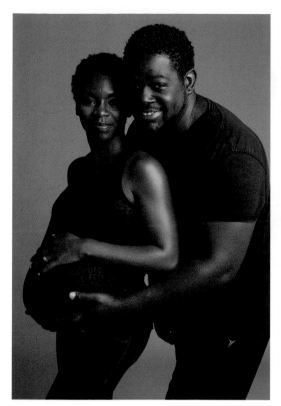

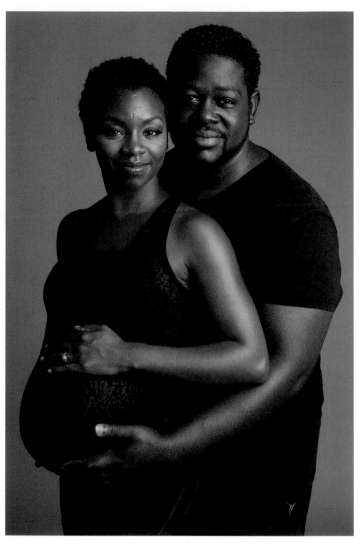

❌ **11.30** Because the father is much taller, he struggles to wrap his arms around his partner in a supportive posture, and instead has poor posture while dominating the frame.

✅ **11.31** By asking him to step back, put one foot in front of the other, and lean forward, we have greatly improved the posture.

Of course, you don't want to forget the general tips for posing couples that we covered already. Those still apply! For example, be very careful if the subjects have drastically different heights. In **FIGURE 11.30**, the father is significantly taller, so when he bends down for a supportive pose, it creates poor posture and he dominates the frame. The solution? Try elevating the mother on a box or have him step behind her with one foot forward, leaning in (**FIGURE 11.31**).

TRAIN YOUR EYE

We've learned a lot about some special considerations for posing maternity sessions, and now it's time to train your eye and test your knowledge. Remember that the general rules of posing don't go out the window, but rather, are just as important as ever. Let's see if you can identify problem areas with the pose and envision possible solutions to best flatter your subjects. I'll be providing you with one possible solution, but remember, there are endless other solutions!

TRAIN YOUR EYE #1

Study **FIGURE 11.32** and see if you can identify the problems in the image.

11.32 Train Your Eye #1

Let's see how you did. Compare **FIGURE 11.33** with the solutions in place in **FIGURE 11.34**.

❌ *Problems*

Hands: The hand on the left is a distracting element that draws the attention of the eye. The arm on the right is not as problematic but does raise the shoulder slightly.

Legs: With the subject standing flat-footed, we lose an opportunity to create curves, and the side-by-side leg placement makes her thighs look larger.

Camera Angle: The camera angle appears to be at about stomach level, which makes her midsection look wider.

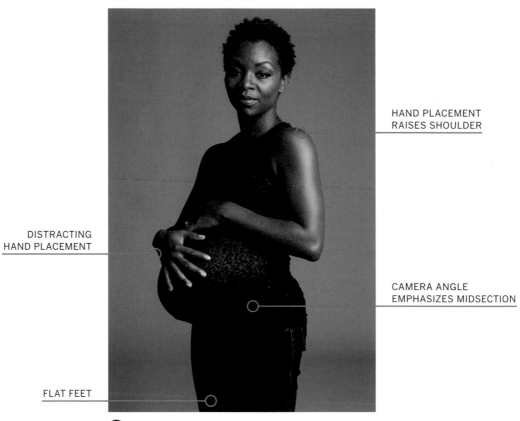

HAND PLACEMENT
RAISES SHOULDER

DISTRACTING
HAND PLACEMENT

CAMERA ANGLE
EMPHASIZES MIDSECTION

FLAT FEET

❌ **11.33** Problems

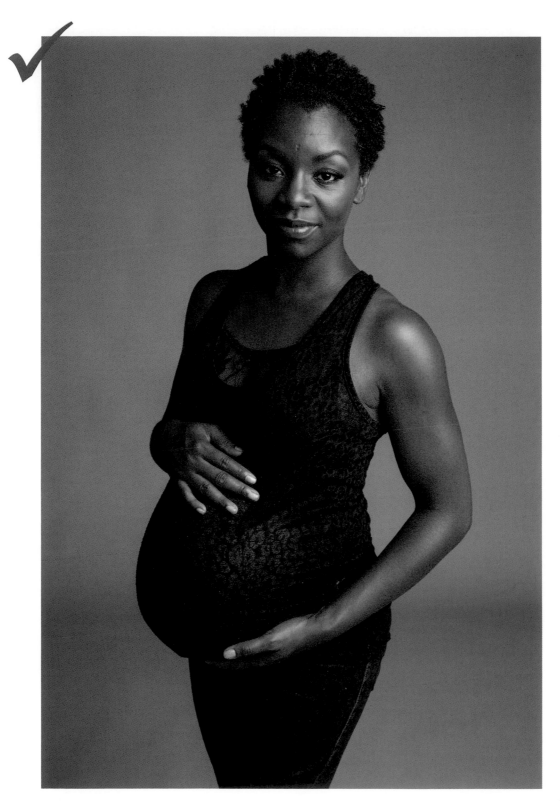

11.34 Solutions

✅ *Solutions*

Hands: The left hand still rests on the stomach, but now in a much less distracting position and with more relaxed fingers. The right arm has been repositioned to contour the subject, thus lowering the shoulder and creating longer lines.

Legs: I have asked the subject to bend the knee closest to the camera to create a narrowing point, resulting in more visually pleasing curves.

Camera Angle: I have elevated my camera angle to about shoulder level, and then asked my subject to lean her chest and face closer to the camera. This puts more emphasis on the face and is slightly slenderizing.

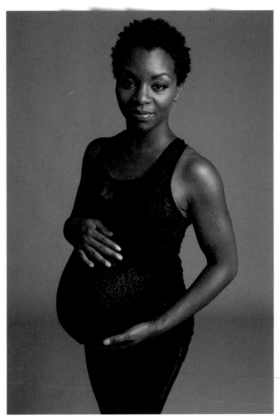

✅ **11.35** Solutions

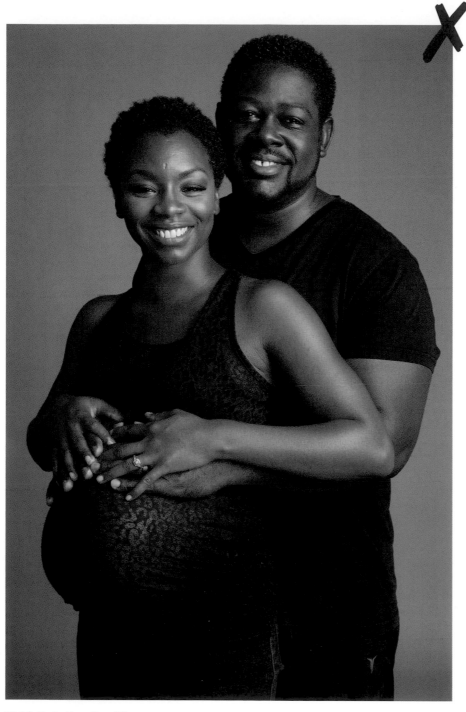

11.36 Train Your Eye #2

TRAIN YOUR EYE #2

Study **FIGURE 11.36** and see if you can identify the problems in the image.

Let's see how you did. Compare **FIGURE 11.37** with the solutions in place in **FIGURE 11.38**.

❌ *Problems*

Hands: The hands are too stacked. This draws the eye to one place and becomes a distracting element.

Feet: The flat-footed position hides some curves and makes the mother look wider.

✅ *Solutions*

Hands: The hands are still together but now are contouring the form and creating pleasing visual movement.

Feet: The front knee has been bent to create a narrowing point and nicer curves.

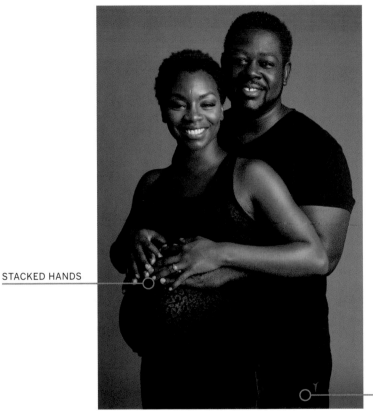

STACKED HANDS

FLAT FEET

❌ **11.37** Problems

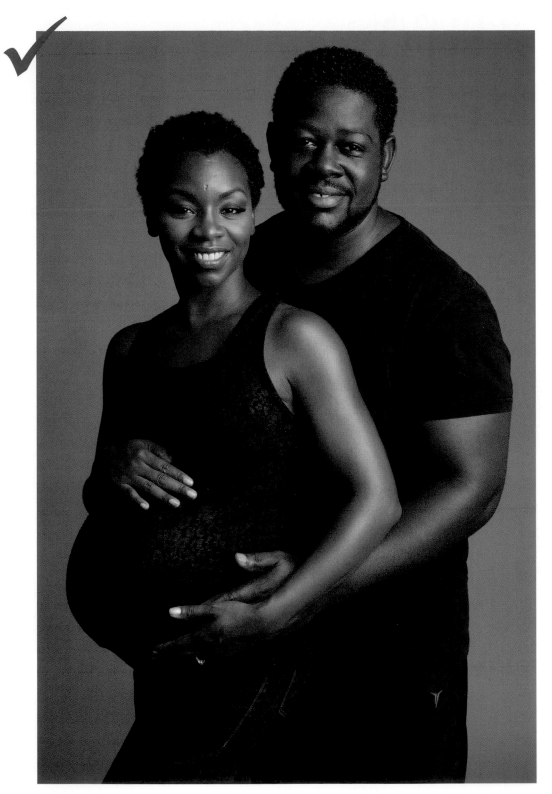

11.38 Solutions

5 GO-TO POSES

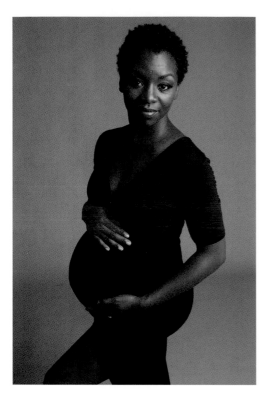

POSE 1 3/4 body position, arms contouring.

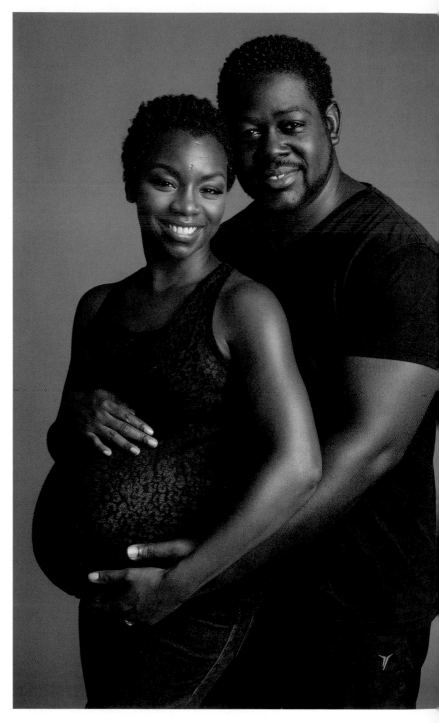

POSE 2 Mother in Go-To-Pose 1, father with hand beneath hers, heads tilted together.

POSE 3 Seated in chair with front knee bent.

POSE 4 Resting on side with top knee over, head supported by arm.

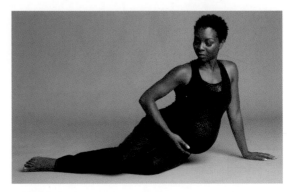

POSE 5 Seated on floor, leaning on hip, with one arm contouring and the other supporting.

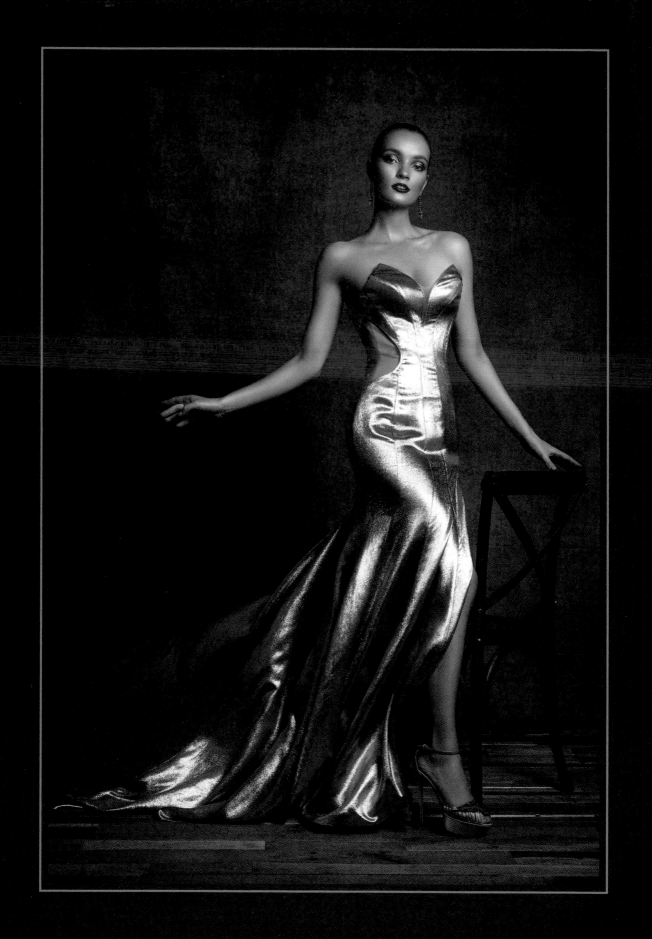

BRINGING IT ALL TOGETHER

Our journey toward perfecting the art of posing is almost complete, but now it's time to test some of the lessons you've learned before you try them out in the real world.

This final chapter is meant to help you analyze problems on the day of the shoot rather than later lamenting the issues you missed. I'm going to take you through some images from real shoots I've done with a variety of subjects and body types.

Using the examples that follow, I invite you to analyze the problem areas that exist and to visualize how to improve the pose to better flatter your subject. I'll share the problems I identified and a solution I used in the actual shoot. This is where you'll test what you've learned and figure out what you have yet to master.

Although this book is about posing, in a couple of these before-and-after examples I've also included a final image to show you what I would retouch. I do absolutely everything I can to get the shot right in-camera, but sometimes I put the finishing touches on a subject in post-processing. It's useful to see the balance of how I flatter the form during the shoot, and then how I perfect the image in Photoshop.

In other examples, I've included behind-the-scenes photos so you can take a peek at my set. This will allow you to see the simple lighting setups that I've used to achieve flattering results for each subject and help you dive a bit deeper into my image-making process.

PRO TIP

Since this is a posing book, I won't go into any retouching techniques, but I recommend that you check out

 Learnwithlindsay.com for tutorials about my favorite retouching tips and tricks. You'll definitely want to watch my videos on skin retouching, using the Liquify filter in Adobe Photoshop, frequency separation, and contouring.

Lastly, for several shots I've included a "before" shot taken without hair, makeup, wardrobe, lighting, or posing. I want you to be able to see the person as they appeared when they walked into the shoot. Hair and makeup can really help your subject feel confident, and it makes your job easier when the subject already feels great about themselves going into a shoot. And, not only can careful selection of clothing help a person feel beautiful, but when it flatters the form, it can also make your job as a photographer infinitely easier.

In this chapter, you'll see the interplay of posing, lighting, hair and makeup, and the clothing and retouching that is used to get that stunning shot. Of course, we'll focus primarily on posing, but it is important to be aware that all these elements work together to create a successful portrait that really wows your subject.

Don't forget to ask yourself these questions as you examine a pose: Where is my eye going in the pose? Is that where it should be going? How can I make a change to improve it? Should I change my camera angle or pose, shift the weight, lean the chest, or vary my focal length? Each element will make a difference.

Before we begin analyzing posing, I've provided a checklist of items to keep in mind as you go through the examples. Consider this list as you do your own shoots. If some of these points are new to you, go back and read some of the earlier chapters of this book for a refresher.

Posing Checklist

- ❏ Improve posture

- ❏ Avoid foreshortening

- ❏ Watch for mergers: try negative space, in-body posing, or contouring

- ❏ Pinky side of the hand faces out

- ❏ Capture engaged expression

- ❏ Place chin out and down

- ❏ Consider proportion

- ❏ Avoid flat feet; shift the weight

- ❏ Employ asymmetry for interest

- ❏ For women, consider bend and curve, and create narrowing points

- ❏ For men, create structure and position shoulders to define broadness

You've read the other chapters, you've got a checklist; now it's time to test your knowledge and put it all together.

Note: None of the images in this section have been retouched unless specifically noted.

PRO TIP

Visit ⤤ **Learnwithlindsay.com/posing** to explore many videos that relate directly to the content covered in this book. If you learn better in video format or want to reinforce what you've learned, it is a great resource that goes hand in hand with this book.

Subject #1: Slender Young Woman

For this portrait session, I'll be creating elegant fashion portraits for this slender young woman. The goal is to flatter her form and showcase her beautiful features.

12.1 Our subject as she enters the studio, before applying makeup and styling her hair.

When posing slender subjects (in her case, 5'8" and a size 0 in U.S. clothing), you are not trying to slender-ize as you may with other subjects. As we've covered throughout this book, every subject will have a different body type and not all poses will work for everyone. In this case, my go-to pose for most women—hips back and chest forward—may not work to flatter her shape. Such a pose may actually put her out of proportion and make her lower half look even smaller than it is.

Very slender subjects may come off as twig-like or lacking flow in their shape, but thoughtful posing will help us avoid that.

Let's take a look at this subject's "before" photo (**FIGURE 12.1**). Makeup will help to give a really lovely glow to her already beautiful skin. Notice how her natural stance and narrow stature make her look very column-like in the "before" shot. I will select poses that help create more interesting shapes for the eye to follow and visual curves to explore.

This set is lit with a Profoto Strobe (Profoto D1 Air) using a Profoto XL Deep White Umbrella with diffusion. To the left of the frame, a large white V-flat (white foamcore) is used as a fill light to avoid dark shadows. The set includes a hand-painted Gravity Backdrops canvas background with vintage apple boxes from Esty.com (**FIGURE 12.2**).

12.2

Shot #1

❌ *Problems* **(FIGURE 12.3)**:

Arm: The arm with her hand resting on her knee is too straight and rigid.

Hand: The hand supporting her body is slightly awkward and could be positioned more elegantly, though it is not terrible.

Mergers: The subject's arm is tight against her side. With slender subjects, I don't worry as much about mergers, and sometimes they can actually be helpful. Here, however, the straight arm is not adding any visual interest.

Pressure: The subject is putting all her weight on one arm. It makes her upper arm bulge out unnaturally, creating a pose that lacks flow.

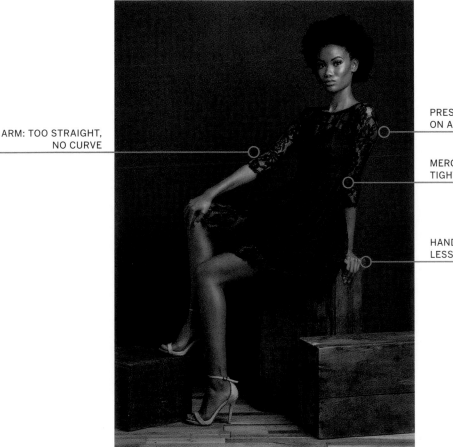

ARM: TOO STRAIGHT, NO CURVE

PRESSURE: LEANING ON ARM CAUSING BULGE

MERGER: ARM TIGHT TO BODY

HAND: TOWARD CAMERA, LESS ELEGANT

❌ **12.3** Shot #1

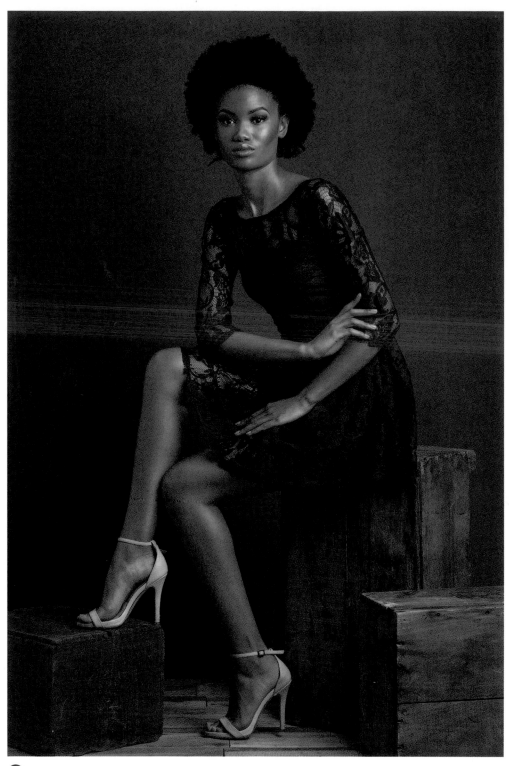

☑ 12.4

✅ *Solutions* (FIGURES 12.4 and 12.5):

Arm: I've completely repositioned the arms to improve the flow of the image. Now both arms are bent, creating elegant triangles in the shot.

Hands: The hand position has been drastically improved, with the pinky side facing the camera. No pressure or weight is being put on the hand or arms.

Mergers: The arm closest to the camera is merged with the side of her body, but because of her slender form, this is not too problematic.

Legs: I've also repositioned the legs to have more angularity to them. This helps bring more flow to the photograph.

Take another moment to analyze the photograph. Consider where your eye travels on her form. Can you see how the position of the arms and legs encourages your eye to move throughout the body in a gentle curving motion? With slender subjects, it is easy to fall prey to poses that are very vertical, too narrow, or lacking curve. For an outfit or portrait like this, you don't necessarily want to create a sexy curve. This is especially true for younger subjects or high school senior portraits. Curve means more than just shape to the bust and the hips. It can also mean the path your eye follows on the form (**FIGURE 12.6**).

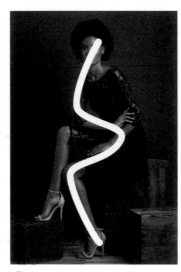

✅ 12.5 ✅ 12.6

PRO TIP

In addition to the placement of her arms, the position of the leg (up on a box) helps create this curve. The boxes allow me to create different levels to pose my subject on. If both feet are flat to the ground, there isn't as much visual interest. Also, the vintage apple box is more interesting than a basic posing stool. Some of these boxes are from Etsy.com, others from antique shops shops, and range in price from $15 to $45 a piece.

Shot #2

✖ *Problems* (**FIGURE 12.7**):

Shape: Overall, the pose is stagnant and boxy, and it lacks flow.

Arms: The position of the arms makes the torso appear boxy. The right angles of the arms trap the eyes so they cannot move freely throughout the pose.

Foreshortening: The hand on the right is wrapped around the arm, creating foreshortening.

Crop: The crop just below the knees is slightly awkward. The two straight lines of the legs become distracting and lack flow.

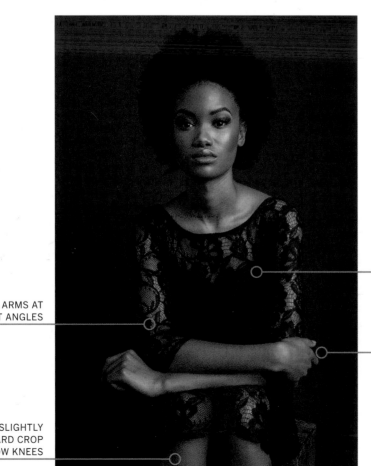

SHAPE: VERY BOXY, NO VISUAL FLOW

ARMS AT RIGHT ANGLES

FORESHORTENING: HAND AWAY FROM CAMERA CREATING FORESHORTENING

CROP: SLIGHTLY AWKWARD CROP JUST BELOW KNEES

✖ **12.7** Shot #2

✔ *Solutions* (**FIGURE 12.8**):

Shape: Because of the position of the arms, our eyes read much more of an hourglass shape and move freely, flowing through the form.

Arms: Her arms now bring a beautiful shape to the pose by creating an appropriate bend.

Hand: The pinky side of both hands is toward the camera, creating elegant curves. The hand near the face also leads our eye to the center of interest.

Crop: The crop is careful to include the tips of her fingers and limbs.

By using in-body posing, we have chosen the placement of the arm to create the illusion of an hourglass on this very slender subject. Notice how the eye will actually perceive the meeting point of the elbows as the center of the hourglass shape (**FIGURE 12.9**). Even though we have not made our subject's body look curvy, we have introduced pleasing "S" curves for the eye to follow through the body (**FIGURE 12.10**).

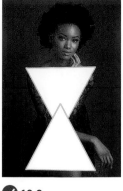

✔ 12.9

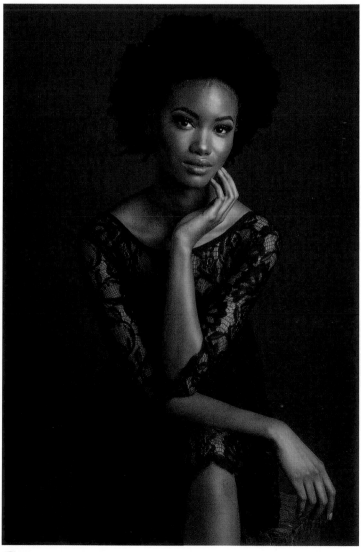

✔ 12.8

✔ 12.10

These solutions are not the only ones. For example, the mid-length portraits of the poses in **FIGURES 12.11** and **12.12** are equally successful, and both originated from subtle adjustments to the original shot. I don't completely reinvent the wheel and start at a new body position every time I want to achieve a unique pose. Instead, I make subtle tweaks—adjusting the placement of the hands, a subtle rotation of the body, or a different crop. This allows me to flow from one shot to the next, capturing many successful images.

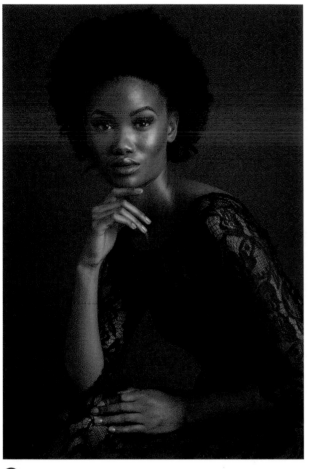
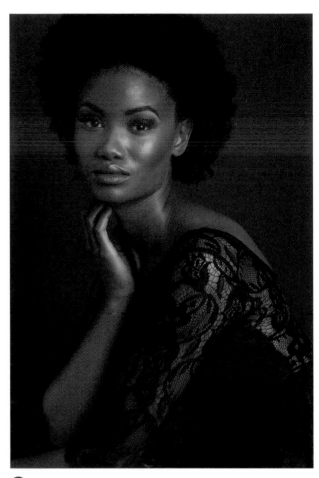

✔ 12.11

✔ 12.12

Shot #3

❌ *Problems* (FIGURE 12.13):

Hands: The placement of her hands is not flattering. The hand peeking out behind her back is awkwardly placed and distracting. The hand to her chest is claw-like and lacks elegance.

Chin: While her laughing expression is beautiful, the raised chin is not ideal and does not flatter her face.

Leg and Foot: Because one foot is kicked back, it appears as if she has only one leg. Additionally, the small part of the foot behind the skirt creates an awkward distraction due to foreshortening.

Merger: Both arms are tight against her body. Although she is quite slender, this makes her torso look very boxy.

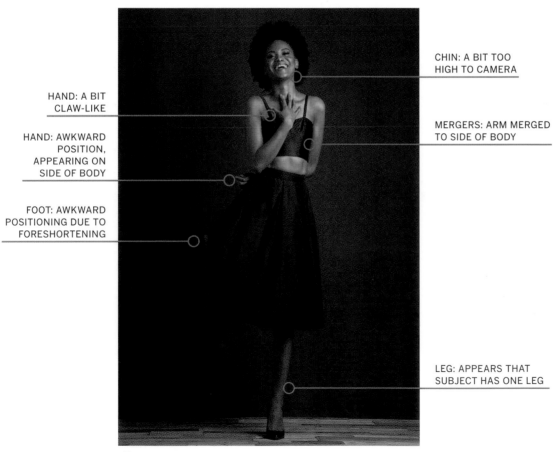

HAND: A BIT CLAW-LIKE

HAND: AWKWARD POSITION, APPEARING ON SIDE OF BODY

FOOT: AWKWARD POSITIONING DUE TO FORESHORTENING

CHIN: A BIT TOO HIGH TO CAMERA

MERGERS: ARM MERGED TO SIDE OF BODY

LEG: APPEARS THAT SUBJECT HAS ONE LEG

❌ **12.13** Shot #3

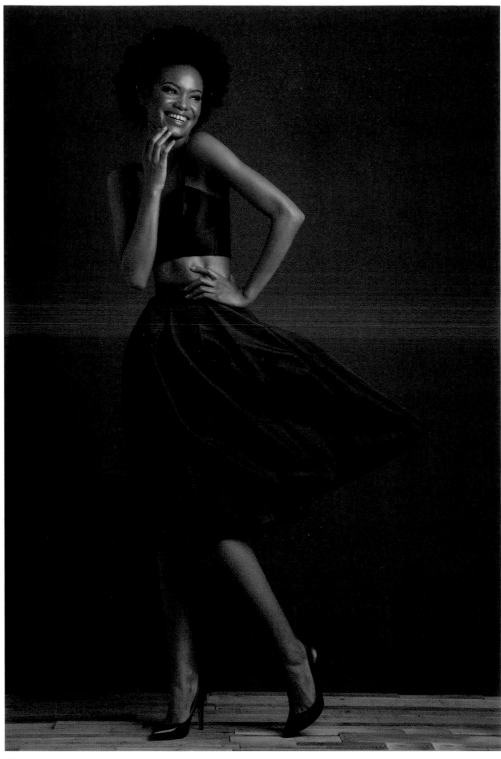

✅ 12.14

✅ *Solutions* (**FIGURES 12.14** and **12.15**):

Hands: The position of the hands has been improved dramatically. The elegant pinky sides of both hands are facing the camera. The hand to the face is playful and draws attention to her beautiful expression, while the hand on the waist helps to define shape.

Chin: Her chin is lowered and her jawline is more defined. The head position is far more flattering.

Leg and Foot: Both legs and the heels of her feet are visible, for a more flattering look. The slightly raised right foot creates visual interest and a sense of movement, avoiding the problem of flat feet.

Movement: The movement to the skirt brings more flow to the pose.

Once again, always ask yourself: What is the purpose of this shot? What am I trying to convey about my subject? In this instance, we want a shot that is joyful and playful, so the improved pose should reflect this mood. For **FIGURE 12.14**, we've maintained the expression and created a sense of energy by introducing movement to the dress. (Full disclosure: someone stood out of the frame, throwing the dress up for each shot.) The movement of the dress creates more interest and flow for the eye to follow.

If we pop into Adobe Lightroom, you can see a series of the images from this shoot (**FIGURE 12.15**). As I'm shooting, I'm analyzing my goals and what I need to flatter the subject. Once you introduce movement, you are bound to get a lot of images that are *close* but not quite right. Remember, with practice you'll learn to identify problems before the shoot is over and be able to make changes to bring all the elements together for a successful image.

Note: The images in this section have not been retouched. My subject had beautiful skin and we were able to achieve our visual goals through posing, so the retouching was extremely minor.

12.15 Experiment, try new things, and keep in mind the goals of the shot. You won't necessarily get it immediately, but with practice you'll learn to identify problems quickly and make adjustments before the shoot is over.

Subject #2: Curvy Woman

When photographing a curvy woman, we must refer back to the guidelines in Chapter 8. Also notice the role that hair, makeup, and wardrobe play in her appearance. Fuller hair can help improve proportion in the frame. Form-fitting and solid-colored clothing will be more flattering to her form. Your images will always be better when you start with a subject who feels incredible and looks incredible before applying any of your photographic magic.

12.16 Our subject as she enters the studio, before hair and makeup. The horizontal lines of her shirt make her appear larger, and styling choices during our shoot will make a remarkable difference.

In **FIGURE 12.16**, her clothing choice of horizontal lines actually makes my eye bounce from side to side over the width of her body. Although not all curvy subjects have to wear dark or solid clothing, for the purposes of our photo shoot, I will select clothing that flatters the form. Then we will be a bit more daring and create a lingerie bodysuit shot. The clothing pieces I selected were all from her wardrobe. My job is to choose the looks that will translate best on camera.

This scene is lit with three strobes. The main light (right) is a Profoto XL Deep White Umbrella with diffusion. The front-left fill light is a white beauty dish with a 25-degree grid to illuminate the lower part of the body and control shadow detail. The third light is a 10-degree grid used to create a subtle glow of separation on the background (**FIGURES 12.17** and **12.18**).

12.17

12.18

Shot #1

❌ *Problems* (FIGURE 12.19):

Mergers: The arm on the left of the frame is tight against the subject's body, creating a merger that makes her appear wide.

Hand: Her hand is in an awkward position, pointing at the camera.

Hips: Her hips are very broad and square to the camera, making her look wider.

Chin: Her chin is too neutral, so the jawline is not as defined as is desirable.

Posture: The subject is subtly leaning back away from the camera, making her head appear smaller and neck appear shorter.

Camera Angle: The camera angle is approximately even with her midsection—quite low in the frame.

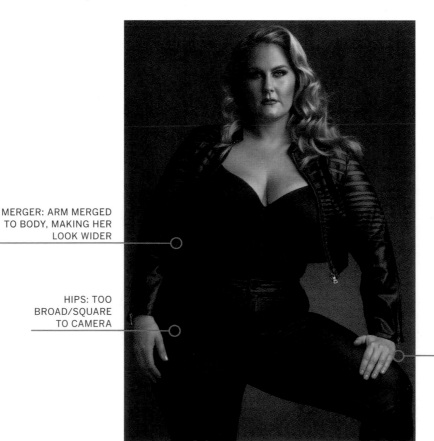

MERGER: ARM MERGED TO BODY, MAKING HER LOOK WIDER

HIPS: TOO BROAD/SQUARE TO CAMERA

HAND: SOMEWHAT AWKWARD

❌ **12.19** Shot #1

✅ *Solutions* (**FIGURES 12.20, 12.21,** and **12.22**):

Mergers: By placing her left hand on her waist, we've created negative space between the arm and the body, which now flatters the form.

Hand: The right hand is in a much more natural and comfortable position.

Hips: The hips are turned slightly away from the camera, making them appear narrower.

Chin: The subject has a more defined jawline, with the chin out and down.

Posture: The subject has improved posture and is leaning toward the camera.

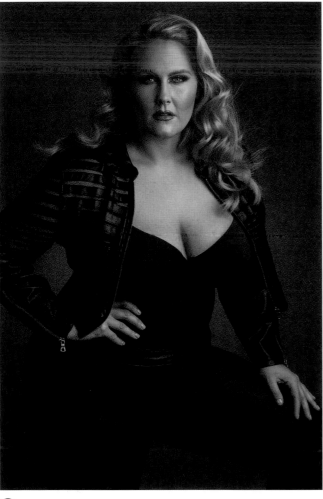

✅ 12.20

Camera Angle: The camera angle is slightly higher. Combined with the subject's lean forward, there is now more attention to the face and bust, instead of to the midsection.

This shot is successful with multiple crops, whether it is a tight close-up, a mid-length shot, or a full-length shot. This full-length image creates strong, powerful, and flattering lines for the subject. The strong angles communicate the subject's strength, which is reflected by the bold choice of clothing and dramatic hair and makeup. With a softer outfit or more demure subject, I may have selected a curvier, gentler pose. This image, however, is all about her strength. Always ask yourself: What is this image about? Are all the pieces—lighting, posing, styling, color—working together to express the purpose?

Let's take a look at the final, retouched shots side by side (**FIGURES 12.21** and **12.22**). Where do you see the changes? First, you can see that the left side of the

jacket along the body is smoother. Its original bulge was making my subject looker wider, so using the Liquify filter in Photoshop was a great way to smooth that line. You will also notice that the shoulders are a bit lower. I often lower the shoulders through Liquify in order to elongate the neck and help the subject look more relaxed. In fact, I use this technique with subjects of all different body types. It's one of my favorite post-processing secrets.

You'll notice that overall, the retouching changes are very subtle. Think "enhance" rather than "transform." I'm not trying to hide a curvy subject's curves; rather, I'm trying to make those curves look as incredible as they can. This may mean smoothing out a few bumps along the way. Notice that the lines on the left thigh and buttocks are smoother, less lumpy, and thus more flattering.

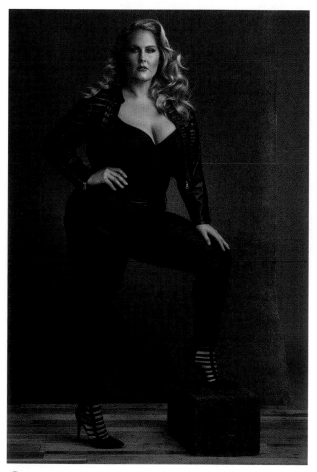

✅ 12.21

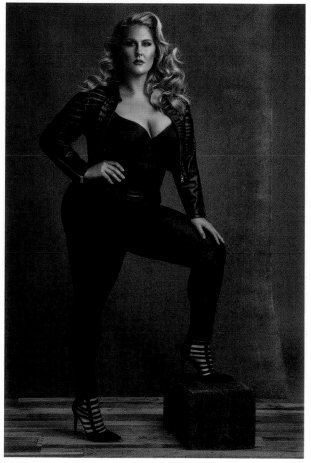

✅ 12.22

Shot #2

❌ *Problems* (FIGURE 12.23):

Mergers: One arm is tight to the body, making her body appear wider.

Foreshortening: The arm on the chair appears drastically foreshortened with no forearm visible.

Posture: The subject is slouching, essentially falling into her shoulders, which raises the shoulders and shortens the neck.

Shape: The body is too square to the camera and appears at its widest angle.

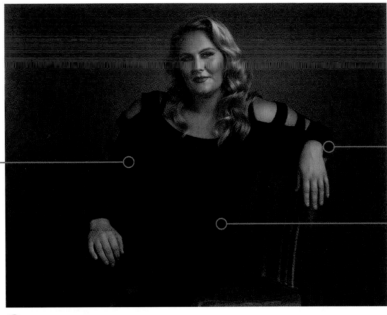

MERGERS: ARM
AGAINST BODY MAKING
IT APPEAR WIDER

FORESHORTENING:
FOREARM STRAIGHT
TOWARD CAMERA

SHAPE: BODY TOO
SQUARE TO CAMERA
(APPEARS WIDER)

❌ **12.23** Shot #2

✅ *Solutions* (**FIGURE 12.24**):

Merger: Although one arm is still close to the body, the bend in the arms works to create the illusion of a waist because the arms meet across the body at the natural waist.

Shape: Her body has been rotated away from the camera. This helps to narrow her frame, including her legs and midsection.

Foreshortening: Her arm has been turned in, eliminating the foreshortening.

Narrowing Point: Her thighs have been posed in a way that creates a narrowing point at the knees.

Posture: The posture has been improved. The neck looks longer and the chin more defined.

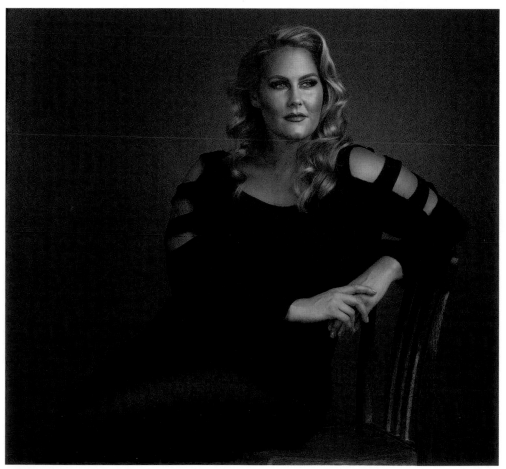

✅ 12.24

Shot #3

❌ *Problems* (FIGURE 12.25):

Merger: Her arms make her form appear wider on both sides of her body by extending beyond the edges of her frame and leaving no negative space.

Shape: Though turned at a slight angle, her shoulders still appear broad to the camera.

Camera Angle: The camera angle is a bit too low, at about chest level, thus emphasizing this part of the form.

Crop: The image is cropped at the widest part of the body—the hips—making the image appears out of proportion. The eye is drawn to the bottom of the frame and her midsection, and away from the face.

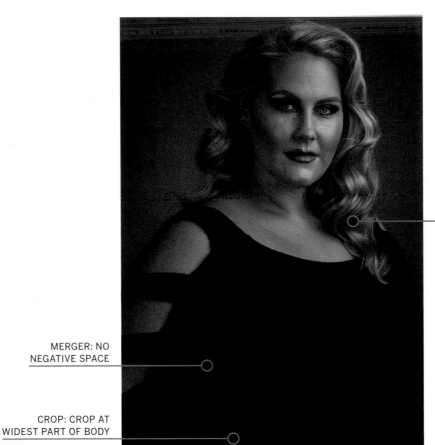

SHAPE: OVERALL BOXY SHAPE

MERGER: NO
NEGATIVE SPACE

CROP: CROP AT
WIDEST PART OF BODY

❌ **12.25** Shot #3

✅ *Solutions* (FIGURE 12.26):

Mergers: The arms have been posed so that they stay within the frame of the body, rather than extend in front of the bust or positioned behind the back.

Shape: By turning the subject to the side, we have narrowed the appearance of her form and created more interesting lines.

Camera Angle: The camera angle has been raised to eye level, bringing more attention to the face and eyes.

Crop: The crop is at the waist, a narrower point of the body, helping the subject to look more slender.

Sometimes improvements to a pose don't need to be drastic at all. It may just be a matter of rotating the body, combined with a higher camera angle. Dramatic changes usually aren't required.

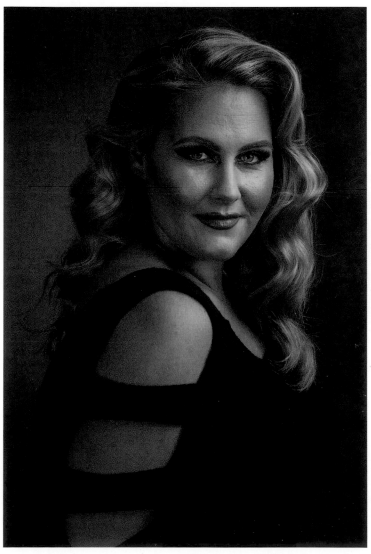

✅ 12.26

Shot #4

❌ *Problems* (FIGURE 12.27):

Arm: Her right arm is slightly foreshortened and looks awkwardly placed.

Mergers: Her left arm is merged across her body, making her appear wider. Also, the arm is too straight.

Thigh: Her thigh is pressed against the stool, creating unflattering pressure.

Feet: She is flat-footed and her feet are symmetrical.

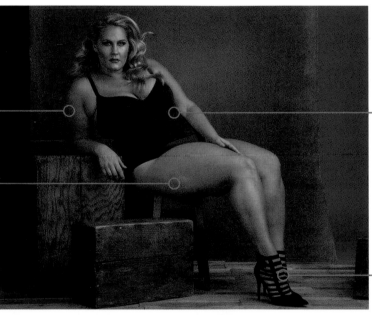

ARM: PRESSURE ON ARM, AWKWARD POSITION

THIGH: PRESSURE ON THIGH MAKING IT LOOK THICKER

MERGER: ARM MERGED AGAINST BODY

FEET: FLAT AND EVEN

❌ **12.27** Shot #4

✅ *Solutions* (FIGURE 21.28):

Arm: Her right arm has been turned to the side to correct foreshortening.

Mergers: Her left arm has been raised to a higher level to create drama and avoid mergers.

Thigh: The pressure has been reduced from her front thigh.

Feet: By placing her feet at different levels to create asymmetry, we've created more flow and interest.

I do as much as possible to get the shot right in-camera. This is achieved through lighting, posing, lens choice, clothing, and more. Nevertheless, with some images and subjects, retouching may help reduce distractions.

What elements of the image are pulling my attention away from my subject's beauty, and can I remove them or make them more subtle? In **FIGURE 12.29**, I use a pose to flatter my subject's form but find some loose skin and cellulite to be distracting from how truly stunning she looks. For the final step of the process, I don't aim to make her look skinnier, but rather, I make changes to downplay areas where she may not want attention drawn. Remember our guidelines for posing women? Draw attention to their strengths and away from weaknesses. Sometimes subtle retouching may do the trick that the camera can't. Am I saying that these areas are innately weaknesses? Certainly not, but from years of experience, I know that most of my female subjects would like less attention to be focused on cellulite, rolls, or loose skin.

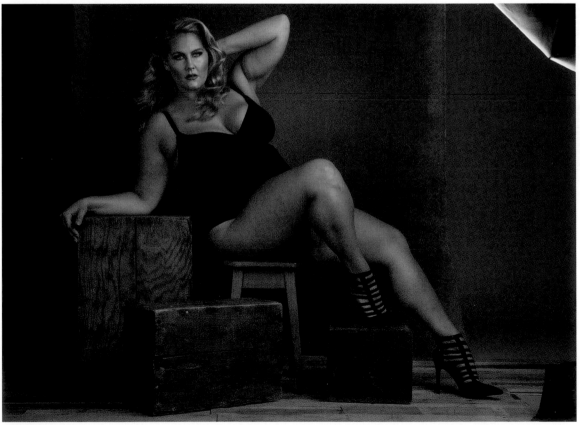

✔ 12.28

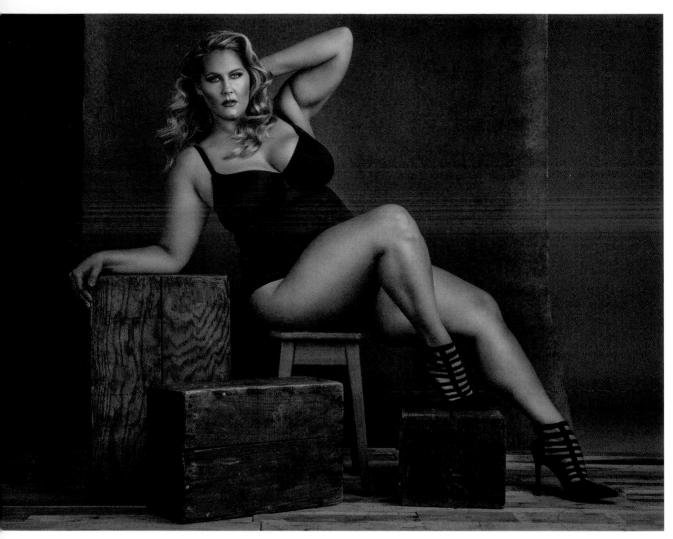

12.29 Retouching has been used to lessen areas of looser skin on her arm and thigh and to remove cellulite or unflattering textures on the thighs.

Subject #3: Family

Family portraits require you to think about composition as a whole, as well as flattering each individual. This portrait is lit with one Profoto Strobe (Profoto D1 Air) using an XL Deep White Umbrella with diffusion. To the left of the frame in **FIGURE 12.30**, a large white V flat (white foamcore) is used as a fill light to avoid dark shadows. The background is the "Couture" Muslin background I designed for Seamless (www.seamlessphoto.com), provider of photography equipment.

Shot #1

❌ *Problems* (**FIGURE 12.31**):

Overall: The frame lacks togetherness. Everyone is too far apart, and they appear disjointed because of the negative space between them.

Crop: The crop on the right of the frame cuts into the subject's elbow, creating an abrupt and undesirable framing. The overall loose crop focuses more on the feet and bodies than the faces of the subjects.

Hands: The hands are not being used to their full benefit to help unite the family and the composition.

Mother on Right: She is standing flat-footed with her hips wide to the camera. There are no curves or narrowing points.

Seated Mother: Her chin is raised and the pose looks accidental.

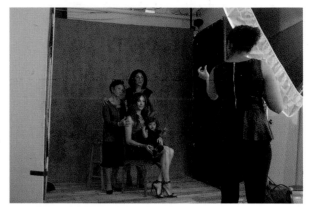

12.30

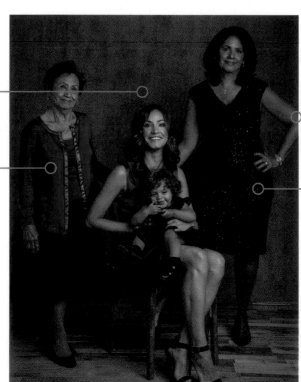

SPACE: TOO MUCH SPACE CREATING VOID

INTERACTION: EVERYONE LOOKS DISJOINED, WITH MINIMAL INTERACTION, LACKING "TOGETHERNESS"

CROP: ODD CROP ON ELBOW

HIPS: TOO WIDE TO CAMERA

❌ 12.31 Shot #1

✅ *Solutions* (**FIGURES 12.32** and **12.33**):

Overall: Everyone has been moved in closer for a tighter composition, with each head being placed to create another triangle. The heads have been tilted together subtly to communicate affection.

Crop: A closer crop has been chosen to draw more attention to the faces, while avoiding cropping off the elbow and fingertips.

Hands: The hands have been placed to create visual flow in the image, unifying the family. Notice that we have avoided foreshortening, or "nubs," when placing the hands.

Mother on Right: Her hips are to the side with her weight pushed back and chest forward, slenderizing her hips and overall frame. Her arm has been placed to create negative space and to show the curve of her lower back.

Seated Young Mother: Her chin is now out and down, creating a more pleasing expression.

When shooting a flattering family portrait, I not only want to flatter each person individually, but also to create a pleasing composition for the group as a whole. For this portrait of four generations, I want to be sure that the poses I choose will help each woman look her best, and also show the closeness of the family.

I begin to build the shot by directing the young mother to sit, holding her daughter in her lap. Often, I ask the oldest person or grandparent to sit for their comfort during the shoot, but in this instance it is more convenient to sit the mother and her young child. By using multiple levels (sitting and standing), I am able to bring interest to the frame while also keeping a tight composition. If they were to stand side by side, this would be much more difficult to achieve.

As suggested in the guidelines for family photography, I begin by placing the mother and child, and then add each of the remaining women to the composition. To create a compelling composition, I envision my triangles to figure out an ideal position for each person.

As I add each woman, I choose poses that flatter her body type. For the woman on the right, I consider her shape and proportions when creating her pose. I direct her to stand slightly rotated to the side, thus narrowing

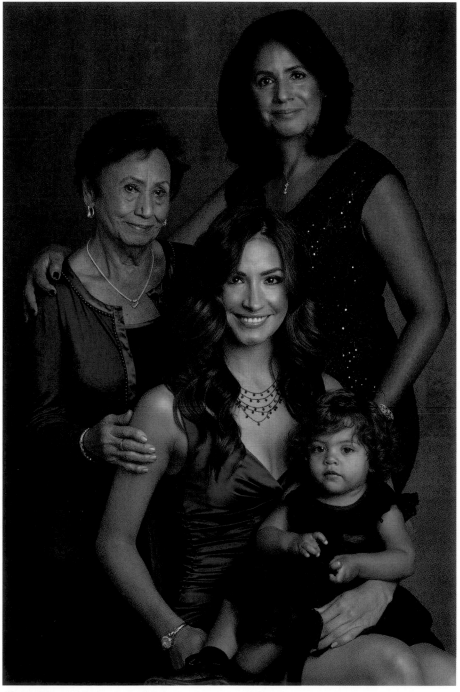

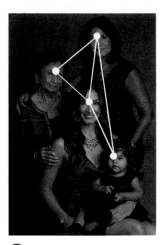

the width of her body. Next, I have her place one foot back and shift her weight onto that foot, making her midsection appear smaller. This improves her overall proportions in the image. Next, I position her arm on her daughter's shoulder, careful not to hide the curve of her lower back. Furthermore, the front of her body is slightly obscured by her daughter to help slenderize her frame.

Once I've correctly positioned each woman, I carefully direct the hands. The hands become an important tool in the frame, giving the eye leading lines to follow through the composition. Notice that I aim to avoid distracting foreshortening with the hands (or having little nubs of fingers sticking out), and instead use the hand placement to help unite the family and create visual flow.

Now that I've achieved triangles, flattering poses, and well-placed hands, it's time for the final, subtle head tilt. Notice the subtle inward tilt of the heads and how it communicates even more love and affection. Next, I focus on achieving just the right expression and getting everyone to look their very best in a single frame. To put it lightly, this is no easy task. It takes years of practice, and sometimes a lot of digital frames (**FIGURE 12.34**).

As I've stated many times before, there is no single right pose. Instead, there are many solutions. Let's assume that I also want to sit the grand-mother for her comfort (**FIGURES 12.35** and **12.36**). No problem! Here is yet another beautiful solution using triangles, head tilt, and uniting hand place-ment. I've used the exact same approach, yet I have a completely different (but successful) configuration.

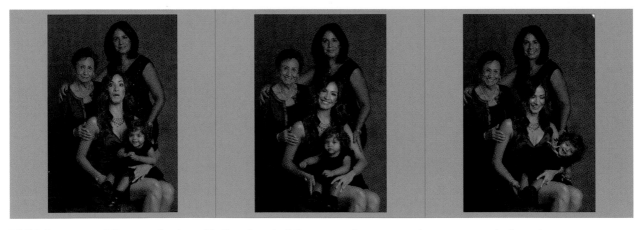

12.34 Once you get the pose in place, it's time to get all the expressions on par. As you can see in these images, sometimes the expressions aren't quite right, and more frames are required to bring it all together.

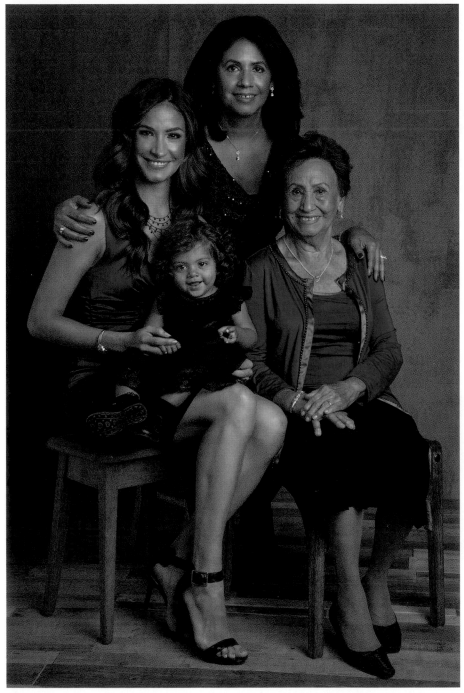

✅ 12.35

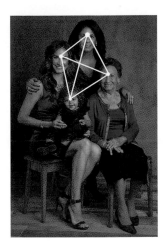

✅ 12.36

Subject #4: Couple

When photographing a couple, make time to capture individual shots. Your clients might be celebrating a special occasion, but they might not have had individual portraits done before. Keep in mind the purpose of the shot: Is it a formal engagement portrait or a more romantic and creative shoot, commemorating a special event? See if you can work that purpose into your shot as well as your poses.

For this session, I begin with portraits of the man and woman by themselves (**FIGURES 12.37**, **12.38**, and **12.39**). Once they are comfortable and have great individual images, I move on to couples portraits, where I can focus on flattering both subjects and creating genuine expression.

Figure 12.37 is lit with two strobes (Profoto D1 Air). The main light to the right of the frame is a Profoto XL Deep White Umbrella with diffusion. The second image is a 10-degree grid pointing from the left of the frame. This creates a glow on the background to create separation between the subject and the background, helping ensure that the form doesn't blend in.

12.37

Shot #1

❌ *Problems* (**FIGURE 12.38**):

Posture: The subject is slouching, with poor posture.

Expression: The expression is weak and unengaged.

Overall: Overall, the pose is hunched and lacks strength or structure.

Hands: The hands are aimless, lifeless, and distracting.

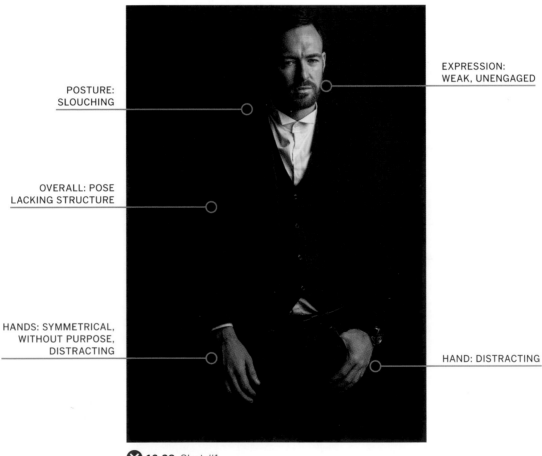

POSTURE:
SLOUCHING

EXPRESSION:
WEAK, UNENGAGED

OVERALL: POSE
LACKING STRUCTURE

HANDS: SYMMETRICAL,
WITHOUT PURPOSE,
DISTRACTING

HAND: DISTRACTING

❌ **12.38** Shot #1

✓ *Solutions* (**FIGURE 12.39**):

Posture: The posture is improved, making the subject look stronger, with more structure to the form.

Expression: The expression is direct and more engaged with the camera.

Hands: The hands have been given purpose and are in a more flattering position. One hand is completely in the pocket, so the fingers are not distracting, and the other is holding the vest, thus creating stronger lines.

Overall: The improvement in posture and hand placement has given a better flow to the image, exuding more strength, and with firmer structure.

12.39 Show the men some love! Even in a couples session, take the time to do individual portraits and vary the look.

Show the man a little love! So often men get the "stand there and put your hands in your pockets" pose. Try some different outfits, confident poses, dramatic lighting patterns, crops, and more. A lot of men don't have the opportunity to be photographed very often, but I'm pleasantly surprised by how excited they get with good portraits of themselves. They want to look good. They want to feel good. Give them the attention and fantastic images they deserve (**FIGURE 12.40**).

✓ 12.40

✓ *Solutions* **(FIGURE 12.42):**

Camera Angle: A higher camera angle improves proportion, bringing more attention to the faces instead of the midsections.

Body Position: She shifts her weight slightly away from the camera, slenderizing her hips and waist, while both subjects lean their torsos toward the camera. She steps a bit farther back and leans toward the camera, which helps to equalize their heights.

Expression: Both expressions are more engaged and reflective of the desired mood.

Shoulder: Her shoulder is relaxed, revealing her neck.

Arm: Her arm is pulled slightly away from her body, releasing tension and slenderizing its shape.

Hands: The distracting elements of the hands have been vastly improved. The hands are now better positioned to create multiple points of interaction and between lines to provide flow for the eye to follow.

✓ 12.42

Subject #5: Curvy Woman

Women come in many shapes, and this stunning woman is a perfect example (**FIGURE 12.43**). She has a petite torso and very curvaceous hips and thighs. Our goal in this portrait is not to eliminate her curves, but to flatter them. Furthermore, we may slightly even out her proportions in order to draw more attention to her face. We will use all of our available tools—clothing, posing, camera angle, and retouching—to create some really "Wow!" portraits.

FIGURE 12.44 is lit with three strobes. The main light (right) is a Profoto XL Deep White Umbrella with diffusion. The front-left fill light is a white beauty dish with a 25-degree grid to illuminate the lower part of the body and control shadow detail. The third light is a 10-degree grid used to create a subtle glow of separation on the background.

12.43 Our subject as she enters the studio—no hair and makeup.

12.44

Shot #1

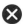 *Problems* (**FIGURE 12.45**):

Merger: The arm on the left is merging with the side of her body, leaving no negative space and no way to see the curve of her waist.

Shoulders: Her shoulders are raised, showing tension and shortening her neck.

Proportion: The shot lacks balance. The viewer's eye is drawn mostly to the bottom of the frame.

Crop: The image is cropped at the widest part of her body (at the hip and thighs), making her appear larger.

Foreshortening: Her hand is slightly foreshortened due to its angle (fingers facing the camera).

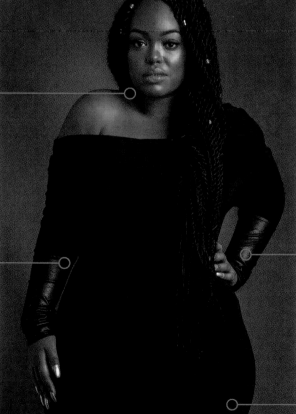

SHOULDER: A BIT HIGH, SHORTENING NECK AND SHOWING TENSION

MERGER: ARM NEARLY MERGED WITH SIDE OF BODY

FORESHORTENING: SLIGHT FORESHORTENING DUE TO ANGLE OF ARM/HAND

CROP: AT WIDEST PART OF THE BODY (MAKING HER APPEAR LARGER)

❌ **12.45** Shot #1

✅ *Solutions* (FIGURE 12.46):

Merger: The hands are carefully placed to leave negative space on both sides of the body, showing her natural waist.

Shoulders: Her shoulders have been relaxed and lowered, and her posture is improved.

Proportion: Her form appears more in proportion. The subject has leaned her chest forward, and we are shooting from a higher camera angle. All of these adjustments bring her face and chest closer to the camera, creating more balance with the lower part of the frame.

Asymmetry: One hand is placed on the waist, defining it, while the other is placed low on the hip and thigh. This creates visual flow and interest.

Crop: The frame has been cropped lower, utilizing a narrowing point in the frame by crossing one leg in front of the other.

During a portrait session, I really try to work a single pose before moving on and trying something else completely different. I flow between variations of the same base pose.

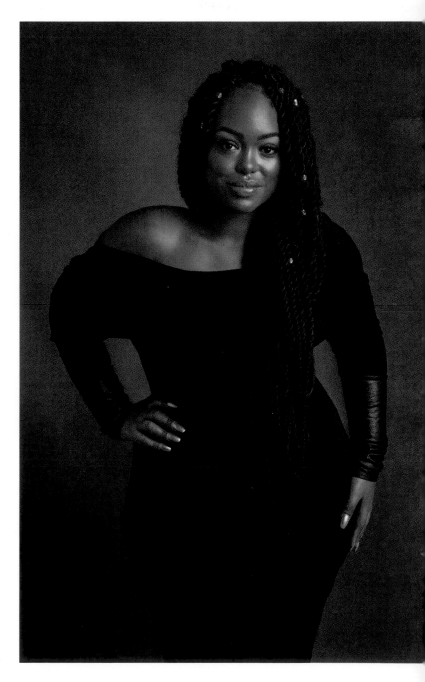

✅ 12.46

I can also vary the expression, the hand placement, and the crop, and each combination gives me a different look. I'll experiment with some standing poses, then perhaps try some sitting poses. I don't, however, feel compelled to capture 50 distinct poses in every body position possible. Instead, I want to really explore a pose and create subtle variations of expression, pose, and crop to give me different moods.

With my portrait subject seated, you can see that I don't need to drastically alter her pose to give myself a variety of beautiful images; all the shots seen here have been captured within about 1 minute (**FIGURE 12.47**).

12.47 Subtle changes to the crop, expression, and hand position can create variety within a single body position. Here, you can see this in action for this same look.

Shot #2

✖ *Problems* (FIGURE 12.48):

Arm: Because of the leaning pose, she is putting all of her weight and balance on her arm. The pressure on the arm, squished tight against her body, makes her arm appear larger than normal.

Hand: Her fist is clenched, showing discomfort in the pose.

Posture: She has very poor posture, collapsing into her shoulders and nearly eliminating her neck.

Shape: While the lower part of her body appears smaller because it is turned away from the camera, it also appears quite flat and lacks interesting curve.

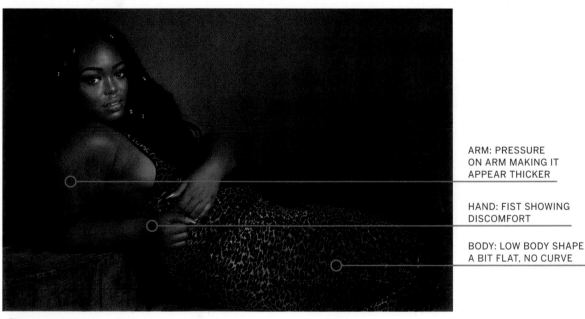

ARM: PRESSURE
ON ARM MAKING IT
APPEAR THICKER

HAND: FIST SHOWING
DISCOMFORT

BODY: LOW BODY SHAPE
A BIT FLAT, NO CURVE

✖ 12.48 Shot #2

CAUTION Be aware of "arm squish"! This can be caused by a number of factors, such as the subject leaning on a wall, putting pressure on their arm, or having their arm pressed too tight against their body.

✅ *Solutions* (FIGURE 12.49):

Arm: We pull her arm a bit farther away from her body to alleviate some pressure, making it appear more slender.

Hand: The clenched hand has been relaxed, producing much more pleasing results. Her left hand is raised to the face, leading the viewer's eye upward to the center of interest in the frame.

Posture: She has elongated her body and pulled up through the top of her head, creating a longer neck.

Shape: She has turned her hips slightly toward the camera, creating a narrowing/tapering point at the end of the frame, which creates a pleasing curve.

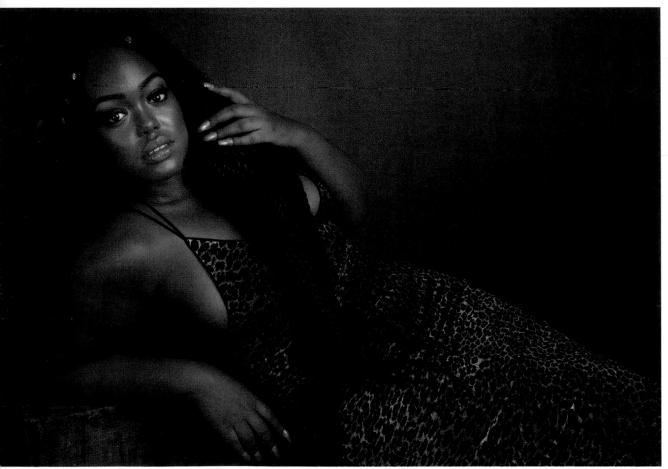

✅ 12.49

Camera Angle: Adjusting the camera angle closer to her face and from a slightly higher angle draws more attention to her face and slenderizes the lower half of her body. This tool of perspective has been applied subtly for this image.

While the improved pose looks great in-camera, retouching is a useful tool to remove distractions and enhance her body shape. Because she had played paintball a few days before the shoot, I've retouched the image using the Clone and Patch tools, to remove the bruises. From there, I use Liquify in several ways to enhance the shape of her body. And although posing has improved the pressure on her arm, a bit of Liquify slenderizes it even more and returns it to its real proportions while also lowering the shoulder. Next, I use Liquify at the very bottom of her thighs as well as the Forward Warp tool to make them just a bit narrower, thereby creating even more pleasing curves for the eye to follow. You will also notice that I've used Liquify to add further definition to the waist, as suggested by the guidelines for curves. Finally, you may notice a shine to her skin that makes it look tighter and smoother. I've used a technique called contouring, which allows me to paint highlights and shadows to enhance certain features, such as her torso and collarbone, and to make the skin on her arm appear tighter (**FIGURE 12.50**).

Retouching is not used to transform her body; it is used to remove distractions and enhance the beautiful curves that we have already flattered through posing.

PRO TIP

Retouching I use Liquify and the Forward Warp tool in subtle ways to help improve the shape of the form and enhance my subject's features:

1. To smooth out bumps and clothing in skin that are a distraction
2. To emphasize a waist or narrowing point
3. To subtly slenderize features, particularly when the posing has made them look thicker
4. To lower the shoulders and elongate the neck

To learn more about retouching, contouring, and Liquify, visit ⎆ **Learnwithlindsay.com** for several tutorials on these subjects.

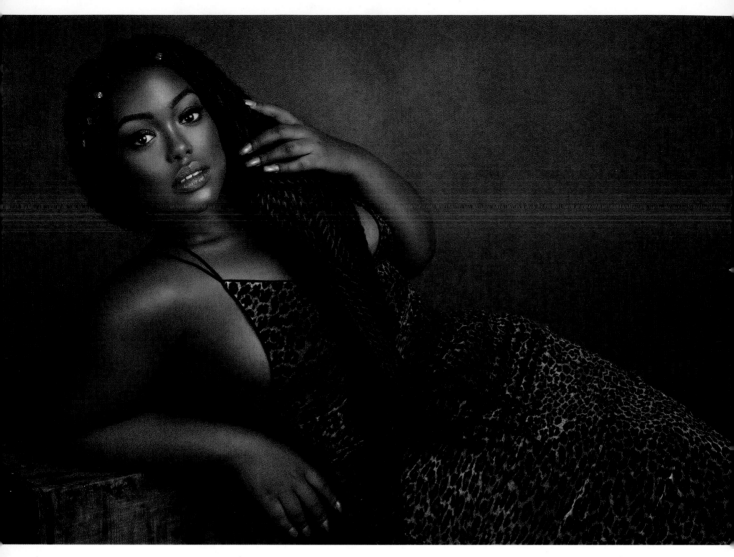

12.50 Retouching has been used to remove distractions and enhance her body shape. The Liquify filter has been used to further define her waist, slightly exaggerate the narrowing point, and slenderize her arm.

Conclusion

It's time for you to take all the information you've learned and start putting it into practice. Sure, you won't have posing mastered right away. It has taken me more than a decade to achieve the understanding of posing that I have today, with hundreds and hundreds of shoots to put my skills to the test.

Don't forget to take a look at your images after the fact, and then pause to reflect on what did and didn't work. We often focus only on the images that made the final cut, but how can we increase the number of successes we have per session? What common pitfalls are you falling into, and can you watch for these in the future? What poses do you like the best, why, and can you utilize them more in your work? Take what you've learned in this book and the analysis of past shoots to continue to grow. Learn to see problems in-camera and watch as your number of winning shots increases.

There are so many things you must think about during a session: lighting, camera settings, focus, concept, and a plethora of other elements that go into making a shoot successful. Posing is just one of these indispensable ingredients, and I hope this book has helped solve some of the mysteries of posing. Use this book as a reference to refresh and inspire your mind just before each shoot, and to build strong foundations to bring out the best in every subject.

Posing is a way to flatter your subjects and part of the photographic style you'll cultivate. You may utilize dramatic poses, whereas another photographer may choose more free-flowing and natural-looking body positions. Regardless, the fundamentals are the same and the choice comes down to personal style. As you grow as a photographer, so, too, will your style. As you shoot, posing will begin to become second nature. Your confidence will grow, and you can pass this comfort and confidence on to your subjects.

I hope your confidence and knowledge have already begun to expand. Now it's time for the most fun and challenging part—shooting, making mistakes, and improving. I wish you the best of luck in your exploration of this beautiful craft and in your quest to master posing.

INDEX

#

10 Steps to Posing Success, 99–100

A

anchor, 175
angles, 129
antique shops, 175
arch, 320
arm squish, 217, 429
armpits, 128
arms, 50, 66, 192, 253, 263, 325, 344, 366, 395
asymmetry, 134, 216
atmosphere, 39

B

back, 322, 325
balance, 263, 293–295
base pose, 100
bend and curve, 124
better side, 39–40
body language, 296
boudoir, 319
bounce step, 152
bouquet, 215
boyfriend shirt, 343
buttocks, 339

C

camera angle, 22–28, 57, 100–105, 116, 230, 254, 308, 345
camera position, 105
cheek, 55
chest, 338
child, 293
chin, 46–47, 52–53, 263
clothing, 78, 117, 255–259, 264
composition, 293
confidence, 3
contour, 77, 366
contrapposto, 144–145, 174, 320–321
couples, 205, 293, 372, 418
crop, 26–27, 31–33, 105, 148, 230, 269, 345
crotch, 193
curve, 320
curves, 249, 249, 251, 331, 365, 402, 425

D

depth, 306
depth of field, 105, 230, 306, 345
direct the eye, 53, 263, 341
directing, 36, 39, 341
direct the face, 35
drama, 138

E

emphasize assets, 116
engagement, 50
exaggeration, 250–252
expression, 84–87, 104, 238, 303
eyes, 48–50, 218, 345

F

face, 57, 84–86, 104
family portraits, 283, 284, 412
fan, 154
features, 40–41, 58
feet, 144, 185, 189, 327
fingers, 301
flow posing, 112–113
focal length, 15, 22–23, 45
focus, 230
forehead, 48
foreshortening, 66, 70, 101–102
Forward Warp, 431

G

gesture, 37
go-to poses, 100, 151, 164, 202, 246,
 280, 316, 356, 386
groups, 296

H

hair, 40, 265
hands, 79, 80–84, 103, 185, 188,
 218, 261, 264, 299, 341, 361, 368
head, 85, 194, 211
 levels, 296
 position, 43–44
headshot, 45–46, 51
height, 26–29, 64, 213, 222,
 295, 308
hips, 250
hourglass, 147

I

in-body posing, 75, 263
interaction, 206

J

jawline, 46, 83, 180

K

kiss, 208, 211
knee, 150, 325, 327

L

leg, 142, 212, 362, 395
lens choice, 14–15, 24, 105, 116, 230
levels, 134
lips, 85
Liquify, 431

M

making the rounds, 225
maternity, 359
men, 38, 167
mergers, 72, 74, 78, 102, 361
midsection, 50, 63, 322, 336
mirroring, 36–37
mood, 138
movement, 152

N

narrowing points, 121–122, 150,
 269, 365
neck, 50, 57, 62
negative space, 74, 126
nose, 54–55

O

overlap, 302
partner, 372
perspective, 14, 18, 20, 22, 116, 250,
 303, 370

P

point of focus, 105, 345
posing checklist, 391
posing couples (see couples)
posing men (see men)
posing pitfalls, 61
posing women (see women)
pocket, 188
posture, 62–65, 103, 267
profile, 360
proportions, 218–221
props, 175, 343

R

relative distance, 20

S

seated poses, 267
selfies, 40
shapewear, 256
shoulders, 50–53, 181, 301
silhouette, 130–131
slouch, 299
stacking, 218
stomach (see midsection)
structure, 168

T

tall, (see height)
tension, 82
train your eye, 9, 90, 156, 195, 239,
 273, 309, 348, 378
triangles, 284–293
tutorials, 390

U

undergarments (see clothing)

V

variation, posing, 99
visual balance (see balance)

W

waist, 259
windup, 153
wrist, 124, 325
women, 115–116